TRANSMEDIA MARKETING

D0219186

Transmedia Marketing: From Film and TV to Games and Digital Media skillfully guides media makers and media marketers through the rapidly changing world of entertainment and media marketing. Its groundbreaking transmedia approach integrates storytelling and marketing content creation across multiple media platforms—harnessing the power of audience to shape and promote your story.

Through colorful success stories and insight from top entertainment professionals, *Transmedia Marketing* covers the fundamentals of a sound twenty-first-century marketing and content plan. You will master the strategy behind research, target audiences, goals, and branding; and learn first-hand how to execute your plan's publicity, events, advertising, trailers, digital and interactive content, and social media. Anne Zeiser enlivens these concepts with:

- Vibrant examples across media platforms—*The Hunger Games*, *Prometheus*, *The Dark Knight*, *Bachelorette*, *Despicable Me 2*, *Food, Inc.*, *Breaking Bad*, *House of Cards*, *Downton Abbey*, *Game of Thrones*, *Top Chef*, *Pokémon*, *Biosphere Infinite*, *Minecraft*, *LEGO Marvel Super Heroes*, and *Halo 4*
- Real-world advice from 45 leading entertainment and media makers, marketers, and executives
- Powerful in-depth case studies—*A.I. Artificial Intelligence*, *Mad Men*, *Lizzie Bennet Diaries*, *Here Comes Honey Boo Boo*, and *Martin Scorsese Presents the Blues*
- Expanded case studies, interviews, and sample materials at www.transmedia marketing.com

With *Transmedia Marketing* you'll be well-versed in the art of marketing film, TV, games, and digital media and primed to write and achieve the winning plan for your media project.

Anne Zeiser is a critically-acclaimed producer and media strategist who has stewarded iconic series for PBS, produced news for CBS, managed national brands for marketing firms, and founded Azure Media, which develops transmedia projects *on air*, *online*, and *on the go* that fuel social impact. With partners from PBS and BBC to Miramax and Sikelia Productions, Zeiser has successfully launched film studios and media organizations, feature and documentary films, television series and specials, mobile games and apps, and online video and media communities.

TRANSMEDIA
MARKETING

From Film and TV to Games and Digital Media

ANNE ZEISER

Focal Press
Taylor & Francis Group

NEW YORK AND LONDON

First published 2015
by Focal Press
70 Blanchard Road, Suite 402, Burlington, MA 01803

and by Focal Press
2 Park Square, Milton Park, Abingdon, Oxon OX14 4RN

Focal Press is an imprint of the Taylor & Francis Group, an informa business

Notices
Knowledge and best practice in this field are constantly changing.
As new research and experience broaden our understanding, changes
in research methods, professional practices, or medical treatment
may become necessary.

Practitioners and researchers must always rely on their own experience
and knowledge in evaluating and using any information, methods,
compounds, or experiments described herein. In using such
information or methods they should be mindful of their own safety and
the safety of others, including parties for whom they have a
professional responsibility.

Product or corporate names may be trademarks or registered
trademarks, and are used only for identification and explanation
without intent to infringe.

Library of Congress Cataloging in Publication Data
Zeiser, Anne.
 Transmedia marketing : from film and tv to games and digital media /
 Anne Zeiser.
 pages cm
 ISBN 978-0-415-71611-6 (pbk.)
 1. Mass media—Marketing. 2. Digital media—Marketing. 3. Marketing—
 Technological innovations. I. Title.
 P96.M36Z45 2015
 302.23068′8--dc23
 2014035112

ISBN: 978-0-415-71610-9 (hbk)
ISBN: 978-0-415-71611-6 (pbk)
ISBN: 978-1-315-88011-2 (ebk)

Typeset in Helvetica
by Florence Production Ltd, Stoodleigh, Devon, UK

Printed and bound in the United States of America by Sheridan Books, Inc. (a Sheridan Group Company).

To Mom, the consummate maker.

To Dad, the consummate marketer.

Contents

Acknowledgments

I've been supremely lucky to have had generous mentors and inspirational influences throughout my career. And, in writing this book, there have been some real stand-outs who helped me get here.

First, last, and always is Martie Cook, who showed me by her doing, who told me by just saying, and made me by gently coaxing.

Linda Reisman, who along with Martie, helped me pioneer the first course in transmedia at Emerson College and connected me to some amazing talent.

Andrea Phillips, who welcomed me further into the transmedia community as I began exploring the course and this book.

The scores of experts whom I interviewed from film, TV, games, and digital media—directors, producers, writers, marketers, publicists, publishers, digital experts, designers, composers, curators, lawyers, distributors, critics, journalists, professors, festival and market programmers, awards professionals, and guild execs—all busy working professionals who gave freely of their time and brilliant insight.

My case study inspirations and contacts—Jordan Weisman, Dustin Smith and Rose Stark, Mark Gardner, Bernie Su, and Bonnie Benjamin-Phariss—whose media and entertainment projects came to life in this book because of their extraordinary commitment.

Emerson College, an amazing institution of professors, administrators, and students. In particular, the Visual and Media Arts Department, where I serve as an adjunct professor, and the inaugural students in my new transmedia class, who were guinea pigs for these concepts and who taught me more than I taught them.

My publisher, Focal Press/Taylor & Francis, which came to me with the germ of an idea for this book, allowed me to make it my own, and guided me tirelessly to bring it to fruition: Emily McClosky, Dennis McGonagle, Peter Linsley, Scott Berman, Sloane Stinson, Megan Hiatt, Denise Power and Nicola Platt.

Jonathan Wolf and American Film Market, which partnered with Focal Press to present this new title and support this emerging discipline.

My intrepid reviewers, Barbara Doyle and John Murphy, whose incisive suggestions were spot on.

Legal counselors, Sandy Forman, Jay Fialkov, Jeff Garmel, and Donna Graves, who shed light on the byzantine world of legal clearances.

Many more who supported me in various ways, but especially my project partners and clients at Azure Media and Susan Schreter, Chris Kelly, and Bruce Zeiser.

And finally, my family of "boys," Paul, Matty, and Curtis, who saw so little of me during this process.

Preface

Over the past decade, I've had countless queries from anxious filmmakers and media makers seeking advice about setting up a Facebook page or a Twitter account. While that's not my core business, they saw it as more in my wheelhouse than theirs. My first response was, "Why?" Some said, "Because these days you need it for a film (or TV show, or game, or book)." I probed further, "What do you want the social media platform to achieve?" Dead silence. A few secretly hoped that simply having a social presence would be enough to place them firmly in the twenty-first century. To their chagrin, I advised them there was no point in setting up social media just to have it. Like every other form of content creation and content marketing, social media must be *part of a thoughtfully-designed plan to achieve enunciated goals with key target audiences*. Fast forward to today, most of us unconsciously espouse that philosophy as we craft our social personas.

Yet now, I get the same kinds of queries around transmedia—the media buzzword *du jour*. Many producers and marketers want their media and entertainment properties to be transmedia, but don't fully understand how adding media platforms to their project fits into the overall story arc or audience experience. Like the art of developing a vibrant and relevant social media graph, being transmedia is more than ticking off a box to say you've done it. You must invest in it, tinker with it, and learn from it.

The great news, when you strip away the semantics, you'll find that the core of transmedia is something you're probably already doing. You're already engaging audiences with your narrative using various media. Through both traditional and mobile media, you're reaching them wherever they are—in theaters, in living rooms, in cars, in museums, and on the street. And your content isn't just randomly distributed across various media streams. It's part of something bigger and more strategic.

Transmedia marketing is a holistic content creation approach—both storytelling and marketing—simultaneously across multiple media platforms. It's *part of a thoughtfully-designed plan to achieve enunciated goals with key target audiences*. Sound familiar?

That's because social media has ushered in a mindset of engaging audiences with media and entertainment properties with additional media platforms—Facebook, Twitter, YouTube, Tumblr, Instagram, Google+, Pinterest, and LinkedIn. A fully-transmedia approach simply expands that universe of platforms to film, TV, radio, books, publications, games, online, mobile, toys, live installations, events, and more.

So, that decade of chasing the Wild Wild West of social media, proclaiming, "There's gold in them thar hills!" had some kernels of truth. The opportunities and lessons of social media and viral marketing preview this modern era of transmedia. Tweets or shared online video teasers, once seen as marketing tools for a bigger product, are media products unto themselves. The socialization of content has blurred the lines between entertainment and its marketing. In any form, media content can both advance the story and market the story. In this new media and entertainment world order, that makes you both a *media maker* and *media marketer*. And to connect audiences with your media projects in this content-saturated world, you must provide multiple media on-ramps. That also makes you *transmedia*.

As a twenty-first-century media maker and media marketer who's telling stories and engaging audiences in entertainment experiences on multiple media platforms, *Transmedia Marketing: From Film and TV to Games and Digital Media* is for you.

Still, you might ask, if your primary job is to write television scripts, why do you need to understand games? Because your pilot's premise might be suitable for an interactive gaming experience that feeds superfans. If you create movie trailers, why do you need to understand social platforms? Because your trailer could be the lynchpin of a mysterious social teaser campaign to promote the film. If you produce films, why do you need to understand target audiences? Because to greenlight your film, you must prove to financiers and distributors that it's marketable to key audiences. And, if you publicize games and digital media, why do you need to understand story? Because to secure press and blogger coverage, you must craft compelling narratives about your media project.

You *can* embrace this new sensibility of making and marketing content across multiple media platforms. Grandma Moses didn't start painting in earnest until she was 78 years old. Her bold and indomitable spirit is what transmedia's about. Remember how foreign your first Facebook account felt when you set up? Now it's second nature to tell your story or telegraph something you deem important on it. You've become an agile content creator and marketer on that platform. And you can be just as facile and compelling on other media platforms—*on air*, *online*, *in print*, and *on the go*.

It's well worth it, because embracing multiple media platforms delivers huge rewards. Transmedia cuts through the morass of content and connects your audiences with deep, participatory experiences. This translates into audiences' active engagement with and co-creation of your content. Then they find meaning and connect personally to it. This translates into audience loyalty for and ambassadorship of your project—the Holy Grail of branding, marketing, and engagement. When your fans use, love, and tell others about your media content or project, that's a smash hit for you.

Transmedia Marketing will get you there because it takes a twenty-first-century holistic approach to content creation across multiple media platforms, using both storytelling and marketing. It teaches media makers and marketers like you the fundamentals of developing a sound marketing and content plan through strategic research, target audience identification, goal-setting, and branding. And it demonstrates how to execute key elements of your plan—from publicity, events, partnerships, and advertising to online content and video, social media, and interactive media.

These key concepts come to life throughout, with real-world insight and quotes from original interviews that I conducted with more than 45 top media and entertainment experts across various media. They include writers, directors, producers, composers, distributors, marketers, publicists, critics, journalists, attorneys, and executives from markets, festivals, awards, and professional organizations.

Transmedia Marketing culminates with several powerful case studies from various media platforms, also based on exclusive interviews, which showcase different content creation or marketing approaches: *A.I. Artificial Intelligence*'s "The Beast"—participatory tribal audiences; *Mad Men*—branding the American Dream*; Lizzie Bennet Diaries*—perspective storytelling, and *Here Comes Honey Boo Boo*'s "Watch 'n' Sniff" Premiere Event—socialized talent and content.

In addition, a macro case study of a project I managed, *Martin Scorsese Presents the Blues*, is woven throughout the book as a teaching tool to demonstrate critical techniques in action. Many chapters conclude with an Author's Anecdote—a takeaway or reflection on the ideas in that chapter—derived from my professional experience or perspective. By the book's end, you'll be versed in the craft of marketing film, TV, games, and digital media, and you'll be ready to write and execute the marketing and content plan for your project.

As an online companion to the central concepts and real-world examples in this book, www. transmediamarketing.com has a rich array of resources to help you develop and market your transmedia project. It provides a primer on various transmedia platforms— film, broadcast, print, games, digital media, and experiential media. It takes a deeper dive on the *Martin Scorsese Presents the Blues* case study, providing a combined marketing plan and project evaluation, plus additional sample materials. And the Web site provides bonus material on content creation and marketing, experts' insight, and transmedia marketing success stories.

The overall goal of this book and its resources is to teach you how to imagine the unlimited storytelling and marketing possibilities for your media project. The perfect outcome is that you're freed from the conventions or boundaries of any media platform or job description to conceive and execute transmedia projects that truly connect with your audiences—the top ingredient for true success.

PART I

Introduction
to Transmedia
Marketing

Media Makers = Media Marketers

Dane Boedigheimer began making videos with his 8 mm camcorder as a teenager. On a lark, the former film student uploaded the first YouTube video in 2009 for *Annoying Orange*—an anthropomorphic orange that annoys the fruits and vegetables around him. Because of the video's overwhelming popularity, he created a RealAnnoyingOrange YouTube channel and pumped out a video series, garnering more than 2 billion views. Boedigheimer segued this into an animated TV series on the Cartoon Network in 2012, plus videogames, toys, T-shirts, and costumes, establishing a franchise worth millions of dollars. *Annoying Orange*'s breakout success on YouTube signaled a key inflection point in the twenty-first-century media landscape—the legitimization of a DIY era of media making and media marketing.

Courtesy of Annoying Orange, Inc.

***Annoying Orange* was born from a DIY maker and marketer sensibility.**

Technology—The Great Equalizer

But media and entertainment weren't always this accessible. Since the early days of entertainment, big studios, production companies, and publishers tightly controlled the distribution and marketing of radio, film, TV, theater, and print. Media was distributed in regimented and sequential "windows"—a timeframe of distribution on a given media channel that's carefully orchestrated to leverage audience demand for the content and profit from its consumption. Films stayed in theaters for many months and TV shows premiered, had summer reruns, and later went into syndication. These distribution windows were dependable and highly lucrative.

Old-school Hollywood studios also judiciously managed the public images of their films and actors, churning out propaganda-like movie trailers and posters and manufacturing artificial lives for contract players. The entertainment press was complicit, making scads of money from studio-approved articles in movie magazines, staged photos, and strategically-designed outings for actors at public events. A single positive review by an influential critic burnished a property's image, amplified by the watercooler effect the morning after. In this **Top-down** controlled world, the audience sat at a great psychological distance from media makers.

The Photoplayer magazine; Licensed in the public domain via Wikimedia Commons

Claudette Colbert on the cover of *The PhotoPlayer* magazine in 1949.

In the past few decades, changing technologies have stripped much of that control from media companies, shifting power over to audiences. Now, audiences are masters of their own media destinies. Broadband viewing—on cable, the Internet, and mobile— has enabled audiences to consume film, TV, and video, whenever and wherever they want it—the "TV Everywhere" phenomenon. They watch on an array of *second screens*: laptops, tablets, smartphones, watches, and video eyeglasses outside of programming schedules or premieres. Over-the-Top (OTT) consumption of broadband Internet video and audio on Netflix, Amazon Prime, Hulu Plus, and Pandora through Internet-connected devices is booming.

All this has threatened traditional business models. People are *cord-cutting*—down-grading or eliminating their cable or satellite TV subscriptions because of cost, convenience, or redundancy. Programmers, audience researchers, and advertisers struggle to track and monetize *time-shifted* viewing and resultant binge-watching. The distribution balancing act—determining how long to offer a media property on one platform before audience demand shrinks and it's time to offer it on the next one—must incorporate newer film and TV distribution windows—from home video (DVD/Blu-ray) and pay per view (PPV) to video on demand (VOD) and download to own (DTO). So, to meet audience demand for "TV Everywhere," properties are racing through the distribution chain, often before maximizing the benefit from the previous window.

Technology has also personalized audiences' relationship with media and entertainment. Audiences engage with content in their own time, from their personal spheres—the couch, the subway, and anywhere else. The public square is virtual and instant. Audiences *lean in*, relating to a media entity's world and linking it to their own. On social media, they interact directly with films', TV shows', or games' actors or characters *and* with their own circle of friends. **Word-of-mouth (WOM)** endorsements by friends, family, and celebrities often carry more weight than experts.

There are huge upsides to all this disruption. Technology has redefined the concept of audience. Audiences don't fit into simple demographic boxes like the prototypical American family of yesteryear—upwardly mobile, young, white, and suburban. Social media monitoring and Amazon-like algorithms provide deep insight into how audiences think and act. People simply don't cleave by demographics of age, education, income, education, race, or education levels. They hew by psychographics of interest, ideology, and predisposition. Because tracking technologies reveal audiences' proclivities and social media gives them a voice, media makers and marketers can understand audiences, and invite them into the process. Audiences' grassroots, organic interactions and influence on the timing, message, storyline, and acceptance of media propel the marketing of media and entertainment today.

As technologies have evolved, content itself has changed, opening up new avenues for transmedia entertainment. Innovations from film, television, radio, magazines, and books have migrated from one medium to the next, making once disparate mediums such

as video and games more alike—non-linear and experiential. Interactive and digital media are fast becoming influential and profitable. The 2013 launch of the *Grand Theft Auto 5* game was the most successful launch in entertainment history. With fewer films receiving financing and theatrical releases, film's superiority over other media platforms is gone. Television is enjoying a renaissance thanks to film talent drifting to the small screen and a new age of creative risk-taking in order to stand out. Cable and Netflix have become *ersatz* boutique movie studios, incubating some of the highest quality content on any screen. Binge-watching on DVRs, VOD, and OTT services allows audiences to build, making executives more patient with new, niche, or socially-"hot" programs.

And now, with the accessibility of producing technologies and distribution platforms, media and entertainment is open to virtually everyone. A fresh crop of DIY media makers has emerged. Audiences are not only consumers, but also are creators, writers, producers, composers, programmers, and distributors of their own media productions. Also, they actively and adeptly market the media they make, branding, posting, promoting, publicizing, and socializing their content to friends, family, fans, and affinity groups. A DIY world of media maker and media marketer audiences has paved the way for a wave of *Annoying Orange*s.

In this new era, the top-down power structure between producer and audience has crumbled. This tectonic shift in power signals a **Bottom-up** revolution, creating legions of empowered audience contributors—media consumers, media critics, media makers, and media marketers—and alternative middlemen to serve the new dynamic. In short, technology has become the great equalizer—between media platforms *and* between creators, distributors, and audiences. If Alexis de Tocqueville were alive now, he'd be hailing technology as the greatest democratizing force of this century.

All innovations in human development—from tools to new communications devices—have threatened the economics and cultural practices of the *status quo*. The nexus of Hollywood and Silicon Valley has born a massive disruption of traditional media and marketing distribution, content, and media consumption models, yet created unfathomable opportunities for film, television, radio, games, print, digital, and experiential media. To harness this converging new media future, twenty-first-century media and entertainment professionals must have a holistic understanding of storytelling, genres, platforms, funding, audiences, distribution, and marketing. Content creators—both *media makers* and *media marketers*—must harness all the available platforms and channels available in today's media landscape. Media content and its marketing must be *transmedia*.

A Maker and Marketer Culture

Turn-of-the-century innovations have vastly influenced economics, politics, and culture. The coming of the nineteenth century ushered in the Industrial Revolution; the twentieth century marked the Technological Revolution; and the twenty-first century catalyzed the bottom-up Maker Revolution. When *Time* magazine featured "You" as Person of the Year in 2006, they were prophetic in understanding that Web 2.0 would be realized through a digital content maker and marketer culture.

Whether woodworking, composing music, programming apps, or producing videos, everyone participates in today's maker culture. Maker culture is so prevalent that collaborative maker spaces and groups—from fine art to robotics—have cropped up worldwide. No doubt, it's a prolific time for creativity and exploration.

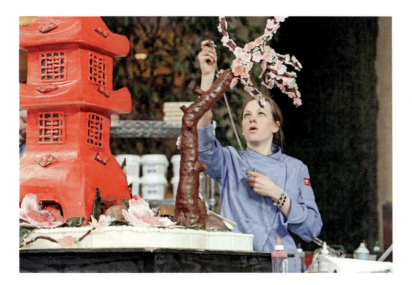

Courtesy of TLC

TLC's *Next Great Baker* celebrates and inspires the maker culture.

And, media is one of the most exciting ways to make stuff. That's because we all hanker to tell stories.

Story is just an artifact of how our brains are wired that we have to find a through-line. We have to find a thread to tie together the things that we know to provide a context and understand them. And the shape of that is a story.

—Andrea Phillips, transmedia creator

Media and entertainment are humans' "go to" storytelling vehicles, whether in the form of the bestselling book, *The Help*, or the videogame, *The Last of Us*.

Audiences are no longer passive recipients of entertainment. Now, with their own published soapboxes, audiences participate confidently with media. Imagine how the big brands felt when some cheeky kid first made a parody of their multi-million dollar, highly-produced TV spot and posted it on YouTube? Out came the lawyers to enforce copyright infringement. Or, how in the early days of blogging, networks desperately tried to ignore it when a non-journalist trashed a new TV show and set off a cascade of negative chatter. Today, parodies are proof of a property's success and key bloggers are deemed top influencers.

Audiences' participation isn't just about weighing in on others' media content, but also about making their own. When you post a short video of your dog chasing his tail on your Facebook page and flag it to all your friends, you've produced, distributed, and marketed that media content. As the "Likes" and comments grow, you can engage directly with your audiences in ways the early Hollywood studio heads could never have imagined. And when a friend posts a "back-at-you" video of her dog doing something equally silly and you share it, you've morphed back into being an audience member and marketer of her content.

Individualized media making is burgeoning, with producers employing an array of storytelling tools. With simple technology such as a camera, computer, Internet connection, video-editing software, and programming language, audiences blog, make music videos, create "mods" (modifications) to existing games, and report in real time on world events from Twitter feeds—as part of their daily lives. Anyone can make media in just minutes, for minimal effort or money.

> *As part of the maker culture, kids can have their own maker studio in their house for a few thousand dollars. Anything they dream up— whether it's a film or a piece of hardware—can be in front of them. And they then can get their own business funded on Kickstarter and sell their products online.*
>
> —**Micheal Flaherty, co-founder and president, Walden Media**

DreamWorks Animation's Awesomeness TV division on YouTube is on the forefront of this DIY culture with a network of teens and tweens creating their own and consuming each other's content on curated YouTube channels. Awesomeness TV partnered with Hearst to create a branded *Seventeen* magazine channel and manage the *Seventeen*'s multi-channel network (MCN), content created by girls who read the magazine.

Smart media brands and projects understand that media content is made and consumed from the bottom up. Doritos uses consumer-generated ads, voted in by superfans, for its Super Bowl commercials. Disney launched an app called *Story* that turns people's

smartphone media into a personal narrative. Walt has invited everyone in to create content in the Magic Kingdom's story world.

Media's now made with the express goal of creativity and interactivity, not just on a single platform of film or magazine, but across many at the same time. What began decades ago as multimedia productions, morphed into cross-platform and multi-platform projects, and has evolved into transmedia experiences.

Screen Australia's transmedia definition:

> **Transmedia** is storytelling across multiple forms of media, with each element making distinctive contributions to a user's understanding of the story universe, including where user actions affect the experience of content across multiple platforms.

This book explores definitions and presents examples of transmedia in greater depth, but for now you can understand transmedia as an interactive story and world experienced on multiple platforms simultaneously. Think *Star Wars*, in which audiences enter and experience *Star Wars*' universe through its many films, comic books, books, radio series, videogames, and merchandized products. Superfans participate directly by adding elements to the universe such as awards shows, stories, videos, blogs, Twitter feeds, and more. Transmedia projects need not be as big as *Star Wars* to be successful. They range from Hollywood franchises such as *The Hunger Games* and *Top Chef* to backyard crowdsourced media projects.

Game platforms such as *Minecraft* and *Roblox* have pioneered audience participation in interactive storytelling, allowing players to create their own narratives and story worlds.

The Minecraft generation is learning to use a storytelling platform in which those playing it are telling creative and interactive stories in real time. I think it's this Minecraft generation that will be leading the charge in defining the future of transmedia, whether it's called that or not.

—**David Gale, film and digital media producer and entrepreneur**

This transmedia maker culture, in which the role of producer and audience member has merged (creating prosumers) and everyone has a turn at creating and critiquing, has created a new aspect of marketing—audience engagement.

Audiences market media, much as they make it, because the tools and vehicles to promote and distribute it have become as accessible as the tools to make it. And because marketing is a deeply ingrained human trait.

DIY marketing is evident in our culture from people's social media pages to the automobiles they drive. If you look to the Old Testament, Adam was the first marketer, convincing Eve to eat the forbidden apple from the Garden of Eden. (Some say it was the snake that first marketed the idea to Adam.) As a fundamentally human enterprise, marketing is used to attract mates, sell soap, elect candidates, raise money for causes, and publicize films.

This book extensively explores the key definitions, tenets, and best practices of marketing and promotion. Marketing and its key elements in the Four "Ps"—Product, Price, Place, and Promotion—together create a compelling value proposition to audiences about a product or idea. Therefore, the assets and attributes of your media project (Product), the cost for audiences to access it (Price), the ways it's distributed (Place), and the tactics to promote it such as advertising, publicity, events, and social media (Promotion) are all part of its marketing strategy.

Marketing is critical to the success of media and entertainment. Shortly after Carly Rae Jepsen's "Call Me Maybe" hit iTunes in 2011, Justin Bieber tweeted that it was the "catchiest song I've ever heard," catapulting it to the #1 song on *Billboard*'s Hot 100 and landing Jepsen a mega deal with Schoolboy Records—all within six months. With Bieber's endorsement and the huge reach of his fanbase, he had created another pop sensation. Good promotion can be the difference between being an unknown and a household name.

Media makers—large and small—understand the vital role of marketing and promotion. Because the democratization of media making has created a glut of content, getting your content to cut through the clutter and be seen is a bigger job than ever. Audience viewing of your media property (butts in seats for film, eyeballs for TV, streams or views for online and mobile) is just job one. Audience participation with that content—vital to branding, positive recall, and ambassadorship—is job two. To get audiences to interact with your media (pass the content along, comment on it, or get involved with the associated issue) requires even more marketing. Marketing is about creating audience awareness and transforming that awareness into engagement.

Sometimes media content and its marketing are the same thing. Is the three-minute sizzler reel for your feature film that you shared via social media and resides on Vimeo or your project Web site a promotional vehicle or part of the story? It's probably both. In a world in which audiences seek both long- and short-format content, the reel serves as both a final product and as promotion for the larger brand, concept, or full-length film.

Distribution is also imbued with marketing. In fact, many new DIY platforms marry distribution and promotion. By sharing your short video on social media and online sites you're both distributing and promoting it. It's not the same as having an opening weekend in an independent theater in New York and Los Angeles and placing a full-page ad in *The New York Times*. Still, it offers a platform on which it can be seen while telegraphing to audiences why they should see or interact with it.

You can do DIY distribution in so many different ways with different levels of efficacy and profitability and penetration. It changes virtually weekly. You can self-distribute theatrically; you can self-distribute digitally. There are various services that allow you to upload everything that you've made and make it available for consumption and sale, which is a way of making money and creating an audience. So there isn't the need any longer to attach any film to the standard forms of distribution such as the traditional independent film distributors that acquire all rights.

—Mark Urman, theatrical film distributor and marketer, president of Paladin

Even crowdfunding vehicles like Kickstarter and IndieGogo build awareness and engagement. Many transmedia content creators use fundraising platforms to unlock special content or privileges to cult followers. More blurring of roles.

Audience engagement with a product or media entity is simply a new definition and requirement of good content creation and marketing in today's world. And where your top-down and bottom-up approaches meet, is the sweet spot of transmedia making and transmedia marketing.

With everyone being part media maker and part media marketer, the lines between creators and promoters are becoming increasingly blurry. No matter how you see yourself, if you're working or playing in media and entertainment, this book is for you.

Who better than you, the one who conceived and Sherpa-ed your media project to reality, to message it and call out what makes it funny or unique? And if you're lucky enough to have a big studio, distributor, TV network, or production company managing your entertainment property's marketing, you still must understand and participate in its marketing as much as you can. Seminal marketing decisions—from your project's title and key art to niche audiences and key promotional vehicles—can make the difference between a smash hit and a boondoggle.

And who better than you, the project's promotional whiz, to tap techniques from the merging media platforms? Many of the old marketing standards for film, TV, and print marketing are still relevant, but have been complemented with new marketing practices from games and digital media—and *vice versa*. The silos between platforms and genres have tumbled down. Marketers of all media and entertainment properties can learn and borrow best practices from radio *and* games and from narrative *and* non-fiction.

That's why this book covers media marketing strategically and holistically—from initial branding to reaching target audiences—across all media platforms. This approach acknowledges the transmedia nature of media making and media marketing in the twenty-first century.

Be Your Project's CEO

To fulfill the promise of being a transmedia maker and marketer, you must think like a CEO (Chief Executive Officer). Of course, CEO is a corporate title, as are all the C-suite titles. It's not suggested as a real-world title, but rather as a sensibility and an ownership approach to making and marketing media.

Before you take umbrage to the business-izing of the creative process, take a look at the inverse. Look at how much entertainment has entered all walks of American culture. Artifacts from of *All My Children*, *Barney*, and *Jeopardy* are exhibited at the Smithsonian. Musicians have joined the business ranks, with Lady Gaga, a creative director at Polaroid and will.i.am, the director of creative innovation at Intel.

Embracing and gleaning insights from the blurred lines between roles, industries, and platforms is a progressive way to experiment from one realm to another. So, whether you're your project's writer, director, publicist, or social media strategist, you should think of yourself as the project's CEO as much as you think of yourself as the CCO (Chief Creative Officer) or CMO (Chief Marketing Officer). Chances are you're responsible for or contributing to creating, financing, distributing, and marketing your project.

> *There are so many different types of people referring to themselves as producers today and there are many different skill sets involved. Some producers are great at nurturing filmmakers, some are great at raising financing, some are great at the stitching together of investors, some are terrific at managing the challenges and rhythms of physical production, and many are great at a number of these roles. I believe if one is an independent producer who develops material, one's job is to keep an eye on the marketplace and how to best shape and define material to achieve both creative and financial success out in the world. Being both ambitious about storytelling and pragmatic about the business realities of the stories you are taking out into the world is as necessary today as it has ever been.*
>
> —Anne Carey, film producer, *The American*, *The Savages*, *Adventureland*

In film, there's a new title, PMD (Producer of Marketing and Distribution). The PMD is prevalent in the indie film world and increasingly recognized in the studio world. That's because tens of thousands of films are produced yearly, yet fewer than 1,000 of them secure theatrical release and receive significant marketing support from the distributor. That's a compelling reason for someone on your project to don that marketing and distribution hat, at least until it brings on a distributor or publisher. You will lose creative

and business control the more entities are involved and the more successful your media property becomes, but start from that leadership perspective.

Or, if you are a small indie film and you "four wall" your film (buy the house and share proceeds with the theater) or are a digital media maker and self-publish, then you will be responsible for the marketing for the duration of your project. As the media maker, that puts marketing and distribution squarely among your CEO responsibilities.

If you're a marketing professional for an indie project, you're already the CMO or PMD. But you should also think like a CEO and CCO. How does your work affect the content and narrative, funding, and distribution? And if you're part of a distributor's in-house marketing team or an outside professional marketing or public relations professional, you know that you are part of a bigger marketing machine, with many people and departments impacting critical marketing decisions. But your voice can be heard and you can positively affect marketing strategy and execution, as well as creative and business aspects of the project, no matter your role.

The key to being a good leader, and that's what being a good project CEO, CCO, and CMO is, is finding and inspiring smart, passionate, and talented people. You do not have to be the smartest person in the room. You have to be the smartest at finding and retaining the smartest people in the room. There are hundreds of books on helming successful organizations and projects and if there were an easy formula, everyone would run a Fortune 500 company or direct an Oscar-winning film.

But what's common to all good leaders is the ability to start with knowns and best practices in an arena, seek and listen to additional or new perspectives, digest it all, and take the "best ofs" to develop a clear plan. Parts of the plan are sure-fire "gotta dos" and other parts are risky, "never been done befores." Everyone on the team must know which are which. Google's co-founder and CEO, Larry Page, calls the risky ventures "moon shots." The measures of success for the safe enterprises are different from those for the riskier ones. So, if you're promoting a new reality mini-series about extreme sports on television, the "gotta dos" might include seeking reviews and coverage from TV and sporting critics, writers, and bloggers and the riskier aspects of the plan might include a bungee-jumping stunt on the Empire State Building a few days before premiere.

In addition, good leaders are interested in and appreciative of all of their employees' ideas and efforts—whether they're successes or daring risks that flopped. All efforts represent mid-stream learning opportunities for the current or next media challenge.

Having assumed the mantle of ownership for the transmedia making and marketing of your project, you have taken the first empowering step toward actually doing it.

Transmedia Marketing for Impact

All things transmedia are not marketing, but in our current world, almost all good marketing is multimedia, and often transmedia. Transmedia marketing merges old and new concepts. What was always true: marketing across more than one platform is more likely to reach people more deeply. What is new: merging story and content creation with traditional promotional messages fully engages your audiences in an immersive experience.

This has been enabled by broadband video streaming, mobile access, and social media, which has bypassed top-down production and distribution models and created a new stream of media makers, marketers, critics, and ambassadors. Their bottom-up creative impulses along with new technologies' capabilities allow transmedia content to simultaneously and indistinguishably advance and market story. As a result, *entertainment content and content marketing have become a single storytelling enterprise*. To successfully make and market media in this new world order, you must embrace transmedia marketing.

Transmedia Marketing, as this book defines it, is the holistic discipline of making media and marketing media across multiple platforms—*on air*, *online*, and *on the go*—through engaging storytelling, rich story worlds, and interactive audience experiences.

The story is the overall media project—both its narrative content and marketing experiences. The worlds are the project's story universe and the target audience's real life. When an audience member retweets a musician's post about a new music single or shows up at a film screening, they have interacted with the media project and accepted it into their real-life world. If they're superfans, they combine their real world with the project's fictional world.

Developing and marketing media projects simultaneously across multiple media platforms creates an integrated transmedia project with multiple pathways for audience engagement—spawning loyal, participatory fans. And using best practices from film, television, radio, print, games, online, digital, and experiential platforms creates stand-out, relevant media experiences.

Transmedia marketing is based on the precepts of strategic planning, but also applies the impulse of creating media and audience experiences. A key aspect of strategic marketing is clarifying the overall goal of the project and its marketing and determining true measures of its success. Is the goal to make money, have high attendance, garner big Nielsen ratings, get good reviews, win awards, promote a star's career, or raise awareness of an issue or a cause? Those goals impact all the choices you make.

That's where writing and refining a sound marketing plan comes into play. This book will help you write that **Strategic Marketing Plan** for your media property. It will help you understand the environment, establish goals, conduct relevant research, identify your audiences, position your project in the marketplace, develop a creative mantle for it, identify traditional and new media platforms and tactics to reach your audiences, and evaluate what worked and what didn't.

In addition to solid marketing planning, transmedia marketing includes instinct, bravery, and agility. Clearly, the big marketing arms of studios know how to market "shoot-'em-up" films to young men. If they've done so successfully before, they're experts at the "gotta dos" for that genre. But by looking at each film or media property in its own right, you can find unique attributes or untried techniques that can put it over the top. And there can be a critical moment to seize an opportunity.

Agility is probably the most important thing in marketing because the marketplace is always changing. Whether it's introducing sound or color to movies or trends coming and going. Without that you're dead and with that you're already in a good place.

—**Keith Gordon, filmmaker and director,** *A Midnight Clear, Mother Night, Waking the Dead, Dexter, Homeland, Nurse Jackie*

In a Season 2 episode of *Dexter*, "The Dark Defender," the crime scene was set in a comic-book store. Comic-book characters, allusions, and art peppered the episode, giving *homage* to comic-book traditions. Seeing the social buzz among comic superfans, Showtime invited those natural ambassadors into *Dexter*'s story world. The episode inspired a line of *Dexter* comic books and other comics-inspired content. This transmedia response activated a new platform with more *Dexter*-branded content, served a philosophically-aligned audience, and created a new revenue stream.

Planning your marketing strategically, honing your instincts, and moving nimbly across all platforms are attributes that are both inborn and can be taught. By approaching your media project as its CEO—as both a transmedia maker and transmedia marketer—you will be poised to flourish in a world where audiences have wrested power from media institutions and become co-contributors of media and entertainment projects.

Author's Anecdote

Crossover of Transmedia Making and Marketing

In the late 1990s, *Zoom,* the PBS tweener hit from the 1970s, returned to television. But American youth had changed a lot. These budding citizens were already media makers on multiple media platforms. I offered up the concept of *Zoom Into Action*—inspiring social good among American youth on multiple media platforms—to Executive Producer Kate Taylor. It played out in myriad ways: the tween cast of *Zoom* encouraged *Zoom*ers (the viewers) to get involved in their communities; the half-hour daily program featured a *Zoom*er doing just that; the Web site showcased *Zoom*ers and allowed them to interact with each other and *Zoom Into Action* ideas; and a weekly slot opened in the program for PBS stations to air local profiles of tweens *Zoom*-ing *into Action*.

The idea was widely embraced by cast, producers, the TV network, stations, audiences, and local communities, and had a rich life *on air*, *online*, and *in communities* for the Emmy Award-winning children's program. Because this idea was an expression of a holistic belief system rather than an executional tactic, it was able to successfully play out as both media content and media marketing on multiple media platforms.

CHAPTER 2

Be Transmedia

Leonardo da Vinci was one of the greatest transmedia storytellers and innovators of all time. He was truly a fifteenth-century polymath—thinking, creating, and expressing across every conceivable platform of his era. Da Vinci was a sculptor, painter, musician, and writer. He was a mathematician, engineer, architect, and inventor. And he was an anatomist, geologist, botanist, and cartographer. While he's known best for the *Mona Lisa* and *Last Supper* paintings, few know he conceived and designed the helicopter, solar power, the tank, the adding machine, and tectonic plate theory. His simultaneous conceptualization and creation in these different realms on different platforms impacted all of his work. He's the inspiration for the term "Renaissance Man."

"Vitruvian Man" by Leonardo da Vinci in the public domain via Wikimedia Commons

Leonardo da Vinci was the original transmedia Renaissance Man.

Being transmedia is as relevant today as it was during the Renaissance. Transmedia is the now and tomorrow of media and entertainment, and it's influencing the creation *and* marketing of content and impacting modern culture. We have our own modern-day multi-platform creators. Spike Jonze's endeavors include magazine founder, consumer goods company founder, video director, music video director, television program creator, television ad director, online awards show director, songwriter, screenwriter, and, of course, feature film director. And that's just so far.

Transmedia is entering media and culture at an astounding pace. The Boy Scouts of America has merit badges for Multi-media, as well as Game Design, Digital Technology, Animation, and Programming. The Producers Guild of America announced a new producing credit, Transmedia Producer, in 2010. This is significant because the Guild rarely backs new credits, but did so in recognition of the trend of developing cross-platform storylines. TEDxTransmedia, the offshoot of the respected TED thought-leader conference franchise, was founded based on the goal of sharing and exploring the evolving definition of what transmedia is and can be in media, politics, medicine, culture, and more.

> *I was inspired by the fact that a TED-style event can be broader, giving more freedom in creating the programme; therefore I changed my strategy in designing the future events and invited speakers or performers from diverse fields that may not be about transmedia entertainment—like musicians, comedians, scientists, philosophers, technologists, architects, students, etc. Transmedia became the method I used to enter in a broader conversation about making a change, using different platforms.*
>
> **—Nicoletta Iacobacci, curator, TEDxTransmedia**

© Lisa Lemée; Provided by TEDxTransmedia

Mitchell Joachim, an innovator and educator in ecological design, architecture, and urban design, presenting at TEDxTransmedia 2011 in Rome.

Roots and Definition

Transmedia's meaning is partially intuitive because today everyone consumes content on multiple platforms. Audiences watch films or Google celebrity gossip on their laptops, get backstory from Shazam or Viggle on their smartphones, and stream YouTube videos or trailers on their tablets. Often, those multiple-screen experiences are about different things, but if they're all about the story universe of *The Walking Dead*, then they might be transmedia. Even though da Vinci mastered and pioneered in transmedia more than 500 years ago, the modern definition and practice of transmedia is relatively new. In some ways it's becoming more specific, but in other ways it's broadening and becoming more inclusive.

In the 1980s and early 1990s, media and marketing professionals were developing **Multimedia** presentations and projects. Placing a video within a PowerPoint presentation, streaming video on a Web site, or sending a clip via e-mail was a big deal. Multimedia was primarily about embedding content in another media platform. By the late 1990s, people were creating and distributing cross-platform and multi-platform projects. **Cross-platform** means using more than one medium to distribute a single piece of content. For example, a television show that is both broadcast and digitally-streamed. **Multi-platform** is creating content expressly for different platforms. These productions can reach across multiple media including film, TV, radio, games, magazine, books, online, DVDs, CDs, and experiential media (exhibits, events, and toys), with content varying for each platform. Some of these elements are robust and not just afterthoughts. For example, a project with a feature film, a companion Web site, a game, and associated merchandise.

These multimedia and cross-platform projects were the roots of transmedia, but they redelivered or repurposed original content for additional platforms. The story was still advanced primarily on a single original platform and then retold or embellished on another. Multi-platform projects began to explore the possibilities of holistic storytelling.

The first documented use of the transmedia term was by Marsha Kinder, who in 1991 discussed entertainment franchises using a model of "commercial transmedia super-systems" in her book, *Playing with Power in Movies, Television, and Video Games: From Muppet Babies to Teenage Mutant Ninja Turtles*. She was referring to entertainment franchises such as *Pokémon*, *Indiana Jones*, *Super Mario Bros.*, and *Star Wars*.

More than a decade later in 2003, MIT's Comparative Media Studies co-founder, Henry Jenkins (now provost professor of communications, journalism and cinematic arts at the USC Annenberg School for Communication and Journalism and the USC School of Cinematic Arts), wrote a classic *MIT Technology Review* article, "Transmedia Storytelling," about coordinating story across multiple media platforms, making characters more captivating. By that definition, for a story to be **Transmedia**, it needs a compelling **Character(s)** that will sustain multiple *Narratives* (such as *Pokémon*) or a **World** that will sustain multiple Characters (such as *Star Wars*). Jenkins further explored transmedia in

his 2006 book, *Convergence Culture: When Old and New Media Collide*, and continues to define and analyze the transmedia concept and various projects on his blog, *Confessions of an Aca-Fan* (which bridges fandom and academia). Jenkins is widely viewed as the father of the current definition of transmedia.

In between the era of multimedia and today's transmedia, many projects evolved from single-platform to fully-transmedia projects and helped define the transmedia *zeitgeist*. When George Lucas made *Star Wars* (later named *Star Wars: Episode IV—A New Hope*) in 1977, his first foray into the *Star Wars* saga, he couldn't have imagined that *Star Wars* would be one of the biggest entertainment brands ever, with prequel films reordered in the boxed DVD/Blu-ray sets, branded LEGOs TV series and merchandise, theme parks, and much more. *Star Wars* defines entertainment transmedia and it has achieved that status because George Lucas has been both the brilliant creator and dogged protector of a rich, expansive, yet integrated story world.

On a much smaller scale, when Ian Brennan and colleagues created the television show *Glee* for Fox, they were hoping for solid ratings and, no doubt, were elated when they got a smash hit. With such huge audience acceptance, producers quickly recognized the multi-platform opportunities to open up new revenue streams beyond TV and expanded *Glee* to YouTube, iTunes, and live performance events serving their fandom base of "gleeks."

The advent of Web 2.0 and social media brought the realization of an era of convergence, which has spawned the current expression of transmedia—a story and world advanced *simultaneously* across multiple media platforms. The platforms work together holistically, yet each serves as a stand-alone media experience. Transmedia narrative worlds that enable audiences to suspend their beliefs are 360°, rich, descriptive, and specific. It takes skill to create them because transmedia requires continuity of character and world among the platforms. Transmedia is also interactive and immersive, encouraging audiences to engage directly with and have impact on the story, characters, and world.

Single-platform and cross-platform media projects are linear and one-dimensional. Multi-platform can be two- or three-dimensional. But transmedia is entirely non-linear—it's four-dimensional.

There are hundreds of additional examples of fictional transmedia projects including *Harry Potter*, *Pandemic 1.0*, *The Hunger Games*, *Prometheus*, *A.I. Artificial Intelligence*'s ("The Beast"), *The Matrix*, *Dr. Who*, *Game of Thrones*, *Perplex City*, and *Dexter*. And there are scores of groundbreaking non-fiction projects such as *Highrise*, *Half the Sky*, *National Parks Project*, *A World without Oil*, *Hunger in Los Angeles*, and *A Day in Pompeii* that use transmedia and interactive storytelling techniques.

Few transmedia pioneers or top media makers on the various media platforms agree on these definitions or even on what projects are and aren't transmedia. That's because it's a fresh and evolving field. Transmedia is organic and experiential. And it's socially and emotionally transformative. If you set aside the semantics, then transmedia can be what you want, as long as it tells a broader story across multiple platforms and engages your project's audiences in that story.

Don't be too hung up on definitions. There seem to be constant battles over what constitutes transmedia as opposed to multiple platforms, cross-media, multi-media, and they eat up valuable energy. Right now is a time to experiment, to try new configurations of media, to explore new functions that transmedia might serve, and these are not going to fit into nice neat little packages. Don't worry so much about defining terms, focus on exploring the terrain.

—Henry Jenkins, provost professor of communications, journalism, and cinematic arts, USC

Today's transmedia projects are native, conceived from the beginning to use multiple media platforms—from film and graphic novels to online and apps—storytelling, and marketing. Comic books, videogames, ARG (Alternate Reality Games) experiences, toys, and merchandise are no longer ancillary products, but rather powerful storytelling devices. Most native projects follow transmedia marketing principles of finding the story's brand essence, creating an overarching story bible and universe for it, providing multiple media points of entry into it, engaging audiences in immersive narrative experiences, and creating or enhancing those experiences with promotional content. The goal of telling the story across multiple platforms is to serve the audience and create superfans. When well-executed, that also can translate into revenue.

Marvel's story universe does all this meticulously across film (*The Avengers*); television (*Marvel's Agents of S.H.I.E.L.D.*); comics (*Marvel NOW!*); and almost every other available platform. The transmedia content offers a rich experience for audiences because it maps out the overall story world, offers multiple character reflections on the story, provides backstory, and deepens audience engagement. Each platform amplifies the other and contributes to the revenue streams.

When developing a transmedia project, consider these criteria to determine how your project can or should be transmedia:

*Whenever I think about how to navigate the transmedia terrain, I think about five interconnected "prongs" and related questions: Is it good **content**?; What **media platforms** will it use and how does that affect the project?; What **technology** will it use and how does that enhance or affect the experience?; What is the **monitization**?; and, Is it something anyone will use or care about and what is the likely **user interest**? If you do not consider all five prongs and are not satisfied with all five answers, you are likely not to succeed.*

—David Gale, film and digital media producer and entrepreneur

Many transmedia projects incorporate some combination of these three transmedia categories:

- **Transmedia native content**—original stories or content are created across all media. The story and characters are fractured into pieces and presented on different platforms, often offering separate revenue streams (*Star Wars*, *Harry Potter*)
- **Transmedia marketing**—a range of original content is created around one product with the goal to drive audience engagement around that product, but marketing elements become content channels in themselves (*Game of Thrones*, *The Hunger Games*)
- **Transmedia technology platforms**—multiple platforms across which producers and audiences distribute content (Apple, Comcast, Netflix)

Because of the crossover of these categories, professionals are joining the burgeoning transmedia field from many walks of life, with a huge influence from games, digital and interactive media, and marketing. This convergence has opened up new opportunities within the entertainment and media industries.

> *More people have access to creating and getting their content out there because of so many new avenues and platforms. This opens up more jobs in entertainment and more jobs overlap.*
>
> —**Nancy Robison, director of education programs, Television Academy Foundation**

Big film studios are now taking meetings with "out-of-the-box" transmedia thinkers from the creative, digital, and marketing fields, because they recognize the potential of these immersive experiences to capture the rapt attention and undying loyalty of audiences.

Bridging Media Making and Marketing

Like good storytelling, sound marketing creates opportunities for authentic audience engagement, which creates loyal and participatory audiences. Sometimes, marketing activities are part of the transmedia storytelling experience and sometimes transmedia content elements are part of the marketing.

Jeff Gomez, CEO of Starlight Runner Entertainment, transmedia pioneer, and transmedia producer for story universes for James Cameron's *Avatar*; Disney's *Pirates of the Caribbean*, *Prince of Persia*, and *Tron*; Sony Picture's *Men in Black* and *The Amazing Spider-Man*;

Hasbro's *Tranformers*; Nickelodeon's *Teenage Mutant Ninja Turtles*; Microsoft's *Halo*; and Mattel/Cartoon Network's *Hot Wheels*, recognizes that storytelling and marketing are intertwined.

> *Starlight Runner recommends to all of our partners and clients that traditional marketing avenues be leveraged as storytelling platforms. So instead of advertising your product by cutting it into bits and pushing it out to your potential audience, it is far better to recontextualize those bits or even create new bits that start familiarizing the audience with the characters, the back-story, and the larger story world.*
>
> **—Jeff Gomez, CEO, Starlight Runner Entertainment**

Often, new content serves as a marketing tool for other content within the transmedia universe. Universal's *Despicable Me 2* sequel grossed more than $300 million in box office sales. But the appeal of the Minions didn't end in theaters. As part of the sequel's release, a free mobile *Despicable Me* role-playing game launched, which rose to be one of the top free iPhone, iPad, and Android apps, downloaded more than 100 million times in its first three months. Several children's books were released and *Despicable Me* universe-inspired virtual items were available in the catalogue for the massively popular multi-player online game *Roblox*. Around the sequel's release, downloads of the original movie *Despicable Me* and existing *Minion Madness* mini-movies on iTunes, Amazon, and Google Play topped the charts. So the new film, games, and books for *Despicable Me 2* also served as an effective marketing tool for existing film and music on other platforms—and *vice versa*.

Other times, content that lives at the boundaries of story and marketing is part of a carefully-orchestrated story universe and audience experience. In the 2013 Emmy Award-winning *Lizzie Bennet Diaries*, a modern-day adaptation of Jane Austen's *Pride and Prejudice*, the story carefully unfolded bi-weekly via Lizzie Bennet's YouTube vlogs and three other characters' on-camera appearances on them. The story also advanced in real time between additional characters' Twitter chatter about recent meals, trips, or flirtations—expanding the *Lizzie Bennet Diaries* world. The audience caught on to the growing social media storyline, interacting with the characters' Twitter accounts, ultimately leading to new characters appearing on *Lizzie Bennet Diaries*' main YouTube channel or on their own spin-off channels. Was Twitter a content platform or marketing? It was both. (*Lizzie Bennet Diaries* is featured in Chapter 31, "Transmedia Marketing Case Studies").

ABC's *CSI* followed a slightly different path, extending the reality murder mystery series to episodic Twitter murder mysteries, inviting fans to solve fictional murders for points and prizes. Using #Twitdunnit, *CSI* creator Anthony E. Zuiker set the murder scene and offered clues through 40 to 50 tweets over about seven hours, allowing audiences

to submit their solutions via direct message. "Winners" got *CSI* merchandise, a Skype chat with Zuiker, or the grand prize of a day on the set with Zuiker. Zuiker's Twitter following increased almost ten-fold.

Today, transmedia producers are using every available storytelling platform to tell stories to audiences in a variety of configurations. The Producers Guild's recognition of transmedia, aided by transmedia pioneers including Jeff Gomez, offers the following description of a Transmedia Narrative and Transmedia Producer Credit:

> A **Transmedia Narrative** production consists of multiple narrative storylines existing within the same narrative story world across three (or more) platforms recognized by the PGA New Media Council as well as Narrative Distribution, Commercial and Marketing rollouts, and other technologies that may or may not currently exist. Narrative elements must be additive to the story or connected thematic universe. Adapting or repurposing material from one platform to another platform without substantial commentary or additional narrative development does NOT qualify for the Transmedia Producer credit.
>
> A **Transmedia Producer Credit** is given to the person(s) responsible for a significant portion of a project's long-term planning, development, production, and/or maintenance of narrative continuity across multiple platforms, and creation of original storylines for new platforms. A Transmedia Producer also creates and implements interactive endeavors to unite the audience of the property with the narrative and this element should be considered as valid qualification for credit as long as it is related directly to the narrative presentation of a project.
>
> A Transmedia Producer may be involved in initial development or be brought in at any time during the long-term rollout of a project in order to analyze, create or facilitate all or part of its content. A Transmedia Producer may also be hired by or partner with companies or entities that develop software and other technologies and wish to showcase these inventions through compelling, immersive, multi-platform content.
>
> To qualify for this credit, a Transmedia Producer may or may not be publicly credited as part of a larger institution or company, but a titled employee of said institution must be able to confirm that the individual was an integral part of the production team for the project.

Notice that the description includes narrative storytelling *and* marketing activities distributed on multiple platforms. It also encompasses both fictional and non-fiction universes.

One of the Guild's early iterations of the transmedia producer credit cited platforms of "Film, Television, Short Film, Broadband, Publishing, Comics Animation, Mobile, Special Venues, DVD/Blu-ray/CD-ROM, Narrative Commercial, Marketing rollouts and other technologies." But because media platforms are changing faster than the Guild can list them, they have removed specific platforms from the credit.

Fully-transmedia projects require writers, designers, producers, graphic artists, technical teams, and quality assurance (Q/A) system testers. Like filmmaking, the core team is the writer, producer, and director, but in recognition of how much audience and marketing rule in transmedia, the director may also be called the "Experience Designer."

Top entertainment and media production and marketing awards also recognize transmedia. For example, the American Academy of Television Arts & Sciences' Emmys includes categories for Interactive Media in Multiplatform Storytelling, Original Interactive Program, Social TV Experience, and User Experience and Visual Design. The Tribeca Film Festival has the Bombay Sapphire Award for Transmedia; and the British Academy of Film and Television Arts Awards acknowledges Multi-platform and Original Interactive Productions. In addition, transmedia projects and marketing are recognized by the online Webby awards and by marketing awards such as The Key Art, PromaxBDA, Cannes Lion, PRSA Silver Anvils, and *PR Week* Awards.

Transmedia is the forum in which content creation and content marketing have truly collided, sharing the goal of creating immersive story worlds and engaging audience experiences. As a media maker and media marketer in this transmedia world you must take a holistic approach to your content creation across multiple platforms. All of your content must hang together as a cohesive whole; provide multiple points of entry into your story universe; tell an overarching story through many smaller stories; and inspire audiences to engage and participate with the story and content. Some of your content will tell the story; some will market the story. Much of it will do both.

Transmedia Storytelling

Whether transmedia marketing experiences create or market content across multiple media platforms, they're always about telling stories. Technology has brought storytelling full circle, creating shared experiences that fulfill basic human needs.

In the future, there's going to be a return to ritual in storytelling that's enabled by technology, such as community-based storytelling. There's a huge hunger for participating in storytelling, as is seen in games and theater.

—Kamal Sinclair, co-director, New Frontier Story Lab, Sundance Institute

Lynette Wallworth's *Coral: Rekindling Venus* (photo by Jonathan Hickerson); © by the Sundance Institute. Used with Permission.

The New Frontier premiere reception at the Sundance Film Festival 2013.

Because marketing is a form of storytelling and transmedia has blended content creation and marketing, an exploration of the art of native storytelling across multiple platforms is valuable. This section of the book is not expressly about how to write your transmedia project or novel, film, or game elements, but more about how to approach your marketing as a multi-tentacled transmedia narrative, with backstory, mood, characters, conflict, and action.

Transmedia storytelling follows the general tenets of good storytelling. But in transmedia story, the whole is always greater than the sum of the parts. Each piece on each platform must have a narrative or communications purpose. Keeping track of a transmedia story or marketing initiative is a matrix of what message is delivered where, by whom, when, and why. It's a lot to keep track of and you must have an exquisite sense of story, character, and timing married with a deep understanding of each platform's assets and audience's engagement with it.

Add to that, the guesswork of how much content on a given platform or how many total platforms a person must see to get the "whole" story. What if they miss a platform

entirely, will they be satisfied? And then there's ensuring each platform has pointers or "rabbit holes" to send audiences to another platform or new plotline. With a movie, audiences watch the entire linear story from beginning to end. The creator knows what they delivered to their audience because it's all in one place. But to create an immersive, holistic transmedia story or integrated marketing campaign on multiple platforms, you must be like a conductor, guiding many instruments' contributions to the overall symphony.

In *A Creator's Guide to Transmedia Storytelling*, transmedia writer and game designer Andrea Phillips lays out the key elements of transmedia story and structure as world-building, characterization, and backstory. A brief overview of her deeper concepts:

- **World-building** (graphics, maps, physical artifacts)—*establishes time, place, and mood*
- **Characterization** (not static, is on all platforms)—*creates a 360° evolving character*
- **Backstory and exposition** (prequels, other characters' POVs)—*delivers seeds of dramatic tension and its significance*

And, to apply even more broadly to transmedia storytelling and transmedia marketing, this author would add:

- **Audience participation** (interactive platforms, user-generated content)—*allows audiences to be both producers and consumers*

Whether played out in *War and Peace* or in a sharable Facebook video, good story has five major beats: *an Introduction*, *an Incident*, *Stakes*, *an Event*, and *Resolution*. As you develop your transmedia narrative, also consider these story elements:

- **Characters**—what are their motivations, how complex are they, do they adhere to stereotypes?
- **Conflict**—what are the pivot points, rising tensions, and changes in relationships?
- **Plot**—what happens to characters because of the conflict and how does it climax and resolve?
- **Mood**—how do creative decisions such as color, contrast, music, and pace affect the story?
- **Themes**—what's the story really about? (not the plot)

All of these key components of story are also significant drivers in a well-conceived and well-articulated transmedia marketing campaign.

Henry Jenkins' view on the future of transmedia is changing with the times and with the myriad possibilities that transmedia presents in both fictional and real-world universes.

My earliest writing was focused on transmedia storytelling, where core parts of a story dispersed across multiple media channels, with each making a unique contribution to our experience of the whole. More recently, I have found myself focused on transmedia learning, transmedia branding, transmedia activism/mobilization, transmedia journalism, transmedia performance, etc. I would now argue that we should think about multiple transmedia logics, with the possibility of any given project mixing and matching these logics.

So, we can picture a documentary from the National Film Board of Canada, which tells a story, but which places a strong emphasis on transmedia learning and mobilization. Or we can picture a Hollywood project where the media extensions are paid for through a promotional budget and thus constitute a form of branding, but also play an integral role in our experience of the story. Or a music-based project which is first and foremost about building up the performer's persona across platforms, but also contributes to fleshing out a storyworld.

—Henry Jenkins, provost professor of communications, journalism, and cinematic arts, USC

Transmedia Platforms

Since the days of cavemen watching fire at night, humans have loved to be entertained. The flickering fire and oral traditions that ensued created one of the first media platforms, delivering a good yarn with special effects. With the advent of each new medium, there's been a hue and cry that first film, then radio, and then TV were about to become extinct. Nothing could be further from the truth. New forms of media rarely cannibalize older ones, but rather enhance them. Especially if you make them transmedia, and they work together.

Today's transmedia is about creating, distributing, and marketing content simultaneously *on air*, *online*, *in print*, *on the go,* and *on the ground*. Like da Vinci, you can tell your story and engage people with it using many vehicles—from films and vlogs to mobile games and live events. Being a transmedia creator, distributor, and marketer may give you an advantage in this exploding media environment.

The more platforms there are, the more voices are likely to be heard, the more opportunities for different sorts of stories to be told. Also the more platforms there are for certain shows to be seen (and potentially binged on), the more likely a risky show may be given a longer leash to find its audience. The wider distribution of these shows on other platforms, including past seasons for binging, is becoming a lifeline and, potentially, a new revenue stream for networks and studios. From a creative point of view, these new players developing original product means the bidding war for talent will grow even more fierce and potentially costly. But I'd like to think it will allow creators to be able to realize their passion projects without having to compromise their vision.

—**Matt Roush, senior TV critic,** *TV Guide* **magazine**

The definitions of media platforms are ever changing. Until late in the twentieth century, mass media included just eight categories: Movies, Television, Radio, Books, Newspapers, Magazines, Recordings, and the Internet. Thereafter, Books, Newspapers, and Magazines combined to become Print; Television and Radio combined into Broadcast; and Mobile entered the mix. Now, Internet and Mobile have merged into Digital Media, Games has become its own category, and Experiential—from theater to theme parks—is a media platform. Already, the Film, Broadcast, and Print categories don't reflect the realities of those media: film and TV overlap to include the many other kinds of video content, some of which is considered digital; magazines aren't always in print; and television isn't always broadcast over the air.

But, for the purposes of categorizing, the current media platforms that might relate to your transmedia project include **Film**, **Broadcast**, **Print**, **Games**, **Digital Media**, and **Experiential Media**. To adopt a modern transmedia storytelling approach as a content creator and content marketer, you must become immersed in these transmedia platforms to mine the opportunities that each offers, and that they offer together. The world is your oyster with such an exploding array of media options.

If you are going to pursue a transmedia strategy in which your media is going to live across multiple platforms, make sure you consider all those platforms from the beginning. If you don't, it's likely to feel tacked on and irrelevant. If audiences consume a platform, you want them to feel like it was a key part of the experience.

—**Nick Fortugno, chief creative officer, Playmatics**

There are many comprehensive resources on each of these platforms and on the genres within them. And there are myriad experts in each arena who you can enlist to gain a deeper understanding and work with you on your project as it plays out on different platforms. (For deeper background on the transmedia platforms of Film, Broadcast, Print, Games, Digital Media, and Experiential Media, go to www.transmediamarketing.com for an overview of the history, industry standards, trends, and major players for each.)

While you can create and promote simultaneously on any of these platforms, don't feel compelled to use platforms just because they exist or they have a shiny, new technology.

> *Be wary of the laundry list of technologies and first find the story. Then look for avenues and platforms that allow for active participation in the story.*
>
> —Kamal Sinclair, co-director, New Frontier Story Lab, Sundance Institute

As you explore the transmedia possibilities, keep your story and project goals at the forefront and then open up your mind to the possibilities for storytelling and engaging your audiences in a unique experience.

Now that you're steeped in a transmedia storytelling sensibility, you're ready to combine that with a marketing approach. To engage your target audiences with your transmedia project, film, TV show, game, or digital media, you must now find and harness your inner marketer.

Author's Anecdote

The Frontiers of Transmedia

In the late 1990s and throughout the 2000s at WGBH, where I oversaw the marketing, promotion, and social impact of PBS national content, I strove to unify the core platforms upon which we produced—TV, online, marketing, and community outreach. I was impelled by the instinct that a cohesive story and universe would provide a more meaningful experience for audiences, especially as the media landscape became more fragmented and cluttered. The more I experimented, the more I wanted to extend the story and audience experience to more platforms, so I forged strategic partnerships with content creators in film, radio, books, magazines, news-

papers, and games. And, since a lot of what I worked on was non-fiction, by the early 2000s, I was creating blueprints for how multi-platform media could catalyze positive social change. I added NGOs and government entities to my palette of partnerships, created calls-to-action for audience participation, and established measurable social change goals.

There was no name for this work, but it felt like the future. At first I called it multimedia and cross-platform, and later multi-platform, transmedia, and TransImpact. My family had no idea what I did. I'm sure some producers and execs at my TV network didn't either, but they let me do it anyway. I sought out and collaborated with a few like-minded colleagues across the country to create these transmedia projects and move them forward. Those many years experimenting in the nascent transmedia field led to founding a company that develops transmedia projects and social impact campaigns around them, creating the first course in transmedia development for Emerson College's Visual and Media Arts Department (among *Hollywood Reporter*'s top 10 film schools in the world), and writing this book.

Transmedia's time has come. Not only is this terrific for the future of media and entertainment, but also for social change, culture, politics, and science. Transmedia has cultivated a supportive and rich community of visionary, left- and right-brain thinkers who create compelling transmedia experiences. Welcome to the community.

Harness Your Inner Marketer

In what profession can you invest a decade or a quarter of a century perfecting your craft, yet the guy in the supermarket thinks he knows as much as you? Marketing, for one. Does he know as much as you? Maybe not, but he still might have some very good marketing ideas. So why does everyone have something righteous to say about the latest YouTube video sensation or about what's arguably the best part of the Super Bowl—the ads? Because marketing is downright fun!

And it's integral to life on Earth. The bright colors or aroma in flowers advertise the hidden sweet nectar to birds, bees, and butterflies, with the ulterior motive of pollination. Moses' Ten Commandments were simply headlines or taglines for an entire moral code of conduct.

© Anne Zeiser

Mother Nature uses marketing to ensure the survival of many species.

Marketing Is Fun and Scientific

Marketing appeals to us all because it taps into a basic human need—to persuade. Being good persuaders gave Neanderthals advantages in terms of food, territory, political alliances, and much more. Having strong marketing skills provides a distinct evolutionary advantage. Let's face it, there are millions of business and creative ideas that have equal merit or benefit, yet some get advanced and others don't. Good internal marketing may make the difference.

At heart, good marketers are cultural or social *anthropologists*. Rather than tell audiences what to do, they watch audiences in their natural states to see what audiences truly believe and what motivates them. It's the fulfillment of deep-seated human needs or desires that impels people to act. Audiences must derive a benefit from watching, buying, or telling a friend. Good marketers are also *psychologists*, determining how to position an idea, game, or political candidate to fulfill that identified human need. Then they carefully communicate both the need and the benefit. It's reverse engineering. Seem sneaky? Welcome to the human race. But good marketing isn't as Machiavellian as it seems. Audiences can be motivated for both altruistic or selfish reasons, but either way, the alignment of their belief systems and that of the product or media property they're considering must be authentic to endure.

The best way to entertain and persuade is storytelling. Storytelling reaches into the limbic part of our brain—that's the part that controls emotions, decision-making, and behavior. It's where a "gut feeling" comes from, and it's non-verbal. When a story fully engages us, it activates these Broca's and Wernicke's areas, plus the part of the brain that the story's about (for example, if it's about food, the sensory cortex, which controls taste, is activated). Stories bypass the neocortex, which controls rational thinking, analysis, and language, and access the instinctual creature. Powerful stuff.

If a story is well-told, the teller and the listener become one. Uri Hasson from Princeton University has found that a good story enables the listener to turn the story into his or her own experience. That's why metaphors work so well in communications. They help the listener to jump into the core narrative through another entry point, hopefully one that the listener will see as their own. Storytelling and persuading are all about communicating need and benefit or cause and effect.

There's evidence of early storytelling from almost 30,000 years ago from France's Chauvet Cave walls. It's no surprise that there are stories that we all relate to that are retold millions of times in many forms—from oral storytelling traditions and ballads to films and multi-player games. In his Jungian-influenced *The Seven Basic Plots: Why We Tell Stories*, Christopher Booker posits that there are only seven archetypal stories: *Slaying the Beast*, *Rags to Riches*, *The Quest*, *Voyage and Return*, *Comedy*, *Tragedy*, and *Rebirth*.

"Panel of the Negative Hands"; Courtesy of the French Ministry of Culture and Communication

This handprint from the Chauvet Cave in southern France is one of the earliest examples of modern humans sharing their experiences with others.

And Carl Gustav Jung posited that there are a finite number of archetypal characters (which will be examined in detail in Chapter 9, "Branding"). The Old Testament of *The Bible* is seen as the perfect expression of those seminal stories and characters, appealing to universal emotions. Does that mean *Breaking Bad* or *To Kill A Mockingbird* are simply retreads of a finite number of stories and characters? If so, these stories' exquisite expression of nuance and compelling packaging makes them feel as fresh as if we'd never heard them before.

Good Marketing Looks Easy

So, all *homo sapiens* want to tell and hear stories. It's built in to human DNA. All you need to entertain and persuade is to be quick, expressive, witty, aesthetic, lyrical, and engaging! In fact, it's much harder than it looks. Anyone writing a novel or screenplay

understands that, but few realize the same is true for marketing. The over-the-shoulder marketer may be able to nitpick your movie poster, but can they come up with an entirely new concept with graphics, logo, tagline, and body copy that's better? That is, that actually works?

Marketing is both a science and an art form, and while much of it comes from the gut, it's usually a trained gut that performs the best. Years of seeing what works and what doesn't and why helps a marketer sense what might work in the future. A good marketer uses the limbic part of their brain to determine the need and benefit and then translates that to the neocortex part of the brain, using language and other expression. In short, marketing is both strategic and creative.

But before marketing goes too high up on a pedestal, there's also a big conceit about marketing. A successful marketing initiative may be as attributable to luck as it is to strategic planning. Would *An Inconvenient Truth* have raised as much awareness about climate change if Al Gore—the chad-robbed almost-president—hadn't helmed it? Would the floundering ABC pilot for *All In the Family* have become an American icon if CBS hadn't taken the chance on it and developed a third pilot? Would *The Blair Witch Project* have taken off if someone had tipped off the public that the video diary footage was a hoax? So, if a marketing person is smart and confident, that's a good sign. But if they're sure-fire cocky, run away as fast as you can. The best-laid marketing plans can be big flops for various reasons, sometimes unknown. And the best marketers have eaten plenty of humble pie.

> *No one has figured out marketing and if anyone ever did, they'd own the world, or they'd certainly own the entertainment business.*
> —Keith Gordon, filmmaker, director, writer, *A Midnight Clear, Mother Night, Waking the Dead, Dexter, Homeland, Nurse Jackie*

Marketing 101

Before hunkering down to actually market your film, television show, game, magazine, podcast, Webisode, or smartphone app, it's wise to understand the semantics and basic concepts behind marketing. For example, what's the difference between marketing, promotion, advertising, sales, public relations, and social media? Not everyone's in complete agreement about the answers, but there are some useful definitions and norms that derive from long-standing marketing best practices.

Starting with the biggest area of confusion, What's the difference between marketing and promotion? The simplest answer is that marketing answers the question, *Why?* It communicates to audiences the value of your sitcom or song. And promotion answers, *How?* It announces that your media property exists and how to find it. So posting a link

about your documentary film is promoting it, but discussing the issue behind it and flagging a unique aspect of your film is marketing it. Marketing is the *über* entity and includes four subsets, including promotion, underneath it.

"I'm available tonight." *That's promotion.*

"I'm a passionate lover." *That's marketing.*

"I'm a passionate lover and I'm available tonight." *That's a date.*

The **Marketing Mix** for a product that creates a value proposition consists of the **Four Marketing "Ps"**: Product, Price, Place, and Promotion. **Product** is about examining the appropriateness of the product for its market. It looks at the quality (production values) and key attributes of the media property, its target markets, and its competition. **Price** is about the audience's assessment of value and benefit *vis-à-vis* the cost. **Place** is about where and when it will be available to audiences. In the case of media and entertainment, it's about its distribution. And **Promotion** is about telegraphing it to audiences. Each of these marketing mix elements is valuable, but as stand-alones they are never enough to do the job. If you have an ad campaign and a huge social media buzz (good promotion), but your self-published book is only available in one obscure place (not accessible distribution), no one's going to buy it. That's why having an integrated marketing plan coordinating all of these four elements is the Holy Grail of marketing.

Promotional tactics are what are most often confused with or used interchangeably with marketing. The main goals of Promotion are to provide key information to audiences, differentiate the product or media project from others, and create audience demand for it. Traditionally, five elements of a promotional plan achieve those goals: *Advertising*, *Personal Selling*, *Sales Promotion*, *Direct Marketing*, and *Publicity*.

Advertising is a paid form of non-personal communication through mass media including print, broadcast, outdoor, online, and mobile ads; brochures; mailers; and in-store displays. Personal selling is person-to-person persuasion including sales and pitch meetings, sales training, incentive programs for intermediary sales, telemarketing, and e-blasts. Sales promotion is offering an incentive for a limited period including contests, product samples, coupons, sweepstakes, tie-ins, premiums, and trade exhibitions. Direct marketing is communicating with audiences using non-mass media vehicles such as promotional letters, guerrilla marketing, and fliers. Publicity is non-personal communication through journalistic intermediaries to stimulate audience demand, including print, broadcast, and online articles; speeches; issue advertising; and events. Publicity includes media relations, community relations, and social media.

So advertising, whether it's a billboard on a highway or a morning drive radio spot, and public relations, whether it's a review in *Hollywood Reporter* or an online event, are subsets of promotion. But there's a huge and very important difference between them. Advertising or "**Paid Media**" is a planned and purchased activity. You know when your radio spot will run and exactly what it will say because you created and approved it. On the other hand, the publicity from your media relations efforts, such as the review of your film, is "**Earned Media**." It is "free," that is, no money exchanged hands between you and the *Hollywood Reporter* for editorial coverage. (In truth, publicity is not free. It costs money to hire good publicists and develop effective publicity campaigns.) **"Earned media"** also takes the form of online media or blog coverage, or social media shares or commentary. "Earned media" often has more credibility than "paid media" because audiences are so sophisticated, they know when they're being advertised to. A third-party endorsement from a trusted blogger or a share from a Facebook friend may legitimize the value of your media property more than a full-page ad. But "earned media" is more of a gamble because you can't control a reviewer's opinion or the context in which the director's quotes are used in a story or what tone the social chatter will take around your media property.

And now, in a vast content-creation era, "**Owned Media**," the content you create for your project—its Web site, blog, social media platforms, video, and infographics—is a huge part of the mix to raise audience awareness and understanding of the value of your project.

All three kinds of media—"paid," "earned," and "owned"—work together to create your transmedia marketing narrative. The ad might make your audiences aware of the film; the trailer might engage audiences with the story and characters; the positive review might inspire them to consider your film; and the social media buzz might motivate them to book a date with a friend to see it on the opening weekend. An old promotional adage is that audiences need seven impressions (times they see or hear about a product) to buy it or see it. With so much content clutter in today's world, many more impressions are required. All the more important to create an orchestra of content to feed the value chain and motivate audiences to act.

Within marketing and promotion there are types of marketing concepts, such as "push" marketing in which producers or suppliers push product or content to audiences (an ad, a teaser poster, a video, or a link to a Web site). In turn, "pull" marketing is when audiences demand product of content to fulfill their needs (clicking on a link or conducting a search on Google because of buzz or interest). "Push" and "pull" marketing strategies are based on the basic economic principle of supply and demand and work together to engage audiences in your product or project.

In traditional marketing, the **Purchase Funnel** shows the process of how marketing and promotion move consumers from first contact to purchase. The funnel looks like an inverted pyramid, with the widest side at the top represented by *Awareness*. Ongoing marketing activities move consumers downward from *Awareness* to *Opinion*, to *Consideration*, to *Preference*, and then to *Purchase*, at the narrowest point on the bottom.

But new online, social media, and mobile digital technologies have altered audiences' reaction to and interaction with content and promotion. Audiences are participating directly with content, and as a result, the lines between producer and audience have become fuzzy. Transmedia marketing enters directly into the maw of this new world order. It reaches the limbic brain and encourages audiences to authentically engage with content and products on multiple media platforms. This difficult and vaunted practice of audience engagement is hailed as one of the most effective ways to market in the current media environment and is largely what this book is about.

> *This next generation coming up has become more savvy and sophisticated so advertisers have a real challenge. The more things are stand-alone or bifurcated, the more we back away and don't feel as if it's real or sincere. We're constantly looking for an organic experience, maybe that's built in to our social life—something that hints at the content and affirms the awareness message.*
>
> —**Chip Flaherty, co-founder and EVP, publisher, Walden Media**

So, both traditional promotion vehicles, such as "For Your Consideration" awards ads and critic reviews, and newer engagement tactics, such as live audience voting on mobile phones and social media campaigns, are important and viable. They all serve their purpose and, when part of a well-designed, creative marketing plan, can make the difference between an "I think I've heard of that" and an "I'm gonna see that."

Who Owns Transmedia Marketing?

Marketing is an organic and evolutionary enterprise, even more so for media and entertainment marketing because of the advent of so much changing technology impacting the media landscape. As soon as a marketing strategy or idea works, it feels *passé*, particularly in this era of marketing-savvy audiences. Being a student of trends and taking the pulse of the cultural climate are paramount to good marketing. So is versatility across disciplines and platforms.

> *We live in such a dynamic time that it's really useful if you can do a couple of different things and if you understand the way that those things interact with each other, because that will give you the ability to be agile as things continue to change.*
>
> —**Andrew Golis, general manager, The Wire, *The Atlantic***

Who should work on a project's marketing? Many people, never just one person. Anyone who's strategic, creative, wacky, or a risk-taker should be invited into the tent, at least for a while. Thinking out of the box can lead to grand slam home run ideas. If a marketing plan is cookie-cutter, it might be adequate, but it never will be brilliant. Media makers often have terrific marketing instincts about their projects, yet are often excluded from the process by bigger organizations. That can be a missed opportunity and seeking the producer's or director's input early on is usually a good idea.

You don't need to be a trained marketing professional to be good at marketing. Millennials and Gen Nexters are some of the best natural marketers since the promoters of traveling circuses. High school and college students shape themselves as brands and understand how to promote that persona through all their media megaphones—from logos on their clothes and tats on their body parts to their iPod play list and social graph. Like big established brands, young people's brands evolve, which is why they remove boozy party photos from their social media platforms when it's time to look for a job.

Still, in this equal opportunity era of anyone being a media maker or media marketer, there are some accepted roles and business practices to be observed in media marketing. Generally, the distributor manages the marketing of a media or entertainment property, with varied amounts of input by the development and production entities. This is because distributors are the outward-facing organizations that are responsible for bringing the property into the marketplace directly to audiences. They understand audiences' appetite for that genre of movie, TV program, book, or game better than anyone else and know how to motivate people to see, read, play, or buy it.

In film, that may be a studio with a distribution arm or a separate distribution company. For mass-market studio films, the distributor is responsible for determining the timing of the premiere, the cities it will run in, the type of theaters (arthouse or multi-plex) and the marketing plan to drive awareness and attendance to the film. But in the DIY indie film world, the filmmaker assembles his own marketing and distribution team, including the indie PMD to secure industry partners and distribution and target the film's audiences. The need for an up-front marketing and distribution strategy is critical because the glut of films has made it so difficult to get widespread or even limited theatrical distribution.

In traditional television, the distributor is usually the television or cable network. They determine the premiere date for a series' season opener or special, the day of the week, the timeslot, the show's title, and the marketing plan to drive viewership. Often, the domestic and international distribution is handled by different organizations. A foreign sales agent may forge separate deals with foreign distributors, which create marketing plans for each territory to meet varying cultural or political standards.

When OTT digital platforms, such as Netflix, Hulu, or Amazon Prime present film and television, they manage the marketing directly if it's their original programming, such as Netflix's *Orange Is the New Black*. If they're solely distributing other creators' content,

they generally promote the property as an extension of the original distributor's marketing activities.

> *That's one of the things that's different between film and TV. As a feature director, you're involved in the whole marketing and sales of a movie. But as a TV show director you really don't interact with the marketing people at all, the whole marketing is its own separate entity.*
>
> —**Keith Gordon, filmmaker, director, writer,** *A Midnight Clear, Mother Night, Waking the Dead, Dexter, Homeland, Nurse Jackie*

Radio marketing is usually handled in house, often associated with the on-air promotion or sales functions. In print, the marketing division of the publisher handles marketing. Magazines and newspapers market through their editorial content by seeking promotable high-profile interviews or "gets" and with headlines and magazine covers. Book publishers have marketing teams assigned to market individual books through reviews and book tours. In games, the marketing is managed by studios that oversee production, distribution, and merchandising or by the publisher, which handles distribution.

In all cases, marketing can be conducted by outside consultants or marketing firms hired by the distributor. Generally, the firms specialize in marketing for that platform (film or games) or in that particular genre (romance, horror). Still, their work is commissioned and supervised by the entity responsible for the marketing.

A Marketing Inspiration—Apple

There are many brands and marketing moments outside of the entertainment and media arenas that are truly inspiring. Because good marketing transcends media, industries, and genres, some brands can be useful inspirations for marketing anything, including film, television, games, and digital media.

Apple is a seminal branding, marketing, and innovation case study for several reasons. No other current consumer brand engenders more emotion—whether positive or negative—than Apple. Some people love Apple like they love their pets. Others despise it and await its demise in a post-Steve Jobs era. No matter where people land on the affinity scale, Apple delves deeply into their psyches. Almost everybody pays attention to Apple's next product or business announcement.

One reason is because Apple knew what it was, and what it wasn't, from day one. Plus, it had something to say about who *you* were if you chose a Mac, feeding a deep-seated cultural yearning to be different. In the 1980s, Apple wasn't IBM, the behemoth ruler of PCs. It was a small, artsy, and rogue computer company. If you had a Mac you

were a counter-culture creator, you didn't draw inside the lines, and you weren't always compatible with the rest of the world—literally and figuratively. Ad agencies and designers used Macs because they had the best programs for art and design, yet documents created on Macs couldn't be opened or read by many PC-driven systems. It took a lot of extra work and a healthy sense of self to be an Apple devotee in the early days.

Also, Apple's branding and promotion oozed that rebellious (The Outlaw) positioning in every way. Who can forget the "1984" TV spot with the athlete breaking down the barriers of conventional computers and lifestyle? This later morphed into Apple's "Think Different" campaign. Everything—from the unique product design and the constant innovation (the iPhone and iPad established the smartphone and tablet categories) to the retail store experience and the unique business models (iTunes)—pays off on thinking differently.

"Think Different" by Apple Computer Inc.; Licensed in the public domain via Wikimedia Commons

Apple touted its rebellious personality in its 1977 "Think Different" campaign.

Finally, Apple has been the ultimate anthropologist, including the user perspective in everything it does. It studied visitor interactions at concierge desks at Ritz Hotels to create the Genius Bar model at its Apple Stores. It examined the various ways humans use their index fingers to create its signature iPhone "swipe." Its products and services have served real human needs that people didn't even know they had, plus offered its users *entrée* to a revolutionary creative and *avant-garde* community. Apple has inspired its audiences to be part of the Apple experience by appealing to a higher drive, much more than it has manipulated them. Appealing to motivation creates long-term brand loyalty.

There are countless other consumer brands—from Nike and Dove to Ford Mustang and McDonalds—that are branding and marketing icons. As you progress through the book, you will understand why Apple and some of these iconic brands are marketing *wunderkinds*, hitting the mark on so many key criteria—from iconic graphic expression

to fully engaging audiences. You will see how the key marketing values imbued in them apply to the various media and entertainment case studies presented throughout, and to your media property. And now it's time to focus on developing the marketing strategy and plan for your media property.

Author's Anecdote

Promotion vs. Marketing

When I started at WGBH, PBS' largest national producer of content, in 1997, my title was Director of National Promotion. My team handled the promotion for 20 ongoing television series—from *NOVA*, *American Experience*, and *Frontline* to *Masterpiece*, *Antiques Roadshow*, and *Curious George*—and numerous mini-series. The main work of the department had been securing television critic reviews and industry coverage. But because we were entering a new era of content available on multiple platforms serving various target audiences, we would need to develop integrated marketing campaigns including feature and consumer press, consumer and trade advertising, Web and viral marketing, consumer and industry events, community and educational outreach, and social change campaigns.

To signal this broader marketing philosophy to outside partners, my title changed to Director of National Strategic Marketing. *Promotion* in the old title communicated only part of what we were doing, getting eyeballs on the television shows and films and visitors to the Web sites. But *marketing* in the new title communicated our broader goals of defining, amplifying, and communicating the value of PBS' content to various constituencies—from children and educators to media and Capitol Hill. Our in-house team engaged these many audiences with the national content and contributed to Emmys, Oscars, Peabodys, DuPont Columbia, Webbys, PromaxBDA, Silver Anvils, *PR Week* Awards, Communicator Awards, and SABRE awards. (By the mid-2000s, my title on special projects morphed to Executive Director of Marketing, Media Platforms, and Impact to reflect the emergence of transmedia.)

PART II

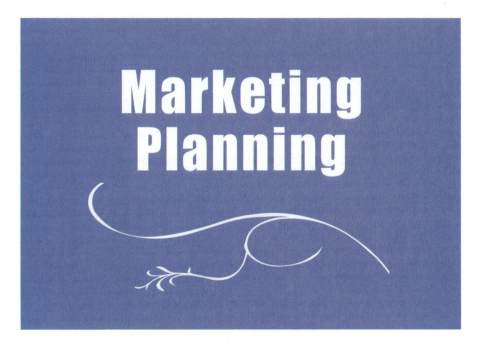

Marketing
Planning

The Marketing Plan

You can't get where you're trying to go unless you have charted the waters you expect to travel. Your marketing plan is the map of the coastline, the currents, and the hidden rocks. It will guide you and your project through limited visibility and bad weather on your long and complicated journey.

Architects have blueprints. Artists have rough sketches. Entrepreneurs have business benchmarks. And successful media makers and marketers have clearly articulated marketing plans. Great marketing outcomes rarely happen because of serendipity or flashes of inspiration. They happen because of sound strategy and diligent planning. Now you're going to write and, eventually, execute the tactics of the marketing plan you develop for your transmedia project.

Why Plan?

Marketing planning is simply a subset of strategic planning, a problem-solving approach derived from the battlefields of ancient Greece. In its modern application, strategic planning is the discipline of approaching any business enterprise by examining the competitive context in which it will be operating; clearly identifying markets, audiences, goals, and positioning; developing a specific plan of action to reach those goals; creating a system for tracking progress of the plan's execution; and closely evaluating the success of the plan in its concept and execution. Strategic planning is an ongoing, organic process. In its modern application, strategic plans are revised and evaluated throughout their execution. The insights you glean from evaluating the outcomes of executed tactics are incorporated into new plans for the future.

Any good strategic planning process includes the development of a marketing or business plan. Because marketing is so critical to the success of any enterprise, for many the strategic plan and the marketing plan are synonymous. A strategic marketing plan offers many benefits. It:

- Establishes a beacon that informs all decisions
- Promotes strategic thinking and creativity
- Challenges assumptions
- Allows for risk-taking
- Includes stakeholders' perspectives
- Leverages all assets
- Finds synergies across disciplines
- Unifies the project team and clarifies roles
- Promotes efficient and cost-effective use of resources
- Creates a logical and accountable structure
- Establishes evaluation criteria
- Is unique to your project

Plans That Work

A marketing plan should be understandable and relevant to all team members and stakeholders. That always begins and ends with the goals and objectives. Articulating goals for the success of a project may engender more disagreement than any other part of the plan. But when you're all on the same page, then the strategies and tactics to reach those goals easily fall into place.

As initially discussed in the previous chapter, you must address all Four Marketing "Ps" of the Marketing Mix in your plan, which together dictate the marketing strategies and tactics for your project. They determine how to choose and use resources to achieve your objectives and what route to steer your boat to get where you're trying to go.

- **Product**—examination of your transmedia project (quality, attributes, markets, and competition)
- **Price**—the cost—both financial and time commitment—for audiences to consume or participate in your project (a cost-benefit analysis)

- **Place**—where and when your project will be available to audiences (distribution strategy)

- **Promotion**—telegraphing your project's value to audiences (your marketing action plan and tactics)

Who's going to write your media project's marketing plan? You can write it, so can outside marketing consultants or firms, or the distributor's marketing department. Usually, there's a combination of contributors, but just one entity drafts and updates it. If you're the project creator and don't have funding and distribution, then you might be drafting the first version of your marketing plan. In the later stages of your project's trajectory, other marketing experts may be drafting or revising it. Either way, it's important to understand the foundation of sound plan development so you can evaluate and contribute to a plan. If you're a social media marketing expert or another kind of marketing contributor, but not writing the overall plan, you should still write a mini-plan for your area of marketing expertise and ensure it's incorporated into the overall plan. No matter what your role, you should not hesitate to add your ideas or open up new avenues of strategic or creative thinking with your marketing team. Good marketing is a team sport.

If you're hiring a consultant or an outside marketing firm to draft your marketing plan and execute all or some of it, there a few things you should keep in mind before hiring them. Approach it like you're bringing on another trusted team partner, not a vendor. Determine whether the firm has worked on other similar projects in media or entertainment or projects that might take the same kind of approach or reach a similar target audience. Look at the firm's past work and see whether it wows you. If you're ready to hear more, share all you can about your project with two to four prospective firms. Ask them to develop a proposal that includes background on their firm, why they'd be a good fit, and some topline marketing strategies on how they would approach marketing your transmedia project, along with a budget and timeline. Also, ask for contacts of previous clients.

Don't ask the firms to draft a full-fledged marketing plan as part of the bidding process, because that's the same as asking them to give away their most precious service—their mindshare—for free. Hungry firms will give you a lot of good ideas and a sense of how they will approach the project. By evaluating their strategic approach and some sample tactics, you'll get a sense of how they think and determine whether it's a good fit. If the recommendations look cookie-cutter, that is, one-size-fits-all, don't hire them. That means they're lazy and uncreative. If you don't know other organizations or projects that have used this firm, then check at least one of the references to ensure the firm was creative, strategic, and responsive. And don't make the decision alone; solicit feedback from other team members. You're all going to be working very closely together.

Elements of a Sound Marketing Plan

A good marketing plan is like building a house. It begins with the blueprint. Then there's the foundation, weight-bearing walls, framing, drywall, roof, windows, plumbing, electricity, and all of the final touches and embellishments. All of those elements are important to creating a sound, functional, and attractive home. Well-built structures have reinforcements and extra safeguards to protect you from high winds or floods. Some of the final decisions, such as what fixtures to use or what color to paint the walls, may change over time as you see your structure taking form. But fundamental decisions such as whether you're building a colonial or contemporary structure will remain steady over time.

"The Eiffel Tower" (ca. 1884) by Maurice Koechlin, Émile Nouguier; Licensed in the public domain via Wikimedia Commons

To create a framework for your project's marketing plan, you must create a blueprint for it.

Plan Structure

Now, you're ready to frame your marketing plan by covering the Four Marketing "Ps" of Product, Price, Place, and Promotion. Marketing plans look like a hierarchical outline with broad goals first, then objectives, strategies, and tactics, each supporting the previous category. Below is an outline for your marketing plan that should be fleshed out with a combination of narrative and bullets. There is leeway in the detail and you should use what works best to communicate your vision and activities. This book will cover the sections of the marketing plan in detail. The suggested headers and sections are:

Title Page

- The title is your media property's working title followed by "Marketing Plan"
- Art (photo, painting, screen shot, or logo can set the tone, but is optional)
- Date (plans are usually updated)

Executive Summary

This two-paragraph project and marketing overview is critical. It should include, but not necessarily in this order:

- Project description (genre, archetypal story, media platforms, plot, characters, mood, themes)
- Marketing and environmental overview (project goals or mission, timing, key Environmental Landscape and SWOT Analysis points, target audiences, overall marketing approach to reach audiences).

It sets up the detailed plan that will follow. It shouldn't be didactic, but must be compelling and engaging. The executive summary, used here and elsewhere, is an important tool to persuade partners or funders to come on board.

Story Bible Overview

This section is optional and primarily applies to fictional properties. It can be just a paragraph or a few bullets if a longer treatment, story bible, or script is available:

- Characters
- Mood
- Theme
- Plot (conflict, contingency storylines)
- Audience calls-to-action (what audiences must do/where they go to get more story, character, plot information)
- Story timeline

Transmedia Platforms

Here, you identify which platforms your transmedia project will use, and which are primary, secondary, or tertiary. Provide a brief description of how your project will play out on each platform and how the platforms relate to each other:

- Film
- Television
- Radio
- Books
- Publications (newspapers, magazines)
- Games
- Digital (Web sites, blogs, social media platforms, apps)
- Experiential (theater, concerts, exhibitions/live installations, events, theme parks, toys)
- Other platforms (including merchandise, music CDs, home video DVDs/Blu-ray)

Distribution

Here, distribution partners (or desired distributors) are described. If there is more than one media platform, each platform's distributor should be identified and the relationships between them should also be included. This section may be combined with the Transmedia Platform section, together providing detail on platforms and distributors:

- Distributors (by platform)
- Releases (how audience accesses the media, windowing of content)
- Timeline (of release by platform)

Situation Analysis

Overview

The situation analysis may begin with a short narrative overview of the overall landscape and challenges and opportunities, but may not be necessary if these critical elements are covered in your executive summary.

Environmental Landscape

In this section, you use secondary research (from existing sources) to fully lay out the "situation" in which you're developing, launching, and marketing your project. You must look at the overall media landscape, as well as the specific marketplace in which your project will be operating. This includes examining similar projects on your project's platforms or within its genre:

- General leisure landscape
 - Leisure time trends
 - Entertainment trends and usage
 - Technology penetration and trends
 - Film, TV, games, digital trends
 - Industry marketing trends
- Competitive audit by platform and genre
 - Specific platform and genre trends
 - Segment analysis by platform, genre, and target audience
 - Competitive project marketing analysis (taglines, audiences, marketing tactics, spending)

SWOT Analysis

The SWOT Analysis examines your project's assets and liabilities by evaluating its **SWOT**:

- **S**trengths (of your project)
- **W**eakness (of your project)
- **O**pportunities (in the marketplace)
- **T**hreats—or Challenges (in the marketplace)

Strengths and Weaknesses are an *internal* assessment of your media property (or Product) and Opportunities and Threats are an *external* assessment of the marketplace.

Marketing Research

All good marketing is based on audience insight and data collection. Whether you have a large budget or not, you must conduct some informal research with your potential target audiences to guide marketing approaches, messages, spokespeople, and other key marketing decisions. In this section, you indicate what research has already been conducted and what additional secondary and primary research you will conduct for your transmedia project:

- Secondary research (collection of existing data or research that is pertinent)
- Primary research (research that is conducted specifically for your project)
- Quantitative (statistically-significant research conducted among a larger target audience population from which conclusions can be drawn: online panels, telephone surveys, etc.)
- Qualitative (not statistically-significant, but offers "directional" insight from small audience segments: focus groups, Beta-testing, dial-testing, etc.)

Target Audiences

Here you identify your project's key audiences. Because your project may have many audiences, it's important to determine which are primary. Don't just say "general public"; be targeted:

- Influencer audiences
 - Press, industry leaders, distributors, tastemakers, educators, government officials
- Public audiences
 - Varies greatly, but can range from soccer moms to tech-savvy college students (be specific)
- Demographic profile
 - Age, gender, ethnicity, education, household income, geography
- Psychographic profile
 - Predispositions and interests

Goals and Objectives

This is the heart and soul of your marketing plan. Goals are broader strokes on what you are trying to achieve. Objectives pay off on the goals and are tangible, concrete, and quantifiable. Sometimes goals and objectives are combined and only goals are used, but in this case, the goals should be measurable:

- Goals (general intentions of what is to be achieved; articulate one to three main goals)
- Objectives (specific, time-bound, and measurable through evaluation; articulate key objectives for each of the general areas you plan to measure)
 - Quantitative objectives measures (box office sales, Nielsens, downloads, views, unique visitors, click-throughs, time spent viewing, shares, tweets, GRPs, media impressions, ad equivalencies, audience awareness)
 - Qualitative objectives measures (reviews, key message pick-up, anecdotal comments, buzz, cultural currency, audience perceptions)

Marketing Strategies

Marketing strategies explain the "how" for goals and objectives. They offer approaches you might use to reach audiences and achieve goals. There are usually several strategies that support an objective and several tactics that pay off on a strategy:

- Strategies (raise awareness among tastemakers, launch product at critical timing or event, create dialogue among certain target audiences)

Branding and Positioning

This is where you establish guidelines for how you want to establish a persona and give voice to your project:

- Brand attributes
- Brand essence (internal expression of what your project is)
- Brand positioning (external expression of what your project is)
- Messaging (what you want to communicate and how)
- Spokespeople (who will represent the project to the public)

Strategic Partners

By forging partnerships with entities that believe in your project and have capacity in areas in which you don't, you can give your project breadth and depth. Many partners will offer support in more than one of these areas:

- Media (media creators, distributors, publishers)
- Marketing and promotion (distributors, sponsors)
- Outreach (membership organizations, partners)
- Cause (non-governmental organizations [NGOS], charities)

Marketing Action Plan—Tactics

This is the nuts and bolts of your marketing plan and where the Promotion "P" of your plan begins. There is no template for this section because your tactics will be determined by many things—from your goals and audiences to your platforms and budget. But ensure your tactics follow the outline and flow of the rest of the plan. Activities that target the media and entertainment industry may help you secure funding, distribution, or industry buzz early on. You'll also have many marketing activities to reach out to your public audiences to get them to watch, listen to, read, play, or interact with your project.

You can set up this section in a number of ways—by timeframe with ordered tactics within each phase, by audiences with tactics targeted to each, or by strategy with various tactics that pay off on each. There is no right or wrong; it's intuitive. If others understand it, then it's working. These examples will get you started:

- Influencer tactics
 - Industry trade publicity
 - Markets, festivals, and industry events
 - Awards

- Public tactics
 - Consumer publicity
 - Trailers and sizzle reels
 - Advertising
 - Online marketing
 - Social media
 - Public events

Evaluation

Since you have set measurable goals, you should evaluate what worked and what didn't, both mid-stream and at your project's end. It's best to conduct your evaluation against your project's stated goals and objectives. Some aspects of your plan are likely to be slam-dunk successes, while others are riskier and are meant to be learning opportunities. When you are setting goals it's important to identify the difference:

- Goals and objectives results (measures *exactly* what you set out to achieve as designated in your Goals and Objectives)
 - Quantitative objectives (box office sales, Nielsens, downloads, views, unique visitors, click-throughs, time spent viewing, shares, tweets, GRPs, media impressions, ad equivalencies, audience awareness)
 - Qualitative objectives (reviews, key message pick-up, anecdotal comments, buzz, cultural currency, audience perceptions)

Project Timeline

While it's impossible to accurately predict how long it will take to fund, develop, produce, launch, and market a project, estimating a timeline is critical. Timing affects funding, distribution, launch strategies, and much more. Below are phases in which your planning and execution activities might occur. Ascribe estimated dates within your timeline:

- Development (research, planning)
- Production (creating content and marketing elements)
- Launch/distribution (where the most content and marketing activity occurs)
- Post-launch (continued deeper audience engagement activities)
- Ongoing (maintenance activities to keep project relevant; social media, new content, etc.)

Budget

This is the section where the rubber meets the road. Start with a marketing budget based on industry norms. On average, big film studios spend one-half to one-third of production budgets on marketing, and smaller companies spend about one-quarter. TV networks and cable companies spend about one-third of the production budget, and games publishers spend about one-third. So, taking the industry average, you should aim for about one-third of your production budget for marketing your transmedia project. If you're an indie producer, be sure to include marketing costs in your crowdsourced fundraising goals.

While you must be able to pay for your ideas, don't shut down a great idea because of money. If you have the potential for a unique project and have articulated a brilliant marketing plan, partners and distributors can help fund both the production and the marketing. The media and entertainment industry understands that success in today's world requires marketing. Still, you can develop fantastic marketing plans with small budgets if you wisely use assets that you "own" or "co-own."

Set up your budget by activity or timeline, but ensure it corresponds directly with the sections of your marketing plan. Within the plan, your budget may just have total amounts for key categories and you can create a detailed budget as an attachment. The budget should include:

- Funding strategy and sources (current and prospective)
- Resources and personnel required
- Production budget by activity (seven key categories)
 - Above-the-line (creatives such as producers, directors, writers, actors, casting directors and their costs such as travel, development, and assistants)
 - Below-the-line (crew, equipment, food, transportation, props, locations and other resources)
 - Post-production (editor, composer, sound designer, visual effects, colorist, etc.)
 - Overhead (office space, legal fees, postage, etc.)
 - Marketing and distribution (research, advertising creative, media buys, public relations, social media, Web and digital design, graphic design, photography, opens and trailers, events, film prints, supplies, travel, etc.)
 - Contingency (a percentage of the overall budget; extra money set aside for something that pops up that you want to ensure you can do)
 - Insurance (a percentage of overall budget; or can be placed within sections of the budget)

You also may want to develop a phased version of the budget, based on a timeline that corresponds with fiscal years, existing financing, or with the stages of production: development, pre-production, production, and post-production.

Project Team

This critical section underscores your project creators' expertise and the project's pedigree. Cite other similar or successful projects and relevant experience of key project personnel and partners:

- Biographies (around 150 words each)
- Partners' boilerplates (one-paragraph company descriptors for the project, production company, distributors, promotional or outreach partners)

The marketing plan begins as an internal document to be shared among the project team members, but eventually, after it is refined, it may become a more public document used with prospective partners and stakeholders. If you are sending it out for these purposes, your marketing plan may also be accompanied by a longer project treatment, story bible, or script and a detailed budget.

The best plans are clearly articulated, yet flexible. The goals rarely change, the strategies occasionally change, and the tactics are often revised. Whether you're marketing a film, TV program, book, game, digital media, or transmedia project, the basic structure of this marketing plan outline will apply. Of course, the promotional tactics will vary by platform, genre, target audience, topic, environmental landscape, and many other factors. Upcoming chapters of this book will cover each of the key sections of the marketing plan.

A Sample Plan—*Martin Scorsese Presents the Blues*

Elements of the marketing plan for the cross-platform project *Martin Scorsese Presents the Blues* appear throughout this book as a working case study to bring key concepts to life and help you write your marketing and engagement plan. This cross-platform project was massive, bridging film, TV, radio, Web, book, music CDs, home video, and experiential media platforms. Its comprehensive transmedia marketing campaign was fully integrated into the media elements, even driving the timing of the media elements' launch.

To follow is a short overview of the integrated project, including an Executive Summary and Marketing Summary. As you'll see, *The Blues* was a huge project with many elements and players. In order for all members of the team to understand and support the marketing plan, the project held an initial two-day marketing planning summit and thereafter, regular project and marketing calls with more than 50 participants throughout the various phases of the project's planning, execution, and evaluation. (For the audience and branding analysis, combined marketing plan/final report case study, and a rich array of content and marketing materials for *Martin Scorsese Presents the Blues*, go to transmediamarketing. com).

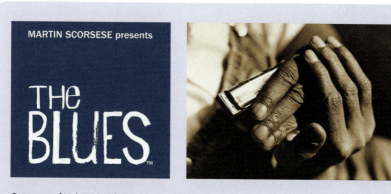

Courtesy of Vulcan Productions

Martin Scorsese Presents the Blues brought the blues music genre to all music lovers.

The Blues Executive Summary

By the turn of the twentieth century, the supremely American music genre—the blues—had suffered a downward slide in popularity and was underacknowledged for its profound influence on virtually all music—soul, country, rock 'n' roll, hip-hop, and jazz. While a handful of blues legends remained, very few recognizable younger artists represented the next blues generation. Blues music sales were down and the genre was often combined with other categories to form hybrids with broader appeal. Common perception was that the blues was a nearly defunct, sad, and overly simplistic art form that spoke only to African Americans.

 To change all that, on September 28, 2003, *Martin Scorsese Presents the Blues*—a week-long primetime film festival broadcast of seven impressionistic independent documentary films—each directed by a different film visionary including Martin Scorsese, Wim Wenders, Clint Eastwood, Mark Levin, Richard Pearce, Mike Figgis, and Charles Burnett—premiered nationally on PBS. Produced by Vulcan Productions and Road Movies, executive produced by Martin Scorsese, and sponsored by Volkswagen, the TV series anchored a cross-platform media project—*on air, online, in print, in schools*, and *on the road*—designed to raise awareness of the blues and its contribution to American culture and music. In addition to the TV series featuring scores of blues and music greats, *The Blues* cross-platform project included a content-rich Web site on PBS.org; a 13-part companion radio series distributed by Pubic Radio International; a companion book by HarperCollins; a high-profile concert at Radio City Music Hall; a theatrically-released concert film directed by Antoine Fuqua; a cadre of music CDs and DVDs/videos from Sony and Universal; a traveling museum exhibit by Experience Music Project; high school music and social studies curriculum; and an extensive "On the Road" grassroots tour of film, music, and cultural events.

The Blues Marketing Summary

To capture the authentic emotional resonance of the blues, *The Blues* took to the road and to the people with "The Year of the Blues." Kicking off in early 2003 with the Congressional Proclamation and a landmark, star-studded concert at Radio City Music Hall with 50+ artists, "The Year of the Blues" was celebrated "On the Road" with a national schedule of 120+ high-profile and grassroots film, music, and heritage events. *The Blues* cross-platform media event crescendoed in the fall with the TV series and was amplified by immense media coverage and buzz. Throughout, *The Blues* was supported by a massive awareness campaign with music icons such as B.B. King, Bonnie Raitt, and Mick Jagger and newer artists such as Chris Thomas King, Shemekia Copeland, and Chuck D. In tandem with the grassroots tour, the campaign included media relations; TV, radio, print, online, and mobile advertising; online and guerrilla marketing; on-air, in-store, and in-flight promotion; and strategic partnerships with American Airlines, House of Blues, W Hotels, Best Buy, Barnes & Noble, Experience Music Project, and the Blues Foundation. The project reached music and film aficionados, cultural leaders, educators, the press, Hollywood, and Capitol Hill. *The Blues* was the "can't miss" media event of the fall of 2003, creating a true cultural awakening and resurgence of the blues.

One of the most extensive awareness campaigns in PBS' history, *The Blues* garnered 1.7 billion positive media impressions via publicity, online marketing, events, and on-air and online promotion. It delivered 1.2+ billion impressions via traditional media coverage, 113 million online, and 2+ million on the ground, through the project's "On the Road" tour.

As many as 60 million people intersected with *The Blues* media components, including 19.5 million TV viewers in the first week of broadcast and 20 million unique Web visitors to the project site in the first three weeks. The project also created lasting cultural impact, reaching key target audiences including 50,000 high school teachers and 1 million students who would study, celebrate, and play the blues for years to come. And, it reached numerous social, media, and political influencers in Congress, in Hollywood, and at cultural events—from the Kennedy Center to the Cannes Film Festival. Finally, *The Blues* project lifted the blues music genre and its artists, generating an overall 40 percent uptick in the sales of blues CDs, a staggering 500 percent increase among key retailers in the few weeks after the project's launch, and the donation of revenue to The Blues Foundation for aging artists.

"Popular interest in roots music [has] grown in recent years, especially after . . . *The Blues*."
—*The New York Times* (3/21/04).

Media and entertainment projects across different platforms and genres sometimes have more in common than meets the eye. For example, films often launch at film markets or festivals to generate industry momentum. Games often rely on industry trade events for product launches. Both push out highly-produced trailers on social media directly to audiences. Both platforms share marketing strategies to launch the media project to the industry at key events to secure buzz and industry support, while reaching public audiences with social sizzle. Yet how they achieve those strategies may be vastly different.

What all entertainment and media projects share is the need for a sound, strategic, and creative marketing plan. Laying out a vision and strategic action plan for your project will be the most valuable work you do. It will serve as a litmus test for major decisions. Does the activity you're considering pay off on your goals for one or all of your target audiences? If not, it's probably extraneous. Conversely, if too many things you want to do don't pay off on key goals or objectives or strategies, then maybe they're not accurate. The plan is like having an operating compass for moving forward and decision-making. It informs your "Yeses" and "Nos."

Know Your Media Project

Storytelling and marketing are rooted in the tension of cause and effect and the relationship between need and benefit. Who would have imagined that there's an elegant link between Buddhism and creating your marketing plan? The first step is knowing yourself. For the purposes of this book that means knowing what your project is and what it isn't. Is it an escapist, romantic interlude or is it biting social commentary? How is it unique? Who would be interested in it and why? What are its assets and liabilities? You must fully understand and honestly articulate the answers to all these questions in order to pitch your project to potential co-producers, funders, and distributors and to market it to your target audiences.

By writing a marketing plan, you are conducting strategic planning for your project. To begin, start with Product in the Four Marketing "Ps"—Product, Price, Place, and Promotion. This means determining what your transmedia project's about, differentiating it from other projects in the marketplace, uncovering the inherent challenges, and mining the opportunities to advance your project in the marketplace. This sets the stage for all that will follow in your marketing plan.

What Is It Really?

One of the hardest questions to answer is what a media project or entertainment property is really about. What is the nub of the story? If you created it, then it's your child, and while in some ways you know it better than most, you also have no objectivity. If you've ever written a logline—the one sentence description of your story or project—you'll find it's almost as hard to write as the entire script or treatment for it. And if you're tasked

with marketing the media project, before you simply peg your project as a game or a documentary or as a comedy or sci-fi, hence assuming certain associated marketing techniques should be used for that property, you must dig much deeper. Find the hidden themes or messages in your story that make it appeal to human instincts and that transcend platform or genre.

> *Whether told over an evening fire, read in solitude, or watched on 10 million television sets all around the country, stories are our greatest communal exploration of the human experience. They examine the choices people make as individuals and the consequences of those actions, celebrating heroism and vilifying misbehavior. They can both help us escape from our lives and help us find meaning within our existence through the lessons they teach, the examples they set, and the values they impart. They can take us on journeys to worlds we've never imagined and allow us to identify more deeply with people from vastly different cultures.*
>
> **—David Magee, screenwriter,** *Life of Pi, Finding Neverland*

When asked what their project's about, many project creators fall into the trap of describing the characters and the plot. That's not what it's about. That's how the characters get there. And the genre is sometimes just the window dressing on what it's about. Is your project a story of transcendence or a tale of unrequited love? For example, the *Romeo and Juliet* story could take place in a space ship between alien species or in ancient India among members of different caste systems. And it can be told or played on an Android app or in a highly-produced feature film. Essentially, it's the same core story. Your story and the specific way it's told has its own advantages and disadvantages that must be fully evaluated, but will lead to critical marketing approaches.

If you get stuck, go back to the seven archetypal stories of *Slaying the Beast*, *Rags to Riches*, *The Quest*, *Voyage and Return*, *Comedy*, *Tragedy,* and *Rebirth*. Or take a look at Sir Arthur Thomas Quiller-Couch's seven core story types expressed in core conflict: *Man vs. Man*, *Man vs. Himself*, *Man vs. Nature*, *Man vs. Society*, *Man vs. Supernatural*, *Man vs. Machine,* and *Man vs. Destiny*. See if it fits directly or loosely into one of those.

Dig further and look for themes within that story. For example, *Titanic* is both a disaster story and a love story, but it's even more. It's also about ego, greed, and inequality. Jane Austen's *Pride and Prejudice* has many themes including status, class, roles, sexism, pride, competition, control, truth, honor, and scandal. Stories with a lot of emotion and key themes below the surface generally withstand the test of time.

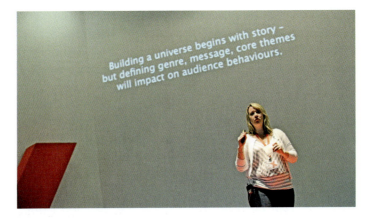

© Lisa Lemée; provided by TEDxTransmedia

Alison Norrington, author, Ph.D. researcher, transmedia writer/strategist/producer, and CEO at storycentral DIGITAL talks about knowing your project at TEDxTransmedia 2012.

One of the best ways to determine what it's about is to ask other people. This is your first foray into doing research, in this case, informally focus-grouping or getting audience opinions about the media property. And this will not be the last time you go outside your bubble to get feedback. Give the script or treatment to project stakeholders and other people whom you trust and ask them some pointed questions:

- What is it about?
- What are the key themes?
- What emotions does it evoke?
- Why do you care?
- What does it remind you of?
- What character do you relate to most and why?
- Who would like it and why?
- Are there other projects out there like it?

Don't tell them what you think and don't stack the deck by directing the questions toward certain answers. Let them answer honestly and truly listen. Collect and document the answers. If someone surprises you by saying it reminds them of Carrie Underwood's song, "Before He Cheats," think about what that really means. Is there more betrayal, pain, and revenge in the story than you knew? Those themes and emotions are key clues to how to market it.

We always start with a purpose—a sentence or two—about what the story system is designed to do. With an entertainment property it's taking a step back and asking, "What is it about this world, what are the themes and rules that make it compelling, and how can we make that interactive?" And then we let everything else flow out of that.

—Chris Eyerman, creative director, 3AM; formerly transmedia creator for *Prometheus, The Hunger Games, Arrested Development*

There's no formula for determining what your story is truly about, but once you've got it, you've got the first 30 seconds of any pitch that quickly communicates your project's themes, conflict, mood, setting, platform, and genre. Suppose you're working on a dramedy that you sum up as "*Girls* meets *The Office* meets *The Odd Couple*." You might describe it as: a modern-day coming-of-age story about two young women (one a free spirit, the other a by-the-books-er) who are thrown together on their first job after college, and who despite their raging differences, hang on to each other for dear life as they stumble their way through ageism, sexism, romance, stupidity, and their own naïveté in a hectic cable TV newsroom.

This shorter description is the précis of the fuller exploration of character and plot in your treatment, story bible, or script. In order for your description or logline to communicate the authentic *zeitgeist* of your project, it must speak to the conflict, themes, and core emotions as much as it describes key story elements and characters.

Situation Analysis

Once you know what your media property is about, you can write your executive summary and other project descriptions. Then you can look honestly at its assets and liabilities in the context of the current media landscape and audience sensibilities. Be prepared: your project will have both assets and liabilities.

In standard marketing practice, the evaluation of the product and its potential salience in the marketplace is called the Situation Analysis. This examination of both internal and external factors appears in an early section of the marketing plan, usually right after an introduction. There are several methods for conducting this analysis including the Five "Cs" Analysis of *Company*, *Competitors*, *Customers*, *Collaborators,* and *Climate*; the Porter Five Forces Analysis of threats of *New Entrants, Substitute Products, Bargaining Power of Customers*, *Bargaining Power of Suppliers*, and *Competitive Rivalry within the Industry*; and the SWOT Analysis discussed in more detail in this chapter. Even the military has their version, the PEST Analysis of *Political*, *Economic*, *Social*, and *Technological* factors.

All methods use a strategic planning approach to accomplish the same thing: evaluate both the internal and external environment to understand an entity's capabilities, audiences, and business landscape.

An effective way to analyze the situation that your media property encounters—its attributes, audience, and the media landscape—is through the **SWOT Analysis**: the evaluation of its **Strengths**, **Weakness**, **Opportunities**, and **Threats**. Strengths and Weaknesses are an *internal* assessment of your *media property* and Opportunities and Threats (or Challenges) are an *external* assessment of the *marketplace*. Because two of these characteristics are positive assets and two are negative ones, sometimes they are reordered into a two-pronged analysis combining the positives, Strengths/Opportunities, and the negatives, Weaknesses/Threats (Challenges). (In this case, it would be SOWT Analysis.)

Seizing the Opportunities

Begin this exercise alone and identify as many internal and external positive and negative attributes as you can. Be prepared to look at both the micro (small or specific) and the macro (big picture). Then, add some of your trusted partners or colleagues to the mix to participate in a group exercise that you document on a whiteboard or on oversized 3M Post-its, which you can easily take back to the office and type up. Follow the SWOT structure provided in the previous chapter, "The Marketing Plan" or the SOWT structure provided below. You'll be gratified by how much your assessments overlap and also be surprised by all the new ideas that others think of.

Strengths

To start capturing the project's opportunities, begin by evaluating the inherent strengths or assets of the media property. They might include:

- Talent or pedigree attached to it (notable actors, writers, producers, directors, partners)—*demonstrates built-in audience appeal and successful track-records*
- Pre-existing brand equity (movie adaption of *New York Times* bestselling book or game version of popular children's toy)—*shows a pre-existing audience base*
- New, first, or unique (first transmedia project about tattoo parlors)—*demonstrates ability to cut through the clutter of content; tap into secondary markets; and, while riskier, has potential for higher yield*
- Project elements (number, size, scope)—*shows how it can be a full-fledged brand and offer transmedia opportunities to reach more people over a longer period of time*
- Approach (mood, feeling, character)—*indicates its ability to appeal to audiences and be a relevant, cultural touchstone*

Opportunities

In addition, there are characteristics of the current or expected launch marketplace that can give the media property a distinct advantage that you should also identify and document. Some marketplace opportunities for your media project might include:

- Part of a growing, "hot" trend (subject matter, cultural movement, geography, platform, genre; provide examples of the trend; property can be part of more than one trend)—*shows potential for big following and multiple audience segments*
- Timing (that will capture interest)—*demonstrates that it can maximize audience interest in a trend*
- Audience power (the project appeals to an influential or growing audience segment)—*indicates ability to reach a large or coveted target audience that can influence others*

This list of opportunities is by no means complete, but it can jump-start your identifying the unique assets and advantages of your film, television show, game, or digital media.

Overcoming the Challenges

Conversely, your media property has characteristics that may present obstacles that need to be overcome. Good marketing is not just about leveraging the opportunities, but also about mitigating the negatives.

Weaknesses

Next, identify your media property's inherent weaknesses. These may include:

- Competition (there may be similar or competing projects)—*shows potential for audience confusion or fragmentation; need to differentiate*
- Unknown pedigrees (no high-profile names)—*demonstrates more marketing needed to give it lift*
- Bad press or reputation (project or players)—*identifies need for positive publicity to overcome negative impressions*
- Not new or fresh (it's a knock-off of other projects)—*signals audiences might be bored or uninspired*
- Complicated (if it's hard to describe)—*shows audiences might not "get it" immediately, hence won't engage*
- Platform/genre (new kind of presentation or platform)—*demonstrates risk for audience acceptance*

Threats (or Challenges)

In addition, looking at the launch marketplace reveals the outside obstacles that need to be addressed. Marketplace challenges may include:

- Timing (keep launch date in mind; if it's "hot" when you're developing it, it might be *passé* by the time it's produced)—*demonstrates possibility of audience fatigue for a trend or subject*
- Perception (audience assumptions about subject or approach)—*shows need to reframe audiences' understanding and make project more accessible*
- World events (something huge eclipses your project)—*identifies need to be agile and make critical business and marketing decisions*

Again, this is not a definitive list of attributes to examine, but it can point you to the negatives you should look out for and the kinds of strategies you need to develop from the get-go to overcome these challenges.

Now that you have done the SWOT Analysis for your media property, laying out its Strengths and Opportunities and Weaknesses and Threats (Challenges), you have a good sense of what you have to work with and what you're up against. Providing deeper insight and proof of these points with stats, surveys, or articles on trends or the competition is fruitful, especially when you're seeking funding, production, or distribution partners.

Often sophisticated marketing and research organizations will precede the SWOT Analysis with an **Environmental Landscape** that offers a comprehensive overview and analysis of the current and projected state of the media or entertainment industry, relevant audience behavior, competitive or similar projects, and overall trends.

For example, if you're launching a desktop game on resource management, the environmental landscape might: cite research on trends in gaming as a whole and in desktop gaming as a subset, as well as who the prevalent audience is for that platform and what their lifestyle trends are; identify and analyze other resource management media projects and examine *Minecraft* as a full case study; and outline top trends in media, the news, and popular culture about resource management. Generally, this is all secondary research or existing information and may be supplemented later by other research that's conducted specifically for the project.

Even if you don't conduct a comprehensive Environmental Landscape survey, be sure to have several environmental landscape "proof points" for every bullet in the SWOT Analysis to make your case more credible. Provide examples and cite statistics to bring the point to life and show you've done your homework. For example, if an Opportunity is that the genre of historical biographies is "hot," prove it with stats on their rise in various realms—from books to film—and provide some insight on which audiences consume them the most. This is valuable both in a written marketing plan and in an oral pitch to decision-makers.

Let your deeper understanding of your project simmer for a while. You will start to see more connections to your project with other trends of themes in the world. By getting closer to it—especially through the eyes of others—you are now ready to develop the first draft of the marketing plan for it.

CHAPTER 6

Research to Win

When preparing for the Super Bowl, football coaches and players spend countless hours studying video replays of their opponents to determine their strengths and weaknesses. They do this research to increase their chances of finding advantages for winning the big game. Yes, talent counts, but so does an intricate understanding of what you're up against. Political campaigns slice and dice data about voters, districts, and key issues in order to win political offices. This kind of knowledge is valuable for leveraging opportunities before and during your project, sometimes in the moment.

We now live in an era of big data, which is seen as unapproachable because of the requisite statistics and math, or seen as or evil because of the perceived invasion of privacy. Facebook has data about what you like, where you go, what you're doing, and with whom you're doing it. They're probably not selling this information to North Korea, but they are using it to understand who you are as a consumer so they can sell advertising targeted to you. A major aspect of being a modern marketer is understanding and managing analytics. That means embracing big data and calculating the marketing Return on Investment (ROI)—what worked and what didn't.

Market Research, the research, data, and even anecdotal information you can glean about your target marketplace and audiences, and **Marketing Research,** the potential effect of your project's materials on your audiences, may provide you with critical insights for the success of your transmedia project. Insights are "truths" about attitudes, beliefs, or behaviors of audiences in a market-based economy. For example, New Englanders love ice cream year-round, and eat more coffee ice cream than consumers in any other part of the US. This may be relevant to your media project with salty "Down East" characters from Maine and influence your decision to partner with Ben & Jerry's to create a branded

ice cream flavor. Insights enable you to understand your audiences as real people, tailor your messages to deliver value, and ensure that each impression counts. Remember, marketing is much more than promotion. It is about delivering value to your audiences through a value chain—from content creation to distribution to consumption. Smart use of data gives value to content, making it much more than a commodity.

The research you conduct may simply be an informal poll of colleagues or friends and family or it may be a statistically-significant quantitative survey and segment analysis of your target audiences. No matter what research you do, it will come in handy in countless ways along your journey—from pitching to partners and branding to identifying audiences and targeting bloggers.

Secondary and Primary Research

In this Internet age we're all researchers. If you want to know how to make the perfect gravy for your Thanksgiving turkey at two o'clock in the morning, you can go online and get multiple recipes. Because of the World Wide Web—the public linking of information— you can easily gather data about any aspect of your project. And, as you're starting your project, you should start with secondary research.

Secondary Research is the gathering of existing research conducted by other organizations. Many research organizations such as Nielsen, Gallup, Pew, Harris, Yankelovich, Forrester, Simmons, MRI, and various newsgathering organizations conduct regular polls about lifestyle, culture, entertainment, media, and technology usage. Sometimes this research is available at no cost, and sometimes it is syndicated and you must pay for it. But even if you pay for it, it is much less expensive than conducting the research yourself. Key secondary research areas include the general leisure landscape trends, media industry trends, entertainment usage, technology penetration, and media platform trends. You may also want to gather information about similar projects that share your project's platform, genre, or target audience. This Market Research is similar to the kinds of information you may have gathered for your Situation Analysis and Environmental Landscape.

Secondary research is an empowering and vital aspect of building your marketing plan. Don't be afraid of the percentages and numbers, but look more deeply into what the data means and how it relates to your project. If you're developing an interactive element for the book *Fifty Shades of Grey*, you may want to create a casual game as a mobile app because you've learned that women in their 30s to 50s are some of the highest users of mobile casual games. But you may also want to password-protect the R-rated content because you've also learned that Mom regularly shares her phone with her school-age children! Simply entering the most relevant search terms into Google or your search engine can yield amazing insights in a short time, at no cost.

But gathering data is not enough. You must organize this research in your marketing plan into a narrative. It may reveal cultural trends, give life to your target audiences, or deliver insight about a technology you plan to use. And you must always provide attribution—the name of the organization that conducted the research, the name of the research study, and the date when it was conducted—for all data and research that you use. Over the course of your project, if you find that newer research becomes available, you should replace it with more current research. Ideally, use research from a known and respected organization. Secondary research also can be qualitative, including anecdotal tidbits such as a quote from a tastemaker, a social media quip from a target audience member, or a publicity clip that colorfully supports existing data or previews a possible trend.

Primary Research is research that you conduct specifically for your project when what's available isn't enough. If you're a small indie project and won't have access to significant research or marketing dollars, you can conduct some of your own research among small groups of friends and family or target audiences. Chapter 10, "What's in a Name?" demonstrates a methodology for conducting your own informal research for titling your project that you can use for any topic or question for which you need outside input. But this research will never be statistically-significant and should never be cited as official research when pitching to producers, distributors, and other partners. However, it is valuable for ensuring that you're on the right track with your media project and its marketing.

Conducting studies and polls is an expensive and complicated enterprise and should be conducted by professional research organizations or departments. Consumer marketing research—a form of applied sociology—is now considered a statistical science that was pioneered by Arthur Nielsen, the founder of research giant Nielsen. It is a vibrant field with many top market research organizations.

Knowing what research to conduct and with whom is very difficult. Often, secondary research reveals gaps in understanding around a topic or idea that you can further examine, such as awareness, attitudes, behavior, and preference. Focus groups with small groups of potential audiences also reveal new areas to explore for additional research. Thereafter, surveys can be conducted with a larger respondent group. Often, focus groups are conducted during marketing planning to test the brand positioning, messaging, and creative marketing executions with known target audiences.

Some research is based on *questioning* respondents, such as the commonly-used quantitative polls and qualitative focus groups. Other research is based on *observing* respondents. The qualitative form of observational research is ethnographic studies, observing subjects in their natural habitat. Watching young children play with toys often offers more insight than talking to them about the toys. The quantitative form of observational research includes experimental techniques such as test marketing or changing variables in a market environment. A retailer may set up an endcap display of a book, DVD, CD promotional bundle in a few stores in a few different locations to see what works best.

Quantitative and Qualitative Research

Whether collected as secondary research or conducted as primary research, most transmedia marketing research takes two forms: quantitative—the *What?*—and qualitative—the *Why?* The best research models are *systematic* and *objective*, combining both types of research, first establishing multiple hypotheses and then testing them. Used this way, research can identify and solve marketing problems that you identified in your SWOT Analysis.

Quantitative Research offers a wide but impersonal view. It uses the scientific method for the systematic and objective collection, modeling, and analysis of empirical data using statistical, mathematical, or numerical techniques. The goal of quantitative research is to reach an unbiased, large respondent pool so that conclusions can be drawn. The researcher randomly samples the larger population to find respondents, who serve as proxies for a larger population. Through a survey or questionnaire, respondents are asked specific, narrow questions, often based upon one or more hypotheses, whose answers can be generalized to a larger population. The design and pre-testing of survey instruments or questionnaires and identifying the best means to collect data—whether over the phone, online, or other means—are critical to maximizing objectivity. The sample size should be large enough so that the margin of error—variation in the results—is small. The sample size must be about 400 for a margin of error of less than 5 percent (a minimal benchmark for statistical significance) and 2,400 for a margin of error of 2 percent.

Then the results are analyzed using inferential statistics, often communicated in the numerical form of percentages. Computer analysis of quantitative data organizes the results by *tabulations* or *tabs*, which are basic frequency counts. For example, 64 percent of males aged 18-to-24 prefer sci-fi over romance. *Cross tabulations* or *cross tabs* report the frequency counts of two or more variables simultaneously, linking them in a table of numerical results. For example, you want to know what ages of people are more likely to watch streamed video on a tablet. The ages appear across the top with subgroups of different ages as vertical columns, and the amount of time spent watching streamed content appears across the left side as horizontal rows. In such a cross tab, you can clearly see the differences in usage between different ages and even the sweet spot for when the most hours are watched daily for most ages.

A common mistake laypeople make when looking at raw data is to assume that correlation implies causation. For example, just because games' Web sites are accessed by computers, doesn't mean that gamers aren't highly mobile creatures. Perhaps gamers prefer the online game experience on their computers over their mobile devices. They may play other kinds of games on mobile apps, watch TV and YouTube on tablets, and update their social graphs on smartphones. Researchers do seek these kinds of empirical relationships and associations by applying linear models, non-linear models, or factor analysis to the data analysis.

Deep analysis, such as **Segmentation Research** or **Cluster Analysis** of the data, can determine the demographic, psychographic, and behavioral characteristics of potential audiences. It segments potential audiences into groups or clusters, offering in-depth profiles of potential target audience groups. If you're lucky enough to have this level of research for your project, you may learn that the "History Buff" (more likely to be male, 40-to-65+ years old, conservative, a voter, a coffee drinker, an American car driver) is the perfect target audience for your project about the Vietnam War. Having your potential audiences segmented is extremely helpful in identifying and targeting audiences effectively.

Qualitative Research on the other hand offers a narrow but personal view. Qualitative research is more subjective then quantitative and generally is used for exploratory purposes. Because it collects from a relatively small number of respondents, it can't be generalized to a larger population. Conclusions are "directional" only, generating hypotheses that ideally are tested further.

Qualitative research asks questions in person or over the phone, but then allows respondents to discuss the topic at hand. The data takes the form of words, sentences, and the meaning and intentions behind them. Researchers look for themes and patterns among a set of participants, and they may probe and push the discussion to get a deeper understanding of their perceptions and the reasons why they think or say what they do. The researcher is not objective, nor are the respondents. For example, the 12 respondents in a focus group who are sharing in a group conversation are influenced by each other. That possible bias must be taken into account when developing hypotheses from a focus group. You may attend focus groups about your project by sitting behind a mirrored glass wall, which allows you to see and hear, but participants can't see you. Most focus groups are taped. Many producers and marketers have been humbled and enlightened by these sessions.

Examples of qualitative research include focus groups, in-depth interviews, and dial-testing of film and TV. While focus groups and other forms of qualitative research may feel unstructured and more like conversations, their design is not. For example, the researcher leading the focus group must fully prepare the areas and questions to explore based on the project's marketing planning. And there is a science to creating the right target groups and finding respondents to populate those groups. Researchers may cull for specific demographic or psychographic factors. Geography matters too. The rule of thumb is to hold focus groups in as many cities as you can afford, to maximize geographic diversity, *and* to hold at least two focus groups in *each* city, to ensure you don't make incorrect assumptions about a city based on just one group of respondents.

Research in Media and Entertainment

Research is critical to media and entertainment. Big film studios will spend upward of $1 million on the research alone. It's worthwhile because a well-researched film can deliver huge box office rewards. Research also protects the tens of millions of dollars of advertising and promotion the studios spend on each film. Key areas in which entertainment and media properties conduct research in both domestic and international markets include:

- Concept testing of a media project as an overall idea during development
- Positioning analysis of other media properties that will premiere or launch at the same time
- Title-testing of the media project
- Testing of audience response to marketing materials
- Tracking surveys of audience awareness of (aided and unaided) and interest in a media project months/weeks before premiere or launch (general and target audiences)
- Test screenings of almost-complete or complete films or TV programs
- Beta-testing of game demos
- Exit surveys after film screenings to determine demographic and psychographic audience profiles and effectiveness of marketing

Research to gain insight around a media project's marketing materials may include:

- Pre-testing spokespeople or talent
- Pre-testing project taglines or signature artwork
- Copy-testing of trailers, ads, or other promotional materials
 - Analysis of audience's attention, motivation, entertainment factor
 - For video and audio, tracking the progression flow of attention and emotion

One of the best techniques for testing audiences' reaction to films, TV, or videos or marketing materials using video is **Dial-testing**. While watching a film, ad, or speech, the viewer turns the dial to the right if they like what they see and to the left if they don't. The respondents' attitudes are merged into a single real-time graph line for each group— by gender, age, or a certain predisposition.

Dial-testing stories, messages, and people is used widely in entertainment, advertising, and messaging. It's how film directors and TV producers know where to insert explosions and car chases to satisfy men or determine the optimal anticipation before the inevitable kiss to appeal to women. It's why scenes end up on the cutting room floor and why some film endings are disappointingly Hollywood-ized. It also helps advertisers know which celebrity, jingle, tagline, or video their target audiences will respond to best.

Permission provided by Dialsmith. Perception Analyzer is a licensed trademark of Dialsmith, LLC.

(Left) A dial-testing device; (Right) The device registers audiences' like or dislike of sections a film, TV program, ad, or video on a screen in real time.

Research is a big part of the internal machinery of television. At the Upfront presentations, where networks and cable companies present their TV programs to potential advertisers and their media-buying agencies, big data is everywhere. From ratings and how long viewers tune in to audience profiles and cross-screen measurement, this research allows advertisers to evaluate a television media buy based on how much it aligns with their own marketing research and goals.

Technology is affecting marketing research just as it has affected every other part of modern life. Smartphones now allow companies and researchers to reach consumers and audiences directly to gather real-time impressions and geotag the data showing whether a respondent is in a particular Macy's store or Showcase Cinema.

In short, marketing research is invaluable. It can help you understand how audiences feel about a brand, how aware they are of a subject or project, what makes your target audiences tick, what to name your project, what messages will work best, and how social media-friendly your project is. Marrying big data, such as marketing research, with small data, such as narrative storytelling, will give your project a win-win advantage.

Author's Anecdote

Focus Groups

Focus groups are some of the most revelatory experiences about human psychology and behavior. I've contributed to focus group design and attended scores of them, and some of the funniest moments of my career have been sitting behind the one-way glass at 8:45 p.m. inhaling snacks to stave off exhaustion. Hearing people's perceptions of the world, social issues, products, entertainment properties, celebrities, or even each other, is fascinating. Sometimes focus groups are like the "Jaywalking" man-on-the-street interviews on *The Tonight Show with Jay Leno* in which people come up with mind-blowingly wacky or stupid answers to the simplest questions (those are the moments when I've wondered why, in this day and age of reality TV and voyeurism, there isn't a Focus Group channel?).

Mostly, focus groups are an excellent opportunity to understand audiences and witness demographic and psychographic differences in action. They demonstrate that East Coasters and West Coasters have more in common with each other than they do with Middle Americans and Southerners. Then there are the stark differences in answers between genders, proving that the *Men Are from Mars, Women Are from Venus* schism rages on. Equally illuminating are the difference between Boomers' and Gen Yers' views on social etiquette or the strident *contretemps* between gadget gurus and tech luddites, dog lovers vs. cat people, and action devotees vs. romance fans.

Also, there are the fascinating takeaways about body language and group dynamics. Pay attention to who purposely sits directly across from the moderator—the other head of the "Thanksgiving table" as it were. This person wants to be a thought leader or maybe even a challenger to the moderator. Also pay attention to who sits next to the moderator. These people are looking for approval and are less likely to challenge. Notice when a strong personality has a vehement point of view about something and others pile onto that point, often without much authenticity or conviction. That dominant person is swaying the group's opinion. This is the lemming effect and is proof positive of why focus groups offer only "directional" insight. But then, someone challenges that strong participant's opinion and the group becomes restless until a second person agrees and the one-to-one conflict is no longer hanging in the air.

Again, marketing is actually about psychology and anthropology.

CHAPTER 7

Audience, Audience, Audience

Why say audience three times? Because saying anything in threes is magical and indelibly etches it in people's minds. Like the old real-estate adage about the three best characteristics of a good home being "location, location, location," it delivers the intended emphasis. Honoring your audiences—listening to what they say, following them where they go, determining what they want, and inviting them to play in the sandbox—is the single most important aspect of good marketing. Nothing is more vital. The most arresting title sequence, sizzling promo reel, or cleanest logo are all lost if they're not targeting the right people, with the right content, at the right time.

Why Audience Rules

We used to live in a Michelin world. Now we live in a Zagat world. Food critics and experts determine the Michelin guide's ratings, which reigned supreme for more than a century as the arbiter of the finest restaurants. Consumers determine the Zagat guide's ratings, which began quietly in 1979 and have become *the* word on restaurants. Because some diners care about price, parking, and kid-friendliness as much as they care about flavor, wine pairings, and ambience, Zagat's more accurately reflects many audiences' needs and views. For them, other diners' opinions are more credible and valuable than food critics'.

Smash hits are determined in almost every realm today by audiences. Hence, the rise of Angie's List, *Rotten Tomatoes*, Yelp, Goodreads, and personal YouTube channels. With their own digital distribution platforms and social media voices, audiences are powerful, not only as producers, distributors, and marketers of their own content, but also as critics,

funders, and ambassadors of your content. Audiences' trust in major institutions—from government and corporations to religions and newsgathering organizations—has plummeted in the past few decades, especially among younger audiences. But their trust in neighbors' and friends' opinions has soared. So, **WOM Marketing** underpins much of today's marketing and outreach.

Technological advances have wrought this democratized consumer landscape, placing audiences on an equal playing field with producers and industry experts. Some feel that because social media has given everyone a voice, audiences have become too influential. The new experts or curators of what's important aren't traditional media outlets, but rather "What's Trending" on social media feeds or riffed about by Jimmy Kimmel. And even if a new generation of trusted "grey ladies" (the nickname for *The New York Times*) emerge to curate the morass of content, audiences will always have an active voice.

Many also contend that audiences have become too fragmented and personalized to categorize. Audiences don't fit neatly into the demographic boxes of age, gender, and race the way they did in advertising's halcyon years after World War II. But because humans are inherently social animals, they always seek connections with others, often through media. In live theater, audiences value the connection of the shared experience. That's why producers and sound engineers inserted TV laugh tracks in the 1950s to create that connection.

Audiences now find affinity around their psychographic traits of pastimes, beliefs, and predilections—digitally. Social media is the public square for sharing passion and finding community based on these commonalities. If someone shares your sense of humor or reflects your POV in a Facebook comment, you feel connected to them. A silly dog video or parody of a movie trailer can unite many people from seemingly different walks of life.

In his book *Tribes: We Need You to Lead Us*, Seth Godin posits that the Internet has ended mass marketing and revived audiences' tribal behavior and groupings—the human social unit that harkens back to 50,000 years ago. Anything that expresses psychographic variables—from an idea to a product—can define a group, target audience, or tribe.

> *Media has allowed our digital media landscape to be more tribal. The shift from broadcast mindsets to digital mindsets has often been framed in terms of social networks or the one-to-one relationship between a consumer and media. But what is just as important is the way in which it has settled us out into social-political tribes online. That's not just left and right; it's also different cultural tribes. We don't just live by ourselves online; we live in these networks online. And that defines the way that businesses are built, the way that information flows, the way in which people get messages and change opinions.*

> **—Andrew Golis, general manager, The Wire, *The Atlantic***

To engage your audiences you must feel their tribal stirrings. Market *with* them by unleashing their natural yearnings—"Can you believe this happened?' or "Check out this cultural meme." Don't market *at* or *to* them by foisting your ideas and product on them—"Watch this" or "Buy that." Your product and message must reflect their beliefs and fulfill their needs for connection in order to motivate them to engage.

People's ideological belief systems are the frames through which they see the world so they surround themselves with other people and cultural paradigms that corroborate that worldview. They see nails everywhere because they're in the business of hammering. We all experience this unconsciously, hundreds of times daily. It's what roots kinship and group culture. And, because many ideological predispositions travel together like traits on a gene (people who are pro-choice are more likely to support marriage equality), people receive ongoing 360° reinforcement of their overall worldviews through their own chosen spheres of influence or affinity groups.

Media recognizes this. Google+ is about organizing your connections by your tribes. User forums or chat rooms are about finding affinity groups. Repinning a favorite skirt from someone else's Pinterest page is about sharing a tribal custom. If you can connect your media project to an idea or a driving force that motivates and binds audiences together, then you have latched onto something that's even bigger than traditional mass marketing. Audience-fueled movements can have the *gravitas* of saving the world or be as superficial as a fleeting fashion statement. The Oscar-winning documentary *The Cove* brought the Japanese slaughter of dolphins into the spotlight, while Beyonce's "Check On It" song launched the twerking craze. *En masse*, people share information (Wikipedia), fund projects (Kickstarter), and solve criminal cases (Boston Marathon bomber). According to James Surowiecki, author of *The Wisdom of Crowds,* crowds are almost always wiser than the very brightest individual.

Identifying and Targeting Your Audiences

In old-school marketing, the primary audience was the general American public. Studios and networks marketed to the masses through the three TV networks and a handful of top news and consumer publications. That top-down strategy assumed that there was an average, single audience persona. In modern marketing, content and audiences are striated into many specific segments and niches, each with their own persona. Often, the primary audience is a niche, which represents a smaller group of passionate and genuine devotees of that content. The idea is now to reach them well and engage them so fully that that they become your project ambassadors, broadening its reach to a wider audience.

In order to engage your key audiences, you must know them as well as you know your family and friends.

Know your audience. I think that's the most important thing. It's the foundation of publicity and marketing. Know how to talk to them, know what they're doing, know how to reach them. If that basic foundation is overlooked, then nothing you do is going to be successful. You're just throwing your money and time away.

—Dustin Smith, VP communications, TLC

The first step in identifying, knowing, and reaching your audiences is describing and differentiating them. Just a quarter of a century ago, audiences were viewers, listeners, or readers. Now, audiences are more likely to be viewers, users, or players (VUPs)—simultaneously. VUPs are active participants with your media, not passive observers of it. In some cases, they are co-creators or prosumers.

When you are designing your marketing plan, there are a number of categorizing dyads that place a finer point on your target audiences. Your audiences may cleave by Influencer Audiences or Public Audiences. **Influencer Audiences** are often gatekeepers within key industries, defined by platform, genre, or subject. Sometimes reaching your public audiences is contingent upon reaching influencers first, who in turn influence other public audiences. Influencers may include celebrities, press, policymakers, government entities, NGOs, and educators.

The Bridge to Terabithia was passed on by every studio several times because they thought no one wanted to see a movie where the girl dies at the end. But then Nina Jacobson stepped up when she was at Disney. She really believed in the movie, but we still had a big challenge ahead of us. The book won the Newbery [Medal] and kids loved this book. That was enough for us, so we worked with teachers for a year. It had a big opening weekend of more than $27 million and the exit polls showed that one out of three kids was there because their teacher told them to go.

—Micheal Flaherty, co-founder and president, Walden Media

The "Law of the Few" in Malcolm Gladwell's bestseller *The Tipping Point* says that influentials with "rare social gifts" are at the epicenter of any social epidemic. Marketers sometimes call these audiences Tastemakers or Audience Ambassadors. Microsoft calls them "MVPs" (Most Valuable Professionals). Ambassadors can be both gatekeeper influencers and stand-outs among your public audiences.

Public Audiences are your final end-users who may be categorized various ways—from Millennials to mystery lovers. Within public audiences there are two further classifications: **Mass Audiences** versus **Niche Audiences**. Television was, and some contend still is, the ultimate mass marketing vehicle. In the 1960s, advertisers with enough

money to buy national TV time on all three TV networks could easily reach most of the country. Online convergence has given rise to audience fragmentation, hence more and more niche markets and audiences reflecting specific demographics and psychographics. Cable and OTT services now produce very niched programming, such as *Breaking Bad* and *Amish Mafia*. Some media properties still have mass appeal such as *Anchorman*, *The Big Bang Theory,* and the Super Bowl, but most have specific, niche audiences in mind.

> *The trend in media—whether it's online journalism, blogs, television, or marketing—is that not everything is for everyone. If you're creating a show or media work, it's much better to create something for an intense base of people who are going to really like it and hope a larger audience follows, than to try to make something that hits every quadrant and doesn't satisfy anybody.*
>
> **—James Poniewozik, senior writer, television critic, *Time* magazine**

Audiences can be further categorized by **Demographics**—factors such as age, gender, ethnicity, geography, education, and income or **Psychographics**—factors such as interest, ideology, and predisposition. Some psychographic profiles or traits include soccer moms, college students, skiers, or environmentalists. These predispositions transcend demographics. Preschoolers and octogenarians alike can be tree huggers.

© iStock.com/rawpixel

It's critical to know your audiences and what makes them tick.

A few demographic categories have had a profound effect on modern US life. The first is *Age*, with two marketing sub-fields. Generational Marketing is based on research that shows that people growing up at the same time, in the same general ecosystem, having been influenced by similar factors, share psychographic profiles. The commonly understood traits of Baby Boomers or Millennials are cluster analyses or audience segmentation studies of quantitative data on these age groups. There are some marketing "knowns" about these two hugely divergent trend-setting generations.

Boomers (1946–64) prefer desktop computers, have landlines, and watch traditional TV. Because they are more likely to be distracted, in messaging they seek repetition, even associating it with veracity. They prefer light-hearted, clever humor and respond best to likable, relatable characters. Millennials (1977–94) are more likely to consume their media wirelessly across multiple platforms simultaneously on laptops or tablets, smartphones, and game consoles. Because they can handle multi-sensory communications, they prefer high stimulation with rich media and dynamic fast cuts in messages. They love satirical, cutting humor and respond best to aspirational characters, such as celebrities.

Life-stage Marketing recognizes that people's interests and needs change in different stages of life. Twenty-somethings care about their credit when they're buying a car. Middle-aged people, dealing with aging parents, become more aware of health and caregiving issues. Different techniques work for different life stages. Nostalgia marketing is effective when audiences approach middle age.

The second noteworthy demographic factor is *Ethnicity*. The ethnic composition of the US has changed significantly in the past 25 years. Hispanics are the fastest growing ethnic group and encompass more than two dozen nationalities defined by their Spanish-speaking origins (as opposed to Latinos, defined by their Latin American country of origin). The Census Bureau estimates that Hispanics will comprise 31 percent of the US by 2060. They've already had a huge influence on American culture—from the box office to the polling booth. Some of their drivers include music, food, and sports. Hispanics are far more digitally connected and pioneering than their non-Hispanic counterparts. They're also no longer just in the seven markets of LA, NY, Miami, Chicago, Dallas, SF, and Phoenix. English is now the language of the Web for Hispanics. Hispanics and Latinos are no longer niches, but are redefining the mainstream. There is much more to say about other demographic characteristics, especially *Gender*, but that would be a whole other book.

Clearly, there are many ways to peel the audience banana. You can categorize your audiences using more than one of these segmentation devices. But then you must weight your audiences, deciding which are **Primary Audiences**—your main targets—and which are **Secondary Audiences**—your lesser targets. This is critical to ensure you apply the bulk of your resources to tactics that will reach your primary audiences. Only you and your marketing team can determine your primary audience. For *Napoleon Dynamite* it was nerds. For *Passion of the Christ* it was evangelicals. For *My Big Fat Greek Wedding* it was Greek-Americans (and other similarly-aligned ethnic groups).

After all the categorization of audiences, it's important to personalize them and remember that they're people, just like you.

As a screenwriter, I view everyone as my audience—critic and casual moviegoer alike. Of course, I want all of them to enjoy my films, but I don't write for one or the other, particularly. If anything, I'm writing for the moviegoer inside of me, playing the story over and over again in my mind and trying to gauge my own reactions.

—**David Magee, screenwriter, *Life of Pi, Finding Neverland***

Engaging and Rewarding Your Audiences

The best way to serve your audiences is to engage them in meaningful experiences. The audience experience is so paramount to transmedia that many projects have a dedicated "Experience Designer." To engage audiences you must inspire and empower them through storytelling and characters that communicate beliefs and allow them to make messages their own. **Audience Engagement** is a long-term strategy that creates loyalty and fans— a sports term from a realm where fan culture is rabid. Superfans from the Big Apple and the Hub fuel the century-old rivalry between the Yankees and the Red Sox. That kind of loyalty, especially from Sox fans during an 86-year losing streak, simply can't be bought. But, it can be earned.

True engagement is a value exchange between your media project and its audiences based on the perceived value of your project's content and the social experience it offers.

The thing that you do, the action that someone wants you to take, has to have reciprocal value for you to do it. And the idea of value is fluid. Post this and earn ten points is not a viable value proposition for anybody today. Gamification gets to be a digital chore. It's very transparent that what the brands want is access to your social graph. But the idea of valuing social capital is a really significant one. Brands need to be smart around how they think about value. If a brand used fan art the way studios feature one-sheet movie posters in theaters, that would be really powerful. It doesn't have to be monetary value, it can be the idea of social capital, but it has to have reciprocal value to what you're asking them to do.

—**Joseph Epstein, digital content and marketing strategist; formerly 20th Century Fox and Sony Pictures Entertainment**

Because engagement is the *au courant* buzzword of marketing, it's thrown about as if it were a commodity. Google set up Engagement Ad campaigns across multiple screens that are available on a cost-per-engagement (CPE) basis. Studies have shown that a Facebook fan is worth $174. But that's misleading; audiences "Like" an entity because they're already engaged with and loyal to it. So engagement is not about counting "Likes," tweets, or video views, but rather about delivering value to audiences.

To engage and earn fan loyalty you must reward your audiences. Remember the limbic brain? The dopamine-transmitting mesolimbic pathway is activated by desire for pleasure and motivation for reward. Like Pavlov's dogs, humans seek reward in many aspects of life—from a promotion at work or a glass of wine at day's end to a compliment from a suitor or new assets in a mobile game.

The reward system has been central to modern consumer life. Because of the scarcity of commodities in the early 1800s, tangible goods were their own reward. For almost a century, the Montgomery Ward catalog and the transcontinental railway were the only pathways to basic goods in rural America. By the 1930s, cash incentives and proxies for them emerged, such as Green Stamps, which were issued by retailers for purchases and could be traded in for consumer products. By the 1980s, airlines and credit card loyalty programs created incentives for consumers to stick with certain brands. By the 2000s, cola companies and pharmacies were issuing virtual rewards.

In traditional marketing, rewards were part of a linear **Buyer's Decision Journey** or Purchase Funnel. Audiences became aware of a product, they formed an opinion, considered, established a preference, and purchased the product. It was a top-down system with the advertiser or brand delivering most of the messaging and input to consumers. Marketing techniques to convert to purchase included promotions, cash awards, and discounts. Those incentives influenced in-the-moment purchases, but didn't establish a long-term relationship with the product.

Today's empowered audiences check out products and media properties on their own, relying heavily on WOM recommendations and engaging with brands that reinforce affinity and community. Audiences' measures of reward today are getting access to new knowledge and experiences, building affiliations, and ratcheting up their status among their tribes. (See Chapter 29, "Media-fueled Social Impact" for the author's Theory of Change decision journey model, Awareness-to-Action Ripples, which moves audiences from awareness, to understanding, to engagement, to action around a media project).

Some of the best immersive and rewarding content experiences are in games, which have a deep understanding of how to ratchet up engagement to hook audiences. It's called "leveling up," when a gamer succeeds at a certain goal or task and is rewarded with new game assets or a brand new world to conquer. That is the player's reward in the brand-to-consumer value exchange. Most people won't act unless they perceive value in so doing. If you want someone to share a video, retweet a Twitter message, or sign a petition, it must be worthwhile. That's why you must know your audiences well, because what's worthwhile

to one person is a total waste of time for someone else. Those rewards can range from unlocking hard-earned exclusive content to delivering a feeling of satisfaction for helping a good cause.

Audience devotion to games is unrivalled in any other entertainment realm. Because game designers fully understand the limbic brain and how to motivate and reward audiences, they create rabid and loyal superfans who find each other. The "Let's Play" video spectator craze on YouTube—watching others play a game—is about gamers sharing their passion for a game's features, challenges, tactics, and workarounds. *Minecraft*-ers are a global tribe. The lessons from *Call of Duty* and *Temple Run* have not escaped many savvy consumer brands and content developers.

Your job as an engagement marketer is to "level up" your audience's interest in and participation with your media project, like games do for their players. Start with a small "ask" like joining a group or following on a social network and then bump up your asks and rewards to engage audiences more deeply until you've got a bigger following. Over time, your superfans will become your best ambassadors, spreading your message and sharing your content. Some general rules of thumb on how to engage audiences:

- Grant exclusive content so that superfans are part of an inner circle
- Raise the stakes and rewards for engaging with your project in steps
- Provide a forum for audience expression and co-creation
- Publicly recognize audience loyalty
- Connect your project to a worthy cause

Start with your project's social media content—Facebook, Twitter, YouTube, Tumblr, and Pinterest, etc. These social networks have different lenses (mini-blog, video-sharing, location-based), rules, language, behavior, and culture, but they're all about virtual community. The best way to understand social networks is to join them. But to engage audiences successfully, you need to be accessible, likable, and authentic. Ellen DeGeneres of the *Ellen* show is the embodiment of likability and "realness." On her Twitter feed Ellen writes, "my tweets are real and they're spectacular." They fully reflect her genuine, easy-going, and witty persona. As you gain Twitter followers or Facebook "Likes" you're building a constituency of interest around your media project.

You can invite audiences directly into your project's universe. For several years, Doritos has won the creative MVP award for Super Bowl ads with their crowdsourced TV spots. They give their audiences standing and voice by allowing them to create their ads, decide which will appear during the broadcast, and choose the $1 million grand prizewinner. The good-natured humor of their 2013 "Goat 4 Sale" and 2014 "Time Machine" winners received high ranks among all Super Bowl ads as most liked and most memorable. Proof that anyone can have a great idea and that inviting and celebrating audience participation is a great marketing strategy.

But once in the tent, not only can they cheerlead, promote, and add humor, they also can complain, criticize, and deface. If you want to maintain control or are thin-skinned, you'll hate this. But if you can relinquish that control and truly listen to your audiences, you will learn more than you ever thought possible. You'll learn what makes your audiences who they are, see new creative possibilities for your project, and understand the power of the collective to promote and, ultimately, self correct. If you trust them, your fans will take care of the obnoxious or mean-spirited comments. And, if you do your job right, these audiences will be some of the most valuable and loyal members of your production and marketing team. In the long run, the bottom-up revolution is much more powerful and can serve you much better than the exertion of top-down control.

Author's Anecdote

Audience Personas for Child Survival

I managed the marketing and impact for *Rx for Survival—A Global Health Challenge,* a PBS multi-platform media and social change campaign from the WGBH/*NOVA* Science Unit and Vulcan Productions, supported by the Bill & Melinda Gates Foundation. In 2005 it brought some of the most critical global health threats facing the world to the forefront of Americans' consciousness. The project was both a cross-platform media blitz with PBS, *TIME*, NPR, and Penguin *and* a public and influencer social impact campaign to inspire audiences to get involved in child survival solutions through CARE, Save the Children, UNICEF, Global Health Council, Girl Scouts, Rotary, and the American Academy of Pediatrics.

In 2004, we commissioned quantitative research conducted by Belden Russonello & Stewart to understand Americans' awareness of, attitudes toward, and predisposition to get involved with global health. To better understand our audiences, we conducted a cluster analysis segmenting US audiences into target groups, extrapolated out to represent the full US population.

Five audience clusters emerged, each offering a unique psychographic and demographic profile:

- Global Yuppie Doers 20 percent of US population
- Struggling Multi-cultural Faithful 19 percent
- Community Family Doers 21 percent
- Global Skeptics 25 percent
- Anti-globalists 14 percent

Three of these audience clusters were most predisposed to our project's calls-to-action.

The Global Yuppie Doers exhibited interest, responsibility, and action. They warmed to the cause of improving health throughout the world, believed that their own actions have an impact beyond our shores, and took actions in their everyday lives in support of causes. They were more likely to be female, young, childless, well-educated, and to have travelled internationally.

The Struggling Multi-cultural Faithful was a racially- and ethnically-clustered group that was not globally oriented, but motivated by community involvement through their churches. They were more likely to be female, less-educated, and struggling on generally low incomes.

The Community Family Doers were not globally oriented, but were heavily involved in their communities, especially around their children. This cluster had moderate educations and incomes.

Goals and Objectives

Now that you have identified and become acquainted with your audiences, you must define and refine what you want to achieve with those audiences. Imagine that your transmedia project is a nautical journey. Your marketing plan charts your course through your project's development and launch. Your goals and objectives are the lighthouses—beacons of light cutting through the fog—that help you navigate the jagged coastline and ever-changing depths and currents.

Babe Ruth, whose "sale" from the Red Sox to the Yankees in 1919 was the source of the Boston–New York baseball rivalry, understood the importance of setting goals and taking risks. He was a prolific hitter, holding a career record of 714 home runs that stood for 39 years, until 1974. Every time he went up to bat he reached for a home run, not just a single or a double:

> "I swing big, with everything I've got. I hit big or I miss big. I like to live as big as I can."
>
> —Babe Ruth from *Words of Wisdom*, edited by William Safire. (As quoted in *Go for the Gold: Thoughts on Achieving Your Personal Best*)

Babe Ruth's laser focus on his goal, plus a whole lot of talent, converted those big swings into home runs. You too must set goals for your project to get where you want to go. Goals establish the hierarchical structure of your marketing plan in which objectives,

strategies, and tactics support each other. Goals are vital to clarifying your project team members' roles in achieving a hit. And they're essential for setting benchmarks to evaluate mid-project progress and post-project success.

Goals—Definition and Examples

Goals are excruciatingly difficult to set. They force you to decide on the one or two things you want your project to achieve. They're the ultimate expression of a content creator's or marketer's vision.

> *Whether it be journalism or marketing, you need to be very thoughtful about what your goals are, because if you aren't, that's when you start taking missteps, that's when you can lose your vision and do things that don't make sense for the project.*
>
> **—Ingrid Kopp, director of digital initiatives, Tribeca Film Institute**

Goals are aspirational and purposeful. That's why they begin with action-oriented verbs. They communicate outcomes that a project intends to achieve. They can operate alone or in tandem with objectives. When goals are accompanied by more specific objectives, goals can communicate broader, more abstract intentions that are not tangible or measurable. When goals are not accompanied by objectives, they must be specific, quantifiable, and time-constrained. Either way, your project must have measurable goals or objectives.

Together, goals and objectives must be **SMART**:

- **S**pecific
- **M**easurable
- **A**chievable
- **R**ealistic
- **T**ime-defined

© iStock.com/porcorex

Setting clear goals is the only way to get a bull's-eye.

Goals can be **Long-term** or **Short-term**. The primary difference is the time required to accomplish them. Short-term goals can be defined by days, weeks, months, or years and are set based on the project's overall timeframe. Short-term goals relate to and often serve as stepping stones to achieving long-term goals. A short-term goal might be "*Greenlight the project's production*." A long-term goal might be "*Earn $2 million in box office receipts*" or "*Change teens' perceptions around bullying*."

While goals should be achievable, there's nothing wrong with setting some of your goals high. The bigger the goal, the harder you and your team will swing. With big goals, when you do connect with the ball, it just might go out of the ballpark.

Objectives—Definition and Examples

Objectives are narrow, precise, tangible, concrete, and measurable. They tend to operate on shorter timeframes than goals. It's often difficult to determine the difference between goals and objectives. The following chart will help you differentiate them:

Goal	**Objective**
• Purpose of overall project	• Accomplishment via specific actions or tactics
• Outcomes	• Outputs or actions
• General, abstract	• Tangible, measurable
• Long-term	• Mid- to short-term
Example: *Raise awareness of media project (and associated themes) among primary audiences*	Example: *Generate 100 million culturally-driven online and social media impressions on affinity group platforms before project launch*

Often, several objectives must be met to achieve a single goal. "*Reach influencers at 15 high-profile industry events*," "*Generate 20 million media impressions*," and "*Receive two top industry awards*" are all objectives targeted to influencer audiences that pay off on the above goal, "*Raise awareness of media project*."

More specifically, **Strategies** define approaches or techniques that achieve measurable objectives or goals. For example, *"Enlist celebrity ambassadors from film and music to co-promote the project through all their channels"* would be a strategy that pays off on the previous *"Raise awareness"* goal and associated objectives. **Tactics** are specific actions or activities that support strategies. A tactic that pays off on the *"Enlist celebrity ambassadors"* strategy might be, *"Beyoncé touts the project on tour for her new album and on Instagram and iTunes."* These hierarchical categories create a pyramid with one or two broad goals on top, followed by objectives, strategies, and finally, many specific tactics on the bottom.

While you may not achieve every aspect of your objectives or execute all of the strategies and tactics to accomplish them, you should achieve your goals in order for your project to be successful. And the only way to determine whether you have achieved your goals is to establish evaluative mechanisms when you set them.

Connecting Goals to Results

By connecting goals to results, you honor all your planning and hard work and ensure that what you learn from the past informs the future (see Chapter 30, "Measuring Outcomes," for an in-depth survey of measuring results). You should read that chapter before finalizing your measurable goals or objectives to ensure you understand measurement definitions, know what you're going to measure, and have the mechanisms in place to measure results. But this section provides a topline overview of measurement.

The assessment of results at the end of an activity or project is **Summative Evaluation**. When you are establishing evaluation mechanisms for your goals and objectives, it's common to confuse outputs with outcomes. Foundations, which fund many cause-related projects, have created these distinctions to ensure their organization gets a good ROI or Return on Engagement (ROE) for their contributions. This kind of accountability is healthy and productive, generating much better results when built in up-front with your plan and goals.

An **Output** is the result of a tactic or action; it might be *"The digital efforts generated 2 million page views on the Web site and 400,000 of these page views converted to watching the teaser trailer."* An **Outcome** is more connected to objectives, and might be *"80,000 of teaser viewers clicked on Fandango and purchased tickets to the limited release of the film."* An **Impact** is directly connected to goals, and might be *"The film made a 20 percent profit."* Proof that you accomplished your goals and objectives should always be measured through outcomes and impacts.

As you remember from the overview of a marketing plan, measurable goals or objectives can be both quantitative and qualitative. For example, to measure our previous goal *"Raise awareness of media project (and associated themes) among primary audiences,"* you might measure the following:

- Quantitative objectives
 - Box office sales; Nielsen ratings; game sales; event attendees; video downloads; page views; unique visitors; click-throughs; time spent viewing; social media "Likes," followers, shares, or comments; advertising GRPs; media impressions; ad equivalencies; poll measurement of audience awareness or recall; participation and support of project partners; increase in media and online coverage on project subject
- Qualitative objectives
 - Positive media reviews; press', bloggers', and influencers' use of project's key messages; comments or quotes from press, influencers, or event attendees; social media sentiment; proof of cultural currency (parodies, memes, popular culture allusions); audience perceptions in polls or focus groups

Each tactic in your plan and each industry specialty will have its own measures for audience reach and participation for key goals. Enlist your transmedia project's marketing experts in social media, advertising, publicity and event management, and the experts in each of your media platforms (Web, book, film, games, digital) to contribute to the development of success measures of your goals and objectives, and ultimately your project. In addition, funders and key partners usually want to measure specific things for their own ROI processes.

Not all you measure is created equal. If you have an experimental objective or strategy, you should note that in your plan and when setting expectations with team members, partners, and funders. The riskier efforts should be equally well-measured, but assessed differently. Risk-taking should never be punished, but rather seen as a learning opportunity or a pilot program. Usually, experimental activities don't dominate your plan and there should be enough proven strategies to support an objective so that it will succeed either way. Nor should you unduly label many aspects of your plan as risky or experimental to release you from accountability. Be honest and secure consensus from your stakeholders on all aspects of goal-setting and evaluative measures for your project.

Conducting deeper evaluative dives as part of your summative process on those new or risky activities will help you determine whether you want to use that technique again. For example, if you try a new online marketing tactic, you might want to closely examine your Web traffic to see how much of it came from search, direct, social, or referral. That may help you know what tactic worked best. Or if you create content on your Web site and want to know if it was more engaging than other content, you might measure how much time was spent in that area and how much it drove click-throughs to deeper content. And examining the degree and way in which audiences participate with your RSS feed or newsletter can help you better understand your loyal audience ambassadors.

You do not need to wait until the end of the project to measure its success. Mid-project evaluations are valuable for determining what's working and what isn't. They allow for changes in strategies and tactics to deliver more favorable results. By looking at your experimental pilots early on, you're conducting **Formative Evaluation**. A pilot you tested in one market or with one group can be tweaked, and a feedback-informed version of that activity can then be widely distributed. But remember what Confucius said, "When it is obvious that the goals cannot be reached, don't adjust the goals, adjust the action steps."

Who does all this evaluation? You and your team can evaluate your project or you can hire outside researchers and evaluators to do so. Keep in mind at the outset of a project that you must have infrastructure, capacity, and the budget to collect all the data to properly evaluate it. You can't go back to partners or event planners after an activity and expect to collect metrics or quotes if you didn't tell them in advance what data you planned to collect. And you must ensure that it's collected the same way among like activities. If you hire outside evaluators, be sure they have worked on similar projects with similar goals and look at their case histories to find synergies with your project. Whether you hire outside evaluators or evaluate your project internally among team members and partners, evaluation must be built in to your marketing plan.

If you set big, beaming goals that are supported by thoughtful objectives, strategies, and tactics, you just might exceed them. Everyone on your project team should know and embody your goals. Your project's purpose is also integral to its external brand salience. People buy into *why* you do things, not *what* you do. So, if your project's goals are about more than making money and have social or cultural value, then communicate them publicly. They just may matter to your audiences.

PART III

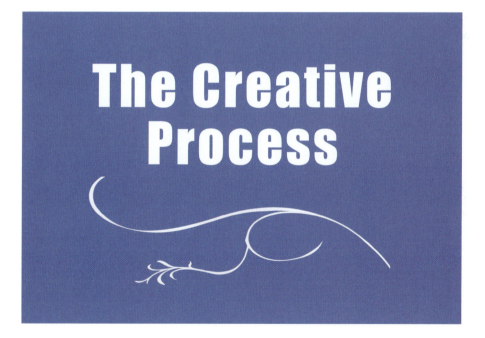

The Creative Process

CHAPTER 9

Branding

Brand is paramount in today's world. The three key elements of being a modern marketer are to be a brand marketer, content marketer, and digital marketer. Social media has made everyone a brand and everyone a brander. Do you register on your social graph as snarky or heartwarming? What reflects you better, driving a Jeep or a BMW? Audiences have an innate understanding that a brand's public expressions, the company it keeps, and what others say about it imbue it with characteristics and attributes.

Good branding is both an art and a science. It involves research, analysis, identification, interpretation, creation, testing, and launching. In an age of industrial branding, creating and refining brands is a specific discipline of marketing. You can identify and refine your brand with the help of your key stakeholders with some branding guidelines and tools.

Authentic branding reflects an entity's purpose, culture, and unique brand attributes. A brand is a coherent set of concepts that reside in audiences' minds. It is the sum of an entity's identity, image, and aspiration:

- **Identity**—what the brand stands for
- **Image**—what the brand represents
- **Aspiration**—how the brand makes audiences feel

Branding is about attaining focus around your project's public identity—its imprint, meaning, and associated values. When a brand is cohesive, it delivers an intuitive understanding, intense power, and clarity of message that crystallizes it for its audiences. Branding your transmedia project is critical because brands live in cluttered, cross-platform environments, often including multiple partners. It's imperative that all elements are unified by a **Master Brand**—an umbrella for all of the project elements and associated activities. Most brands have multiple platforms, initiatives, and communications that can further

dilute the message if the brand is not crisp and integrated. And most brands serve multiple target audiences. To achieve the multiplier effect of brand recognition among myriad audiences, it is essential that the core brand message is clear and consistent, so it can be tailored to a specific audience without losing its central meaning.

Your media brand can be a production or distribution company, a media project, a character, you, or all of these. When brands relate to each other, there's often a brand hierarchy between companies, projects, and personalities. The master brand NBCUniversal, Inc. has a **Sub-brand** of NBC. Its Sub-brand is *The Today Show*, and its sub-brand is Matt Lauer.

Because media projects now bypass the better-known brands of traditional distributors, the project brand is becoming increasingly important. When loyal *Arrested Development* fans followed it from Fox to Netflix, the show's brand became primary and the distributor's brand, secondary. Strong media project brands can boost the distributor brand, just as *House of Cards* has put Netflix and *Transparent* has put Amazon Studios on the map as original content creators.

> *For the younger generations the importance of networks has declined, if not gone away. Netflix and sources of streaming are much more important as a cultural force. Their sense of what's important on TV is determined by what they can stream online, so viewers are going to identify with TV shows. They may be delivered by apps in the future.*
> —**James Poniewozik, senior writer, television critic, *Time* magazine**

Gatekeeper Brands and intermediary brands can be powerful in media, entertainment, and technology. The fact that Intel's Pentium Processor is "Inside" HP, Dell, and other computers became a selling point for those computers. David E. Kelley transcended TV networks by making award-winning television programming for ABC, NBC, and CBS. A Pixar animated film has special salience among Disney's annual slate of children's films.

Brand Discovery through Archetypes

Branding is an inside-out process that unfolds in five stages. The first stage includes an audit of a brand's operating environment and its challenges and opportunities, which you completed in the Situation Analysis of your marketing plan. The next involves a closer examination of your project through identification of audience and goals, also completed. The rest are covered in this chapter, including finding your project's inherent brand essence; translating the internal brand essence to external positioning and attributes; and finally, capturing your brand identity into a creative brief. With this outward-facing brand manifesto, you can create brand expressions such as the project name, graphic identity, and descriptive language for the brand.

© iStock.com/jgroup

The bulk of a brand's essence is unseen and lies below the waterline.

The first order of business is to find your project's **Brand Essence**. Brand essence is like a brand's internal DNA or its core truth. Imagine an iceberg in which most of its heft resides below the waterline. The ads, taglines, and sizzler reels are what you see above the waterline. Under the water is a brand's archetype; origin story; brand pillars, values, or traits; brand personality; brand worldview or belief statement; and the brand promise. Since you know your project's origins, marketplace, story, platforms, audiences, and goals, then you can find its brand essence. Brand essence is *internal* and communicated as a personal narrative about the brand. It:

- Encapsulates how an audience should connect with and feel about the brand
- Communicates a brand's heart, soul, and spirit
- Relates to the brand's uniqueness to deeply-rooted human needs

To find your brand's essence you must understand its **Brand Persona** or **Brand Personality**. Just like you better understood your audiences with psychographic traits, imagine your brand as a real person. What is its personality? Is it fun-loving, serious, or a risk-taker? Make a bulletin board of images that represent the brand's traits: what food would it eat, what films would it watch, what vacations would it take?

Create a few distinct personas that your property could be. What goes with each is imagery, language, and how it relates to the audience. All of those things are part of that personality. And then, try them on, almost like clothes.

—Linda Button, brand personality expert, co-founder and principal, Tooth and Nail

A simple, intuitive, and clarifying branding construct to determine your brand's personality uses the archetype, a long-standing storytelling character device. Archetypes are prevalent through human storytelling since our earliest oral and written storytelling traditions, populating mythology and literature. Plato wrote about these seminal characters, which recurred in some of the greatest stories of all time. Achilles in Greek mythology and *Superman* are both The Hero, and Little John in *Robin Hood* and Chewbacca in *Star Wars* are both The Regular Guy.

Starlight Runner has its own proprietary strategy, Deconstruction & Alignment, which allows us to derive brand essence and discern the fundamental aspirational components of a story world, brand, or even a socio-political campaign. The technique removes the guesswork. We're not giving you our opinion, we are discovering the facts. The approach that goes into our Mythology documents and brand analysis breakdowns is derived from all kinds of influences. Joseph Campbell, Carl Jung, Mark & Pearson, Strauss & Howe, the appendices in the back of Tolkien's epic fantasies, the Handbook of the Marvel Universe. You name it!

—Jeff Gomez, CEO, Starlight Runner Entertainment

Carl G. Jung identified and described seven archetypes in his Archetypal Theory as universal constructs that symbolize basic human needs, aspirations, or motivations. Margaret Mark and Carol Pearson apply Jungian archetypal storytelling and psychology to brand identity in *The Hero and the Outlaw*. They identify 12 familiar and intuitive personas or **Brand Archetypes**. Archetypal identity involves ascribing a dominant archetype to your brand, which creates a value-based method of brand discovery.

To visually understand how these archetypes connect to motivation, the 12 brand archetypes are mapped along two continua across the Y and X axes. The Y axis maps *Stability* vs. *Change*. The X axis maps *Community* vs. *Individualism*. The archetypal mapping places four motivational brand groupings in quadrants, each with three brand archetypes: Security and Control, Risk and Mastery, Belonging and Enjoyment, and Independence and Fulfillment.

Brand Archetypes

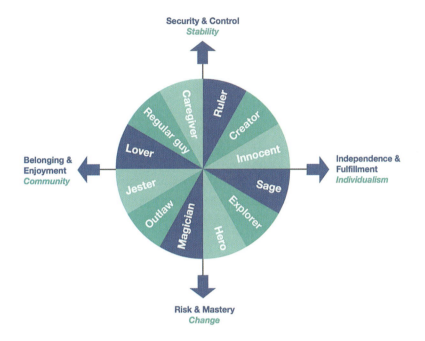

Courtesy of Azure Media; Design: Elles Gianocostas

The 12 brand archetypes mapped across the continua of stability vs. change and community vs. individualism.

To unlock your project's brand essence and determine its brand archetype, tap your internal and external stakeholders. Brand discovery is another form of informal primary research. Interview your team members, partners, and primary target audiences about their understanding of and relationship with your project. Document each respondent's age, gender, ethnicity, and job description and connect the responses to each individual to look for patterns. Keep different target audiences' responses together. Provide respondents with the same information about the project, story, characters, platforms, elements, clips, and visuals. Then ask them to describe the project as if it were a real person and provide a list of **Brand Attributes**—descriptive adjectives of those characteristics. These responses will provide focus and reveal critical facets of your media project's brand archetypes.

Place all the attributes into one list. Bundle words or ideas with similar meanings such as happy, joyful, or happy-go-lucky. Note frequency of similar words or thoughts. Also note the language choices of your target audiences because they may become important

later in your project's messaging. Younger audiences might say "epic" or "awesome," while older audiences might say "cool" or "hip" to communicate the same idea. Pay extra attention to your target audiences' responses. Because they are your end-user, their opinion has the most bearing on the success of the project. If their responses differ from your internal team's responses, then you have a brand disconnect between what you want the brand to be and what the brand truly is. In this case, outsiders are more likely to be accurate than insiders because they're more objective.

Ideally several key attributes and characteristics emerge among all respondents that sync up with one of the brand archetypes below, revealing your brand's true essence. Sometimes, several archetypes emerge because some brands have more than one archetype contributing to them. Ultimately, you must choose *one* governing archetype. That is the archetype that is truest to your project's overall values, mission, vision, and personality—the one that best captures the authentic *zeitgeist* of your project.

To find your transmedia project's persona, compare its brand attributes to those conveyed in each of these 12 brand identity archetypes. (The first example in each archetype is from *Star Wars*).

Archetypes of Security and Control: Stability

The Caregiver

The protective nurturer and gentle provider. Helps others by meeting their needs. Much respected and trusted, icons of home, security, and continuity.

- Motto: Love your neighbor as you would yourself
- Core desire: Protect others from harm
- Goal: To help others
- Greatest fear: Selfishness or ingratitude
- Strategy: Does things for others
- Gift: Compassion or generosity
- Trap: Martyrdom or entrapment of others
- AKA: The saint, altruist, parent, helper, or supporter
- Fits if it:
 - Gives audiences a competitive advantage
 - Supports families (fast food to minivans) or nurturing (e.g. cookies, teaching materials)
 - Serves the public sector (e.g. healthcare, education, aid programs, and other care-giving fields)

- — Helps people stay connected with and care about others

- — Helps people care for themselves

- — Is a non-profit or charitable cause

- Examples:

 Shmi (Anakin Skywalker's mother), *Sesame Street,* Bob Hope, Lady Di, Campbell's Soup, Pampers, Volvo, Kleenex, Nestlé, Heinz, American Express, Marriott, Nordstrom, AT&T, Blue Cross/Blue Shield, Fleet, Amnesty International, Michelin, Allstate

The Ruler

A powerful leader. Part of the establishment. Sets the rules that others play by. Can be benevolent or evil.

- Motto: Power isn't everything; it's the only thing

- Core desire: Control

- Goal: To create a prosperous, successful family or community

- Greatest fear: Chaos or being overthrown

- Strategy: Exercises power

- Gift: Responsibility or leadership

- Trap: Authoritarianism or dictatorship; inability to delegate

- AKA: The boss, leader, aristocrat, king, queen, politician, role model, manager, or administrator

- Fits if it:

 - — Is a high-status product used by powerful people to enhance their power

 - — Makes people more organized

 - — Offers a lifetime guarantee

 - — Empowers people to maintain or enhance their grip on power

 - — Has a regulatory or protective function

 - — Is moderately to high priced

 - — Can be differentiated from more populist brands or one that is a clear leader in the field

 - — Is a market leader that offers a sense of security and stability in a chaotic world

- Examples:

 Darth Vader, Microsoft, *The New York Times*, Universal, IBM, Mercedes, American Express, British Airways, Barclays

The Creator

A nonconformist. Motivated by self-expression, not by fitting in.

- Motto: If you can imagine it, it can be done
- Core desire: Create something of enduring value
- Goal: To give form to a vision
- Greatest fear: Having a mediocre vision or execution
- Strategy: Develops artistic control and skill
- Gift: Creativity, imagination, or innovation
- Trap: Perfectionism or miscreation
- AKA: The artist, inventor, innovator, musician, writer, or dreamer
- Fits if it:
 - Promotes self-expression, gives audiences choices and options, helps foster innovation or is artistic in design
 - Is in a creative field like marketing, public relations, the arts, or technological innovation
 - Can be differentiated from a "do-it-all" brand that leaves little room for the imagination
 - Has a DIY sensibility that saves money
 - Saves audiences time or inspires creativity
 - Is part of an organization with a creative culture
- Examples:

 Music band at Mos Eisley Cantina, LEGO, TED, Adobe, Sony, Swatch, Target, 3M, Williams Sonoma, Dyson

Archetypes of Risk and Mastery: Change

The Outlaw

Achieves freedom (from the establishment) through defiance, disobedience, and nonconformity. Enjoys being a little bit bad. May not be admired, but enjoys being feared.

- Motto: Rules are made to be broken
- Core desire: Revenge or revolution
- Goal: To overturn what is not working
- Greatest fear: Being powerless, trivialized, or inconsequential
- Strategy: Disrupts, destroys, or shocks

- Gift: Revolution or radical freedom
- Trap: Destructiveness or criminality
- AKA: The rebel, revolutionary, wild one, the misfit, or iconoclast
- Fits if it:
 - Has employees or audiences who feel disenfranchised from society
 - Breaks with industry conventions
 - Helps retain values that are threatened by emerging ones or paves way for revolutionary new attitudes
 - Is low to moderately priced
 - Has a dangerous or risk-taking quality
- Examples:

 Han Solo, Apple (early days), Google, MTV, Greenpeace, Harley-Davidson, Virgin Airlines, Diesel Jeans, Honda, PETA, TRUTH

The Magician

Transforms. Overcomes the impossible. Creates delight with imagination and cleverness.

- Motto: I make things happen
- Core desire: Understanding the fundamental laws of the universe
- Goal: To make dreams come true
- Greatest fear: Unintended negative consequences
- Strategy: Develops a vision and lives by it
- Gift: Transformation or finding win-win solutions
- Trap: Manipulation
- AKA: The visionary, catalyst, inventor, transformer, charismatic leader, shaman, healer, or medicine man
- Fits if it:
 - Is transformative or changes the paradigm
 - Has implicit promise to transform audiences
 - Has a new-age quality
 - Is consciousness-expanding
 - Is user-friendly
 - Has spiritual connotations
 - Is a new or contemporary product
 - Is medium to high priced

- Examples:

 R2D2, Disney (early days), Apple (later), Pixar, MacGyver, Polaroid, Intel, Absolut Vodka, Smirnoff, Calgon, Santa Claus, The Hunger Project, Michael J. Fox Foundation for Parkinson's Research

The Hero

Proves self through amazing physical acts. Strong, but uses a controlled strength to benefit others.

- Motto: Where there's a will, there's a way
- Core desire: To prove one's worth through courageous acts
- Goal: Expert mastery in a way that improves the world
- Greatest fear: Weakness, vulnerability, or being cowardly
- Strategy: Is as strong and competent as possible
- Gift: Courage or competence
- Trap: Arrogance or always needing another battle to fight
- AKA: The warrior, crusader, rescuer, superhero, soldier, dragon slayer, winner, or MVP
- Fits if it:
 — Has inventions or innovations that will have a major impact on the world
 — Helps people be all they can be
 — Solves a major social problem or encourages others to do so
 — Has a clear opponent to beat
 — Is an underdog or challenger brand
 — Is strong and helps people do tough jobs exceptionally well
 — Can be differentiated from competitors that have problems following through or keeping their promises
 — Has audiences that see themselves as good, upstanding citizens
- Examples:

 Luke Skywalker, Jerry Bruckheimer's programming, US Army, Nike, FedEx, BMW, Home Depot, Ford, Tag Heuer, Duracell, Land Rover

Archetypes of Belonging and Enjoyment: Community

The Jester

Is fun and energetic. Overthrows established or serious way of doing things. Speaks the truth when no one else will. Adds levity to tense situations. Has access to powerful people.

- Motto: You only live once
- Core desire: To live in the moment with full enjoyment
- Goal: To have a great time and lighten up the world
- Greatest fear: Boredom or being boring
- Strategy: Plays, makes jokes, or is funny
- Gift: Joy and fun
- Trap: Cruel tricks or frittering away one's life
- AKA: The fool, trickster, joker, practical joker, or comedian
- Fits if it:
 - Gives people a sense of belonging
 - Helps people have a good time
 - Is low to moderately priced
 - Is or is produced by a fun-loving company
 - Needs to be differentiated from self-important, overconfident established brands
- Examples:

 Jar Jar Binks, Hulu.com, Xbox, Doritos, Geico, Pepsi, Budweiser, IKEA, 7UP, Taco Bell, Fanta, Miller Lite, Snickers, Billy Crystal

The Lover

Pursues perfect enjoyment through physical experiences. Has dreamlike quality. Is easy to fall for.

- Motto: You're the only one
- Core desire: Attain intimacy and experience sensual pleasure
- Goal: To be in a relationship with the people, the work, the experiences, the surroundings they love
- Greatest fear: Being alone, a wallflower, unwanted, or unloved
- Strategy: Becomes more attractive—physically, emotionally, and other ways
- Gift: Passion, gratitude, appreciation, or commitment
- Trap: Doing anything and everything to attract and please others; losing identity

- AKA: The partner, friend, intimate, romantic, sensualist, spouse, or team-builder
- Fits if it:
 - Helps people belong or find friends or partners
 - Functions to help people fully enjoy life
 - Is low to moderately priced
 - Is produced by a freewheeling, fun-loving organizational structure
 - Can be differentiated from self-important, overconfident brands
- Examples:

 Princess Leia, *Marie Claire,* Hallmark, Victoria's Secret, Godiva, Häagen-Dazs, Alfa Romeo, Starbucks, Jane Austen

The Regular Guy

Is down-to-earth and accessible. Bonds with others by being humble, hard working, and friendly.

- Motto: All men and women are created equal
- Core desire: Connecting with others
- Goal: To belong
- Greatest fear: Being left out or standing out from the crowd
- Strategy: Develops ordinary solid virtues, is real, applies the common touch
- Gift: Equality, realism, empathy, or humility
- Trap: Blending in or becoming a lynch mob
- AKA: The Average Joe, good-ole-boy, girl-next-door, everyman, working stiff, solid citizen, good neighbor, mensch, realist, or silent majority
- Fits if it:
 - Gives people a sense of belonging
 - Offers everyday functionality
 - Is low to moderately priced
 - Is produced by a solid company with a down-home organizational culture
 - Can be positively differentiated from more elitist or higher priced brands
- Examples:

 Chewbacca, Disney (later), eBay, Lowes, Dunkin' Donuts, Miller Beer, Sonic, Walmart, Cover Girl, Chevy, Wendy's

Archetypes of Independence and Fulfillment: Individualism

The Innocent

Achieves a pure life by always doing the right thing.

- Motto: Free to be you and me
- Core desire: To get to paradise
- Goal: To be happy
- Greatest fear: Being punished for doing something bad or wrong
- Strategy: Does things the right way
- Gift: Faith and optimism
- Trap: Boring because of naïve innocence
- AKA: The utopian, purist, traditionalist, mystic, saint, or dreamer
- Fits if it:
 - Offers a simple solution to an identifiable problem
 - Is associated with goodness, morality, simplicity, nostalgia, or childhood
 - Is low to moderately priced
 - Is produced by a company with straightforward values
 - Can be differentiated from brands with poor reputations
- Examples:

 C3PO, Hallmark, Coca-Cola, Fisher-Price, Ivory, Dove, Avon

The Sage

Provides intellectual solutions to problems. Offers expertise and advice. Has serious objective tone. Finds truth through research, objectivity, and diligence.

- Motto: The truth will set you free
- Core desire: To find the truth
- Goal: To use intelligence and analysis to understand the world
- Greatest fear: Ignorace, or being duped or misled
- Strategy: Seeks out information and knowledge; self-reflects and understands thought processes
- Gift: Wisdom or intelligence
- Trap: Dogmatism or studying details forever without acting
- AKA: The expert, scholar, detective, advisor, thinker, philosopher, academic, researcher, planner, professional, mentor, teacher, or contemplator

- Fits if it:
 - Provides expertise or information to customers
 - Encourages audiences to think
 - Is based on new scientific findings or esoteric knowledge
 - Is supported by research-based facts
 - Can be differentiated from others whose quality or performance is suspect
- Examples:

 Yoda, CNN, Ask.com, Intel, Gallup, McKinsey & Co., Harvard University, Oprah's Book Club, Philips, HSBC, Albert Einstein

The Explorer

Learns what's valuable by discovering new things. Challenges audiences to do new things and, in so doing, to learn about themselves.

- Motto: Don't fence me in
- Core desire: The freedom to find out who they are by exploring the world
- Goal: To experience a better, more authentic or fulfilling life
- Greatest fear: Getting trapped, conforming, inner emptiness, or non-being
- Strategy: Journeys, seeks out, and experiences new things; escapes from entrapment and boredom
- Gift: Authenticity, autonomy, or ambition
- Trap: Aimless wandering, self-indulgence, or becoming a misfit
- AKA: The seeker, finder, pioneer, wanderer, individualist, or pilgrim
- Fits if it:
 - Helps people feel free or be nonconformist or pioneering
 - Helps people express their individuality
 - Can be obtained in less traditional ways
 - Is rugged or sturdy for use in the great outdoors
 - Is consumed on the go
 - Can be differentiated from a successful regular guy/gal brand or conformist brand
 - Comes from an explorer culture that creates new and exciting products or experiences
- Examples:

 Jedi Knight Order, Red Bull, PBS, North Face, Jeep, VISA, Virgin, Marlboro, Bounty, Subaru, Levi's, Johnnie Walker, Richard Branson

Reaching consensus among your internal team members about the dominant archetype for your media project is important to your shared understanding and consistent expression of your project. PBS' *Martin Scorsese Presents the Blues*, first introduced in Chapter 4, "The Marketing Plan" as a case study used throughout the book and expanded at transmediamarketing.com, was The Explorer brand archetype. *The Blues* was about discovering value in new experiences. It challenged audiences to do new things and, in so doing, to learn about themselves. *The Blues'* The Explorer internal brand essence, communicated from the POV of a target audience member, was:

> *The Blues* is my celebration and journey. This influential music genre reflects the human experience; its power helps me feel my connection to humanity and American culture.

Brand Positioning and Expressions

Now you are ready to go public with your internal brand essence. The most dominant of your brand attributes are your **Brand Pillars**, which buttress your brand. To discover your brand pillars, look at your brand attributes—adjectives or descriptive phrases generated by your respondents—along with your governing archetype profile. Create a list of five to 10 of the most fundamental attributes (the ones that you heard the most) that support your brand persona. The best brand attributes or pillars are those that establish the brand persona, create top-of-mind relevance to key audiences, motivate audiences to participate, and competitively differentiate and define.

Your brand's personality (archetype) and its reigning attributes (brand pillars) create a brand promise (how the product or service delivers on the brand story, supported by your messaging). A fully-articulated brand:

- Tells a story
- Conveys a clear message
- Connects to audiences emotionally
- Delivers value
- Is consistent
- Generates loyalty

Your brand pillars will help you translate your internal brand essence into an *external* **Brand Positioning** that guides all of your public brand expressions. A brand positioning:

- Describes where a brand fits and competes in the marketplace (does what for whom)
- Is built on relevant points of difference that will make people want to participate (why and how)

Martin Scorsese Presents the Blues' brand pillars of its The Explorer archetype were:

- Authentic, honest, gritty
- Personal, human
- Pioneering, self-discovery
- Free-spirited, freeing
- Life-affirming
- Passionate, emotional, and inspirational
- Culturally-relevant, compelling, thoughtful
- Contemporary POV; new experiences

Those brand pillars generated *The Blues'* external brand positioning statement:

For music lovers seeking enriching entertainment, *The Blues* is an inspiring *entrée* to personal discovery of blues music's profound reflection of culture and humanity

—a musical journey

A brand positioning statement is not intended to be PR or marketing copy, but summarizes the feeling and meaning those external expressions should convey. For *The Blues*, "a musical journey" was also used as the project tagline. Brands typically are made up of various external brand expressions, many of which can be trademarked, that appear above the waterline, including:

- Name—the word or words to identify a company, product, service, or concept
- Tagline—the marketing phrase that delivers the brand's promise
- Logo—the visual trademark that identifies the brand

- Graphics—the signature art that signifies the brand
- Colors—the distinctive use of color in the product or graphic identity
- Shapes—the signature shape of a product or logo
- Sounds—the unique tune or set of notes that denote a brand
- Movements—the unique movement in product design
- Messages—the phrases or descriptions that become associated with the brand

The Creative Brief

To guide above-the-waterline brand expressions and keep true to your brand, you need a short one- or two-page brand overview—a creative brief. You must share it with anyone on your team developing transmedia elements, the Web site, social media platforms, advertising, publicity, events, or other audience-facing materials.

The creative brief should lay out:

- The scope of the specific marketing assignment
- The marketing objective
- Target audiences
- What audiences currently feel
- The key message
- What you want audiences to feel
- Why audiences should believe the message
- The tone
- Execution of considerations
- Mandatory elements

The creative brief is a template for your marketing goals and brand, and then is tailored to the specific assignment, its marketing objectives, and execution considerations. Key elements of the creative brief for *Martin Scorsese Presents the Blues*' tune-in promotion campaign are included in Chapter 24, "Advertising Creative," and the entire brief is viewable at transmediamarketing.com. You'll notice how key elements of the marketing plan and brand identity are encapsulated in the creative brief.

When you create your above-the-waterline brand expressions, you want your project's brand to receive credit for and accrue equity from all that it does and inspires. Ensure that your brand is clear, differentiated, universally accepted, and culturally-relevant to your audiences and partners.

Brands appeal to humans because they feed our hunger for discovery, community, and accomplishment. Strong iconic brands tell timeless archetypical stories and contribute to audiences' personal brand stories, engendering connection and trust. That story is told through: the product or service itself (and how it delivers on the brand promise); iconic brand elements (logo, look, smell, sound, and feel); personification (character, founder, or celebrity); message (tagline or language); brand rituals (practice, behavior, and memes); and the brand's rational alibi or reason (audiences' relationship with its value proposition).

Brands can have such deep emotional resonance that they are passed down from one generation to the next. Perhaps your grandmother used Tide to wash clothes and so do you. Brands are also used to rebel against establishment or signal a separate identity from your parents. Your father always drove an American car, so now you drive a Japanese car. Audiences connect to brands for different emotional reasons, but it's the connecting that matters.

Author's Anecdote

Brand Personas

© Anne Zeiser

Masterpiece's "It Girl" brand persona and inspiration board with ads, brands, and imagery representing her traits, personality, and habits on the wall of my office in 2007.

In 2007, *Masterpiece* went through a rebranding exercise with outside consultants. I contributed to the rebrand, including discovering this "It Girl" persona.

The idea, to bring the new *Masterpiece* television series brand to life as a smart, happening, and hip woman with timeless appeal. The persona expresses her characteristics, role models, love interests, lifestyle affinity brands, and favorite haunts. The "It Girl" represented the aspirations of the next generation of clever women of the twenty-first century. The new brand's first public expression was the *Masterpiece Classic* on-screen festival, *The Complete Jane Austen,* which included a high-profile digital, publicity, and partnership campaign.

Now, with her makeover and ongoing stellar, brand-defining programming like *Downton Abbey* and *Sherlock, Masterpiece* has become the "It Girl" of television drama. (See Chapter 11, "Visual and Aural Identity," for the backstory on *Masterpiece*'s rebrand).

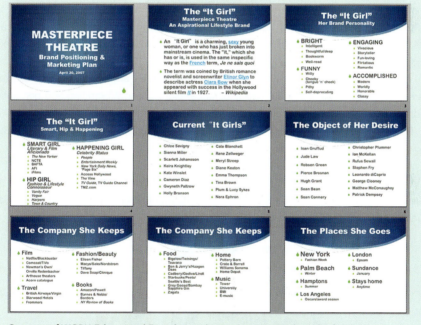

Courtesy of WGBH Educational Foundation. *Masterpiece* is a trademark of WGBH Educational Foundation.

CHAPTER 10

What's in a Name?

The name or title is one of the most important marketing decisions you can make for your media or entertainment project. No surprise, because it creates the first and most lasting impression. That's why expectant parents agonize over a child's name. It can be the difference between being cool or being bullied. Naming consumer products—cars, paint colors, and food—is a multi-billion dollar business, rooted in social science, psychology, and marketing artistry.

William Shakespeare's ". . . that which we call a rose/By any other name would smell as sweet" might apply if content and substance reigned, and if branding and perception didn't matter. But today, names matter, and matter supremely in entertainment.

For example, having just won the Oscar in 1947 for *The Best Years of Our Lives*, Sam Goldwyn released his next star-studded film, *The Bishop's Wife.* It was expected to be a box office hit, but was a total bust. Fast-tracked audience research revealed that its title was too boring. With the film's name already public, a full retitle was impossible. So new ads called it *Cary and the Bishop's Wife.* MGM pulled out their biggest asset, Cary Grant, and led with him in the title. It saved the film.

Cary and the Bishop's Wife poster; Licensed in the public domain via Wikimedia Commons

On the strength of Cary Grant's appeal, MGM added his name to the film's title.

Modern Hollywood understands the value of a good name in a crowded and fragmented landscape. To protect *E.T. The Extra-Terrestrial*'s title and plot, Steven Spielberg filmed it in 1981 under the cover name *A Boy's Life*, requiring cast and crew to read the script behind closed doors and wear ID cards to get on to the set. Just imagine some of your television favorites with a different moniker. *Friends*' original title was *Six of One*. *Lost*'s working title was *Nowhere*.

Who titles a film, TV show, game or Web site? The first crack goes to the creator. That's *you,* if you're a media maker. Your title may not survive. But good titles often do, and they certainly help advance your concept with studios, production companies, funders, and distributors. Even studio chiefs acknowledge they're swayed by strong titles when considering a project; it helps them remember it in a sea of proposals and scripts. And a lousy title can be a turn-off. If you're putting your project in front of decision-makers, get a solid working title so they know what it's about.

Somewhere in the process from development to production, the distributors' marketers and researchers will work tirelessly to come up with the best title for a property. That's *you* if you're a media marketer or a small independent producer doing it all. Either way, titling is part of your job. It's both fun and excruciating. And doing it well is much harder than it looks.

The Good Title Checklist

Good names are like what Supreme Court Justice Potter Stewart said about obscenity, "I know it when I see it." Titles are as subjective as it gets, but most people agree on the really good ones.

Movie and media project naming doesn't follow the same rules as naming a consumer product or company. In that realm, "trademarkability" is a top criterion because of the overabundance of products and domain names, creating difficulty in obtaining them legally. Titling in Hollywood is more about reaching audiences emotionally, driving the perpetual quest for the dual and often competing traits of evocativeness and clarity.

Among media platforms, there are differences in what flies. In television, visual electronic program guides (EPGs) are a huge consideration. The show's length determines the number of characters that fit in the program box on the grid: a half-hour show gets about 10 characters; two-hour specials get many more. And in a world of social TV with Twitter's 140 characters, brevity is paramount.

Films have more freedom for longer titles, and their titles can be more suggestive and less literal than TV titles. The primary job of a game title is to create a picture of the world the gamer will inhabit, but in the end the quality of the gameplay always rules over branding. For Web-based properties, memorability, length, and ability to get the URL drive the naming process. The takeaway: you must always take your platform(s) into consideration when titling your project.

Still, titling entertainment on any media platform follows some basic rules. To build a relationship with audiences, it must stand out and telegraph what the project's about. The "perfect" title is descriptive, but not boring; memorable, but not *cliché*; clever, but not alienating; provocative, but not inappropriate. It should never promise more than it can deliver.

To achieve all this, it should possess a number of critical attributes outlined in the Good Title Checklist, which will guide the titling of your project. Ideally, your title:

- Supports brand essence
- Is meaningful
- Is simple and accessible
- Is fresh and unique
- Is evocative
- Is timeless

Supports Brand Essence

You've identified your project's audiences and brand essence and developed its creative brief in recent chapters. Your title is one of your first brand expressions from all of that marketing planning. A good name must capture the unique essence, spirit, and tone of your media brand. Is your project The Hero or The Jester brand archetype? The name must also acknowledge the psychographic profiles of your target audiences. Are your audiences casual or sarcastic? Are they seeking escape or are they poised for vicarious, hands-on battle? Hold your prospective title up to your brand attributes as a litmus test of whether it's a good title for your project.

Is Meaningful

Every good title delivers meaning. You never want to create barriers to entry for your audiences, so it's always best to start by telling them exactly what your project is about. A good title clearly stands for the brand's essence and is specific about the content of the film, show, game, app, or Web site. Avoid being too vague or generic or you'll fall into the "what's this about?" category. That's the death knell for all media properties. Adding an unusual adjective to a noun, as in *Desperate Housewives*, moves it from the generic to the specific, and delivers tone, Also, if you can think of 10 films, TV shows, games, or blogs sharing your platform that could also have your title, then it's too generic.

Part of delivering meaning is being relevant to your audiences. By saying something familiar, you can provide intimacy between your brand and your audiences. And titles that are believable will give your project legitimacy, stature, and integrity.

Is Simple and Accessible

Often the simplest titles, that say a lot, but don't ask much of the audience, are the best. Short titles of three words or fewer is a good rule of thumb for keeping your title simple. *Cheers*, *Alien*, and *Civilization* are examples of dynamic single-word titles. If you're creating a new media property that needs brand recognition, a long title can hurt.

In addition, titles that are pleasant to the ear, like a song that rolls off the tongue, and are pronounceable are more likely to be accepted, remembered, and passed along by your audiences. Unless you're in the horror genre, don't choose titles that are unpleasant or unappealing. Titles that use alliteration or strong letters will stand out and be memorable. Titles that fit into daily language or have potential to become memes, placeholder nouns, or verbs are highly successful—think Google and Googling.

Is Fresh and Unique

A great title is catchy. It stands out and is distinct from other properties. By being smart, clever, or cool it can create audience demand or speak to the *zeitgeist* of an idea or generation. One of the best ways for you to achieve "social currency" is to use humor. The UK phrase that inspired *The Full Monty* became mainstream in the US and *Animal House* became a lifestyle. *Curb Your Enthusiasm* is an unexpected title that propels you into Larry David's unique POV. Without someone of his stature behind it, though, it might have been too offbeat. Remember, there's a delicate balance between witty and "cutesy."

Is Evocative

An evocative title creates an emotional connection, conjuring up visual, auditory, and conceptual associations. It captures the audience's interest and imagination, but also asks the audience to do some work. Evocative titles don't deliver meaning perfectly, but use metaphors and abstractions to provoke and evoke. For example, Disney's *Eight Below* could stand for the eight sled dogs or eight below zero or eight degrees below the Artic Circle. It leaves a lot up to your imagination, but not too much.

Intriguing and mysterious titles do better in film than television. In general, you should approach these carefully because there's a fine line between a title being a muse and serving to confuse.

Is Timeless

If you want your media property to stand the test of time, its name should be enduring and flexible. It should have sustainable meaning to support its future viability. Yet it should also be timely and relevant. Concepts that drive us as humans like *Revenge*, *Greed,* and *Crave* never seem to go out of favor as stories or titles. If you search the Old Testament or Greek mythology, you'll find the roots of most good stories, themes, and even titles.

Titling of most media platforms share these guiding attributes of the Good Title Checklist. But specifically, names for original works and adaptations to the Web need to be unique, short (ideally below 10 characters), easy to remember (don't use hyphens), and deliver on expectations. Good Web titles also must meet some other special criteria that are specific to the format. For example, Web and domain titles need to be easy to spell, easy to type (avoid *q*, *z*, *x*, *c*, and *p*) and purchasable. If you can, choose a ".com" over other extensions like ".net" because it's more easily remembered. Once you have your name, purchase it along with the other extensions to protect it and avoid brand confusion.

The Bad and the Ugly

Along with the Good Title Checklist, you also can learn from problem titles. If you understand the criticisms—from misrepresenting the content and insulting the audience to asking too much of audiences and boring them to tears—you'll be more prepared to avoid similar titling hazards.

Cougar Town is one of the worst titles that's appeared on the TV grid for multiple seasons. It's hard to imagine how it survived ABC's marketing machine. A cougar is a new pejorative term for an older woman on the prowl for a younger man. What woman—old or young—wants to think of herself or any other woman that way? Half of the audience is instantly offended. Plus, how will women as sexual predators play in conservative parts of the Midwest and South? While a trendy term that might generate initial buzz, *Cougar Town*'s timeliness doesn't outweigh its off-putting effect.

A much deeper TV title, *The Good Wife*, was coined in the wake of the Eliot Spitzer scandal and was reinforced by a fast succession of powerful men downed by sexual improprieties (Mark Sanford, Arnold Schwarzenegger, Anthony Weiner, General David Petraeus). But if you didn't know that the title gives an ironic nod to a woman dealing with her partner's scandal, at first blush you'd think it was about the travails of a dutiful wife. A potentially risky title, but one that's strong once you know what it's about.

Then there are the titles that drone on and on, like *The New Adventures of Old Christine* and *How I Met Your Mother*. Both captured audiences because of their stars, Julia Lewis Dreyfus and Neil Patrick Harris, but these titles are neither EPG- nor Twitter-friendly. Audiences have taken the liberty of shortening them to *Old Christine* and *HIMYM* respectively.

Film is littered with problematic titles. The classic *Reservoir Dogs* doesn't fit the film because it has no inherent meaning and no apparent connection to what's on screen. Director Quentin Tarantino has always balked at explaining the meaning of the film's title, simply saying ". . . it's more of a mood title than anything else. It's just the right title, don't ask me why." Despite its name, the film met critical acclaim.

Then there are the badly-titled films that may have sunk them. *Gigli,* a title (and movie) that bombed, should have done much better because it starred then real-life lovers Ben Affleck and Jennifer Lopez. At the time, they were such a cultural phenomenon, their couplehood had its own name, "Bennifer." The 1973 film, *SSSSSSS,* starring Dirk Benedict as the victim of a mad doctor trying to turn him into a snake, also was a bust. To boost flagging box office sales ascribed to the title, it was released in the UK as *SSSSnake.* Too little, too late. Over time, though, the film has developed a cult following as one of the better man-becomes-creature flicks.

Zero Dark Thirty, about the Navy SEAL's quest to take down Osama Bin Laden (conducted at 12:30 a.m.), has a title that has been extensively discussed and criticized. Director Kathryn Bigelow explains the title's meaning, "It's a military term for 30 minutes after midnight, and it refers also to the darkness and secrecy that cloaked the entire decade-long mission." The fact that the title was a press interview question was both good and bad. It proved the title stood out and generated buzz, but also that it was a barrier to audience understanding. The military community was energized by the hype, with much online and social network chat about its meanings.

The game industry has its share of badly-titled videogames including *ASO: Armored Scrum Object*, *Tech Romancer,* and *Cacoma Knight in Bizyland*. And the Internet is simply bursting with bad Web site names and blog titles.

The primary rule of thumb for adapting from one platform to another, sequeling, and moving between geographic markets is if the title is working and has a following on one platform or setting, you should use the title—in some form—on the next one. The name recognition of an already-established title is worth untold audience share and marketing dollars.

Today, geography, language, and culture are key reasons for changing a title from one platform to the next or from one market to the next. A well-known transmedia example is the first *Harry Potter* book and movie. British author J.K. Rowling titled her first book *Harry Potter and the Philosopher's Stone*. Scholastic later published it in the US with the title *Harry Potter and the Sorcerer's Stone* because they thought American children wouldn't buy a book with the word "philosopher" in the title. When Warner Bros. bought the movie rights, it kept the American book title.

As a result, the scenes in the movie that mention the stone were filmed twice for the US and UK releases, one version saying "sorcerer's" and one "philosopher's." And in the US book, "philosopher's" was replaced with "sorcerer's." By all accounts, Rowling was not happy with the title change.

People will always disagree about titles. When you assess whether a property has a good or bad title, first put it in context—what is its platform, era, geography, and target audience's unique POV?

Like audience psychographic profiles and brand archetypes, project names can take on personas. Recognizing and applying these personalities can also help you find a strong title for your media project. (Learn how to find or create your project title's personality at www.transmediamarketing.com in "Titles Have Personalities").

Finding Your Title

Armed with the rules of the road, and the various contexts for titling, you're now ready to find the title for your film. This simple, doable DIY titling process builds on the marketing stages covered in this book so far, and will yield many title options. It draws on all the same principles of professional studio titling—knowing your audience, mining themes, and seeking emotional connections—but on a smaller scale. (This titling process is also a template for how to find your project's brand attributes, brainstorm ideas in various areas, and informally focus-group your ideas with your target audiences).

Phase I

First, look at your archetype, brand attributes, and tone from your creative brief. They should have captured your project's top *themes* that will be useful for brainstorming titles and name concepts. For example, if your feature thriller is about a recent college grad who stumbles onto a stalker murder mystery on Facebook when he's supposed to be looking for a job, the themes might be mystery, discovery, and illumination. But in leaving college and moving to the "real world," your protagonist may also be dealing with themes of assimilation, belonging, fear, and change.

Again, you will embark on informal primary research for your project. Gather five to 10 smart and creative people, but with different strengths and perspectives. Make sure half of them *are* your project's primary target audience(s). Write the themes as headers on poster-sized 3M Post-its and place them on a wall. Let everyone know the session's goal is to get closer to a project name and share the Good Title Checklist. Briefly describe what the project is, what it's about, and for whom it's intended. Then, brainstorm words or ideas that come to mind under each theme. Write ALL of it down. There are no right or wrong ideas. Just capture people's visceral emotions around each theme.

At the end, you will have a long list of words and ideas for each theme. These are not titles, but rather are *naming approaches*. Ask your group to rank ideas, not based on suitability as titles, but as core ideas. Give everyone in the room from five to 10 sticky dots to place on the ideas they like best. They may use more than one dot on an idea if they really like it.

At the end, you'll see which ideas or naming approaches have the most group resonance. Combine similar ideas like community, group, and friends or discovery and quest. Each idea represents one naming approach. For your Facebook stalker murder mystery, you may see naming approaches like mystery/questions, discovery/search, clues/evidence, obsession, disappearance, "Friends of Friends"/clique, privacy/secrecy, terror/fear and transformation/change. Look for patterns of theme or tone in your top naming approaches.

Take these naming approaches and live with them for a few days. When you're not actively thinking about it, your true feelings surface and you may make subliminal connections and spawn new ideas.

Phase II

Then take the top five naming approaches, which may be similar to your original themes, and put them each on the top of a fresh sheet. Brainstorm actual *words* that could communicate each approach. Google the words, use a thesaurus, listen to music about that topic, and have conversations with people about the core ideas. Populate the naming approaches with words the same way you did on the first round. Look for commonalities across the words on the sheets. If the same word or thought appears across two naming approaches, you might be on to an idea that has double meaning. Or you might be able to put two words together from the two lists, one as a qualifier to the other.

If you're lucky, at the end of this process, you will have a couple of working titles. If not, go back to the beginning of the process and add a few more themes, brainstorming them into naming approaches and then to specific words for each approach. If you do this, be sure to combine and evaluate all of the outcomes from the first and the second rounds so you can see the whole picture and find new connections across them all.

Phase III

When you have three to five working titles, you must test them with informal focus groups. Find eight to ten people that fit each of your top two target audience profiles (psychographic and demographic) and ask them to rank the titles. Create a chart for each target audience and document each of the 16 to 20 respondents' ages, genders, and other key attributes and their responses to questions. Ask them why they did and didn't like each title. Ask everyone the same core questions and ask follow-up questions. Look for differences between genders, ages, geographies, or personal interests. You may learn your target audiences aren't what you thought and you may be surprised by the favored title. Listen to these sample target audiences, especially if they don't choose your favorite title.

For your Facebook thriller, this process might yield a preference for *Stalked* or *Cyberstalked* for older audiences, but *Liked* or *Blocked* for younger audiences who've used these terms colloquially since teenhood. They may see it as a *double entendre*, associating *Liked* with a Facebook action gone awry, plus the deeper film theme of needing to belong after the bubble of college.

Whether you have the final title or not, you should have a working title you feel good enough about to use with prospects. And before you do, you should at least conceptually explore the title's graphic expression.

Supposing you adore your newly-minted title, can you own it? Not really, since you can't copyright titles. Copyright is a bundle of protections granted to the creator of a work to cover the expression (your original screenplay) of an idea. Even a work that is copyrighted, like a novel, has no special protection for its title. Only names of products and companies can be legally protected with a trademark or registration. If you've seen a ™ on a movie like *Transformers* it's there to protect the brand's toy line, not the movie title. But you can secure your title's associated Web domain, blog, Facebook, and Twitter names. So go ahead and use your working title and focus on advancing your project. (Copyrighting and trademarking are covered in Chapter 32, "Market It!").

This may be close to the end of the titling road for you if you have a small-scale project. Or you may be working with established industry players such as production, distribution, financing, and creative partners. Once your project is in production, a team of marketers and researchers might turn their attention to your title. Usually, the media project's distributor spearheads this process. In film, it's the studio or independent distributor; in television, it's the network or streaming company; and in games and books, it's the publisher. Hard as it is, you must step back and let them do their job. Hopefully, you'll be apprised of the process and can weigh in. The bigger the organization in control, the less likely that will be.

Phase IV

The entertainment industry's titling process is an art form. The marketing team starts by having writers and creatives do title exploratories. Sometimes they throw working titles into the mix, if for no other reason than to prove they don't work. Just like you did, they look for the project's core message, themes, and intended emotional takeaway. They execute a battery of brainstorm and research exercises to deliver a set of working titles, usually paying off on several naming approaches. And they experiment with possible on-screen title treatments, posters, Web sites, and ads.

In film, and often in television, working titles are professionally focus-grouped with various potential audiences in geographically-dispersed cities. Carefully chosen target audience members watch a clip and discuss its marketing and title. Sometimes, audiences watch and dial-test the entire film or TV program, reacting to the story, actors, title, taglines, and full ad campaigns. When the James Bond movie *Licence Revoked* was screen-tested in the US, audiences associated it too strongly with driving, so the title was changed to *Licence to Kill*.

The final approval of a movie title rests with the studio executives, because the film is their property. Smart executives ensure they get approval from the producer and the director, and any powerful stars attached. When a movie enters production, producers can give the title some exclusivity by registering it with the MPAA, a non-governmental system for the motion picture industry.

In television, the network has final say, but it must pass muster with business affairs for usability against other entertainment properties. *Spin City* started as *Spin*, but ABC couldn't get the rights from *Spin* magazine. Fox failed to secure the rights to *Teenage Wasteland*, a lyric from The Who's "Baba O'Riley," so settled instead on the generic *That '70s Show*.

In the game industry, potential titles are brought to Beta gamers who test gameplay and marketing concepts for new games. If it's a small game developer, then the feedback is anecdotal. If a bigger publisher is involved, then it's more in-depth. Game titles can be trademarked and the underlying code can be copyrighted. Online titling is the Wild Wild West. If you can secure the name you want on your desired platform—the Web URL, the blog host, or the Twitter or Facebook account—then you're in business.

Debates about titles and how to produce the best ones are legion among both industry professionals and audiences. Even with all of these titling strategies and marketing professionals on the case, many media titles still see the light of day while breaking top titling rules—being abstract or, even worse, vague.

Rogue titles don't necessarily sink media properties, nor do great titles ensure their success. While catchy titles surely bring visibility, signal meaning, and attract audiences, there's much more to a media project's success than just a good title—great writing, casting, directing, acting, cinematography, editing, and design. But strategic and creative marketing helps.

Visual and Aural Identity

When a brand touches audiences, it activates the senses. How it looks, how it sounds, how it feels, even how it smells are part of its identity. Those visual and aural elements help tell your brand's story. Now that you have named your media project, you are ready to bring it to life on screen.

The visual identity of a brand is created through consistent use of visual elements such as fonts, colors, and graphics that are specific to a brand. The pioneers of visual brand identity design were Paul Rand, Saul Bass, and Chermayeff & Geismar.

Logos

The core expression of graphic identity is the logo—the visual trademark or mark that identifies the brand. Like every brand expression, your logo must be guided by your brand archetype, brand positioning, and creative brief.

A good logo reflects a brand's core, has personality, and tells a story. But its consistent and thoughtful use is what gives it lasting meaning. The National Geographic Society has continuously published the yellow-bordered nature magazine for more than 100 years. Now, the yellow border alone has come to signify all that *National Geographic* stands for.

The five key elements of good logo design are:

- Simple
- Memorable
- Timeless
- Versatile
- Appropriate

Logos often include the name of the entity and an accompanying graphic mark. For example, Nike's logo—perhaps the best logo of all time—includes its name and the Swoosh. The Nike Swoosh is a simple shape with so much visual expression that it signifies movement and embodies the brand's The Hero archetype. A Portland State University design student developed it in the early 1970s for just $35. As a stand-alone symbol, the Swoosh is visible and tells Nike's brand story.

Colors used together in a certain way in a logo can signal a brand. For example, Dunkin' Donuts' signature use of pink and orange—an unusual color combination—has come to represent The Regular Guy (or Regular Joe) donut and coffee brand. Signature aspects of a logo are so fiercely protected that they engender lawsuits. ExxonMobil, which has used its logo continuously since 1971, sued Fox cable network's FXX, targeting 18-to-34-year-old males, over its use of interlocking Xs in its graphics.

The use of a logo is as important as the look of the mark itself. Coca-Cola's logo is not a particularly aesthetically-pleasing or clean logo. But the trademarked dynamic ribbon on its cans and packaging has been used so brilliantly and consistently over time that the logo lives in the pantheon of great logos.

Context always matters with logo use and sometimes they're misused. Ralph Lauren designed the 2012 US Olympic uniforms, but manufactured them in China, which created a huge furor. But more egregious was the enormous size of the Polo pony logo on the ceremonial uniforms, rivaling the visibility of the Olympic rings. As the heretofore custodian of classic prep style, Ralph Lauren's logo use was an overly commercial appropriation of the world stage of the Olympic Games, creating a Newport, R.I.-masquerading version of the screaming American tourist.

Traditionally, logo use is rigidly proscribed, requiring consistency. One big exception is Google's mutating logo, touted as one of its most creative assets (Google is The Outlaw). When you go to Google's home page you will see a different mashup or riff of the Google logo every day. A good reason to go there regularly. The Google doodles began inadvertently on August 30, 1999 when employees left the office for the Burning Man Festival and placed the festival's icon on Google as a cryptic "Gone Fishing" sign. This has led to Earth Day, Thanksgiving, Claude Monet, Leonardo da Vinci, *Tetris*, Audubon, LEGO blocks, and *Sesame Street* Google doodles. Now Google Doodles employs several full-time doodlers and a part-time engineer.

The Nike story aside, professional designers generally develop logos. To find a good designer, ask friends and colleagues who have had logos designed for their brands or projects. Look carefully at prospective designers' work. Make sure they've worked with other brands with a similar personality. And be sure they have worked in the same media. Some print logos don't translate well on screen, so your designer must be versed in all the transmedia platforms on which your logo will appear.

You should share all of your branding materials with your project's designer and have an input session with them. In advance, think about what story you want the logo to tell,

what look and feel you want, and how your logo will be used. Good design professionals will interview you to ensure they secure all of the information they need to develop an expressive and functional logo. If you're using print applications of the logo, you will want to determine up front how much color your want in your logo (from 1C to 4C). Four color processing creates any color, but is much more expensive to print than fewer colors.

You must consider the the format, platforms, and all the possible expressions of your logo before you design it.

Print

This medium associates higher cost with increased volume (more pages) and more colors:

- Letterhead
- Book or game box covers
- DVD or CD covers
- Posters
- Collateral (postcards, banners, T-shirts, mugs, etc.)
- Color and black and white advertising

Online

This medium requires low resolution and small page size; allows for unlimited color and changing of images. Important to ensure logo visibility on small mobile devices:

- Project Web site
- Project blog
- Project social media sites
- Online advertising
- Others' blogs and social media sites

On-screen

This medium offers the advantages of motion; can animate or change relationships between elements over time, but that increases cost. Screen sizes vary:

- Film trailers
- Television (as presentation platform)
- TV on-air promos or ads
- Online streaming
- DVD players
- Game consoles

Generally, designers offer you two to five design directions or approaches first, with sample logos. You should choose one or two directions you like. Go over all directions with your designer and be clear about what you like and don't like about each so your designer can learn more about what you're looking for. The designer then comes back with some fully-articulated logos for each direction. Hopefully, one will sing for you with some minor tweaks. Ask your trusted core team to weigh in as well. These are the people who have helped you with the brand archetype and project title.

Be sure to look at the final logo in black and white, vertically and horizontally, in small and large scale, on various media platforms, and alongside project partners' logos. All of these test cases will ensure your logo works for you in various ways. By testing it in real-world situations, you may find the need to change the size or thickness of the font to ensure it shows up on your Web site or when viewed on an iPhone.

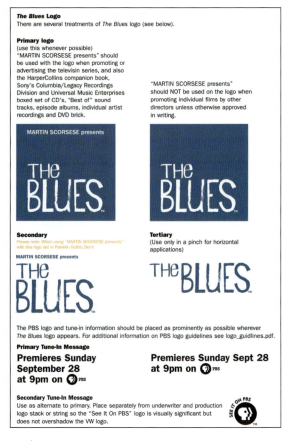

Courtesy of Vulcan Productions

Logo page for *Martin Scorsese Presents the Blues* in the project's graphic identity style guide.

Graphics and Art

Brand logos are accompanied by other graphics in their packaging or brochures that are part of their overall visual identity. Have you ever had a hard time finding a product on the grocery store shelves when it changed its packaging? That's because you had unconsciously registered the colors and patterns of the package in your brain to identify it. The visual dictates of the brand proscribe how all these graphics can be used.

The distinctive use of color can be critical to a brand's visual identity. Color can be expressed in the logo, as well as its other brand ambassadors such as UPS' brown trucks and uniforms. Color also is important to the product itself. No one can own color completely, but some can ensure exclusive use of it in an industry. For example, Owens Corning is the only brand of fiberglass insulation that can be pink.

Signature shapes in the logo and product also connote the brand to audiences. The logo's shape can be presented in creative ways. At the 2014 Rose Bowl football game, the Stanford University marching band formed the logo of Snapchat, the growing social company founded by three Stanford grads.

© Daniel Brusilovsky

Snapchat logo formed by Stanford's marching band at the 2014 Rose Bowl game.

Shape of the product also defines the brand. The classic Coca-Cola bottle shape is still highly associated with the brand. It's so iconic that the bottles are collector's items. The curve of the VW Beetle made it stand out among its flat and long-lined competitors

when it was introduced into a crowded US car market. That curved shape was the basis of several ad campaigns.

Brands and logos have associated fonts that must be used in designed materials—from letterhead to on-screen credits. When you look at the palette of fonts in Microsoft Word, you'll see but a microcosm of the fonts available to designers. Even brand fonts are hardwired with audiences. For instance when the *New Yorker* made changes to the magazine font, its superfans went nuts. Regular readers of voluminous content in a particular font in news and information outlets will notice what seem like subtle changes.

Even movement, scent, and flavor contribute to a brand. The upward movement of the Lamborghini car doors, the rose-jasmine-musk scent of Chanel No. 5, and the eleven herbs and spices fried chicken flavor of KFC are trademarked.

Media properties' signature photos, screen grabs, or designed art must be carefully chosen along with the project logo to visually present the project. (Press photography and press art are covered in Chapter 15, "Press Materials" and project key art is covered in Chapter 20, "The Art of Art").

The Graphic Style Guide

To capture all of these graphic aspects of your brand and ensure all of your team members and partners use them consistently, have your logo or marketing materials designers create a visual identity style guide for your project. Include that as part of the scope of work when you hire them. The goal of a visual identity style guide is to create distinct and unified expressions for your project brand. Chermayeff & Geismar created the practice of developing brand identity style guides with its major client, Mobil Oil.

Style guides are important to preserving your brand's integrity when it's presented to public audiences. They lay out the "rules" of your brand, integrating logo, logotype, font, color palette, and brand architecture (relationship of your brand to other key brands such as distributor). A style guide can be but a few pages long for a small project or hundreds of pages for a big story universe like *Star Wars*.

Some of the key aspects of the visual style guide include:

- Brand overview—use key aspects of the creative brief
- Inspiration piece—a brand expression that sets the brand tone
- Logo—primary and secondary uses
- Logo colors—specific use of color in logo
- Logo—other uses (black and white; reversed out)
- Logo sizing—dictates for minimum size
- Clear space—use of space around the logo

- Typography—associated fonts and their use

- Typography color—specific colors

- Partner logo use—hierarchy and size

- Partners' logo dictates—mandates from their style guides

- Brand color palette—brand colors across logo, typography, and art

- Images and photography—image-use specs and style

- Collateral-use samples—letterhead, poster, postcard, brochure, ad, title treatment, promo, etc.

- Project title-use in text—how to be used in non-designed copy

- Boilerplate language—project description paragraph

- Producer and partner boilerplate language—company description paragraphs

- Credit language—contract-mandated attribution of production credits

Whenever the guide presents a "rule," it should provide a concrete example so users will understand the point. The style guide's mandates should be strict enough to protect the integrity of the brand's essence, but loose enough to allow for creativity. Think of all the people connected to your project who will be creating content and marketing materials for it and make sure they have a copy of your project's visual identity style guide. That can include Web designers, social media experts, film editors, and marketing creative teams. Make sure that the guide works for them and secure their feedback. If it misses a point, or a "rule" isn't clear, revise it.

Sound and Music

The multi-sensory aspects of branding include sound—from the spoken word to musical notes. Aural cues in combination with visual ones are powerful branding devices. Sound can elicit emotions and conjure up memories. NBC's three musical chimes speak "N," "B," "C" to audiences. Fleetwood Mac's "Don't Stop," with the signature line, "Don't stop thinking about tomorrow," was Bill Clinton's campaign theme song. The tick, tick, tick of the Heuer stopwatch *is* the *60 Minutes* brand. And the two repeating notes from *Jaws,* "dun" "dun" . . . "dun" "dun" . . . "dun" "dun," exquisitely communicate impending terror.

Music is a fundamental way that people comport themselves to the world. We use music as a way to make sense of things, to enunciate or focus or otherwise manage our feelings, and to bring meaning to our experience of the world. This IS fundamental. All humans do it, and all do it with music. The same music doesn't mean the same things to all people at all times in all places. But music DOES fundamentally mean things—that's how it works. The way it means things is the same way that languages of all sorts mean things. We learn the meanings.

—Sheldon Mirowitz, film composer, professor of film scoring, Berklee College of Music; founder, Vérité Music

A common sound branding device to promote consumer brands is the music **Jingle**, which began with radio advertising in the 1920s and was popularized in television in the 1950s and 1960s. Jingles often supported brand taglines and were designed to stick in the mind. If catchy enough, jingles become part of popular culture. "I'd Like to Buy the World a Coke," was performed by British band The New Seekers for the 1971 Coke ad "Hilltop." It was such a commercial hit that the jingle was recorded as a full-length song and spent several weeks at the top of the music charts. Other classics include Campbell's Soup, "M'm M'm Good"; McDonald's "Big Mac"; Alka-Seltzer, "Plop Plop, Fizz Fizz"; Oscar Mayer, "I Wish I Were an Oscar Mayer Weiner"; Toys 'R' Us, "I Don't Wanna Grow Up, I'm a Toys 'R' Us Kid"; Band-Aid, "Stuck on Me"; and Pepsi, "Simply Irresistible."

Radio programs, TV shows, videogames, and films have theme music written specifically for them played during the title sequence at the beginning or during the end credits. If the music has lyrics it is the media property's **Theme Song**. Classical music has been used as entertainment theme music, including "March of the Swiss Soldiers," the finale of Gioachino Rossini's *William Tell Overture* in the opening of *The Lone Ranger* television show, and the "Minute Waltz" by Frédéric Chopin in the *Just a Minute* radio show. Other music is original to the program, like Randy Newman's Emmy-Award winning, tongue-in-cheek "It's a Jungle Out There" for *Monk*.

Many television theme songs' lyrics are used to set up the program's premise such as *The Brady Bunch*, *Gilligan's Island*, *The Nanny*, and *The Beverly Hillbillies*. Because of their kitschy nature, these have became popular in college beer-drinking games. Some theme songs, such as *Happy Days*' (a top-five song in 1976) and *Pokémon*'s, have had commercial release success. "The Prelude" theme music has been a branding through-line for all of the *Final Fantasy* videogame series. And some theme music isn't music at all, such as the pulsing helicopter blades in *Airwolf*'s theme.

Music **Scores** are the music throughout movies and TV programs. (Scores are not to be confused with movie soundtracks, which are collections of songs that are used in films). Scores serve the story by heightening action, amplifying emotions, and adding texture.

There are four basic jobs that score accomplishes: First, music can establish tempo and pace, clarify or smooth the edit, help add grace or poetry or impact to the flow of the picture, and aid in transitions ("technical" jobs); second, music can help show time and place and help clarify the narrative of the story ("narrative" jobs); third, music can help the audience identify and feel the emotional content of the story (the "emotional" job); and fourth, music can help define the basic ideological universe and worldview of the story (the "moral" job).

—**Sheldon Mirowitz, film composer, professor of film scoring, Berklee College of Music; founder, Vérité Music**

Traditionally, film scores used live orchestras and TV music used synthesizers, but those rules no longer stand, and either can use a drum machine. A melody can carry a two-hour movie and not feel overplayed, but, especially in a world of TV binge-watching, melodies must be much more subtle in television. Another difference between film and TV is that in commercial television, the program breaks for ads, therefore bumpers and cues are used to come in and out of breaks.

Perhaps the king of modern-day film music scores is John Williams, who has written some of the most iconic and memorable film scores of all time, from *Jaws* and *E.T.* to *Star Wars* and *Jurassic Park*. Other notable film composers are Hans Zimmer, who scored *Man of Steel* and *Pirates of the Caribbean*, and James Horner, who scored *Braveheart* and *Titanic.*

"John Williams tux" by TashTish; Licensed under Creative Commons via Wikimedia Commons

John Williams is the most prolific and best-known modern composer of entertainment properties.

The aural properties of a media or entertainment project can be extremely powerful branding and storytelling elements. Music is so critical to Ken Burns, film producer of PBS documentaries *The Civil War*, *Baseball*, *Jazz*, *National Parks*, and *Prohibition!*, that it drives his editing process. He records it before editing begins so that it is central to the emotion.

(The legal protection of the visual and aural aspects of your brand is covered in Chapter 32, "Market It!").

A Rebrand—*Masterpiece Theatre* Meets *Masterpiece*

Since 1971, *Masterpiece Theatre* has defined British period or literary adaptation drama in the US, with stand-outs from *Upstairs Downstairs* and *I, Claudius* to *The Forsyte Saga* and *Prime Suspect.* The longest running primetime drama series in the US has won a slew of awards, including Emmys, Golden Globes, Peabodys, BAFTAs, and Academy Award nominations. Despite all that success, the anthology drama series' executive producer, Rebecca Eaton, was gripped with fear about the future of her series at the 2005 Emmy Awards. She learned from a British producer colleague that HBO was developing the mini-series *The Queen* about Queen Elizabeth II, starring Helen Mirren.

> *I was floored. Helen Mirren had only appeared on American television in our Prime Suspect and she had been only associated with Masterpiece (Theatre) in this country. That was a very large red flag that we were not going to be the only game in town for our British partners.*
>
> —Rebecca Eaton, executive producer, *Masterpiece*

Not only did the series feel increased competition for programming, but also it was struggling for funding. They hadn't replaced longtime underwriter, ExxonMobil, and because of diminishing enthusiasm for British drama, PBS was cutting funding for *Masterpiece Theatre* and its sister drama series, *Mystery!* With fewer new programs in its schedule and major disruptions to the series' schedules, ratings were going down. Eaton saw all the signs that her beloved baby was in trouble. She needed to clearly identify the problems and put in place practical and affordable solutions.

Concurrently, CPB and PBS had conducted extensive quantitative and qualitative audience research about PBS' primetime schedule. The research showed that *Masterpiece Theatre* was the series that translated the most into local PBS member support. So, CPB and PBS gave the series some money to determine action steps to steer the future of the *Masterpiece Theatre* brand. The series enlisted Bob Knapp, managing director of Neubrand, to interview key stakeholders—from viewers and stations to TV critics and funders—to gather unvarnished assessments of the brand. Additional audience focus groups delved more deeply into attitudes and possible solutions.

This secondary and primary qualitative research revealed that while people loved the programming and found it of extremely high quality, they had trouble finding it. Also, they were afraid of committing to so much programming in one sitting and were put off by its stodgy on-air presentation. Knapp encapsulated the findings as "*Masterpiece Theatre* may be the jewel in the crown of PBS, but it's dusty and hard to find." Clearly, the series wasn't on the radar screen of the next generations of viewers.

Courtesy of WGBH Educational Foundation. *Masterpiece* and *Masterpiece Theatre* are trademarks of WGBH Educational Foundation.

The original *Masterpiece Theatre* logo with its grand flourish.

Over the course of a year, the programming, content, and marketing teams at *Masterpiece* executed a three-fold solution. First, they organized the programming into three genres: Classic, Mystery! and Contemporary that would occur during three specific times of the year to make it easier for viewers to find their favorite fare. Second, they refreshed the brand by dropping the "Theatre" in the name, changing the series' visual and aural identity, and using separate hosts for each genre. Third, they reached out to new younger female audiences through digital avenues.

To respect the loyal fans, the visual and aural rebrand needed to honor the grandiose essence of the classic brand, yet simplify it into a more contemporary and accessible expression. Each sub-brand got a new open created by Kyle Cooper of Prologue. *Masterpiece Theatre*'s open since the late 1970s had antique books and literary artifacts set to signature theme music, "Rondeau" from *Symphonies and Fanfares for the King's Supper* by Jean-Joseph Mouret.

Masterpiece Classic's new open reinforced the series' legacy of classic stories, timeless characters, and quality of actors with the new *Masterpiece* logo and the faces of top actors Helen Mirren, Damian Lewis, Judi Dench, Eamonn Walker, and Keira Knightley appearing throughout flipping book pages. Man Made Music composed new music for each open and, for *Masterpiece Classic*, created a shorter, synthesized trumpet riff of the "Rondeau" theme music.

Courtesy of WGBH Educational Foundation. *Masterpiece* and *Masterpiece Classic* are trademarks of WGBH Educational Foundation.

Stills of the new *Masterpiece Classic* open, resolving on the sub-brand's logo, which retains elegance in the word "Classic."

Masterpiece Mystery!'s open had a dark, mysterious background, incorporating the signature Edward Gorey artwork and the *Mystery!* series' original typeface. *Masterpiece Contemporary's* open used more abstract book pages and very clean lines throughout.

Courtesy of WGBH Educational Foundation. *Masterpiece* and *Masterpiece Contemporary* are trademarks of WGBH Educational Foundation.

The *Masterpiece Contemporary* sub-brand reflects its programming genre with an unique graphic expression.

The series carefully chose three hosts to set the tone for each sub-brand and attract a following. The Web site transformed from a scholarly, educationally-driven site to an interactive, visual entertainment site that mined the assets of the actors and the production.

The launch vehicle for the brand refresh was the January 2008 *Masterpiece Classic, The Complete Jane Austen*—a film festival of the classic author's entire *oeuvre*. The launch campaign (designed by the author) integrated publicity, events, and digital marketing. To engage rabid Austen fans, the series partnered with the Jane Austen Society of North America to create online and on-the-ground events, including one with Miramax's *Becoming Jane* and Anne Hathaway. The publicity and online audience engagement for the mini-series were astounding. *The New York Times* set the stage with a major pre-launch rebrand story about the series' new look.

The premiere night broadcast of *Persuasion* boosted the series' ratings over the previous season by 71 percent. *The Complete Jane Austen* doubled the series' audience of 18-to-49-year-old women and increased the males in that demo by 50 percent. *Masterpiece* eventually picked up a full slate of underwriters, leading to the juggernaut it is today.

> *With the on-air look, social media, and publicity of The Complete Jane Austen, we were laying the groundwork for the phenomena of Sherlock and Downton Abbey.*
>
> —Rebecca Eaton, executive producer, *Masterpiece*

By refreshing its visual and aural identity, *Masterpiece* presented the same programming in a more appealing and accessible package, especially for younger audiences and reached them where they were.

What audiences see and hear has a tremendous effect on what they think and feel because the visual and aural expressions of a brand signal meaning and tell a story to your audiences. But even with your brand archetype, project name, and sensory brand expressions, you don't automatically have a brand that is meaningful to the public. When creating a new brand for those who don't know it, you must build its reputation first and over time imbue the brand with meaning. What you say and what you do publicly all contribute to that.

Positioning and Messaging

Good communications are rooted in thoughtful positioning and messaging. Compelling public positioning for your transmedia project is not about telling your audiences that your project is great or even why. It's about channeling your inner anthropologist and psychologist and finding what aspects of your project fulfill deep-seated audience needs. You are "selling" the benefits of your project, not its attributes. For example, Victoria's Secret doesn't sell colored bras and underwear (attributes). It sells a feeling of sexy self-worth for women (benefits). Two driving needs for most women.

Honing Your Message

Within the hierarchy of brands, master brands and their sub-brands have distinct, but connected positioning and messaging. For example, TV networks establish a brand positioning and all of their programming should support it.

> *TLC's overall messaging for its programming is the intersection of remarkable and relatable.*
>
> —Rose Stark, VP marketing, TLC

As you refine your project's positioning, you should look at it along with your distributor's and partners'. To find your project's unique positioning, revisit your brand attributes from your brand archetype interviews and creative brief. How do they translate into external messages for your press materials, interviews, blogs, ads, and other promotional materials? What tone should they take?

You should frame your project's message to reinforce a worldview. Your brand pillars from Chapter 9, "Branding" will yield your project's message points. *Martin Scorsese Presents the Blues'* brand pillars of its The Explorer archetype were:

- Authentic, honest, gritty
- Personal, human
- Pioneering, self-discovery
- Free-spirited, freeing
- Life-affirming
- Passionate, emotional, and inspirational
- Culturally-relevant, compelling, thoughtful
- Contemporary POV; new experiences

The Blues' brand pillars generated tailored messages:

- *The Blues* is:
 - A celebration of the blue's profound influence on all music genres in the past century
 - A reflection of American culture—past and present
 - The first word on the blues; not the last
 - A collection of impressionistic visions that capture the spirit and power of the blues
 - A pioneering cross-platform project expressing the blues' "real" essence
 - A geographic and musical journey into this global and American art form
 - Authentic, honest, approachable, expressive, free-spirited, compelling, thoughtful, life-affirming, human, and inspirational
 - Created and supported by the best in film, TV, radio, books, CDs, home video, concerts, museum exhibits, and music
- *The Blues* is about:
 - All music genres—soul, country, R&B, hip-hop, rock 'n' roll, jazz, grunge, world
 - History—politics, economics, race, migration, struggle, celebration, religion
 - People—artists', directors', and fans' personal stories
 - You/me—our connection to humanity through the music we love—a personal journey

These messages were not intended as literal copy, but rather as copy point guidelines so every communication delivered the overall positioning.

By finding your positioning and messages, your project will find its own voice. The more you describe your project to the unindoctrinated, the better your message points become. You can actually see what flies and what doesn't on the faces of your audiences. You will refine and hone your message points throughout the course of the project.

A Story in a Logline

A key part of your project's messaging is its logline. This is a one-sentence description of your film, television show, or online property. It's a brief synopsis of the dramatic narrative with a compelling emotional hook.

The logline serves many purposes. It's the beacon to remind you where you're going with the story when you're developing your project. It's one of the first things potential agents, producers, funders, and distributors see in pitch documents to help them wrap their heads around your project. It's the "elevator pitch" you use when introducing your project to influencers and audiences. And it's the basis for the short blurb in content program guides that tells you what your film or TV program is about. Loglines are also written for new seasons of television programs.

Loglines are amazingly difficult to write and if they don't work, then the script and story probably don't work either. You can start with two or three sentences and then distill it down to a single sentence. Once it's one sentence, every word matters. Write it, rewrite it, and then rewrite it again. Your logline must answer these three questions:

- Protagonist's goal—who is the main character and what does he or she want?

- Antagonist impediment—who or what is standing in the way of the main character achieving that goal?

- Unique aspects—what makes this story different?

Use action words and descriptive words. The protagonist must be action-oriented and fiercely drive the story. In fictional film, don't use character names, but rather descriptions of them such as "a dedicated elementary school teacher" or "a self-absorbed princess" or "a former Wall Street con artist seeking redemption." In television, use the actor's name with the character name. Add stakes or consequences to boost the drama, such as "must penetrate the Pentagon by midnight to prevent a nuclear apocalypse." If needed, provide a set up of the story's time, place, or rules, such as "in a post-WWIII world where food and water are the only currency." Don't reveal the super-twist ending. Leave the audience

hooked and wanting more. So, you're not telling the whole story, but selling it to audiences. The reader should walk away with a feeling of internal journey.

It's valuable to look at loglines from various media platforms.

Film

- *Midnight Cowboy*—Naïve Joe Buck arrives in New York City to make his fortune as a hustler, but soon strikes up an unlikely friendship with the first scoundrel he falls prey to.

- *The Hangover*—After a wild Vegas buck's party, a dysfunctional bunch of guys wakes with no memory of last night, a tiger in the bathroom—and no groom.

- *Raiders of the Lost Ark*—Just before the outbreak of World War II, an adventuring archaeologist named Indiana Jones races around the globe to single-handedly prevent the Nazis from turning the greatest archaeological relic of all time into a weapon of world conquest.

- *Erin Brockovich*—An unemployed single mother becomes a legal assistant and almost single-handedly brings down a California power company accused of polluting a city's water supply.

- *People vs. Larry Flynt*—A pornography publisher becomes the unlikely defender of free speech.

- *The Hunger Games*—In a future North America, where the rulers of Panem maintain control through an annual televised survival competition pitting young people from each of the districts against one another, 16-year-old Katniss' skills are put to the test when she voluntarily takes her younger sister's place.

- *The Godfather*—An epic tale of a 1940s New York Mafia family and their struggle to protect their empire, as the leadership switches from the father to his youngest son.

Television

- *The Goldbergs*—A dysfunctional *Wonder Years* set in the simpler times of the 1980s, inspired by Adam F. Goldberg's childhood.

- *Trophy Wife*—A reformed party girl named Kate (Malin Akerman) finds herself with an instant family when she falls in love with a man named Brad (Bradley Whitford) who has three manipulative children and two judgmental ex-wives.

- *Nashville*—A family soap set against the backdrop of the Nashville music scene revolving around one star at her peak (Connie Britton) and another on the rise (Hayden Panettiere).

- *Elementary*—A modern take on the cases of Sherlock Holmes, with the famed detective (Jonny Lee Miller) now living in New York City, with Watson (Lucy Liu).

- *Breaking Bad*—When a high school chemistry teacher, struggling to financially make ends meet, is diagnosed with cancer and his health insurance won't cover the cost of treatment, he turns to selling drugs and cooking crystal meth to secure a financial future for his family.

Developing Taglines

Now you're ready to create a project tagline—a short piece of marketing copy that appears after the project title on posters, trailers, and other promotional items to sell the film. In the era of *Mad Men* they were called slogans. Good taglines must be memorable, convey a benefit, be differentiated from competitors, and impart emotion.

Heavyweight champion Muhammad Ali gave himself an unforgettable persona with "Float like a butterfly, sting like a bee. The hands can't hit what the eyes can't see." Sometimes taglines arise from the public. After the Boston Marathon bombings "Boston Strong" started as a viral Twitter hashtag and became a worldwide tagline and meme on T-shirts and on Fenway Park's "Green Monster" wall. *ABC's Nightly News* commandeered the slogan for a feel-good segment at the end of its newscast called "America Strong."

More often, taglines are painstakingly drafted by marketing copywriters, paired with graphic designers in advertising agencies' creative teams. The best marketing slogans endure. "Got Milk?" was developed by Goodby, Silverstein & Partners for the California Milk Processors Board in 1993 and was later licensed for use by the National Dairy Council. The simplicity, good-natured appeal, matter-of-factness, and versatility of this tagline supported the milk mustache campaign, which led to the first rise in US milk sales in more than a decade. But Rich Silverstein almost dismissed it for its clunkiness and because it was grammatically incorrect.

Legend has it that Nike's "Just Do It" slogan came from notorious murderer Gary Gilmore who said, "Let's do it" just before the firing squad executed him in Utah in 1977. Dan Wieden, co-founder of Wieden & Kennedy, who created the slogan in 1988 by tweaking Gilmore's last words, had no idea the slogan would resonate the way it has. It has transcended sports and become the "seize the day" mantra for life in general. In its first year alone, the slogan increased Nike's North American domestic athletic shoe market share from 18 to 43 percent.

Both "Got Milk?" and "Just do it" are short. And both are supremely personal, speaking directly to and reflecting their target audiences. The first is playful and invites you into the fold. The second is cuttingly-honest and challenges you directly. Some other memorable consumer brand taglines include:

- "Where's the beef?" (Wendy's)
- "You deserve a break today" (McDonald's)
- "Tastes great, less filling" (Miller Lite)
- "We try harder" (Avis)
- "They're Grrrrreat!" (Frosted Flakes)
- "Reach out and touch someone" (AT&T)
- "What Happens in Vegas, Stays in Vegas." (Las Vegas Convention and Visitors Authority)

There is no formula for creating good taglines, but many use common approaches:

Make a promise:
- "The quicker picker upper." (Bounty paper towels)

Do the right thing:
- "Eat fresh." (Subway)

Link with an abstract need:
- "A Diamond is Forever." (DeBeers)

Convey risk:
- "A mind is a terrible thing to waste" (United Negro College Fund)

Cite three key elements:
- "New. Fast. Efficient." (Air France)

Tie-in with the logo:
- "Get a Piece of the Rock." (Prudential Insurance)

Media and entertainment properties' taglines must tell a mini-story or describe the story world, and pay off on the project title. *American Idol*'s tagline, "This Is Real," was created and chosen by its audience. Many entertainment projects have compelling and memorable taglines.

Film

- "In space no one can hear you scream." (*Alien*)
- "Houston, we have a problem." (*Apollo 13*)
- "They're back." (*Poltergeist II*)
- "Just when you thought it was safe to go back in the water." (*Jaws 2*)
- "Who ya gonna call?" (*Ghostbusters*)
- "A long time ago in a galaxy far, far away . . ." (*Star Wars*)
- "The list is life." (*Schindler's List*)

Television

- "A comedy for anyone whose boss is an idiot." (*The Office*)
- "If one family doesn't kill him . . . The other one will." (*The Sopranos*)
- "When news breaks, we fix it." (*The Daily Show*)
- "As addictive as Vicodin." (*House M.D.*)
- "Putting the herb in suburb." (*Weeds*)
- "America's favorite serial killer." (*Dexter*)

Games

- "Gotta catch 'em all!" (*Pokémon*)
- "Have ye what it takes?" (*Legend of Zelda: Ocarina of Time*)
- "The world's largest army of Super Heroes is under your control." (*Marvel Ultimate Alliance*)
- "Nothing is true. Everything is permitted." (*Assassin's Creed*)
- "Behold . . . Rapture." (*BioShock*)
- "Finish the fight." (*Halo 3*)
- "You are Bond. James Bond." (*GoldenEye*)

The seeds of your transmedia project's tagline are embedded in your message points. Share your creative brief and message points with your creative team of in-house marketers or outside branding or marketing experts. When evaluating the best tagline for your project, don't get too caught up in being clever. It's more important to say what you are or how you will make your audience feel. And be sure it delivers on the brand archetype, brand positioning, title, logo, and other brand expressions.

Martin Scorsese Presents the Blues used a key message point to create a short tagline that delivered the brand promise:

- Message point
 - *The Blues* is a geographic and musical journey into this global and American art form
- Brand promise/tagline
 - a musical journey

Courtesy of Vulcan Productions

The Blues used the tagline, "a musical journey" on air and on marketing materials.

Social media is revolutionizing language, making many communications headlines and taglines. Catchy, short, meaningful phrases always have been and always will be in vogue. The Ten Commandments were the taglines of the Old Testament; hashtags are the taglines of the twenty-first century.

Pitch Points

A pitch point is a story angle or news hook that gets press, bloggers, and other influentials to pay attention to your project. When you're approaching these gatekeepers, you can't just say this project is fantastic; you must shape your media project into its own compelling story.

The Strengths and Opportunities from your SWOT Analysis may yield some pitch points about your project. For example, if your project is the first of its kind or the pedigree of its talent is noteworthy.

Sometimes new message points emerge because your project connects to key aspects of the cultural or media landscape at the time you are launching it. If your project is a thriller about nefarious uses of personal information and a major story breaks about how the CIA is collecting personal data on citizens, then that connection becomes a pitch point for as long as the story is relevant.

The most important way to find a point of *entrée* with these intermediaries is to be a full-time student of news, current events, trends, and culture. You must be on top of economics and world conflict as much as the latest semi-celebrity gaffe or social video. *The Hunger Games* isn't just about a twisted fantasy world, but speaks directly to current themes of access and management of resources—from food and healthcare to education and renewable energy.

> *I come from the school of knowledge equals power. And if you're in this business you need to know what's going on over in Syria and you need to know what's going on with the Kardashians—it's all one. Get up early and go online and start the day knowing what's going on.*
>
> —Glenn Meehan, supervising producer, *The Talk*; co-creator *Big World, Little People*; formerly managing editor, *Entertainment Tonight*

Peruse both credentialed newsgathering operations from wire services to newspapers as well as the "news" that's being circulated by your friends and acquaintances through Facebook or other social networking services. If you have a long commute, listen to NPR. There is no better in-depth radio news source.

The New York Times is still the newspaper of record and holds the most credibility in journalistic circles. But there are many other excellent papers, including *The Los Angeles Times*, *The Washington Post*, *The Chicago Sun-Times*, and *The Boston Globe*. News magazines and sites such as *Time, Newsweek, US News & World Report, The Week* and *Vox,* and syndicated news services such as Associated Press and Reuters, are reliable sources. And the television news services including ABC, NBC, CBS, and CNN make news a priority. For more in-depth coverage of a subject, look to *The New Yorker, The Atlantic,*

Rolling Stone, and *Vanity Fair*. For opinion, *Huffington Post*, *The Drudge Report*, *The Onion,* and *The Daily Show* add spin to world events.

For political news, *The Washington Post* and *Politico* reign. The business papers of record are *The Wall Street Journal*, *Investor's Business Daily*, and *The Financial Times*. *Fast Company* and Bloomberg are other credible business sources. For tech news, keep up with *Yahoo Tech*, *The Wall Street Journal*, *Mashable*, *TechCrunch*, and *Wired*. For media and marketing, top outlets include *Ad Age*, *Ad Week*, *Brand Week*, *DMA News*, *Creative*, *MediaPost*, *PR Week*, and *Marketing Week*.

To stay on top of entertainment and celebrity news, follow *People*, *Entertainment Weekly*, *TV Guide*, *TMZ*, *Inside Edition*, *Access Hollywood*, *Extra*, and *Entertainment Tonight*. For deeper industry news, follow trade publications such as *Deadline Hollywood*, *The Wrap*, *Variety*, *Hollywood Reporter*, *Screen International*, *ReelScreen*, *World Screen*, *Filmmaker*, *Broadcast & Cable*, *Broadcasting*, *TV Week*, *Billboard*, *IGN*, *Game Informer*, and *Publisher's Weekly.* Depending on your media platforms, there are hundreds more online sites and blogs that will help get you up to speed.

Look for a connection between what's going on in the news and the underlying themes of your project. When you're pitching to press and influencers, you want to think the way they do and help them do their job. And their job is to cover news and present content that is relevant, noteworthy, and entertaining.

The Talk's supervising producer, Glenn Meehan, used world events when he was preparing for *The Talk's* phone pre-interview with Patti LaBelle. He was scheduled to pre-interview LaBelle the day that South Africa's Nelson Mandela died. So, he Googled Patti LaBelle and Nelson Mandela and learned that she had performed for him. Meehan probed that connection, and she opened up at length about her thoughts and memories of the world leader, even sending him photos. This became a rich area of discussion on her appearance on *The Talk* on the day of Mandela's funeral. By finding the links to salient current events or trends Patti Labelle's appearance created an authentic and timely connection with the show's audiences. Pitching smart story angles to writers and producers is what gets media coverage.

In addition to finding newsworthy links, as a long-term student of the world and people, you may see cultural trends. Trends are recurring human behaviors motivated by need fulfillment. Link your project to a trend and find other examples of that trend from any walks of life to prove your point. Don't be afraid to acknowledge high-profile entertainment or media projects that are part of the same trend. You can't avoid them so turn your competition into an asset to inspire coverage of that trend.

The marketing of *The Blues* became a story in itself because the blues genre had never had so much attention and because PBS had never launched such a massive cross-platform, multi-partnered project. In the middle of its marketing campaign, *The Blues* added pitch points about the project's marketing to its messaging document because *Variety*, *Crain's*, and other outlets were covering the project's marketing.

Create a story pitch outline document for anyone handling outside communications. Include your guiding message points, which are the description of your project, and add news or trend pitch points. This will be an organic document based on what is current and newsworthy and what has already been announced for the project. Whatever is new or unique rises to the top.

Choosing Spokespeople

Now that you have crafted your core message points, you must decide who is going to deliver them. The internal and external spokespeople you choose are message choices. A young digital animator delivers a different message than a veteran film director. A professor of history delivers a different message than a comedian.

The internal project spokespeople are generally culled from the project founders, creators, and distributors. The external project spokespeople are chosen from project actors or musicians or talent that is brought to the project to help explain or promote it.

If it's a fictional project, the actors are a huge asset, especially if they're well-known or popular. If it's a film, the director, the distributing studio, and key actors are your top spokespeople. If it's television, the executive producers or showrunners, TV network programming executives, and actors will present the project. If it's a game, the producer and publishers are generally the spokespeople for the project. If it's a book, the author is always the key spokesperson.

Sometimes projects benefit from real-life spokespeople such as experts on key project subjects or themes, especially if they're serious. In the 1990s, Lifetime had many made-for-TV movies about domestic violence against women as part of an overall awareness campaign and used experts on the subject as part of its promotion.

Celebrities—from actors, musicians, athletes, and even politicians—both part of the project or attached in other ways, always make popular spokespeople, especially on the talk show circuit, but it's sometimes harder to control the message with them. Audiences' awareness of a celebrity can be determined via their QScore or social saliency.

The non-fiction project *Martin Scorsese Presents the Blues* had both internal and external spokespeople. The internal spokespeople included executive producer Martin Scorsese and other film directors, Clint Eastwood, Wim Wenders, Mark Levin, Richard Pearce, Mike Figgis, and Charles Burnett. It also included the four day-to-day project leads: Margaret Bodde, producer (and executive director of Martin Scorsese's The Film Foundation), whose primary focus was to ensure that Martin Scorsese's (Cappa Productions now Sikelia Productions) vision and goals for the project were achieved; Alex Gibney, the series producer (and founder of Jigsaw Productions); Bonnie Benjamin-Phariss, director of documentary films at Vulcan Productions; and the author (Anne Zeiser), the project's marketing lead and director of national strategic marketing for WGBH, which presented

the project nationally for PBS. The radio series, CDs and home video, book, and museum exhibit had spokespeople available to provide detail on each platform.

And because the project was about the music, *The Blues* also assembled an external stable of music artists for press interviews and performing at events, including B.B. King, Ruth Brown, Isaac Hayes, Koko Taylor, Chris Thomas King, Jay McShann, Keith Richards, Corey Harris, Peter Wolf, Bobby Rush, Angelique Kudjo, Shemekia Copeland, and the J. Geils Band. In addition, Bonnie Raitt and Mick Jagger agreed to join B.B. King to be part of the project's ad campaign.

All project spokespeople should be chosen based on the following criteria, especially *vis-à-vis* your target audiences:

- Credibility
- Visibility
- Likeability
- Influence
- Speaking ability
- Willingness to participate in media interviews, promotional activities, events

The last one is important. If you have a popular person willing to attach their name to your project, but they can't or won't help you get the word out about it, you should not use them. You will only frustrate media and other influencers because you can't offer access to your spokespeople. Very high-profile people have limited time, so be sure to negotiate and clarify their press interviews and event appearances up front, so there are no surprises later.

It's also important that when you look at your stable of spokespeople you are representing a diversity of perspectives, including gender, age, ethnicity, and geography. Also, all of the voices for your project must be singing the same tune at the same time. There's room for harmony—that is, some spokespeople may sing soprano and others alto—but together they form a chorus. Your messaging document is the sheet music for the chorus and everyone has an assigned part.

Messages are unique to projects. Only you and your marketing team can find them. You want to convey who you are, how you want your audiences to feel, what you want your audiences to do, and what benefit they will derive from your project. Again, signal benefits, not features or attributes. In a few short words, your messages must communicate the value proposition between your project and your audiences. And they must tell the story in a creative and engaging way to compel your audiences to take some action. If they do, then your project is ready for its début to its influencer and public audiences.

PART IV

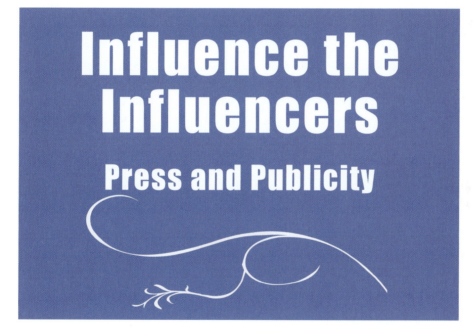

Influence the
Influencers

Press and Publicity

The Project Launch

How, when, and where you announce and release your project to its audiences are critical decisions. The old saying "timing is everything in life" applies aptly to the début of media projects. This is where strategy, experience, and creativity must come together to usher your project into the world.

If your transmedia project is funded, greenlit, and in production, then you have a marketing plan and are probably ready to go public. You simply need to finalize your launch strategy. Some key launch decisions may have been made well before the project went into development and were incorporated into your marketing plan. But in many cases, because securing funding and distribution, and executing the production take time, the final launch decisions may not have been made.

Distributors and their marketing departments make these decisions about launch strategy, timing, and vehicles. Understanding the considerations they're weighing can help you contribute to the discussion. And if you're an independent, you must fully understand the terrain of launch strategy to launch it yourself.

Target Audience Strategy

The first thing you need to decide is *to whom* to launch or announce your project. Should your transmedia project début to powerful gatekeepers or should it bubble up through social audiences? When you are deciding how to launch, consider your brand archetype and target audiences and your project's business and marketing goals to determine what launch strategy best serves your project.

If you still have critical business aspects of the project yet to be secured, such as finishing funds, distribution, and strategic partners, then launching to industry influencers is usually your best bet. Announcing your project at major industry events telegraphs its importance within that industry and garners philosophical and business support for it. Markets, festivals, conferences, and press events are all effective ways to reach influencers because major trade press and industry business people already gather at these events. Announcements at them may create overall industry buzz. Otherwise, you must reach out to all of those key trade press and business entities individually.

That strategy may not fit the persona or needs of your project. If you don't need distribution or funding, then going directly to the public might be a better fit. One of the most astounding public débuts in entertainment history was the stealth launch of Beyoncé's *Beyoncé* album in 2013. Without industry press, retailers, or radio stations, Beyoncé went straight to her superfans with an Instagram message, Twitter post, and a Facebook and YouTube video inspired by Michael Jackson's *Thriller* music video. Despite dropping the bomb at midnight, the "anti-marketing" campaign went viral almost instantly, selling 828,773 albums on iTunes in just three days.

But that strategy wouldn't have worked if Beyoncé hadn't been a superstar. Even without that much sizzle you can launch directly to your audiences through affinity groups' online platforms or events, but plan for a much longer awareness cycle that must be fueled with ongoing content. Or, you can choose a dual launch strategy launching with industry influencers, while also seeding key target audience groups.

Timing

Next, you need to decide *when* to launch. Most media properties seek an open hole for their project to launch. Gaming out the optimal timing for your project is a complicated matrix. There are two major sets of dates for you to determine: When will your project be announced to the public? When will your project premiere or be released to the public?

Premiere or Release

Start first with the later date—your project's public premiere or release—because that affects your entire timeline. The production schedule usually determines when a project is ready. Add to that, the period of time required for the distributor to get your project into the pipeline. Film studios, television networks, and game publishers all have their own schedules. Plus, you want enough time to promote it to your audiences—at least six months. But all of this does not need to be consecutive—the promotion can overlap with post-production. Factoring in all those fixed timeframes, there is still some leeway.

Look at the rhythm of the yearly calendar. Summer is mellow. September is about going back to work and back to school after vacations. The six weeks between Thanksgiving and New Year's are family-oriented. Factor in your project's content and themes. Launching *Jaws* mid-winter wouldn't have been as effective as launching at the beginning of the beach-going season. If your project's about a timeless romance, Valentine's Day may work for your project announcement or premiere.

Think about your project's platforms. When does the most audience consumption of them occur? Christmas and summer are popular for the release of children's films and blockbusters because of vacations and the fantasy mood of the "dog days." Fall and now January are big times for TV watching, so many TV programs premiere then to capitalize on the high HUT levels (Households Using Television). Most book and game sales occur in the fourth quarter of the year for gift giving, so publishers launch their "big" titles between October and mid-December.

What about the awards or business cycles or events? Perhaps you want to choose a premiere date just before voting for your media platform's biggest award so your project's top-of-mind. Big movie studios release their Oscar-worthy films in November or December to boost their chances of getting a nomination before the voting cutoff in early January for the late-February film awards. Recently, Christmas Day has become a sweet spot for the wide release of films because more people are on vacation and it's days before Oscar nomination voting begins.

The traditional network television cycle begins with creative pitches from summer through fall, development into the winter, pilots and Upfronts (selling advertising to sponsors) in the spring, promotion in the summer, and premieres in the fall. If a new program falls into the maw of this creative, business, and promotion machine, it may lead to a fall premiere. Program premieres in television used to be circumscribed to a single week in September, all covered in a single issue of *TV Guide*. Fall is still a dominant time for launching new television seasons, but now it's spread out over four to six weeks to accommodate the glut of network, cable, and digital programming. There is no longer a single TV premiere launch time, because cable successfully opened up new winter, spring, and summer launch windows. January is the new September, launching stand-outs such as *Downton Abbey, American Idol*, *The Bachelor*, *Girls*, *Suits*, *Pretty Little Liars*, and *True Detective*.

Consider your competitors' schedules. You don't want to be launching a comedy about a newsroom at the same time as another network's newsroom comedy is launching. Also, look at other programs from your distributor. Networks and cable outlets rarely premiere their own new programs in the same week, but rather spread them out so that they don't compete and each of them garners maximum media attention. They know that TV critics can only review a finite number of programs in any given week—another reason why the fall season expanded. In addition, consider November, February, May, and July sweeps when Nielsen ratings set advertising rates. Broadcasters showcase their prestige shows

during sweeps, which pumps up viewing, but also stiffens competition. May is common timing for fall season program finales because of sweeps and because it just precedes Emmy voting, which begins in early June.

The game industry launches their new consoles and titles timed to the industry's key events. Microsoft announced its new Xbox One game console and Sony launched its PlayStation 4 at the E3 (Electronic Entertainment Expo) in 2013. But based on very different launch messaging, they had very different results.

> *If you watched the back-to-back Microsoft and Sony press conferences, which followed each other chronologically at E3, it was amazing. Microsoft comes out and says, "You'll be able to watch TV on your Xbox One, and you can snap it so you're playing your game while you're watching TV on the same screen. Oh, and it has to have a constant Internet connection, but just deal with it. And oh yeah, you're not going to be able to share games with your friends." It's very messy and the audience is kind of puzzled. And then Sony comes out and says, "If you want to lend a game to your friend for your PS4, you just hand them the box." Every single thing that the audience had problems with in regard to the Xbox One, Sony basically said, "Yeah we don't do that." It just crushed.*
>
> **—Susan Arendt, managing editor, GamesRadar+**

A spate of new game titles always releases within new consoles' month-long launch window. Microsoft announced 23 Xbox One titles and Sony revealed 33 PS4 titles at Gamescom.

Also, if your game or app is connected to a branded property on another media platform, look for key high-profile dates, such as the home video release or sequel of the film or TV show to launch it.

Given how much media is out there, an open hole for a launch may not exist. Sometimes distributors will counter-program against a blockbuster film premiere or a huge television event. The idea is that theater-going or TV watching may be higher, but different target audiences may want an alternative. A slice 'em and dice 'em action film might be strategically counterprogrammed with a romance. Other times, similar projects will go head-to-head, trying to out-promote each other and siphon off the other's audience.

In addition to the time of year, there's the day of the week. The "opening night" is still important in film, TV, games, books, and theater because it gives that platform's critics a date for their review coverage, which serves as a call-to-action. The reviews and other promotions create sampling and additional buzz.

Almost all films premiere on Fridays to capture the most moviegoers over the course of the all-important opening weekend. Most in-theater movie watching occurs on weekends. Fridays are also very popular for games and big book launches. The *Harry Potter* books popularized midnight public releases at book stores, later adopted by the game industry with big releases such as *Grand Theft Auto 5*.

In television, Sunday night is one of the biggest television viewing nights because of its high HUTS, but is highly competitive. Monday was a dead zone until *Monday Night Football* gave it lift. Thursday has been a coveted night for networks to position their best fare because sweeps launch on Thursdays and it's the last big TV-viewing night before consumers make their purchasing or moviegoing decisions. Thursday has been the home to a pantheon of stand-outs from *The Dean Martin Show* and *Friends* to *CSI* and *The Big Bang Theory.* Friday and Saturday are low TV-viewing nights because more people go out. But quieter nights offer a less crowded field for new programs to find audiences. All of this TV timeslot strategy is becoming less and less relevant in an era of "TV Everywhere" in which audiences can watch whenever they want. Netflix has changed the game further by offering entire seasons of new shows for binge-watching all at once.

In broadcast, time of the day must also be considered. Primetime television is 7:00 p.m. to 10:00 p.m. (Central and Mountain Time) and 8:00 p.m. to 11:00 p.m. (Eastern and Pacific Time) and is when ratings rise. Family-friendly fare airs in the first hour of primetime, and adult subjects in the final hour. In radio, audiences are highest during morning and evening "drive time," when people are commuting to and from work.

Not only do you need to determine the first release date of your media project, but also associated releases as part of your distribution strategy, such as home video. Home video launches offer promotional opportunities such as launch parties and retail events, but require fresh angles and content such as Value Added Material (VAM). Home video releases for holiday films are often held for a year until that holiday occurs again because distributors are leveraging audiences' emotional connection to the calendar. More and more properties have day-and-date release—a simultaneous release of the film in theaters or TV broadcast with DVD/Blu-ray and VOD.

Public Announcement

Now that you know when your project in its various formats will release to the public, you must backtrack from that date and decide when to announce or reveal the project to your target audiences. Essentially, this is the kick-off date of your marketing plan. A year or more is optimal to build awareness and support for the project leading up to its premiere or launch. If you announce the project to the industry during its development, that timeframe can be even longer. Your public audiences can be activated during the industry announcement phase, and superfans track industry news.

These timelines vary drastically among industries and platforms and based on the nature of the project. The larger the project, the longer the lead times. Most projects are announced to the industry many months or years before they are presented to public audiences. Animated films take several years to make, so their announcements can be three or four years before launch, yet independent films that get scooped up by a distributor at a film festival may have just a few months from deal to screen in order to leverage the festival buzz. Television programs are announced to the industry further in advance if they include a known commodity, but most are presented to public audiences a few months before premiere. Big console games, highly-anticipated next versions of big titles, or games created by AAA publishers can announce from several years to 18 months in advance. *BioShock Infinite* announced five years before launch. Yet casual, social, and mobile games announce to the public about eight weeks before launch because these are more transactional game-buying decisions.

In that year-long timeframe, you begin with promotional elements, such as a preview Web site, social media teasers, a few key events, online marketing, and long-lead publicity to build audience and buzz. Then add trailers, a deeper Web site, advertising, critic reviews, and high-profile events during the last six months. Once you announce your project to your public audiences, you must have resources to provide them with a steady stream of content leading up to its premiere. So, if your budget doesn't allow, announce to your public later when you're sure you'll have plenty of promotional assets to sustain awareness, especially for a big push in the last six weeks.

Your strategy about to whom to launch your project—the industry vs. the public vs. both simultaneously—will influence your public announcement's timing. Check the calendar and apply all of the above release date timing criteria to its announcement date. A season, anniversary, industry gathering, or public event may dictate that timing. If you and your team know your project and the environmental landscape intimately, the best timing for your transmedia project announcement and launch will reveal itself.

Once you've determined the industry and public announcement dates and the public launch date, you should revise your marketing plan and timeline accordingly. Then you can set in stone the timing of all of your media and promotional elements.

The Launch Vehicle

With your influencer and public audience strategy and timing determined, you can now decide *how* to launch your transmedia project. You can do the big "reveal" in four key ways: via an event; a press conference or broad-based press release; a publicity exclusive with a major media outlet; or directly to your audiences through digital platforms, promotional assets, or stunts.

Industry events make excellent launch vehicles and they spill over to public audiences.

The television part of the SXSW film festival has expanded greatly in the last few years. Lena Dunham had a lot to do with that in that she got a lot of early exposure from her film [Tiny Furniture] that premiered here. Then HBO used SXSW to promote Girls before it was on the air. That was a demonstration that we could be an effective promotional tool. HBO also brought the throne from the Game of Thrones and set it up in a hallway and people lined up to have their picture taken sitting in the throne.

—Roland Swenson, managing director, SXSW Conferences and Festivals

Television programs may launch at the Television Critics Association Press Tour, an industry-only event, which generates a rash of press coverage and social media that also reaches public audiences. At the 2014 E3, a trade-only event, Sony streamed its press conference on YouTube to include its public audiences. Consider your project's roots or core audiences' psychographics. A property inspired by comic book superheroes or with geek-friendly themes might launch during Comic Con. *X-Men: Days of Future Past* débuted there with a big Sentinel robot head and online content about the film's evil corporation, garnering 400 million social media impressions in a week.

Non-entertainment public events such as music festivals, heritage events, and sporting events can be excellent launch vehicles to reach your target audience, especially if they're broadcast live. The Super Bowl, whose ads cost upwards of $4.5 million to reach 110 million viewers, is a gangbuster way to launch, promote, and brand entertainment. Films from *The Avengers* and *Monsters vs. Aliens* to *Transformers: Age of Extinction* and *The Amazing Spider-Man 2* have launched there. But a Super Bowl spot should be supported by a larger campaign. The 2012 Olympics was a global showcase for big US music artists Jay-Z and Rihanna and lesser knowns Wanted, Dizee Rascal, and Mark Ronson. Broadway shows often promote on other major entertainment award shows such as the Oscars, Golden Globes, and Grammys.

Also, you can host your own launch event with a press conference in your top media market. (Chapter 16, "Media Events," covers how to host press events and Chapter 17, "Markets, Festivals, and Trade Events," covers various types of industry events).

Sometimes an exclusive story placed with a major media outlet is the perfect launch vehicle for your property. For *Martin Scorsese Presents the Blues*, Dan Klores Communications and WGBH National Promotion negotiated three exclusives at key inflection points. The first, to announce the project and "The Year of the Blues" to public audiences, was with *USA Today* on the cover of the Life Section. It provided a mainstream vehicle to highlight the cross-platform project's goal of raising awareness of the music genre's

influence on American culture. The second, to promote tune-in a few days before premiere, was with *The Today Show*. They were the only TV outlet offered an interview with Martin Scorsese, who talked about the role of music in his life, why he created the project, and the influence of blues music. The six-minute story included a live intro by Matt Lauer and a produced package with key footage from the series. And the third, to push the project the day of premiere as broadly as possible, was the cover of *Parade* magazine with B.B. King, including feature copy on the artist, the music genre, and the project.

The release of the poster or trailer to the public now serves as a major launch vehicle. Today, trailers are to films, TV shows, video projects, and games what posters were to movies in their Golden Era. In 2012, Steven Spielberg and Joseph Gordon-Levitt answered fan questions and launched the trailer for *Lincoln* in a Google+ Hangout and also broadcast it live on the ABC Super Sign in Times Square. Sony released the trailer for the *The Amazing Spider-Man 2* using a combination of exclusive media placement and publicity stunt. Just days before the film's premiere, a Spiderman character ran down New York streets with the DVD onto the live *Good Morning America* set. The trailer then premiered live on *GMA* and later was released online and on social media.

What began with Barnum & Bailey has become a rich tradition for announcing and promoting entertainment with publicity stunts. If these attention-getters are amusing, ironic, or compelling enough, they generate "earned media" from the press or social media. Some stunts are simply cute. *Despicable Me 2*, the animated film sequel about little yellow henchmen and the evil Gru, which premiered in the US in July of 2013, was introduced to US film audiences six months before via the Despicablimp, a 55-foot-high and 165-foot-long blimp depicting a Minion. It crossed the country three times, appearing at key events, and audiences could track its journey via the film's Web site. Universal Pictures ensured that the blimp was in Hollywood on the day of the press junket and later at its US premiere. If the film had premiered in April, the blimp wouldn't have been as effective because fewer US audiences would have been outside.

"Despicable Me 2 Blimp" by Gavin St. Ours; Licensed under Creative Commons via Wikimedia Commons

Universal's *Despicable Me 2* Depicablimp over California.

Another technique is manipulating audiences' understanding of what's real and what isn't. On Halloween in 1938, CBS radio broadcast *War of the Worlds*, Orson Welles' 62-minute live news alert adaptation of the H.G. Wells novel about Martians invading Earth. The radio broadcast, set in real-world Grover's Mill, New Jersey, had up-front disclaimers that it was fiction and aired continuously with no commercial breaks, like breaking news. In a tense pre-WWII climate and with a realistic news report presentation that many people dipped in to after the disclaimer, panic ensued. In one month alone, the broadcast generated 12,500 newspaper stories. The production was excoriated for irresponsible deception and even the FCC investigated, but it launched Welles' career as a dramatist.

"WOTW-NYT-headline" by *The New York Times*; Licensed under fair use in the context of *The War of the Worlds* (radio) via Wikipedia Commons

The fallout from the *War of the Worlds* radio broadcast makes the front page of the October 31, 1938 issue of *The New York Times*.

Following that tradition, in 1993, D.C. Comics, the owners of *Superman*, announced they were putting out a comic, *The Death of Superman*. It created a frenzy of media coverage, and fans rushed out to buy it, thinking this was the demise of their superhero. In fact, it was a hoax to release additional comics and boost flagging sales. Fans were not happy, especially those who bought the comic issue at inflated prices.

And in 1999, filmmakers distributed tapes of the real-life genre horror flick, *The Blair Witch Project* to college campuses, presenting them as authentic video diary footage of missing film students. The Independent Film Channel was complicit, labeling the clips as documentary footage. The film's *faux* Web site, IMDb profiles, police reports, missing posters, and circulating rumors backed up the life-like trailer's story of the missing characters,

sustaining the hoax. Its pre-social media virality garnered the $22,000 film more than $250 million in box office receipts. A technique that wouldn't likely work with the sophisticated audiences of today.

"Missing poster" by Artur13 in Richard Cravens at blairwitch.wikia.com

The missing poster *for The Blair Witch Project.*

As arresting as these stunts are, they are also risky because they are usually live and interface with unknowing public audiences. In a post-9/11 world, issues of threat and safety must be considered. To promote *Mission Impossible III* in 2006, boxes that played the *Mission Impossible* theme song when the rack door was opened were installed on 4,500 newspaper racks in L.A. Some of the boxes fell over on top of the newspapers, exposing the red wiring. This caused a bomb scare and required police to blow up one box to see if it was a bomb. While it surely got attention, it was not the kind that Paramount intended.

There are many ways to launch, but because the press influences both the entertainment industry and public audiences, many projects announce with industry trade and consumer media. The media are among some of the most powerful influencers and can have a tremendously positive or negative effect on your project. Securing positive media coverage for your media project requires knowing how to work effectively with the press.

Author's Anecdote

Launching Coffee in the Streets

Since 1966, Peet's Coffee has been the gold-standard for specialty coffee. Headquartered in Berkeley, California, Peet's is known for its early introduction to the West Coast of darker roasted Arabica coffee, such as french roast and coffee grades for espresso drinks. As part of a reorganization and rebrand in 1995, bakery and sandwich retailer, Au Bon Pain decided to make Peet's Coffee its exclusive brew. But Au Bon Pain's then East Coast customers had little knowledge of or taste for specialty coffee. Coffee was a basic staple like gasoline, not a coveted savory experience. And they thought specialty coffee was bitter and strong.

Managing this introduction as a senior vice president at an advertising and marketing firm, I knew we needed to reframe East Coasters' concept of specialty coffee. To introduce the new coffee line, I worked with my team to position specialty coffee like fine wine. We wanted to signal that specialty coffee was a rewarding experience, a small oasis in an otherwise hectic start of the day. Our public launch was an outdoor professional "cupping" session in crowded Harvard Square, next to Harvard Yard and a vibrant Au Bon Pain. Peet's chairman, Jerry Baldwin, and Au Bon Pain's CEO, Ron Shaich, rolled up their sleeves and "sipped and spat" out coffee into vessels, just like professional wine tasters. The crowd was intrigued and quickly got into the tasting game. As they tasted the new bean blends, they took a personality test to determine their coffee personality, whether they were "The Regular Joe," "The Coffee Stylist," "The Coffee Guru," or the "The Coffee Flirt."

The Peet's Coffee launch secured coverage in all of Boston's major daily newspapers, magazines, and broadcast outlets and was picked up by national wire services that delivered the story across the country, reaching Au Bon Pain's entire retail store footprint. Now, specialty coffee is a major contributor to Au Bon Pain's international success.

CHAPTER 14

Media Relations

Influencers are gatekeepers, intermediaries, and tastemakers who influence other audiences. And the media are influencers. Media relations is a subset of **Public Relations**, which is a broad set of communication activities designed to create and maintain positive relations between an entity and its publics such as audiences, press, industry leaders, partners, employees, stockholders, and government officials. Public relations is credited with making smoking acceptable for women and then, decades later, making smoking uncool for teenagers. Publicity falls into the Promotion "P" of marketing.

Even in an era of peer power through WOM on social media, the press still wields tremendous influence. In entertainment, respected critics' endorsements of a media property can pave a path for success for a film, television program, book, game, or Broadway show. The practice of working with the press is called media relations because it's about having a trusting relationship with members of the press. The press is a target audience, and your job with all audiences is to serve their needs. The best way to get the press' attention in a crowded field and persuade them to cover your media project is to do their job for them. Think about, write for, and produce materials for your project just like a journalist would. You must watch, listen to, or read their coverage and then pitch a story about your project that serves their media outlet's audiences.

Advertising vs. Publicity

Begin with the recognition that advertising and publicity are two entirely different disciplines. While they're both important tools for raising awareness of your media project with target audiences, they have different sensibilities and use different techniques. Advertising is "paid media" and publicity is "earned media," as discussed in Chapter 3, "Harness Your Inner Marketer." If you pay someone $10 to say that you look fantastic at a certain party, that's advertising. If you show up at that party looking fantastic and someone says so of their own accord, that's publicity. With advertising, money changes hands, and for that fee you know when, where, and what will be communicated publically. With publicity, you build an authentic reputation and with some deft media relations, you secure public notice of it.

Advertising	Publicity
• Is engaging and entertaining	• Is informative
• Identifies the sponsor or product	• May not identify sponsor or product
• Costs money for the media buy	• Media coverage is not bought (but publicists cost money)
• Has a controlled message, placement, and timing	• Has no controlled message, placement, or timing
• Can be replicated in the same media outlet or elsewhere	• Is not replicable in the same media outlet (must find new story angles)
• Is recognized by audiences as advertising (they may tune-out)	• Is seen by audiences as highly credible

When advertising your transmedia project, the distributor's creative teams design and craft the message based on the intended medium, and media buyers purchase the placement and timing of ads in chosen media outlets. There are no surprises. Because audiences recognize that it is advertising and are bombarded by so many ads wherever they go, they may pay less attention. So the presentation and message must be highly arresting, clever, or engaging to be noticed.

Publicity or media coverage is the byproduct of media relations, which is managed by the distributor or talent's publicists. They also may handle social media and events. Publicity includes industry news, critics' reviews, and feature coverage, much of which is generated by publicists' efforts. Through a reciprocal relationship with the press, the publicist provides information, story ideas, and access to key spokespeople, and the journalist covers the project, production or distribution company, or talent if it's relevant or interesting to their media outlet's audiences.

The relationship between the producer and the PR person that represents the client is one of the most important relationships because you need them and they need you. And where does that relationship start? It starts with the first phone call, which I still tend to make because I think there's too much e-mail. And it starts with complete trust.

—**Glenn Meehan, supervising producer,** *The Talk***; co-creator,** *Big World, Little People***; formerly managing editor,** *Entertainment Tonight*

All of this happens behind the scenes without audiences seeing it. Audiences read, watch, or listen to that media outlet because they like or respect it. They're there of their own volition, so are already engaged.

Publicity tools include written pitch letters and press materials, graphics and photography, video trailers and clips, and review copies of the property (provided by hard copies, e-mail, links, and FTP sites). Media relations also includes phone conversations with the press to pitch stories, deliver background information, and provide formal spokesperson interviews, as well as face-to-face interactions during screenings, live interviews, press conferences, set visits, and industry events. Some of the most valuable assets of publicists are their media lists, contacts, and relationships with key journalists. There are paid services that provide these databases, but they're not nuanced or personal.

Within each industry, journalists and publicists are a relatively small, insular group, so if your product has a TV and a game element, you should hire publicists with expertise in each arena. In entertainment publicity, publicists can represent the distributor, such as a studio, TV network, or game or book publisher; the media project itself; or a personality such as an actor, director, author, or celebrity. Generally, publicists are paid a monthly fee to publicize that entity. When you hire a publicity team, you are looking for two attributes: ability to pitch a good story and solid press and blogger relationships.

If a media project has a big studio, property, director, or star, there may be multiple publicity firms involved in the promotion of that project. This can get complicated because of varying agendas. High-profile projects require precise coordination among all the publicists to clarify who's approaching which journalists, when, and with what message or story angle. It's OK to split up "ownership" of sections of the media list among different agencies based on their core competency, but only one publicist from a project should approach any one journalist.

In days gone by, entertainment publicists had reputations of being shills or hacks, which comes from the old studio days when publicists were spies for the studios. Their job was to protect the studios' properties and stars—at all costs. Today, most entertainment publicists are skillful strategic and creative thinkers. Many are former journalists or producers, which gives them an edge in translating creative vision into a story that's a good fit for a media outlet.

© iStock.com/kotomiti

Garnering publicity or "earned media" is an art form.

Journalists vs. Bloggers

A decade ago, bloggers were seen as people with too much time on their hands and didn't meet the core criteria as mainstream journalists—credible media outlets didn't employ them. As bloggers became more influential in their respective realms, this created quite a conundrum for entertainment publicists.

In film, television, book, and game publicity, publicists give critics advance access to the property so critics' reviews will be ready at launch time. The entertainment industry also holds advance press junkets in which the project and its talent—stars, directors, or producers—are made available to select journalists for presentations and Q & A sessions. By the mid-2000s, film, TV, book, and game bloggers were requesting preview copies of the media properties and seeking *entrée* to screenings, press junkets, and industry events. Publicists, producers, and industry event planners didn't know what to do. Most decision-makers said "No" to these bloggers.

Meanwhile, mommy bloggers were becoming a *tour de force*, representing more than 35 million women bloggers and blog readers. Some individual bloggers were garnering hundreds of thousands of visitors every day. In 2005, they started their own conference, BlogHer, while the *Huffington Post*—the online news aggregator and blogger platform—emerged, influencing the daily discourse and adding credibility to and shaping the blogger model. Savvy entertainment publicists recognized that key bloggers had significant reach and impact on their audiences and began treating them like credentialed journalists.

We held the very first bloggers junket for Veronica Mars. Because it was targeting a fairly young demographic and had been strictly an e-mail relationship, we didn't really know who these bloggers were. They started out as fans. Were we dealing with 15-year-olds or 30-year-olds? That junket became the template for other blogger junkets and also laid the groundwork for the Save Veronica Mars Campaign. Some of those bloggers have ended up creating big businesses out of what started as working out of a kitchen.

—Rachel McCallister, chair, MPRM

As the recession hit in 2008 many mainstream media outlets shuttered their entertainment beats. Top film, television, book, and theater critics who had worked for major media outlets began writing their own blogs. And many bloggers who originated online went mainstream. Most of the respected critical voices in games originated online. As did some influential entertainment sources such as IMDb, the online database of information about film, television, and games; *Metacritic*, the online aggregator and ranker of many movie, game, book, TV, and music reviews; and *Deadline Hollywood* and *The Wrap*, the online entertainment news sources and blogs, which some contend rival the clout of industry veterans *Variety* and *Hollywood Reporter.* All that has ratcheted up the credibility of online coverage and criticism.

For younger audiences or hard-core enthusiasts, online sources are the only top-tier influencers. Millennials and Gen Nexters, who grew up seeking and sharing information online, may see an affiliation with a newspaper or radio show as boring or uncool, but a "thumbs up" from a trusted blogger or YouTube personality—someone more like them— as more credible.

The question of journalists vs. bloggers now includes online personalities. YouTube has created a rash of influential vloggers such as Swedish gamer, PewDiePie; Web-based comedy duo, Smosh; Chilean comedian, HolaSoyGerman; and commentator and entertainer Jenna Marbles. All of these YouTubers began with simple DIY home video posts.

PewDiePie was a huge driver behind the success of first-person PC horror game Outlast. He had a background in playing scary games for his community and freaking out while he's playing them. PewDiePie was one of our top three of our targets for the campaign, alongside IGN and Gamespot.

—John O'Leary, account manager, LaunchSquad

While at his previous technology and digital communications PR firm, O'Leary offered PewDiePie *Outlast*'s demo to play and record at his leisure from his own computer, a rare opportunity for non-traditional media. This resulted in a very popular video titled, "Scariest Game?" two months before the game's launch, which has received almost 9 million views. PewDiePie liked the game so much that he created 15 more *Outlast* videos with titles like "So Scary You Will Poop!" that were released on his YouTube channel episodically, like an Internet TV show. On launch day, he posted two gameplay videos, the first receiving more than 4 million views and major attention. All of his videos received millions of views and added virality. On launch day, because of PewDiePie and other launch buzz, Twitter was afire and *Outlast* was the "Trending Topic" for the day.

Many bloggers and vloggers clearly publish important news, features, and reviews for media properties. The influential ones are treated like journalists. Still, there are some differences. Bloggers' worlds are less controlled than staff writers or producers at media outlets because they do not have as many layers of bosses, such as editors or senior producers, who approve or assign stories. They may have more discretion about the timing of blog posts and about story length. And bloggers, born from the online tradition of everyone having a soapbox, infuse or exert opinion much more freely.

In film, some superfans and bloggers with zealous interest in sci-fi, fantasy, action, and comics have come to loggerheads with traditional critics. When *Dark Knight Rises* launched, AP's Christy Lemire's and blogger Marshall Fine's reviews panning the film appeared on *Rotten Tomatoes.* Superfans flooded the site with comments and some hurled death and rape threats against critics of the film. Unable to handle the volume and the vitriol, the site disabled the comments function and took down all comments.

One thing that's happened in film criticism is a rise in fanboy criticism, which is empassioned and partisan. There are people on various sites who are devoted to a specific kind of film and are not interested in anything outside of their particular passionate fanbase. They don't bring a genuine critical sensibility to bear. They are fans before they are critics.

—Ty Burr, film critic, *The Boston Globe*; author of *Gods Like Us: On Movie Stardom and Modern Fame*

Vetting bloggers requires more work than evaluating journalists. It's difficult to determine the reach, audience make-up, and influence of blogs the way you can of a newspaper or a television program. As blogs become bigger advertising opportunities, that data will become more available. Still, if you look at the body of the blogger's work, over time you can learn a lot about the quality of the coverage, its tone, its reach, and its influence among your target audiences. Look to see if the blog is widely quoted or shared through other online sources or social media.

What makes someone a good critic is not what media platform they review for, but that they don't approach their review with an agenda and are open-minded about each media property, whether they like the genre or not.

Entertainment Publicity

Entertainment publicity covers press for trade and consumer audiences and includes both news and feature stories.

Trade Publicity

Trade publicity supports film, TV, games, or book projects' business goals. It creates buzz and credibility about your project, thereby contributing to funding, distribution, and partnerships. Industry journalists cover the news of the studios, production companies, publishers, projects, and talent in that industry.

Some key examples of the many trade media outlets for entertainment are, general: *Variety*, *Hollywood Reporter*; film and TV: *Deadline Hollywood, The Wrap*; film: *IndieWire*, *Reel Screen*, *Filmmaker, Screen International*, *Box Office Magazine*, *The Film Journal*; TV: *TV Week, Electronic Media, C21Media, Broadcast, Multichannel News, World Screen, Emmy*; games: *Electronic Games, Electronic Gaming Monthly*; books: *Publisher's Weekly*, *Kirkus Reviews, Booklist, Library Journal*; magazines: *MagazinePublisher.com*; newspapers: *Editor & Publisher*; theater: *American Theater*; and music: *Billboard*.

This kind of industry publicity presents a chicken-or-the-egg problem. The trades rarely cover a project that isn't real or greenlit unless it's from a big studio or production company that has a track-record, yet trade publicity is an important credibility-builder for getting it greenlit. Having a credible spokesperson, producer, or partner, or other proof that your project is being taking seriously, helps secure these stories. Or pitching how your project represents a new industry trend may garner media coverage. Be sure to have examples of several other industry projects or examples that are part of this trend.

When the project goes into production, a *unit publicist* is hired. Their goal is two-fold: to secure publicity during the production phase through press materials, interviews, and set visits; and to secure key promotional assets during the production for later use. Production footage; interviews with the cast and crew, director, and cinematographer; and still photography will be used for the electronic press kit (EPK).

After production, many films seek entry to film festivals, because acceptance to the festival confers legitimacy, and trade press and distributors attend. With just the right amount of buzz, a distributor might pick up a film at the festival.

Reviews

Reviews are the bread-and-butter of entertainment consumer publicity, appearing closer to premiere to affect audience's decisions. Critics' jobs are to review the properties in their industry—film, television, games, books, digital media, music, and theater—so they are usually open to looking at media projects, even smaller unknown ones.

Media properties are reviewed in the trades and consumer outlets such as *Entertainment Tonight*, *TMZ*, *The Today Show*, *TV Guide*, *USA Today*, *People Magazine*, *Rolling Stone*, *Time*, *Premiere*, *Wired*, *The New York Times*, *The Los Angeles Times*, *Washington Post*, *Chicago Sun-Times*, *Spin*, *Kirkus*, *Huffington Post*, *Mashable*, NPR, *IGN*, *Kotaku*, *Polygon*, *Gamespot*, *Games Radar+*, *Game Informer*, *Destructoid*, *Rock, Paper, Shotgun*, and *GamesCritic.com.* Publicists who really know their industry also know the niche critics who cover certain genres or independent projects.

The distributor's PR team sets up screenings or sends out review copies or links to films, TV shows, games, and books. These review programs can take place six months before the public release of a project to ensure critics have time to see all the fare for their busiest times of year. Reviews from festival screenings and through advance DVDs, games' Betas, or books are often held back or embargoed and appear from a couple of weeks before release to the day of the project's release or premiere.

If a film appears at a festival before its public distribution, festival reviews must be handled with kid gloves.

> *To get distribution, you have to get positive trade reviews such as Screen International, Variety, Hollywood Reporter, and IndieWire. If you have a reputable film reviewer from New York Times or Los Angeles Times, those can also work to your advantage. But with all the others, you want capsule reviews, and you ask them to hold their full reviews until you have distribution. Because nine months later when you arrive with a theatrical release nobody will want to talk to you because they've already covered you. You need to pick and choose the top outlets and people that will do the most for you in that moment, and then you stop.*
>
> **—Kathleen McInnis, festival strategist and publicity consultant, See-Thru Films**

Once a film has theatrical distribution, the distributor sets up live in-theater screenings in each major city a few weeks before the film's release for press (2:00 p.m.) and promotional screens for tastemakers (7:00 p.m.). Sometimes screening DVDs are provided to film critics and on occasion links for streamed films, but movie critics prefer live screenings. If the press screening is held a day or two before a film's release, that either signals that

the studio knows it is not a good film and is avoiding reviews or that the film has such a rabid audience they don't need the reviews.

Films seek a theatrical release in New York and Los Angeles and a positive review from *The New York Times* or *The Los Angeles Times* for a shot at the Oscars because most Oscar voters are in those two cities (though an LA release is all that's required for eligibility). *The New York Times* tries to review every film with a New York theatrical release—some 900 film reviews per year. The big "gets" for positive film reviews are *Variety*, *Hollywood Reporter*, *IndieWire*, *The New York Times*, *The Los Angeles Times*, *Rolling Stone*, and *Entertainment Weekly*.

In television, screeners are provided to television critics six to two months before the premiere and, to signal a program's importance, sometimes TV programs host a press conference at the summer or winter TCA Press Tour. The big "gets" for television reviews are *TV Guide*, *USA Today*, *Hollywood Reporter*, *Variety*, *The New York Times*, and *Entertainment Weekly*, and the syndicated reviews at Associated Press (AP) and *The Wrap* (Reuters America).

Game reviews are a two-part process. A copy of the game—from its early Beta version up to its final Code Release version—is sent out to game journalists, even when the game is not complete. Previews are longer stories describing the game and some of its key features and characters. The final game is then provided to reviewers a few weeks before release. Larger console games may have reviews before public launch and casual games' reviews may appear after launch. The big "gets" for game reviews are *IGN* and *Kotaku* (distributed through the Gawker network). Other influential reviewers are *Destructoid*, *Gamespot*, and *Game Informer*, and for PC games, *PC Gamer* and *Rock, Paper, Shotgun*.

During the review process, publicists must not oversell critics, but rather put the property's best assets forward. The publicist's job is to raise awareness of the project by bringing the property to the attention of reviewers. It's the job of the creator to create a property that garners a positive review. So reviews are white-knuckle time for producers, distributors, and publicists, particularly if it's an influential media outlet or critic. Critics may rave about your project or they may pan it. So why take the chance? Because a positive, third-party endorsement from a respected, credible source may influence your audiences significantly. One great review can be more persuasive than an entire ad campaign.

Reviews have a multiplier effect, especially syndicated reviews appearing in multiple media outlets. Reviews are included in full or in part in aggregator sites such as *Metacritic*, *IMDb*, *Rotten Tomatoes*, *Review Gang*, *TestFreaks*, *GameRankings*, *Farmitsu*, *Mobygames*, *Epinions*, *Any Decent Music?*, *Goodreads*, and *iDreamBooks*. Most critics don't like the oversimplification of their reviews to dyads of "good" or "bad," but prefer sites that allow for more nuanced and deeper depiction of their reviews.

News and Features

Throughout the lifecycle of the project, publicists also seek trade and consumer news and feature media coverage. News stories are when something is breaking or "Trending" in the news and media outlets are covering it. If you can link your project to that story, then you boost your chances of getting covered. Your project may have themes or plot lines connected to that news event, you might have a relationship with the entities in the news story, or you might be part of a trend. The new term for this is "newsjacking," but good publicists have been linking projects or products to news stories off the entertainment pages for decades.

A feature story is a human-interest story focusing on people, places, things, events, or trends (technically critics' reviews are feature stories because they're not tied to the news). A feature can be a color piece that describes or sheds light on a theme; a behind-the-scenes exclusive access; a profile of a person or entity; a how-to explaining how something is made; an historical survey; an analysis of a subject or theme; a first-person testimonial; an expert roundup with a selection of opinions; or an audience poll. Feature stories can come from any place and any industry and are generally about whatever the writers and editors think will strike their audiences' fancy. Feature writing is more expository and opinionated.

Features can occur any time leading up to your project's launch and after. They are difficult to place and time-consuming, but can have a critical effect on the awareness of a project, especially if they're timed to meet a project's particular needs. They're about creating a story about your project out of whole cloth. You are competing with every project, every idea, every trend, and perhaps, in a broad-based media outlet, every industry. The feature writer needs to be sold on the value or relevance of a story about your project.

Publicists must know the media outlet well and pitch different story angles to different media outlets. Good publicists pitch the story differently to different reporters or producers within each media outlet based on their "beat," or area that they cover. That's why you messaged your media project, so your publicity team could identify themes and story angles for pitching to the press. The more fine-tuned the pitch is to a reporter's beat, the better the chances of getting coverage. Also, seed your social platforms with dialogue around trends to demonstrate the salience of your story idea.

Once a reporter gets "hooked" on a story angle, the publicist provides background information, interviews, access to the production or set, photography, art, and other things the reporter requests. Even if you or your publicist does secure coverage, you still don't know whether that coverage will be favorable, make the desired points, include quotes from project spokespeople, appear when you want it to, and support the goals of your project.

For *Martin Scorsese Presents the Blues*, Dan Klores Communications, offering Scorsese for a phone interview, secured an exceptional *New York Times* Op Art syndicated opinion

piece with politics, culture, and poverty writer, Bob Herbert. His "Keeping the Blues Alive" story landed when the project had its special screening and party at the Sundance Film Festival. Festivalgoers saw it, and it spawned the intended broad-based buzz and dialogue about the fate of blues music in this country.

Often publicity is sought for a specific market or event. If one of your project partners is based in a certain city, then a special press push in that city makes sense. If your talent is attending events, especially in the top entertainment markets of New York and Los Angeles, or the top games and digital market of San Francisco, seek appearances and media interviews while there.

Entertainment publicists also provide key information about a project to digital and printed media listing services. The information may include the title, several lengths of description from logline to specific episode descriptions, and photography. Each industry has their own technical requirements, but what's common to them all is that a lot of information must be conveyed in very little space. In particular, there are length restrictions for the project title, so keep that in mind when naming your media property.

Entertainment journalists work in various media—newspapers, magazines, online, radio, and television. Learn the rhythm and the deadlines for their media coverage. Don't contact newspaper reporters at the end of the day when they're about to submit copy to go to press or broadcast journalists when their program is about to go on the air. Print journalists are thinking about the written word, broadcast journalists are thinking more about visuals and sound, and online journalists are a hybrid, but are becoming increasingly oriented toward audio-visual. So lead with the assets that are most likely to grab them and align with their sensibilities. In all cases, they are time-pressed, impatient, and wary because they get so many pitches that are off the mark.

Clearly, media relations is not a controlled process. You won't always get the results that you hope for. Sometimes the story gets canceled entirely or it only includes your project in passing or focuses on an angle you don't like. Your quotes might be taken out of context and communicate something completely different from what you intended. If you don't like the story, NEVER complain to the journalist. (You may go back and correct material or factual errors). You will destroy your reputation and relationship with that journalist for the rest of your career. You cannot be in the creative media making or media marketing business without suffering a great deal of rejection and a bruised ego.

A key way to shape the story you want for your announcement, reviews, or feature stories is to put your project's story into the written word through journalistically-correct press materials.

Author's Anecdote

Running a Press Operation from Mt. Everest

A few days before Memorial Weekend in 1997, I started as the head of promotion and publicity at WGBH. My first day on the job I met with *NOVA*'s senior executive producer, Paula Apsell, to take over the science documentary series' communications because it was without a regular publicist. *NOVA* was filming one of its most important specials from Mt. Everest—the climb of David Breashears, Ed Viesturs, client David Carter and cameraman Pete Athans—and, along the way, testing their minds' and bodies' reactions to lack of oxygen due to high exposure. Dr. Howard Donner and producers were at Everest Base Camp at 17,600 feet. The team would broadcast the world's first live Internet audio from the summit, supported by online dispatches throughout the climb. Leading into the long weekend (the expected timing for the summit), we finalized the communications team of *NOVA* senior producers, the film's co-producer at Base Camp, a freelance publicist, and me. The first live Internet broadcast from the summit was already big news.

The climbers documented their triumphant summit of the 29,038-foot mountain on the morning of May 23 to 20,000 listeners via the live Internet stream. But as the team descended, a lower respiratory infection Ed Carter had picked up became a life-or-death situation. His airway became dangerously blocked, which at high altitude can be fatal. News of Carter's fate went global because the mountain had claimed 16 lives in the previous two years, eight in 1996 documented in John Krakauer's bestseller, *Into Thin Air*. Because *NOVA* had online communications from Everest, it became the most reliable information source. Our patched-together press team became communications central for the international press as the story unfolded. Using satellite phones, Internet postings, and e-mail from Everest as our sources, we updated hundreds of media outlets—from AP to CNN—over the most critical 48 hours. At one point Carter began choking to death and Viesturs administered the Heimlich maneuver on the side of the mountain. Luckily, Carter survived his near-death climb. This gripping tale was captured on *NOVA*'s *Everest—The Death Zone*, narrated by Jodie Foster, and on the IMAX film, *Everest*.

The moral: you must always have your press team at the ready for anything. As soon as Carter was safely back at Base Camp, I turned my attention to hiring a senior publicist for *NOVA*.

Press Materials

A media project has many audiences and the materials and messages for it must be packaged to meet the needs of each audience. A teen on social media might just want the meme or parody of a project, while a funder might want the project's revenue projections.

Press materials or press kits are the portfolio of materials on a company or product developed specifically for journalists. Well-written press copy is critical to presenting your transmedia project properly and providing journalists with the information they need to do their jobs.

Writing Good Press Copy

Press copy is generally written by publicists or in-house writers. All major players and partners involved in the project should approve the release and know about the release strategy. Sometimes lawyers also approve press releases to ensure business relationships and production credits are communicated correctly. It's important to write, edit, and review press materials with press copy guidelines in mind.

The key to writing good press materials is to write in a journalistic style—answering the "what, who, when, why, and where?" The best way to become a good press release writer is to read daily newspapers, which generally still follow a news story format. Because a press release is written as a news story, it follows the basic precepts of news copy: an engaging headline that states the most newsworthy piece of information, all key information delivered quickly up front, details provided in subsequent paragraphs, and an ending that speaks to the future.

Press materials should be written to inform, not oversell. Marketers and MBAs are notorious for creating buzzwords for everything. While these terms are fine among internal audiences, they're not advisable for the press. One of the biggest traps in drafting press releases is using superlatives. Journalists want to decide for themselves whether a project is special; they don't want to be told. Examples of buzzwords or characterizations that are press copy turn-offs for journalists are:

- Best—leader, leading-, top, best-of-breed, best-in-class, largest, award-winning, premier, exclusive, legendary, well-positioned, dynamic, elite, marquee

- Innovative—state-of-the-art, breakthrough, groundbreaking, unique, one-of-a-kind

- People—user, end-user, influencer, evangelist, all-star, guru, wizard

- Jargon—synergistic, sticky, mindshare, feature-rich, out-of-the-box, scalable, leverage, paradigm, deliverables, horizontal/vertical, user-friendly, ecosystem, sea change, return on investment, transformative, leverage, push the envelope, snackable content, pain points, low-hanging fruit, game-changer, issues (instead of problems)

- Non-professional language—awesome, amazing, cool, whatever, crazy, totally

- Grammar and punctuation—English class matters. No typos allowed. Your copy must be impeccable.

Keep a couple of rules of thumb in mind when writing press copy. If you're using an adjective or adverb, ask yourself whether you really need it. If you are using a noun, ask yourself if there's a simpler, more direct word. You may be terrific at flowery writing or a special turn of a phrase, but hold that impulse. That's for advertising and promotional copywriting.

Press Releases

The primary written vehicle for communicating to the press is the press release, media release, or news release. Press releases generally announce a piece of news, such as the beginning of a project, new partners or talent joining the project, project release dates, special events, awards, and other "hard" news. They are used to generate news stories, and with deft pitching can generate feature stories.

Never release or speak publically about the launch date for your project without the permission of your distributor(s). This is their news, not yours. The date for the release of the final eight episodes of the final season of *Breaking Bad* on Netflix was hugely newsworthy because of the popularity of the AMC program, the powerhouse that Netflix has become, and the rising trend of binge-watching.

Press releases follow a standard format with some common structural elements:

- Headline—summarizes the news and grabs attention
- Subheadline—provides synopsis of secondary news
- Dateline—has release date and originating city (if requesting a news embargo, then the dateline is after the date the press release is released)
- Introduction—first paragraph (or two) covers the "what, who, when, why, and where?"
- Body copy—paragraphs that provide further explanation and background on the introduction; often has non-gratuitous direct quotes from key players woven throughout
- Boilerplate—a short paragraph providing background on the issuing company or project; multiple boilerplates are required for multiple partners
- Close—use of the symbols "-30-" or "###" or the word "ENDS" after the boilerplate and before the contact information to signal the end of copy
- Contact—the name, phone number, and e-mail for the media relations contacts; add cell phone numbers if you're releasing at a live event

Traditionally, a standard news release was about five paragraphs, about 500 words. But, with complex projects, multiple quotes, and multiple boilerplates, short press releases are rare. In addition, because so many online media outlets have limited staff to write stories, many press releases are drafted as finished articles, which can be dropped in "as is." These press releases are longer, include longer quotes, and provide more than just the basic facts. This type of press release is now the norm.

Martin Scorsese Presents the Blues Press Release

Over the course of a year, there were a variety of press releases drafted for *Martin Scorsese Presents the Blues* including: "The Year of the Blues" public announcement; Radio City Music Hall Concert release; MIPCOM release; Cannes Film Festival release; television airdate/multi-platform release; Volkswagen sponsorship release; Television Critics Association Press Tour release; Clint Eastwood joins the project release; and TV series premiere release.

A sample television-centric announcement press release for *The Blues* follows. Its main news, signaled by the headline, was the announcement of the television series' airdate and schedule, which concurrently served to announce the launch of PBS' new fall television season. The secondary news, signaled by the subheadline, was the multi-platform aspect of the project, including TV, radio, Web, book, music CDs, DVDs, concert, concert film, "On the Road," and educational outreach components.

MARTIN SCORSESE presents

THE BLUES.

Sponsored by
Drivers wanted. VW

A presentation of
VULCAN PRODUCTIONS **ROAD MOVIES**

WGBH · PBS · cpb

pbs.org/theblues

MARTIN SCORSESE'S *THE BLUES* KICKS OFF
PBS FALL SEASON WITH
SEVEN-NIGHT BLUES TELEVISION FESTIVAL

THE BLUES Multi-Media Project, Sponsored by
Volkswagen of America, Inc., To Include TV/Radio Series,
Educational Initiative and Nationwide Tour

New York, NY – May 15, 2003 – *The Blues*™ project today announced that Martin Scorsese's much anticipated series, *The Blues*, will lead PBS' new fall season beginning on Sunday, September 28th. In what is being billed as a Blues Television Festival, PBS will air the entire series over seven consecutive nights at 9pm, beginning with Scorsese's film, *Feel Like Going Home*, and concluding with Clint Eastwood's film, *Piano Blues*, on Saturday, October 4. Check local listings for broadcast dates and times.

Under the guiding hand of Executive Producer Martin Scorsese, and sponsored by Volkswagen, *The Blues* consists of seven impressionistic and iconoclastic films that capture the essence of the blues while exploring how this art form so deeply influenced people the world over. In addition to Scorsese and Eastwood, the other directors and films in the series include: Charles Burnett, *Warming by the Devil's Fire*; Mike Figgis, *Red, White and Blues*; Marc Levin, *Godfather and Sons*; Richard Pearce, *The Road to Memphis*; and Wim Wenders, *The Soul of a Man.* Along with Scorsese, Paul G. Allen and Jody Patton of Vulcan Productions and Ulrich Felsberg of Road Movies are executive producing the series; Alex Gibney is the series producer, Margaret Bodde is the producer and Richard Hutton is the co-producer.

"All of these directors share a passion for the blues," said Martin Scorsese. "The idea of different perspectives from filmmakers who love the music seemed like the right way to approach such personal and evocative music. Out of the seven films, all together, the audience will ideally come away with the essence of the music — the spirit of it rather than just plain facts."

COLUMBIA · LEGACY · UMe UNIVERSAL MUSIC ENTERPRISES · HIP-O RECORDS / CHESS · Amistad An Imprint of HarperCollinsPublishers www.amistadbooks.com · PRI Public Radio International · · Year of the BLUES

Courtesy of Vulcan Productions

The press release announcing *The Blues* television series and airdates (page 1).

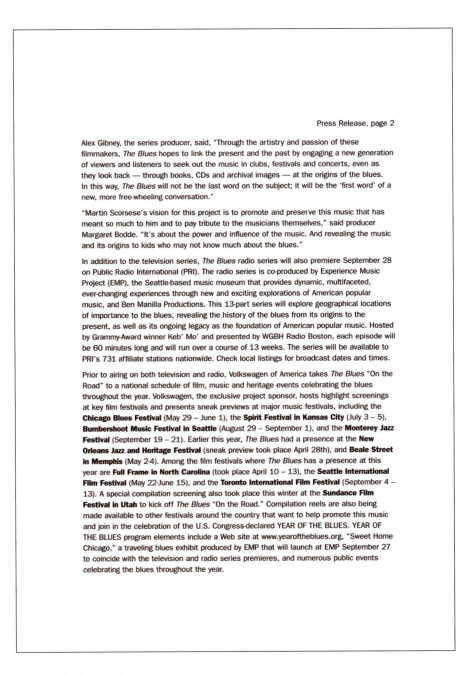

Press Release, page 2

Alex Gibney, the series producer, said, "Through the artistry and passion of these filmmakers, *The Blues* hopes to link the present and the past by engaging a new generation of viewers and listeners to seek out the music in clubs, festivals and concerts, even as they look back — through books, CDs and archival images — at the origins of the blues. In this way, *The Blues* will not be the last word on the subject; it will be the 'first word' of a new, more free-wheeling conversation."

"Martin Scorsese's vision for this project is to promote and preserve this music that has meant so much to him and to pay tribute to the musicians themselves," said producer Margaret Bodde. "It's about the power and influence of the music. And revealing the music and its origins to kids who may not know much about the blues."

In addition to the television series, *The Blues* radio series will also premiere September 28 on Public Radio International (PRI). The radio series is co-produced by Experience Music Project (EMP), the Seattle-based music museum that provides dynamic, multifaceted, ever-changing experiences through new and exciting explorations of American popular music, and Ben Manilla Productions. This 13-part series will explore geographical locations of importance to the blues, revealing the history of the blues from its origins to the present, as well as its ongoing legacy as the foundation of American popular music. Hosted by Grammy-Award winner Keb' Mo' and presented by WGBH Radio Boston, each episode will be 60 minutes long and will run over a course of 13 weeks. The series will be available to PRI's 731 affiliate stations nationwide. Check local listings for broadcast dates and times.

Prior to airing on both television and radio, Volkswagen of America takes *The Blues* "On the Road" to a national schedule of film, music and heritage events celebrating the blues throughout the year. Volkswagen, the exclusive project sponsor, hosts highlight screenings at key film festivals and presents sneak previews at major music festivals, including the **Chicago Blues Festival** (May 29 – June 1), the **Spirit Festival in Kansas City** (July 3 – 5), **Bumbershoot Music Festival in Seattle** (August 29 – September 1), and the **Monterey Jazz Festival** (September 19 – 21). Earlier this year, *The Blues* had a presence at the **New Orleans Jazz and Heritage Festival** (sneak preview took place April 28th), and **Beale Street in Memphis** (May 2-4). Among the film festivals where *The Blues* has a presence at this year are **Full Frame in North Carolina** (took place April 10 – 13), the **Seattle International Film Festival** (May 22-June 15), and the **Toronto International Film Festival** (September 4 – 13). A special compilation screening also took place this winter at the **Sundance Film Festival in Utah** to kick off *The Blues* "On the Road." Compilation reels are also being made available to other festivals around the country that want to help promote this music and join in the celebration of the U.S. Congress-declared YEAR OF THE BLUES. YEAR OF THE BLUES program elements include a Web site at www.yearoftheblues.org, "Sweet Home Chicago," a traveling blues exhibit produced by EMP that will launch at EMP September 27 to coincide with the television and radio series premieres, and numerous public events celebrating the blues throughout the year.

Courtesy of Vulcan Productions

The press release announcing *The Blues* television series and airdates (page 2).

Press Release, page 3

Volkswagen is also underwriting an extensive educational outreach program that will tie in with the broadcast of the series and provide high school teachers of English, social studies and music with free teaching resources to help bring the blues into classrooms. Also produced by EMP, the educational materials will include on-line lesson plans, a teacher's guide with CD, and a broad range of teaching strategies and resource materials. The broadcast series-related education initiative will reach teachers this coming August.

"We are of course proud to join what we believe is a remarkable opportunity for this music as well as a celebration of the men and women who created a truly inspirational art form," Karen Marderosian, marketing director of Volkswagen of America, said. "Our goal is to help introduce as many people as possible to this music through our support for *The Blues* on PBS and in major cities around the country."

Beyond the educational program, *The Blues* will have a major Web presence at **www.pbs.org/theblues**, where blues lovers, film aficionados, teachers, students, and others will be able to access additional information related to the series and the art form.

The Blues series on PBS is the cornerstone of an integrated multi-media project that includes, in addition to the programs described above, a companion book published by HarperCollins, entitled Martin Scorsese Presents *The Blues: A Musical Journey*; value-added DVDs, a CD box set, individual soundtracks for each show, a single "Best of" album and twelve individual artist recordings released collaboratively by Hip-O Records/Universal Music Enterprises and Columbia/Legacy; a "Salute to the Blues" benefit concert that took place at Radio City Music Hall on February 7, 2003; and a film of the concert for theatrical release directed by Antoine Fuqua (*Training Day*) and executive produced by Martin Scorsese.

ABOUT *THE BLUES*™

The Blues, executive produced by filmmaker Martin Scorsese and premiering Sunday, September 28 at 9pm on PBS, anchors a multi-media project to help raise awareness of the blues and its contribution to American culture and music worldwide. *The Blues* is a seven-part television series of personal and impressionistic films viewed through the lens of seven world-famous directors who share a passion for the music. The films, by Scorsese, Charles Burnett, Clint Eastwood, Mike Figgis, Marc Levin, Richard Pearce, and Wim Wenders capture the essence of blues music and delve into its global influence — from its roots in Africa to its inspirational role in today's music. Sponsored by Volkswagen, *The Blues* project initiatives include an extensive Web site at www.pbs.org/theblues; a 13-part radio series; educational outreach; a companion book, and value-added DVDs, a CD box set, individual soundtracks for each show, a single "Best of" album and individual artist recordings. *The Blues* project will also go "On the Road," to a national schedule of film,

Courtesy of Vulcan Productions

The press release announcing *The Blues* television series and airdates (page 3).

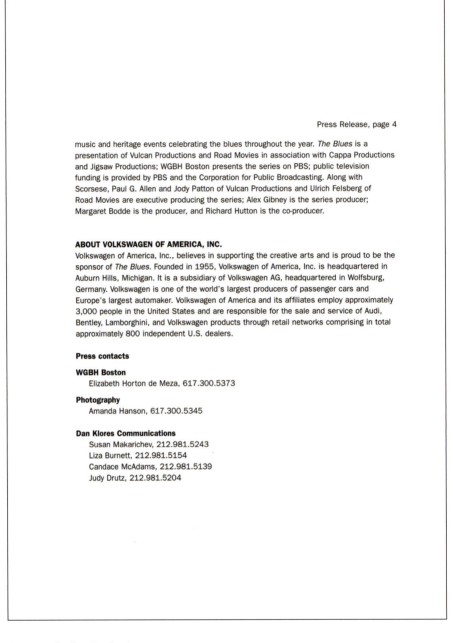

music and heritage events celebrating the blues throughout the year. *The Blues* is a presentation of Vulcan Productions and Road Movies in association with Cappa Productions and Jigsaw Productions; WGBH Boston presents the series on PBS; public television funding is provided by PBS and the Corporation for Public Broadcasting. Along with Scorsese, Paul G. Allen and Jody Patton of Vulcan Productions and Ulrich Felsberg of Road Movies are executive producing the series; Alex Gibney is the series producer; Margaret Bodde is the producer, and Richard Hutton is the co-producer.

ABOUT VOLKSWAGEN OF AMERICA, INC.

Volkswagen of America, Inc., believes in supporting the creative arts and is proud to be the sponsor of *The Blues*. Founded in 1955, Volkswagen of America, Inc. is headquartered in Auburn Hills, Michigan. It is a subsidiary of Volkswagen AG, headquartered in Wolfsburg, Germany. Volkswagen is one of the world's largest producers of passenger cars and Europe's largest automaker. Volkswagen of America and its affiliates employ approximately 3,000 people in the United States and are responsible for the sale and service of Audi, Bentley, Lamborghini, and Volkswagen products through retail networks comprising in total approximately 800 independent U.S. dealers.

Press contacts

WGBH Boston
Elizabeth Horton de Meza, 617.300.5373

Photography
Amanda Hanson, 617.300.5345

Dan Klores Communications
Susan Makarichev, 212.981.5243
Liza Burnett, 212.981.5154
Candace McAdams, 212.981.5139
Judy Drutz, 212.981.5204

Courtesy of Vulcan Productions

The press release announcing *The Blues* television series and airdates (page 4).

Media alerts or media advisories are cousins to press releases, but are shorter and specifically for publicizing events to the press. They serve as an invitation to the press for the event and provide some background information. Ideally, they are sent out several weeks in advance of the event to give reporters time to fit the event into their schedule.

Press Release Distribution

Traditionally press releases were mailed and faxed. Now they are e-mailed and distributed by online news release services such as Business Wire and PR Newswire. If you're e-mailing a press release, also be sure to also paste it into the e-mail so the journalist doesn't need to open the attachment.

The news in a press release has a shelf-life. If it's breaking news, media outlets will scramble to run the story first. In that case, online media outlets have the advantage with instantaneous distribution. So, to coordinate the timing, embargo the release and send to the top non-online media outlets and pre-brief them. This way, the story can run in tandem with the online outlets. Be sure to have your spokespeople available for interviews the moment your press release goes public.

In an era when new information is dropping by the moment, don't expect a press release that's three weeks old to be newsworthy. But sometimes interest bubbles up later because a larger or different kind of media outlet picks up a story from a small media outlet.

Items in Page Six at the New York Post get picked up and distributed to a lot of different places. Hollywood Reporter is picked up by Reuters. While some of the blogger pieces may be small, some are considered "dynamic bookings" because they often get picked up and repeated in other outlets. Often times if you get someone booked on Ellen or The View, it gets picked up on blogs and social media.

—John Murphy, president, John Murphy PR

Unless it's major news, two competitors of equal stature won't run the same story because they are looking for fresh and exclusive stories. That's why having many story angles and spokespeople is vital to securing multiple stories from a single press release.

Press Kits

Press kits are an ensemble package of materials about a project including text, video, graphics, photography, and review copies provided to the press to enable them do their job. Press kits are commonly used for company launches, product launches, press conferences, and events.

Press kits used to be creative, highly-designed packages that were developed to catch a reporter's eye and win design awards. Some of the most creative and stunning press kits have come out of the entertainment industry. But with the move to digital information and the high costs of production, printing, and shipping, those days are gone. Today, most press kits are **Electronic Press Kits (EPKs)** with digital marketing and promotional elements provided on CDs, DVDs, USB flash drives, Web sites, or by e-mail. Each document in the kit is provided electronically on project or company letterhead. All press kits can also be housed on your Web site in a downloadable format.

Hard copies of press kits are still used at live events and are useful business sales tools for potential funders, partners, and distributors. They are organized in a file folder with the property's logo on the front. The press release should always be on the top of the right side and background materials on the left side.

Whether an EPK or a hard copy, press kits include common components of:

- Press release—with current news announcement or an overview of the project
- Backgrounder—with historical information on the project
- Fact sheets—for the overall project and for each key platform or project component provided in outline and bulleted format (includes specifics and timelines)
- Biographies—directors, producers, writers, actors, artists (no more than 200 words)
- Art—high resolution photos, designed artwork, posters, logos, title treatments (JPEG or TIFF)
- Video—CD/DVD/flash drive/link of video and audio sizzler or promo reel, scene cuts, and clips such as behind-the-scenes footage, trailers, teasers, and gameplay (rights must be cleared for media use)
- Review copy—flash drive/link of movie, television show, book, game, or digital media
- Collateral/promotional item—poster, postcard, or tchotchke (optional fun promotional item)

Television and film press kits are similar, requiring a press release, film or series description or synopsis, film or series fact sheet, TV episode fact sheet and descriptions, cast and crew bios, press contacts, and live links to the film or program's trailer, Web site, and social media platforms.

At film festivals and industry market events, press kits are provided in a PDF format and are posted online so film press and potential buyers can access them from anywhere. These are single, long PDFs including technical information about the film's length and format; the logline; a 100-word synopsis of the story; a 400-word film synopsis; the director's vision statement; bios; production credits; awards; sales, distribution, and press contacts; and live links to clips and online assets. The art should include the film logo, concept art, headshots, and production shots.

Game press kits expand during the publicity process.

We launch a press kit the first time when we introduce a game title and then it evolves over time. We always come at it from the level, "What does someone need to write a fully-informed story about this game at this time?" For a first announcement it might be a fact sheet that has teaser details and a couple of pieces of concept art. As we move along to preview time, we want to give people a better understanding. Maybe it's directly taking screen shots from the game, a trailer, and an in-depth fact sheet. And, when you get to launch, you're looking to provide the full information and as many high quality assets as possible.

—John O'Leary, account manager, LaunchSquad

The assets include high-quality screenshots (five to 50); an icon and game logo; a photo of the game package; and an option to download all screenshots onto a zip drive.

Book press kits require a short press release; a one-sheet on the book's specific features; an author bio; an author Q & A; the book tour schedule; PDFs of book excerpts; a high resolution photo of the book cover; agent, publisher/publicist contact information; and online assets.

Photography and Art

Compelling visuals represent media properties. The close-up shot of Heather's video camera-lit face and terrified eyes, punctuated by a tear running down her cheek, from *The Blair Witch Project* became a memorable and eerie visual communicator of the film's premise.

Visuals are critical to your press kit. Online and print journalists rely heavily on still images. With the abundance of video, still photos must work even harder to compete. Photographs are about observation as much as they are about a creating a fixed piece of art. Journalists and photo editors choose photography and art based on how well the images combine with the story elements to advance the narrative—a pillar of photojournalism.

There are different types of photos that you may need, including formal cast shots, action shots, behind-the-scenes production shots, and photos of the product if it is a DVD, CD, game, or book. Cast and product shots are taken in studio and cast, action, and behind-the-scenes shots are taken on set after the final take or during a break.

Action shots offer the best opportunity to tell a story. Screen shots or re-enactments are the action shots for television, film, online video, and theater. Gameplay screenshots are the action shots for games and other interactive media. All action shots should include key characters in action, relating to each other, or in conflict. In documentary film, press photography includes key interviewees' headshots or at work, historical photos, re-enactment shots, screen shots, or production shots. Securing photos of high quality or strong narrative value can be challenging for documentaries.

© John Rogers; Courtesy of Vulcan Productions; Courtesy of WGBH Educational Foundation. *NOVA* is a trademark of WGBH Educational Foundation.

A signature shot of Charles Darwin from PBS' *Evolution***, a co-production of the WGBH/***NOVA*** Science Unit and Vulcan Productions, depicting his conflict with the Anglican church after the death of his beloved daughter. Taken during a shooting break in England, this was the most-used shot, appearing thousands of times on magazine covers, newspapers, and in online coverage.**

Behind-the-scenes shots should include film equipment, showcase the production values, and include the cast and crew in action or during a break. Think about who stands stage right (camera left) because captions run left to right. All photos should be supplied with complete captions and credits.

Pictures and art can be vertical and horizontal. Vertical shots focus viewers' attention on a single subject, removing the sense of peripheral vision. Verticals are best for posters,

cover art on magazines, Sunday TV book inserts, and headshots. Horizontal shots are best for photos of large casts and action shots because they convey background and perspective. Horizontal shots are generally favored online. Keep those in mind when you're preparing photography shot lists and designing concept art.

Company or project logos, designed art including illustrations, photography with graphics, or fully-designed graphic art are also supplied. Photography and art should be supplied in high resolution (high res) format. That means that the resolution or DPIs (dots per inch) are high enough that the image will be crisp and not pixelated. Different media have different minimum DPI requirements. High-end art magazines require 600 DPIs, although the print standard is usually 300 DPIs. The online standard is 72 DPI and it's not advisable to put larger files online because they will take more time to load and use up unnecessary bandwidth.

The image size or its dimensions are important and are also provided by "width \times height" such as 1280 \times 1024. A screen shot taken on a computer is always 72 DPIs, but if it's taken on a 19-inch monitor at full size, when it's shrunk down to a smaller size its DPI will increase and may be of high enough quality to use in other media. Always set your computer to capture images at the largest dimensions possible to increase the quality or resolution of screen shots with online screen grabs.

File size is different than image size. It's a measure of how much space the image takes up on a hard drive (kilobytes or megabytes). Never attach high resolution photos or graphics to e-mails to journalists. They can slow down or crash the media outlet's system. Compress them onto a zip drive or use a file sharing system or FTP site.

(Concept and key art for entertainment projects are covered in detail in Chapter 20, "The Art of Art").

Pitch Letters

Pitch letters are cover letters to the press accompanying a press release or press kit informing journalists of news and soliciting media coverage. Traditionally pitch letters were a page in length and mailed with press releases and press kits. Now they are e-mailed and are a few paragraphs in length, serving as a lead-in to a press release or other information. The subject line should briefly say what it's about, using key words to help a journalist identify it in their Inbox. It should not be in all caps.

Good pitch letters are professional, but natural. Natural doesn't mean starting with personal comments, cheesy opening lines, or using MBA-speak. Just get to the point quickly. A pitch letter starts with a brief synopsis of the news and one or two tailored story ideas. Formulaic pitch letters never work. The pitch letter should also provide logistical information such as events dates/times, interview availabilities, contact information, which photos are attached, and an alert that the press release is pasted in the e-mail.

Like press releases, pitch letters should not be jargony or *clichéd*. David Pogue, a technology and science reporter who runs *Yahoo Tech*, contributes to *Scientific American* and *CBS News Sunday Morning*, and hosts *NOVA ScienceNow*, wrote an amusing and useful post on his Tumblr blog, *Pogueman* about a publicity e-mail pitch he received (October 18, 2013).

A Note from Pogue—A Free PR Critique

If you're a tech writer, you hear from a lot of public relations people pitching their clients' wares. Usually, if I'm not interested in what they're pitching, I just delete them. (The pitches, not the people.)

Today, though, my Inbox encountered a particularly persistent PR woman. She hadn't gotten the hint. She followed up twice to ask why I hadn't replied.

"Not to bug you," she wrote, "but just wanted to get your thoughts on the last email. If you're in—cool. If not, please give me some feedback."

Feedback? She wants feedback? I've got some feedback for her. In fact, I'm prepared to offer her a complete critique, complete with some insight into the life of a tech writer. No charge.

Here's her pitch — with my notes interspersed.

Hi David. Wanted to chat with you about a shift in eBooks—digital publishing mobile apps such as [her client's name], which is at the forefront of what we like to call the content convergence trend.

Wow. "Digital publishing mobile apps?" "Content convergence trend?" So far, we have one sentence and seven buzzwords. And no mention of her product.

Rule #1 for PR folks: Know your target. If she knew anything about me, she'd know that <u>buzzwords are my pet peeve</u>. (Actually, if she knew anything about *any* tech writers, she'd know that buzzwords are a *universal* pet peeve.)

All right, going on:

Convergence tech *and the **"single screen" lifestyle** have brought a rise of **digital content platforms** displaying a **wide array of media**, usually a **massive library of digital content** (Netflix, Xbox, Kindle, eBook)—but what's next? As our media grows closer, the lines begin to blur and the once passive audience is now becoming **participants in their media through interactive content**.*

Observation #1: Your prose is so filled with buzzwords (boldface added), I have no idea what you're saying.

Observation #2: Two paragraphs in, and I still don't know what the heck you're pitching.

*There are a ton of companies who are digitizing e-books, but not the way that [my client] is. For example, [rival company] may have what they call "interactivity," tapping a screen to switch pages, but [my client] **takes interactivity to a deeper level**—choose your own ending stories, point and shoot games, sound and visual effects when touched—that's the **next level of interactivity** [my client] is pushing. In this way, [my client] is **laying the groundwork for opportunity**—we are on the **forefront of the trend**.*

Oh, good! She's switched from buzzwords to clichés.

Unfortunately, it doesn't last long. We're back to empty buzzwords:

*In addition, the **platform** itself **serves as a discoverability hub** that tackles a different and **underserviced set of media**—mobile games, interactive comics, graphic novels and **lifestyle content**. The crossroads for all four of these companies is "original content"—[my client] was founded on a **platform of original content**, while the others started as a **distribution platform for existing content** that are now beginning to see the merits of **originally created content**. As an original entity from day one, [my client] is taking on the **digital publishing space** with a **multiple tiered approach** that combines the **innovation of new content**, **licensed content from premiere partners**, as well as inviting **independent content creators** to create and share their work.*

*As **thought leaders** in the **original content space**, we have some big plans and aspirations and would love to keep you updated along the way!*

Would love to hear your thoughts on this and possibly work together on a feature.

Six paragraphs in, and I still don't know what she's pitching. What's the product? How much does it cost? What machine does it run on? Is it out yet?

I'd be surprised if she got a single feature article out of her pitch, even from no-name bloggers.

But maybe I'm being too harsh. Maybe she's fresh out of college and this is her first summer in PR. Maybe she doesn't know how busy newspaper writers are.

Maybe, to be fair, the *client* directed her to incorporate such opaque, nebulous prose, perhaps over her strenuous objections. (I happen to know that that happens.)

So maybe it would be kinder simply to rewrite her pitch in a way that would be much more effective.

Here's my rewrite:

Hi David:

E-books are great and all, but they're still just words on a screen. We make something more ambitious: multimedia comic books. As you read, you can tap the screen to trigger animations, play little games and even change the story line.

Our first title, "Superhamster," is a $1 app for iPad. It's been in the App Store's top 20 e-book downloads for six weeks, with an average user review of 4.8 stars. If you're interested in a review copy, say the word; we think your readers would love it.

Now, if she had sent me *that* pitch—well, I'd probably still have deleted it.

But that product, and that PR rep, would have caught my attention. She would have had more success getting other reviewers interested. And in my heart, I'd have thanked her for her clarity, brevity and intelligence.

So there's your free advice, PR folks. Write your message in English—or risk being flushed right down the discoverability hub.

Permission provided by David Pogue

Pogue's comments apply to all press materials and press communications. This publicist's pitch letter didn't work, and well-written ones often don't either. The conversion rate of PR effort to actual story placement in media relations is low. Don't dismay. And don't hound the reporter. The subject line and opening sentences are enough for the reporter to decide whether they're interested or going to pass. If you don't hear back after a week, a telephone or e-mail follow-up is OK. Beyond that, let it go. Put your energy into a different reporter or media outlet.

All of your communications with the press need to hang together as a professional, informative, and respectful body of work. When the spokespeople, messages and story angles, written materials, and pitch are in harmony, the whole is greater than the sum of the parts. Then your project's story is more likely to be covered by the press.

Author's Anecdote

Communicating a Timeless Concept With a Press Kit

© Camilla Anne Jerome; Courtesy of Vulcan Productions; Courtesy of WGBH Educational Foundation. *NOVA* is a trademark of WGBH Educational Foundation.

For *NOVA*'s 2001 *Evolution*, the press kit cover was an exact replica of Charles Darwin's hallmark 1859 *Origin of Species* book. The inside included a DVD press kit and a trivia game about evolution in everyday modern life.

CHAPTER 16

Media Events

The most effective way to communicate is first, in person; second, over the phone or Skype; and, finally, through the written word. There are times when interacting live is more compelling for your influencer audiences than press materials, pitches, or telephone interviews. Industry events, major announcements, and important dates can be reasons to showcase your project to the press. Press events can be serious affairs such as press conferences or they can be more promotional in nature, but where the press is also invited. You can create your own press event for your project from the ground up or insert it into a bigger, pre-existing event such as a conference, trade show, market, or festival, covered in the next chapter.

Choosing Talent

The two main considerations in choosing talent for your event are to determine the purpose of the event and the target audience. Is it intended to sell the project to distributors, generate superfan buzz, boost an actor's visibility, or a combination of goals? If it's a business announcement, then senior executives who know the particulars of the deal should be present. If it's a sneak peek to industry journalists and critics, then cast and crew who can deliver sizzle should be present.

In your marketing plan, you identified a number of spokespeople for press interviews and events. Now determine which of these make the most sense for the publicity and business goals of that media event. Your spokespeople at a press event need two strengths. First, to be able to handle the press in an interview situation; second, to possess showmanship or presentation qualities. Even if the event is for serious business purposes, the press event should not be boring. Spokespeople who are authentic and engaging are more widely covered by the press.

Each spokesperson at the press conference should wear a "hat." For example, one person may handle the business presentation and questions; another may explain the project's creative process; and another (often the talent or celebrity attached to the project) may provide the sizzle. Not only should you reach the goals of the press conference, but also communicate the project's overall messages. One of the key messages of *Martin Scorsese Presents the Blues* was to present the past and future of the music genre. The project had both established and up-and-coming music artists appear at events. Their verbal interplay usually segued into a spontaneous musical riff, communicating the project's key messages.

In advance of any media event, the entire formal (non-social) part of the conference is mapped out for messaging and flow. Each spokesperson is media-trained using the project's Q & A. Clarify which spokesperson delivers what type of information. More than one person can speak about the same issue, but each should offer a different perspective.

One person, either a senior publicity executive, project director, or producer, must be chosen to "host" the press conference. They should be adept at running the show, getting all the news and backstory delivered, ensuring that all spokespeople have a chance to speak, handling difficult questions, and delivering an informative and worthwhile experience to the journalists. This is a very important role at media events and should only be run by people with confidence and experience.

Press Conferences

Press conferences are used to make major announcements, update breaking news, or serve as ongoing press vehicles for influential entities. Whether a foreign policy announcement at the White House or the début of your media project at an industry event, press conferences are all pretty similar. There are short, formal remarks or presentations, followed by a longer Q & A.

From several weeks before the press conference up to the day of the event (for breaking news), the project sends a media alert to invite press. Producers, assignment editors, and editors decide whether the event is newsworthy and assign reporters to attend. Publicists try to determine in advance who's coming through their media follow-up to the alert, but many journalists simply show up.

The press arrives at a check-in area where they receive a press package with a press release and background information. Only some sign in so be sure to have a publicist there who knows journalists by sight to identify which press are attending. Track their reactions and needs during the conference. The last thing you want is a journalist from the most powerful industry trade publication being cut off during the Q & A. And follow up and track their coverage after the conference.

The room is usually set up theater style with a podium, dais, table, or stage where speakers present. The press sits in the audience. The designated host introduces the press conference by briefly welcoming members of the press and stating the reason for the press conference. The host makes the announcement or provides background or throws to a producer, director, or other significant entity on the project. If the conference is about a film, television, online video, or game property, a one- to three-minute trailer or sizzler reel is shown after the introduction or announcement. Additional talent such as actors, screenwriters, and musicians join the Q & A.

After the formal remarks, members of the press ask the spokespeople questions during the Q & A. The host must be attentive as to whose hand was raised first and try to honor questions in that order. Sometimes a stationary mic is set up and members of the press line-up in order to ask questions. More often, fleet-of-foot publicists get the mic to journalists quickly to maximize the number of questions asked. Ideally, three-quarters of the press conference is devoted to the Q & A. Journalists attend to dig deeper and get specific quotes; they can get the formal part of the press conference from their desks. If there is a lull in the questions, then the host should add some information to fill the void or ask a "softball" question to another spokesperson onstage. Every person onstage should speak at least once.

It's OK to end the press conference with a few questions left unanswered, but be sure that all the obvious questions have been answered and all top-tier media outlets have had a chance to ask questions. Depending on the venue and the circumstances, spokespeople can be available after the press conference to do interviews.

Film Festival Conferences

In film, press conferences generally occur for major films having their world premiere at a film festival. Then the festival holds special **Press and Industry (P & I)** screenings for accredited journalists and industry professionals, organized by the festival's press and industry office, which is where the press sign in and receive their accreditation and access press releases, press film notes, film theme sheets, photos, screening schedules, and press conference schedules. Press screenings are separate from public audience screenings, open to festival pass and ticket holders.

The first public screening at the festival, often the film's world premiere, includes a brief introduction of the film by the producer and a film screening. Afterwards, key members of the production's cast and crew go up on a stage and are available for Q & A, which lasts 20 to 30 minutes.

Before the festival, the filmmaker and publicist develop a complete film festival press strategy, determined by the goals of the project—whether to find distribution or be a media launching pad for a film with distribution. The Toronto Film Festival is a key venue to début Oscar contenders for the following year.

The film festival publicity campaign usually starts with a canvassing of the press to have your film included in day one, "curtain-raiser" pieces. The publicist lets the press know about the screening dates and times, and sets up a day for interviews with filmmakers and film talent on site at the festival. This generally occurs after the first P & I and public festival screening.

—John Murphy, president, John Murphy PR

Television Critics Association Press Tour

In television, the Television Critics Association Press Tour (TCA Press Tour) is a biennial, two-week event in which networks and cable present their new programs and new seasons to about 200 of North America's top television critics. The July press tour launches the fall television season and the January tour launches winter/spring. Networks are allotted approximately two days for press conferences, and cable channels split up the remaining days. Which cable channels get a presentation slot in the days allotted to cable is always hotly contested because of the growing number of cable channels.

Traditionally, the summer press tour was the more critical event because of the glut of fall premieres; it was also where the networks' promises to advertisers the previous May in the Upfronts were first held accountable. But with year-round premieres, the winter tour has become equally influential. Networks host Executive Session press conferences in which the network presidents present the networks' "State of the Union" and announce upcoming programs or acquisitions. The heads of programming are also present. These can be tough sessions given that 85 percent of new television programs fail and critics are a discerning and jaundiced lot.

The rest of the press conferences are dedicated to individual programs, which also follow press conference format and include a three-minute sizzler clip and a Q & A with program creators, cast, and crew. Conferences last between 30 and 45 minutes and occur from about 9:00 a.m. until 6:00 p.m. daily with just a few writing breaks for the critics. There is no fawning or clapping at this event. Critics conduct interviews for stories and reviews, secure exclusive quotes, blog, and live-tweet from press tour. Each tour generates 40,000 stories, with approximately 45,000 more stories held back and released at premiere. It is an astoundingly grueling, but productive industry event. That's why TV critics call it the "Death March with Cocktails."

Game Conferences

Press conferences will occur as part of the larger industry events such as E3, PAX, or the Game Developers Conference. The biggest press conferences, hosted by Sony and Microsoft to introduce new consoles and the titles associated with those hardware launches,

are highly-produced affairs. They may book a major offsite venue with as many as 1,000 attendees, video clips, light shows, game demos, a formal presentation and Q & As, followed by a party. Game publishers sometimes host smaller media events and announcements for credentialed journalists and top bloggers behind closed doors at the event site, which in turn generate buzz among all conference attendees.

Media Tours and Press Junkets

Sometimes talent is taken on media tours, from city to city. This is common in book promotion where authors of big books conduct multiple city tours with readings at retail stores and libraries and press interviews in each city. To save time and money, media tours are often conducted by satellite. Satellite time is purchased and talent is available for Q & A for a specified amount of time. Television networks or online entities can access the talent during the satellite time and tape the interview for broadcast or streaming.

Sometimes it's the other way around and the press travel to the talent in junkets. Junkets can be on the set while the film or TV program is in production, at a special location to provide exclusive "hands on" access to a new game, or, closer to premiere, at hotels where talent provide several days' worth of interviews to press. Usually there is a film poster or film art behind the talent for photos and video clips. Publicists are always in attendance and in advance try to steer the interview to reflect the film in a positive light. Press junkets are very expensive. Usually, just top-tier journalists and very influential film bloggers receive invitations to press junkets.

Credentialed industry journalists also receive special access to talent or the project at press conferences and media interviews at key industry press events, such as the Television Critics Association Press Tour or during the game industry's "Judge's Week" before E3.

All-purpose Events

Finally, there are all-purpose promotional events, which are designed to create buzz among influencers and press that showcase media and entertainment properties.

If you host a US-focused launch event or party for a game, you'd want to do it in San Francisco, Los Angeles, or New York to reach the largest group of consumers and press. You want it very games-focused, so maybe you'll have the game on demo there and a projector that has video of the game in action on a loop.

—John O'Leary, account manager, LaunchSquad

For digital media, San Francisco is a top influential market because it's a technology hub and the home of many games and interactive media influencers. In film, promotional screenings are held in as many media markets as the distributor can afford, followed by a party at a nearby restaurant, club, or special venue.

That venue can signal value and deliver a subliminal message. A game about evolution gone awry might be held at the American Museum of Natural History in New York. A television program about the history of radio might take place at the Paley Center for Media in New York. A film about espionage might hold an event at the Spy Museum in Washington, DC. And a documentary with significant policy implications might host a Capitol Hill screening for legislators. Timing matters too. A media property about fashion or high art might host a high-profile screening during New York's Fashion Week.

When entertainment industry organizations host or co-host the event, they confer credibility, such as the Paley Center for Media, The Television Academy (formerly the Academy of Television Arts & Sciences), the Academy of Motion Picture Arts & Sciences, the Entertainment Software Association, the professional guilds, and media outlets such as *Variety*, *Hollywood Reporter,* and *IGN*.

Sometimes project-specific events are attached to larger existing events. Events about the intersection of technology, media, and culture include TED, the Aspen Ideas Festival, and the SXSW Festivals. There are serious influencer events such as the World Economic Forum, and lighter "fanboys" and "fangirls" audience events such as Comic Con. Many events take place around entertainment awards ceremonies and film markets and festivals.

Your project's presence and the feel of the event will vary from one event to the next. It can range from theoretical discussions with academic experts to all-out celebrations with live music, dancing, and alcohol. The all-purpose event is somewhere in the middle with a short presentation, high-profile talent saying a few words, a clip or full screening, and an after-party with cocktails. Even though these events have a social element, the press is invited and should be handled using traditional press protocol. The press receives press packages and publicists are on hand. Photographers shoot pictures of high-profile talent and tastemakers—both candid and staged photos in front of a step-and-repeat banner (backdrop with logos repeating in a stepped or diagonal pattern). Lengthy interviews don't usually occur at these events, but these events may warrant mentions or inspire feature stories.

Because these events require large venues, food and beverages, and high-profile talent, they are very expensive. Usually, only big blockbuster or tentpole projects can afford them. With all the alcohol flowing, it is important to ensure that all project representatives are careful about what they say throughout. Overheard comments end up on attendees' Facebook pages, "Page Six" of the *New York Post*, and TMZ.

All events—press conferences or parties—require logistical planning, such as staffing, signage and branding, giveaways, press materials, venue selection, audio-visual, lighting, security, fire regulations, permits, valet parking, and refreshments. These details are time-consuming and critical, so be sure to have an experienced event specialist handling the event logistics along with your publicity team.

Public Speaking

If your project participates in the vast array of press, industry, cultural, and economic events presented in this and the next chapter, then you or others may be presenting the project formally at announcements or informally through panel discussions. A big part of being a media maker and a media marketer—the CEO of your project—is being able to present yourself and your project in a natural, engaging, and compelling way. For many people, public speaking is terrifying. For most it's a bit nerve-wracking. Like everything new or scary, the more you do it, the easier it gets.

Presentations

If you have a formal presentation for your project to the press, industry, or tastemakers, your primary job is to find your authentic voice. This isn't about whether your voice is high-pitched or fast, it's about natural breathing, trusting your words, and connecting with the audience.

Start with the recognition that the audience is always rooting for you. They're there to learn from you, not judge you. You have something that they want—information, perspective, and expertise—so you're in the power position. Your job is simply to serve up what you already possess. And then, consider the old saw, "What's the worst thing that can happen?" You lose your way or the A/V goes haywire? You can always laugh it off and look like the hero. And you want to use as many visuals as are reasonable to take some of the heat off you during your presentation.

And you must prepare well. The most natural presentations are extremely well-prepared, but don't look like they are. The best news announcements get to the point quickly, but set the stage for the announcement so it has a bigger bang ("A year ago at this event, there was but the promise of technology to do X. Today, it's arrived"). They explain the details of the news clearly and simply, and then go straight to the Q & A. The best general presentations start with an engaging or personal open. Then they set up three messages and pay off on them by providing detail and relevance. They close by wrapping those three things into a single idea. Both news announcements and general presentations end with thanking attendees for their interest.

Once you have your presentation outlined, present it by yourself to check for time until it's the right length and you know it well. If it's too long, talking faster is not the solution. Cut it back. Then present it to colleagues, friends, and family. Don't use a full script. Use cards or an outline. And never use a text-heavy PowerPoint or Keynote presentation. Think visuals or simply talking naturally to the audience.

Conference Moderators and Panelists

If you're invited to moderate or participate in an industry panel, say "Yes." Industry panels position you as an expert, allow you to network with industry influencers, and get exposure for your media project. The best conference panels are provocative and spirited. They ask more questions than they answer.

Panel moderators and panelists alike should be brief and authentic. Don't go off track, use jargony words, or assume your audience knows what you're talking about unless something's already been discussed.

If you're a panelist, get the audience thinking more deeply or in new ways about a subject and bring a specific perspective to the panel. Know what "hat" you represent on the panel and be sure to forward it (the writer, the interactive tech guru, the horror expert, etc.). Feel free to build on others' thoughts or perspectives or respectfully disagree. Also, panels are not a forum for shameless self-promotion, but you can use your media project as an example of a key point—if it appears natural and seamless.

If you're a moderator, bring out the best possible discussion for the sake of the audience. Look for ways to catalyze lively interactions among panelists and with the audience, and let the panelists and audience shine. Moderators can make connections between things speakers have said so the whole discussion feels cohesive.

The best panels are animated and fun, delivering insightful information through unexpected or revealing stories.

© Anne Zeiser

Two of *Martin Scorsese Presents the Blues* directors, Mark Levin and Wim Wenders, on a Sundance Film Festival panel about directing both fictional films and non-fiction documentaries.

Social media has changed news cycles, press events, and industry events. Traditionally, reporters had elite access to news and would rush back to their desks after a press conference to file a story. Now, reporters, bloggers, and attendees post to social media sites during events, so news breaks from non-press events and everywhere else. Social media has threatened journalistic protocol and pulled down the veil of secrecy and exclusivity at press events.

So remember that everything you and your project talent say at every event is instantly public, whether it's a small university gathering or a big industry event. Embrace this new era. Ensure there's Wi-Fi at your venue. Create an official hashtag for the event so attendees can track each other's comments. Track the social chatter around your press announcement or event to get a sense of what's being said, and respond accordingly.

Author's Anecdote

Journalism's Smackdown with Social Media

As part of a network awareness campaign for PBS to position the network as the presenter of quality content, I was among a team of media relations heads who developed a national press event entitled "News and Documentary TV in a Tabloid Culture." It was held at and moderated by Reuters in New York. Panelists included PBS president and CEO, Paula Kerger; *Frontline* senior executive producer, David Fanning; journalist and author Carl Bernstein; then *US Weekly*'s Janice Min; *Vanity Fair*'s Michael Wolf; NPR's "On the Media" host, Brooke Gladstone; and Columbia School of Journalism professor, Todd Gitlin.

More than 50 journalists attended, including ABC, NBC, and CBS. The event also garnered coverage from *Broadcast & Cable*, *New York Post*, *New York Daily News, Huffington Post, Media Bistro*, and *BuzzMachine*. But the most interesting and ironic aspect of the event was when Michael Wolf got into it with Todd Gitlin, launching *ad hominems* about how journalists who can, report; and journalists who can't, teach. It got tabloid-ugly and a savvy blogger captured the f-bomb-laden exchange on his cell phone and posted it on YouTube. PBS' big P-head logo was prominently displayed, signaling that it was the host of this tabloid expression of "quality journalism."

PART V

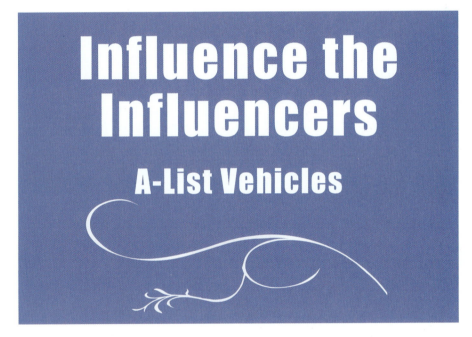

Influence the Influencers

A-List Vehicles

Markets, Trade Events, and Festivals

Whether your project launches first to the entertainment industry, press, or public audiences, attending industry events is important to your project's success. Sometimes, a presence at these events simply adds to existing buzz and credibility. Other times, it's the difference between getting your project produced and distributed, and not.

Each industry, platform, and genre has its own set of events. Industry events vary from public-facing events to those that are solely for working professionals. Either way, a lot of business occurs behind the scenes at them. Start with this overview of key industry events and then make your own list of events for your project. Look at how these events sync up with your project's timeline, business needs, announcement and release strategy, and publicity efforts. Then consider using these events to achieve key objectives of your marketing plan.

Markets and Trade Shows

Trade fairs, markets, and exhibitions have been around since the Middle Ages as a means for business-to-business (B2B or B-to-B) deal-making, communications, and promotion. These events efficiently reach your industry audiences at one place, at one time, allowing for direct contact, product demonstrations and launches, and marketing communications.

In entertainment and media, there are a number of key markets where the primary reason for gathering is the sales and financing of projects to worldwide distributors. If a project has strong presentations or one-on-one meetings at these events, a distributor might license it and even co-finance it. So these events are critical for the early days of a project. They're valuable for pitching projects to potential co-producers, financers, and distributors and for staying apprised of industry trends and players.

The core business of markets is selling and buying. Sales agents and distributors are looking to sell or license properties domestically and internationally. They rent space at markets so they can screen films or present media projects, disseminate marketing materials, and meet with representatives of distribution territories.

At the American Film Market (AFM), the top film market, creating the right climate for deal-making among the world's film producers, distributors, buyers, and sellers is so important that the hotel rooms at the market's host hotel are turned into temporary offices for independent production companies looking to license and sell their upcoming films and projects. Behind closed doors, film companies screen trailers and clips and buyers and sellers negotiate distribution and financing deals, which results in $1 billion of business yearly. Twenty of the Academy Awards' last 31 "Best Picture" winners were licensed or financed at the AFM. Major AFM-presented films include *Million Dollar Baby*, *Mr. and Mrs. Smith*, *The Lord of the Rings* trilogy, *The King's Speech*, and *The Hurt Locker*.

American Film Market is the bookend to Cannes Marché du Film. They're six months apart. One is in Hollywood, which is the destination for everyone who is a professional in the film industry. The other is side-by-side with the most significant film festival that takes place. They're very similar—the same amount of business is done and the approach is the same—exhibitors selling film, participants buying film. You'll have the same distributors or exporters and the same buyers or importers. At AFM you may have more North Americans and at Cannes more Europeans. And, because Cannes is concurrent with the festival, the focus is a little more about finished films and at AFM is a bit more about presales—films in development and in production.

—Jonathan Wolf, executive vice president, Independent Film & Television Alliance; managing director, AFM

Permission to reprint photos provided by IFTA®

(Left) The entrance to the American Film Market (AFM) at the Lowes Santa Monica Beach Hotel, which takes over the beachfront resort area for more than a week every November; (Right) The AFM hotel lobby is where attendees meet up before screenings and meetings.

Many markets also have film or other showcase festivals occurring simultaneously. They're audience-friendly, but have a palpable undercurrent of hard business. Many audience festivals have turned into industry festivals, becoming *de facto* markets, where business occurs, but is less visible than in a market.

To make the best of markets, trade shows, or festivals, you must plan for them well in advance. Start by working with your marketing, publicity, and distribution team to determine how and when markets fit into your overall strategy. If you're looking for domestic distribution, you can hire a producer's representative, to whom you license the rights for a fee or pay a percentage of the domestic deal. Some are terrific, but many prey on content creators desperate for distribution by name-dropping to get an up-front fee, yet produce nothing. If you have a great product, strong contacts, and perseverance, you might be able to land a domestic deal without a producer's rep. If you're looking for foreign distribution, you should hire a sales agent. This is an area of specialized expertise and relationships. Also, there are film sales agents who sell to television and aggregators who sell digital rights for Internet and mobile distribution.

Before attending a market, you must understand the roles of these distribution players, bring on those that make sense for you, and have a POV on what kind of distribution deal you're willing to accept. Never sign away the worldwide rights to a single entity, unless it's a major studio. If you do not have a completed project, but have a script, director, and producer, you are probably looking for both financing and distribution. In film, distributors may invest in a pre-sale into foreign territories in which they obtain the film at a lower price and are more involved in its development. You must have materials for this sales process. The biggest sales piece you have is the project itself—clips and Betas of digital properties.

If your project's a film, have at least five minutes of selected scenes on your Web site to convince companies to take a meeting with you. At the 2014 European Film Market, The Weinstein Company paid $7 million for *The Imitation Game* about cracking the German Enigma Code during WWII on the strength of a 15-minute compilation reel. For a completed film, you must decide whether you will allow parties to view your film in advance. Your sales agent will want to set up a controlled screening at the event. But, if you have a limited track-record, you might need to show the film before the market. Either way, have press materials, lookbooks or visual bibles, and trailers at the ready.

Be sure to attend the beginning of the marketplace so you have meetings before all the deals have been made. Check out event attendees as soon as you're registered and start setting up meetings for the market about three weeks prior, ideally with heads of acquisitions. If you're trying to get your project bought, remember that selling is the first priority, buying the second. Also, ensure you have lawyers available to look at any deal made during the event.

Practice your pitch as often and to as many people as possible. Your pitch could happen anywhere, at a cocktail party or in an organized meeting. So have both the 30-second version that might pique people's interest and the full pitch ready to roll off your tongue.

To decide which events to attend for what reason, seek advice from as many producers, marketers, distributors, sales agents, and other professionals as possible.

Media and entertainment have myriad top film, television, games, and digital markets and trade events.

Film

- CineMart (simultaneous with International Film Festival Rotterdam)—Rotterdam, Netherlands (January/February)

- European Film Market (EFM) (simultaneous with Berlinale Film Festival)—Berlin, Germany (February)

- Hong Kong International Film & TV Market (FILMART)—Hong Kong (March)

- CinemaCon—Las Vegas, Nevada (March)

- Hot Docs—Toronto, Canada (April)

- Cannes Marché du Film (simultaneous with Cannes Film Festival)—Cannes, France (May)

- CineEurope—Barcelona, Spain (June)

- Sunny Side of the Doc—La Rochelle, France (June)

- Toronto International Film Festival (TIFF)—Toronto, Canada (September)

- Independent Film Week (formerly Independent Film Market)—New York, New York (September)
- ShowEast—Hollywood, Florida (alternating between Orlando and Miami) (October)
- American Film Market (AFM) (simultaneous with AFI Fest)—Santa Monica, California (November)

Multiple Media Platforms

- NAB Show—Las Vegas, Nevada (April)
- TIFFCOM Asian Market—Tokyo, Japan (October)
- MIPCOM (Marché International des Programmes de Communications)—Cannes, France (October)

Television

- NATPE—Miami, Florida (January)
- MIP TV (Marché International des Programmes de Télévision)—Cannes, France (April)
- Television Upfronts—New York, New York (May)

Games

- D.I.C.E Summit (Design, Innovate, Communicate, Entertain)—Las Vegas, Nevada (February)
- Game Developers Conference (GDC) (simultaneous with Independent Games Festival)—San Francisco, California (March)
- PAX East—Boston, Massachusetts (April)
- Electronic Entertainment Expo (E3)—Los Angeles, California (June)
- PAX Prime—Seattle, Washington (August/September)
- Gamescon—Cologne, Germany (August)

Technology

- International Consumer Electronics Show (CES)—Las Vegas, Nevada (January)

Festivals

Festivals are audience and industry showcases in which media projects can début, screen, and demo; garner publicity; and secure distribution. Unlike markets, festivals are about exhibition and screenings. Most festivals are also open to the public, attracting fans in film, television, games, or interactive media platforms or in documentary, comics, or anime genres.

> *I look at festivals as media outlets, not that different from a magazine or a TV network. We're taking content and we're putting it out into the world. And we operate by a lot of those same principles—our content is not for sale, it's curated. We make decisions about what we want to put out there and people can't just buy their way into our content. That's an important distinction and it gives us a lot of freedom to promote what we like and what we believe in, as opposed to who's got enough money to pay for it.*
>
> **—Roland Swenson, managing director, SXSW Conferences and Festivals**

Many events serve audience and industry in about equal parts, such as the Sundance Film Festival and the Penny Arcade eXpo (PAX) for games. They began as audience events and evolved into industry events. So the list of markets and festivals is somewhat fluid.

Festivals are a business boon to the host locales, attracting locals and tourists. South by Southwest's (SXSW) concurrent music, film, and interactive festivals infuse about $220 million yearly into the Austin, Texas economy. Festivals are supported by industry and corporate sponsors, which pay for a presence at the festival. Money is also raised through grants and ticket sales.

Film

Before the *entrée* of the Toronto and the Sundance Film Festivals in the late 1970s, there were only a handful of small festivals, mostly outside of North America. Robert Redford's Sundance precursor, the Utah/US Film Festival, was an intimate audience festival for film devotees. Today Sundance absorbs a yearly influx of 45,000+ festivalgoers ranging from film die-hards to corporate promoters. Additionally, the Sundance Institute supports the creative work of emerging and current filmmakers and film professionals through Sundance Labs on Features, Documentaries, Shorts, Film Music, Creative Producing, New Frontier, Theater, and Native American projects.

Now there are 3,000 film festivals worldwide: some are informal celebrations of the art of film and others showcase platforms for Hollywood tentpoles. Festivals also focus on

niches, such as documentaries, shorts, or Latino filmmakers, or genres, such as comedy, horror, or science. Across the board, festivals offer newcomers the opportunity to showcase their work alongside better-known filmmakers, receive press attention, get exposure to prospective agents and buyers, and win awards. Most festivals accept submissions from anyone regardless of previous work or budget. Some have categories for students.

Within film festivals, there are both audience- and market-focused festivals.

> *At an audience-based festival you get to fully enjoy why you do this as a filmmaker, because they're about engaging with fellow filmmakers, engaging with film lovers, being able to have conversations one-on-one with your audience, and watching other people's films in a much more intimate and relaxed setting. At a market-based festival you want to be sure distributors, buyers, and sales agents are aware of you for the current film, and agents, managers, and producers for the next project. And you want to drive audience interest because that's what sells a film.*
>
> **—Kathleen McInnis, festival strategist and publicity consultant, See-Thru Films**

Some of the most influential industry festivals with concurrent markets or a significant business climate include Cannes, Toronto, Sundance, Berlinale, Venice, Telluride, SXSW, Tribeca, and AFI Film Festivals. An "Official Selection of . . ." at a major industry film festival confers instant credibility and garners attention. Many festivals have become major Hollywood affairs launching films and writers', directors', and stars' careers. Sundance and Cannes did so for *sex, lies and videotape* and Toronto did so for *Slumdog Millionaire*. This X-factor makes these events all the more attractive to filmmakers and to studios as junket venues to promote their film slates, even if they're not festival selections. As a result, many festivals have become bloated with submissions, crowds, and industry gatekeepers.

There are two tracks for screenings. The first, and most sought-after track, is films in competition, which will be judged by a jury of film judges for their artistic merit, production value, creativity, and overall impression. The second track, films in exhibition, is films screened for audience enjoyment. These films still get exposure to press and potential buyers. Audiences also vote on their favorites. At the end of the festival, juried and audience awards are bestowed in various categories. Winning a "best" in a category, especially at a prestigious festival, boosts a film's status. Conferences, panels, and workshops on filmmaking, writing, marketing, and business occur alongside the screenings. Also, sponsors, major film and entertainment organizations, and media outlets have physical sites and host parties throughout festivals.

If you're looking to enter the film festival circuit, research the submission criteria on the festivals' Web sites. Films must be finished, and, at some festivals, may not have screened at other venues. You must submit by the festival's submission deadline and into their categories such as Drama, Drama Short, World Cinema Drama, Documentary, Documentary Short, World Cinema Documentary, Animation, and Experimental or Interactive. Withoutabox allows you to submit online to more than one festival. But, you must begin by consulting with your distribution and marketing experts to analyze how festivals can support your film's goals.

Festivals are a case where more is not better. Too many festivals can over-expose your film and make it look undesirable. And, while a big industry festival may seem like a slam-dunk for your world premiere, it also could be too overpowering of a venue for your film to meet its best reception. A seasoned festival strategist (PMD) can help you develop a plan based on your film's genre, content, natural audience, and business goals, and identify festivals that might embrace a film like yours.

> *My top festival advice for filmmakers is first, know that it is in your power to set your goals and expectations. You are offering a product as much as festivals are offering you a spot for that product. Second, think about the circuit strategically. Look at your festival strategy in three-month bites to be able to be fleet-of-foot and adjust as you get responses and find where the film is fitting. Quit going to Withoutabox and throwing away all your money just because they send an alert that there are 30 festivals whose deadlines are coming up.*
>
> **—Kathleen McInnis, festival strategist and publicity consultant, See-Thru Films**

If you're looking to sell your film to distributors at festivals, know that the odds are against you. Sundance receives more than 12,000 submissions for about 130 slots and the Tribeca Film Festival receives more than 3,000 submissions for about 90 slots. And, at each festival, 10 or fewer films find distribution.

If your film is lucky enough to be accepted into a major festival, then the work is just beginning. Some films spend as much as $50,000 on festival premieres in an effort to secure distribution. If you're accepted into Cannes, Toronto, or Sundance, hiring a producer's rep or sales agent along with your publicist might make sense. You set up and promote screenings, secure press coverage, and host parties to demonstrate your film's audience potential to distributors. A few positive reviews in key trade press may entice managers, reps, and agents to sign you on or get noticed by distributors' acquisitions teams. (The rest of the reviews are banked for the theatrical release.) In the past, hype from audience screenings has contributed to buying frenzies among distributors. But because distributors have learned that festival audiences are fervent film aficionados that rarely predict a film's general audience appeal, they're more wary of festival audience love.

Buzz for a finished film that doesn't have distribution can be the kiss of death. Say someone takes their film to a film festival and it gets buzz and an award, but three months later it's still available. That buzz and awareness on a B-to-B level within the industry has turned into a stink because the assumption is that buyers all passed.

—Jonathan Wolf, executive vice president, Independent Film & Television Alliance; managing director, American Film Market

If you don't sell it at these big industry festivals, your chances with the studios and mini-majors are slim. Still, many filmmakers hold out hope that their film will find distribution through film festival exposure.

But if a film already has distribution, the festival's premiere can kick off the theatrical release of the film. A successful festival presence creates valuable buzz that is difficult to duplicate with advertising and promotion, but it's squandered when there's a gap between the festival premiere and the theatrical release. But if it's close, a film can amplify its festival presence with screenings and parties with high-profile talent to garner trade reviews and industry and popular culture press—all to tee-up the film's theatrical release. Toronto kicks off many fall theatrical releases and Tribeca cost-effectively garners press and tastemaker notice in the nation's most expensive advertising media market—New York. But this approach must be handled carefully with your distributor if you have a theatrical release in the same city as the festival premiere. You want to ensure you don't siphon off ticket sales from local theater operators.

Or, you can let the festival screenings serve as the only theatrical run in that city. The festival screenings become the film premiere and segue into a limited theatrical release in New York and Los Angeles (making it eligible for Oscar consideration). For films that don't secure a traditional theatrical release, the festival circuit can serve as the film's theatrical release, fueling the next distribution window. If the next window is home video, it can have a day-and-date release of home video with the festival's world premiere. If it's broadcast, then home video is orchestrated around the broadcast. Additional festivals, producer-organized community and in-theater screenings, and other events offer market-by-market opportunities for press and promotion to build audience and demand for the home video or broadcast. This strategy concentrates the publicity and promotion for festivals, theatrical, and home video into one (or two) big multi-platform pushes for these collapsed distribution windows. Where festivals partially- or fully-serve as the theatrical release for your film, you must coordinate the reviews to sync up with your changing distribution strategy. Distribution and marketing are inextricably bound to each other.

Film festivals are not just about live screenings. Toronto and Sundance both have online film festivals, which have the potential to reach large audiences. Transmedia and interactive storytelling are emerging at various festivals. Sundance has New Frontier, a non-competition section of the festival with social and creative space that showcases

media installations, multimedia performances, transmedia experiences, and panel discussions. The Sundance Institute's New Frontier Lab supports media creators in this space. Tribeca features a TFI Interactive track, which explores film, media, gaming, technology, and society storytelling in the digital age. Storyscapes is an installation celebrating interactive storytelling, which bestows Tribeca's Bombay Sapphire Award for Transmedia. SXSW Interactive Festival explores interactive storytelling and includes crossover programming with its Film and Music Festival tracks. SXSW's Digital Domain explores new directions in narrative and non-fiction storytelling in Web-based environments.

Klip Collective's *What's He Projecting in There?* (photo by Ryan Kobane); © by the Sundance Institute. Used with Permission.

The 2014 Sundance Film Festival.

While film festivals have always been the dominion of film, the small screen is getting into the game. Recently, the Munich International Film Festival created a television sidebar, which highlighted new episodes from *Mad Men*, *Downton Abbey*, *Ripper Street*, *Banshee*, *Veep*, and *Enlightened*.

There are hundreds of film festivals worldwide. Some key film festivals include:

- Sundance Film Festival—Park City, Utah (January)
- International Film Festival Rotterdam—Rotterdam, Netherlands (January/February)
- Clermont-Ferrand Film Festival—Clermont-Ferrand, France (February)
- Berlinale International Film Festival—Berlin, Germany (February)
- SXSW Film Conference and Festival (part of SXSW Music, Film, Interactive)—Austin, Texas (March)
- Full Frame Documentary Film Festival—Durham, North Carolina (April)
- Hot Docs—Toronto, Canada (April/May)
- Festival de Cannes—Cannes, France (May)
- Seattle International Film Festival—Seattle, Washington (May/June)
- Venice Film Festival—Venice, Italy (August/September)
- Telluride Film Festival—Telluride, Colorado (August/September)
- Toronto International Film Festival—Toronto, Canada (September)
- New York Film Festival—New York, New York (September/October)
- AFI Fest—Los Angeles, California (November)
- International Documentary Film Festival—Amsterdam, Netherlands (November/ December)

For a comprehensive film festival list, go to Indiewire.com. Or, you can find film festivals by genre, format, or geography by simply Googling key words connected to them.

Interactive and Games

Other media platforms—from digital to games—have their own festivals:

- SXSW Interactive Conference and Festival (part of SXSW Music, Film, Interactive)— Austin, Texas (March)
- Independent Games Festival—San Francisco, California (March)
- Festival of Indie Games (FIG)—Boston, Massachusetts (November)

General Festivals and Events

There are various other festivals and events that present creators' ideas and projects and demonstrate how media and entertainment can influence thinking, popular culture, and social good. Comic Con, the top event for the comics industry, is among these because it has transcended its genre and become a broader event about comics and graphic novel-inspired universe fandom and geekdom. And SXSW, which operates at the intersection of music, film, and technology, has become a major cultural influencer event.

© Tye Truitt

The Flaming Lips perform for music, film, and interactive crowds at Auditorium Shores at the SXSW Music Festival in Austin, Texas 2013.

Creativity, Ideas, Intersection of Art and Technology

- TED Conference—Palm Springs, California (February/March)
- SXSW Conferences and Festivals (Music, Film, Interactive)—Austin, Texas (March)
- Aspen Ideas Festival—Aspen, Colorado (June/July)
- Comic Con—San Diego, California (July)

Social Responsibility

- World Economic Forum—Davos, Switzerland (January)
- Media That Matters—Washington, DC (February)
- Skoll World Forum—Oxford, UK (April)
- SOCAP—San Francisco, California (October)

There are thousands of events worldwide that you and your project can attend. You'll find there's nothing like the energy and feedback from a live event. But events are time-consuming and expensive, so be sure that every event you attend serves a clear purpose. But when used strategically, one event, as demonstrated with *The Blues* below, can advance multiple objectives in your marketing plan.

A Sundance Film Festival Strategy—*Martin Scorsese Presents the Blues*

To reach film and music devotees, a year before its 2003 premiere *The Blues* went "On the Road," appearing at more than 120 film, music, and heritage events worldwide. These events included 17 film festivals, including the Cannes Film Festival (Director's Fortnight), Venice Film Festival, Toronto Film Festival, Full Frame Film Festival, SXSW Music, Film, Interactive Festivals, and Sundance Film Festival; 14 music festivals, including the New Orleans Jazz Festival, Monterey Jazz Festival, Chicago Blues Festival, and Beale Street Music Festival; 15 cultural events, including "Salute to the Blues" at Radio City Music Hall, "The Blues" at SummerStage at Central Park, "Year of the Blues" at Kennedy Center, Bumbershoot, and Crossroads; 30 regional community and station events across the US; and various other events—from college tours to industry conferences. The goal was to capitalize on the project's talent and spokespeople to attract attendees and promote the genre and project—by making music.

Securing a major presence at Sundance was integral to reaching the film community. Because the films had a national US broadcast release on PBS, a non-competition exhibition was required. But as the seven films were more than 14 hours long, full screenings were impossible. The project arranged for three Special Screenings of a 100-minute compilation reel of the seven films with festival programmers. Once that unique opportunity was secured, *The Blues* expanded its presence to create maximum impact.

On January 18, 2003, *The Blues* participated in PBS' party at the Filmmaker Lodge House of Docs party. The morning of January 20, the *New York Times* opinion piece on the cultural impact of the blues appeared. At noon, two of *The Blues* directors, Wim Wenders and Marc Levin, sat on the "Crossing the Line" panel about directing documentary and narrative film.

At 5:00 p.m., *The Blues'* first Special Screening at Holiday Village II with an introduction by Sundance chief Geoffrey Gilmore (now creative director of Tribeca Enterprises and the Tribeca Film Festival) followed by an onstage Q & A with directors and producers.

©Anne Zeiser; Courtesy of Vulcan Productions

The Blues' producers at the special screening at the Sundance Film Festival.

At 7:00 p.m. after the screening, *The Blues* hosted an all-purpose, by-invitation-only party at the Canyons Resort in Park City. Producers, directors, talent, press, and other invitees drank, ate, and rocked to the sounds of Peter Wolf and the Legendary Sleepless Travelers until the wee hours.

Photos: © Mychal Watts; Courtesy of Vulcan Productions

(Left) The Blues party set up at the Canyon Resort; (Center) The project's all-access pass for various Sundance events; (Right) Peter Wolf rocking Sundance's after-hours crowd.

On January 23, director Dick Pearce appeared on the "Docs that Rock" panel about the role of music in film, and on January 24 and 25, there were two more Special Screenings. *Martin Scorsese Presents the Blues* appeared on CNN, NPR, E!, News Daily, *Entertainment Tonight*, *Extra,* AP-TV, Sundance channel, *Variety*, *Hollywood Reporter*, *The Boston Globe*, Rollingstone.com, and other media outlets. One event offered multiple awareness and positioning opportunities. As a result, the buzz for *The Blues* was palpable throughout the festival.

The Blues pursued grassroots WOM at small and mid-sized music festivals to build credibility among musicians and music lovers and present the films' authentic approach to the music. And it chose high-profile film venues like Sundance and Cannes to leverage the big-name film directors and create awareness among film aficionados. This simultaneous deployment of a bottom-up strategy for music and top-down strategy for film created maximum awareness of the project. Even if you don't have a project as big as *The Blues*, you can enhance any event opportunity by using every business and promotional asset available.

Awards

Your project has been financed, produced, distributed, marketed, and reviewed. Hopefully it's been critically acclaimed by the press, other influencers, and your audience. So it's time for it to receive the laurels that it deserves.

"It's an honor just to be nominated." No doubt, but it's even better to win, especially in entertainment and media. A big industry award increases audiences' notice of a media property, often translating into revenue. Awards also boost creators' credibility, giving lift to future projects. Entertainment awards are so valuable that the nominations are touted as if they are the awards themselves. "Golden Globe nominee" or "Emmy-nominated" are much-used qualifiers for people and media properties.

In an industry with massive egos and false modesty, awards are an entire subculture. Entertainment awards' timelines connect to a project's launch and distribution and have their own promotional initiatives. By the time you are eligible for awards for your project, most critical distribution and marketing decisions have been made that may affect your project's ability to garner critical acclaim, so from the beginning you should be aware of how they work.

The Awards Process

The awards process begins with your story and the talent you bring to it. Hopefully, the well-told projects are the ones that win awards. When you're first putting your project together, you're not thinking about awards. But its launch date and where it's distributed affect the awards process. Premiere dates and geography determine its eligibility for different awards' year cycles and for domestic or international awards or categories. Because Oscar's cutoff is December 31 and the holidays are big moviegoing times, the end of the year is loaded with movies.

The submission process is critical. Read award submission guidelines' fine print for deadlines, formats, and categories. One small mistake and you're out. In TV there are multiple Emmy competitions, each with different categories and deadlines. A television or digital program may be entered into only one Emmy competition—ever. If it is entered in more than one competition, it is immediately disqualified.

Bigger awards, such as the Oscars, Golden Globes, Emmys, and Grammys, have two public announcements—for nominations and the final awards. Awards publicity and For Your Consideration marketing campaigns occur before each of these announcement periods to raise awareness of media properties and sway voters.

By jdeeringdavis, San Francisco, CA, USA from Flickr; Licensed under Creative Commons via Wikipedia Commons

The Golden Globes recognize both film and television.

No doubt, awards are a boon to you and your project. If you're proud of your film or game, you should enter it into awards. And if your project is transmedia, firing on many platforms, you might be able to enter it into different competitions for different platforms. Below are key film, television, radio, print, games, digital media, transmedia, experiential, music, and entertainment marketing awards, listed by the final award date. (Note that entertainment awards have seasons. The film awards season is right after New Year's and the music award season is in February and November.)

- New York Film Critics Circle Awards (January)
- People's Choice Awards (January)
- Alfred I. DuPont-Columbia University Awards (January)
- Critics' Choice Movie Awards (January)
- Newbery and Caldecott Medals (January)
- Golden Globe Awards (January)
- Producers Guild Awards (PGA) (January)
- Screen Actors Guild (SAG) (January)
- Directors Guild Awards (DGA) (January)
- Critic's Choice Television Awards (January)
- Technology and Engineering Emmy Awards (January)
- Humanitas Prize (January)
- Global Mobile Awards (February)
- D.I.C.E. Awards (February)
- *MediaPost* Appy Awards (February)
- Writers Guild Awards (WGA) (February)
- Grammy Awards (February)
- British Academy of Film and Television Awards (BAFTA) (February)
- Independent Spirit Awards (February)
- Academy Awards (Oscars) (February)
- Streamy Awards (February)
- George Polk Awards in Journalism (February)
- National Journalism Award (March)
- SXSW Interactive Innovation Awards (March)
- SXSW Gaming Awards (March)
- SXSW Film Awards (March)
- Austin Music Awards (SXSW Music) (March)
- Shorty Awards (March)
- Game Developers Choice Awards (March)
- Parents' Choice Awards (March)
- NAACP Image Awards (March)
- GLAAD Media Awards (March–June in different cities)
- IDG World Expo Game Marketing Awards (April)
- Game Marketing Awards (April)

- Bombay Sapphire Award for Transmedia (Tribeca Film Festival) (April)
- Games for Change Awards (April)
- NAB Crystal Radio Awards (April)
- Webby Awards (April)
- George Foster Peabody Awards (April/May)
- *Billboard* Music Awards (May)
- Pulitzer Prize (May)
- National Magazine Awards (May)
- SoMe Awards (May)
- Sports Emmy Awards (May)
- Tony Awards (June)
- Golden Trailer Awards (May)
- Social Impact Media Awards (May)
- E3 Conference Awards (Best of IGN, Game Trailers, Game Critics) (June)
- Radio Mercury Awards (June)
- Daytime Entertainment Emmy Awards (June)
- Alma Awards (June)
- PromaxBDA Promotion, Marketing and Design North America Awards (June)
- MTV Music Awards (August)
- Primetime Emmy Awards (September)
- NAB Marconi Radio Awards (September)
- News and Documentary Emmy Awards (September/October)
- *Hollywood Reporter* Key Art Awards (October)
- Booker Prize (October)
- Oppenheim Toy Portfolio Awards (October)
- *Mashable* Mashies (October)
- Mobile Excellence Awards (October)
- Appster Awards (October)
- National Book Award (October/November)
- International Emmy Awards (November)
- *Billboard* Touring Awards (November)
- YouTube Music Awards (November)
- American Music Awards (November)
- Country Music Awards (November)

- Puma Impact Awards (November)

- GameSpot Awards (December)

- VGX Awards (December)

- International Documentary Association Awards (IDA) (December)

To steward your project's awards, set up an awards process that is managed by someone who is thorough and detail-oriented. The first phase is pre-nomination. At this time, organize the possible awards your project is eligible for by submission date and work on submissions well in advance. Set aside money for travel, publicity, and ads or other promotional efforts. If money is tight, place most of your promotional assets after the nomination. You can still get the project and its talent top-of-mind through "earned media" such as social media and publicity.

If your project is nominated, promote the nomination with a link to the official announcement from the bestowing organization via social media, your Web site, e-mail blasts, publicity, and all other communications. Use the bulk of your promotional budget to secure publicity appearances for talent, place FYC ads, and host screenings and events (see Awards and For Your Consideration campaigns below). Ensure everyone related to the project stumps for it. Decide who from the team will attend the awards ceremony.

Congratulations, you've won! Immediately update all your online, social media, press materials, and other assets with the award. Create spots for broadcast, online, and mobile about the win. If you can, place thank you ads in industry publications or Web sites and thank your audiences and the industry for their support in your communications.

It is essential to have a publicist to help you navigate and maximize a big win. There is a complicated press machine backstage at the Oscars, Golden Globes, Emmys, Tonys, and Grammys for winners. To follow is typical press activity after an Emmy winner picks up their real statue (the one onstage isn't really theirs). It begins with a photo shoot for the Academy's *Emmy* magazine. Winners pose for a sea of 50 to 100 photographers at the General Press Photographer's press opportunity. Then, a special photo shoot for key media outlets, including the broadcaster, CBS, and *People* magazine. Thereafter, a General Press Conference in the Press Room with some 100 media outlets in person and scores of outlets connected electronically. Finally, winners take the Winners Walk in which they conduct separate interviews with *ET*, *Access Hollywood*, *Extra*, *Inside Edition*, *OMG! Insider*, *CNN*, Yahoo, and *Jimmy Kimmel Live*. All of this occurs in one huge tented press area with separate "rooms" for each event. Winners are sent through the chutes in a carefully-controlled and timed process.

Around the win or nomination, the project's publicist pitches stories and appearances with mainstream and industry press and books events. There's about a month of halo effect after a win, which you can capitalize on to lift the winning project and support the next one.

Awards and For Your Consideration Campaigns

To boost your chances of securing a nomination or an award, you might launch an awards publicity campaign or For Your Consideration (FYC) advertising campaign to reach the academies, guilds, and other juried institutions' voting members to remind them of your project, ensure that they watch or play it, and keep it top-of-mind during the voting process. But you must have a budget for these efforts to cover design, printing, duplication, postage, fees for marketing teams, and travel.

Awards campaigns are now prevalent in film and television, since consummate promoter Harvey Weinstein, the co-founder of Miramax and co-chairman of The Weinstein Company (TWC), created the awards and FYC campaign phenomenon for film and now television. In 1990, he launched a guerrilla campaign for *My Left Foot* by bringing the film and Miramax talent directly to Academy voters with screenings at the Motion Picture Retirement Home and calls to Academy members' homes. In 1998, Weinstein spent $5 million on *Shakespeare in Love*'s awards campaign, upsetting DreamWork's Best Picture frontrunner, *Saving Private Ryan*. And in 2013, Weinstein hired Obama's deputy campaign manager for an assist on *The Silver Linings Playbook*.

Publicity impacts voters' awareness of a property. Actors and talent are visible everywhere through major publicity and social media pushes. Sometimes actors leak tidbits about their personal lives or other oddities during awards season in an effort to get the spotlight on them in any way possible. Not to mention all the glad-handing that talent does at parties during awards season.

Publicity was an enormous factor in our awards campaign for (the eventual Best Documentary Oscar winner) 20 Feet from Stardom about the unheralded backup singers for music greats like Elvis Presley and Aretha Franklin. We had the luxury of having several subjects whom we asked to perform at various high-profile events in addition to having them appear and perform on several talk shows in the key voting window. Not only was the subject matter a relatable story of the underdog finally getting his/her much-deserved due, but it was an inspirational film that played through the roof for audiences.

—Liza Burnett Fefferman, executive vice president, publicity, RADiUS-TWC

Weinstein's brilliant promotional strategies have paved the way for independents to get into the game, while upping the ante for the majors and studios.

Film

The most coveted US film award is the Oscar. To meet criteria for Oscar eligibility, a film must have a theatrical premiere in the previous calendar year in Los Angeles County (except for foreign films), be feature-length (at least 40 minutes), and be submitted on specified film formats. Oscar FYC campaigns target the 6,000 members of the Academy of Motion Picture Arts & Sciences (AMPAS), who are segmented into different branches such as directors, writers, and actors. All branches are permitted to vote for Best Picture.

By Greg in Hollywood (Greg Hernandez) from Flickr; Licensed under Creative Commons via Wikipedia Commons

The red carpet at the 81st Academy Awards.

Academy Award nomination results are generally announced to the public in late January. Nominations create star-studded mini-events with the nominee luncheon and "class photo" and soirees at high-profile venues. Final Oscar winners are determined by another round of voting in which all members may vote in most categories. Final award winners are announced through a live TV broadcast in February with a spate of major after-parties, including the exclusive Governor's Ball and the *Vanity Fair* party.

FYC campaigns for the Oscars begin with ads in outlets such as *Variety*, *Hollywood Reporter*, *The Los Angeles Times*, *The New York Times*, *Deadline Hollywood*, and *The Wrap*. The ads' headlines actually say "For Your Consideration" followed by the categories in which the film or talent has been submitted or nominated. The best ads use compelling graphics or key art, with minimal copy, often using quotes from positive reviews.

The most coveted ad placement is the cover of *Variety* or *Hollywood Reporter*. For *The Dark Knight* in 2008, Warner Bros. bought the cover of *Variety* and two full-page ads inside, one for Heath Ledger for Best Actor and the other for Best Picture. Warner Bros. also launched an Oscar Web site with scripts, soundtracks, and other information.

FYC campaigns also provide screeners to voting members of the Academy. Screeners are extremely important, especially for lesser-known films. A virtual unknown in 2005, *Crash* would never have received a nomination without its screener campaign. To keep over-the-top promotion in check, the Academy has strict rules governing screeners' packaging and marketing. But there's still some room for creativity. Academy voters received signed letters from director Steven Spielberg and pages from John Williams' score for *Lincoln*. For *Les Misérables,* they received iPods loaded with the film's songs.

Oscar awards campaigns also include Web sites with bonus material and special screenings in New York and LA. Academy members can see every Oscar submission at the Samuel Goldwyn Theater in Hollywood. In addition, key media outlets such as *Variety*, *The Los Angeles Times*, and *The Wrap* host screening event series for Oscar hopefuls, running about $10,000 per film.

The cost to chase an Oscar is huge. Smaller indie, documentary, and foreign films campaigns run to $100,000 to $200,000, mostly spent on media buys. Studio and minimajor pushes run in the millions.

The Academy Awards mark the culmination of a major winter awards season for film, including the Golden Globes and guilds' awards such as the Directors Guild, Writers Guild, Screen Actors Guild, and Producers Guild. Throughout the year, there also are myriad film juried awards on the film festival circuit, including Sundance, Cannes, Venice, and Toronto.

Television

In television, the biggest award is the Emmy. To be eligible for a primetime Emmy, a program must have run from June to May the previous year. The Academy of Television Arts & Sciences' (ATAS) or Television Academy's awards ceremony takes place in August or September in Los Angeles, usually televised live from the Nokia Theatre L.A. in downtown Los Angeles. The red carpet and the sighting of the stars is a television event in and of itself. The Primetime Emmys announce their nominations in June—in recent years on *The Today Show*—and televise the awards ceremony in September in rotation among ABC, CBS, NBC, and Fox.

The Emmy categories are run by three sister organizations: ATAS for primetime; the National Academy of Television Arts and Sciences (NATAS) for daytime, sports, news, and documentary; and the International Academy of Television Arts and Sciences for international. Each has separate Web sites and awards submission policies. Both the Primetime Emmys and the Daytime Emmys host separate Creative Arts Emmy awards before their main ceremonies.

FYC campaigns for the Primetime Emmy Awards focus on the more than 16,000 ATAS or Television Academy members, representing 28 professional peer groups, including performers, directors, producers, art directors, publicists, technicians, and executives. The Television Academy publishes *Emmy* magazine and conducts philanthropic and scholarship efforts through its foundation.

To secure nominations and wins in television, distributors and producers launch industry FYC awards marketing campaigns in early summer, on the heels of May sweeps and as summer series launch. HBO began providing screeners to Academy members in the 1990s to ensure they'd see them before casting their votes. Other networks and cable companies followed suit. Through the 2000s, Emmy screeners and promotional packages took on prominence in these campaigns, with complex promotional packages that housed DVDs and provided programming information. It was not unusual for the mailers alone to cost a network $20,000, but since then the Academy has placed restrictions on them. Some networks provide screeners online and via mobile apps, but voters are complaining about the unmanageable array of online viewing options and passwords and are requesting DVD screeners again.

Studios and broadcasters such as HBO, Showtime, AMC, and Starz use the screeners to brand their networks, often sending out entire seasons instead of just one or two episodes. This worked for Showtime's *Huff* in 2005, which got seven Emmy nominations even though the show was already off the air. It was also a successful strategy for AMC's final season of *Breaking Bad* in 2013.

© Camilla Anne Jerome

For Your Consideration mailers for the Primetime Emmys.

Like the Oscars, Primetime Emmy FYC campaigns include ads in *Emmy*, *Variety*, *Hollywood Reporter*, and on industry Web sites. The special June FYC issue of *Emmy* swells to 300 pages to house the many FYC ads. Increased social media, publicity, screenings, and events also mark this time of year. Program talent participates in Emmy roundtable discussions, Television Academy events, trade publication events, and online videos, such as those hosted by *The Los Angeles Times*.

In addition, networks' and cable companies' marketing machines develop creative strategies to reach Academy voters wherever they are. *Dexter* distributed "Killer Combo" two-flavored ice cream sandwiches (to reflect the character's two sides) to voters in New York and LA. AMC invited Academy members to an LA screening of *Mad Men*'s season finale the day it was set to air, including a Q & A with creator Matt Weiner and cast members. In 24 hours, there were more "Yeses" than seats. Netflix launched a campaign for political thriller *House of Cards* in which they offered a free Netflix subscription for six months, a $50 donation to the Red Cross, or a $50 American Express gift to residents who would place political campaign lawn signs on their front lawns. Estimates for Primetime Emmy FYC lobbying campaigns, including screeners, ads, billboards, and events, range from $100,000 to more than $1 million.

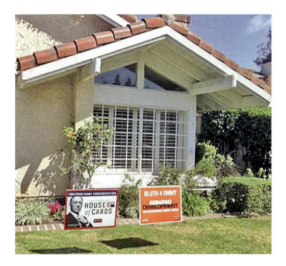

Deadline Hollywood, 6/24/13

Netflix used political campaign signs on lawns for its Emmy awards campaign for *House of Cards*.

Properties also conduct these kinds of sophisticated promotional campaigns for the Golden Globes, the Hollywood Foreign Press Association's film and TV awards, and many other entertainment and media awards to secure nominations and wins.

Entertainment Marketing Awards

There are numerous entertainment marketing awards. The biggest is *Hollywood Reporter*'s Key Art Awards, honoring film, television, home entertainment, and game advertising and communications. It is managed by the CLIO Awards, the top US award for the advertising industry. The Key Art Awards celebrate and reward creative excellence and its impact on modern culture, recognizing that new ideas, technologies, and techniques are expanding the ways in which filmmakers, television producers, and game developers reach audiences in an increasingly competitive landscape.

> *"Key Art" was coined to classify the advertising creative that's produced to market a film. Historically, this meant the movie posters we know and love and have come to regard as iconic. But it's expanded, particularly in recent years, to encompass a wide array of mediums, from packaging to out-of-home. Obviously, digital has had a profound impact. It's also come to be associated with the packaging and marketing of entertainment in a variety of forms, TV to videogames.*
>
> **—Nicole Purcell, president, CLIO; oversees *The Hollywood Reporter*'s Key Art Awards**

The Key Art Awards accept entries in June for theatrical, television, home entertainment, and game platforms in various categories, and the awards ceremony is held in October at the TCL Chinese Theatre in LA.

Another major entertainment marketing award is the PromaxBDA Awards, honoring television and online video. PromaxBDA is considered the leading global resource for education, community, creative inspiration. and career development in the media and media marketing of television and video content on all platforms, inspiring creativity, driving innovation, and honoring excellence. The organization hosts many events, from a large international conference to numerous networking and smaller industry gatherings throughout the year.

The PromaxBDA Promotion, Marketing and Design Global Excellence Awards competitions—one for North America and others for many other parts of the world—recognize marketing excellence for TV and video that was broadcast or published in the previous calendar year. They announce the awards at the June Awards ceremony—part of the annual PromaxBDA conference held in Los Angeles. The marketing, promotion, and design categories range from TV, Video and Print to Mobile and Interactive. Like all awards competition, the PromaxBDA's entries reflect the changes in media.

In years past, there were a lot of the physical, collateral, and premium items that came in for consideration for a PromaxBDA Award—all part of marketing campaigns. We see less and less physical work because everything's going digital. But when I'm in a room full of professionals looking at all this work it's interesting to see how captivated they are by certain art. There's something about the tangible that people love. That poster that you can walk up to and look at every intricate detail has so much more of an impact on the people than a digital file. The most successful campaigns are the ones that humanize what we're looking at.

—Stacy La Cotera, VP, Development and Global Awards, PromaxBDA

The Golden Trailer Awards focus on feature film previews and promotion including trailers and teasers in most film genres. They also have categories for TV Spots, Posters, Title Design, Advertising, and technical and foreign categories. The Golden Trailers also honor videogames trailers, posters, and advertising.

In addition, SXSW has Film Design Awards, with its Excellence in Title Design Award and Excellence in Poster Design. The Emmys recognize television and interactive branding and promotion, including categories in Main Title Design.

In games, the IDG World Expo Game Marketing Awards celebrates the best practices in marketing, promotion, and advertising for the videogaming and interactive entertainment community. The awards are part of the Game Marketing Summit (GMS), a full-day conference in April in San Francisco for the interactive entertainment industry marketing and brand executives. The Game Marketing Awards recognize excellence in strategy, creativity, execution, and results for Digital Media, Video, Print, Premium, Collateral, and Interactive. Categories include Video Assets, Integrated Marketing, Advertising, Retail, Trade & Packaging, Interactive, and Creative Craft.

And the marketing, promotion, design, and public relations industries honor excellence in all industries, including entertainment and media. Some examples include, advertising: CLIO Awards, Cannes Lions Awards (part of the International Festival of Creativity), New York Festivals, OBIE Awards; public relations: PRSA Silver Anvil Awards, *PR Week* Awards, *PR News* Platinum PR Awards, *Holmes Report*'s SABRE Awards, and *PR Daily*'s Digital PR & Social Media Awards; marketing communications: Communicator Awards, Golden Quill Awards, Effie Awards, and Content Marketing Awards; and digital marketing: Design, Advertising, & Digital Awards, *Mashable* Mashies, Web Marketing Association Web Awards, Effective Mobile Marketing Awards, Marketing on Mobile Awards, Shorty Awards, and SoMe Awards.

Now that you've taken this meandering path down ego lane, it's time to get back to work and do awards-worthy work on your project. The last piece of the influencer puzzle is identifying and securing strategic partners who will lend credibility to your project and amplify the promotion and outreach you do for it.

Author's Anecdote

Not Taking Awards Too Seriously—A *Non Sequitur*

How often do you get an award delivered with a comedy riff by a former *Saturday Night Live* writer and current US senator? I completely forgot I was at an awards ceremony at the *PR Week* Awards when *Evolution* won the Arts & Entertainment Campaign of the Year Award because of Al Franken, who had us all in stitches. If he kept on writing TV comedy, imagine the *Under the Dome* sitcom he could write about DC.

Courtesy of *PR Week*

PR Week's 2002 Arts & Entertainment Campaign of the Year Award (I'm in the middle).

Strategic Partners

When developing and promoting a transmedia project it is important to understand your strengths and weaknesses *vis-à-vis* your expressed goals. One of the best ways to shore up expertise in your weaker areas is to forge partnerships with entities that are experienced and have a track-record in that arena. Rather than reinvent the wheel, it's often smarter to leverage another organization's existing know-how, clout, and infrastructure.

In January 2009, the inauguration of President Barack Obama became the largest live cross-platform event in history. CNN partnered with Facebook, marrying a traditional news brand with a vibrant social community, giving CNN an advantage for the major media event. CNN was the most watched cable network (setting a daytime ratings record) and the most watched Web site, with 25 million live Web streams. By combining complementary media assets, CNN and Facebook "won" the day through a savvy strategic partnership.

The Power of "Us"

Strategic partnerships can create content across transmedia platforms—*on air*, *online*, and *on the go*—and reach target audiences through those media platforms and *on-the-ground* efforts. Consider various kinds of partners for your transmedia project:

- Content creators
- Content distributors
- Media and entertainment organizations
- Non-governmental organizations (NGOs)—professional associations, advocacy, educational/cultural, civic, faith-based organizations
- Government entities or policy-makers
- Educational institutions and museums (zoos, aquariums)
- Consumer products and retailers
- Sports entities

Partners may create and distribute content for various platforms; share content on their platforms; co-promote content; communicate with their networks' membership and constituencies; host or participate in industry or audience events; create consumer promotions; spearhead community outreach efforts; and participate in advocacy activities.

If you're a TV network development executive and you're making a foray into Webisodes, then working with online video storytelling pioneers will give you a leg up. If you're a documentary filmmaker exploring an interactive or game component for your project, a production partnership with a game developer makes sense. If you don't want to be responsible for creating on new platforms and finding distribution, you can partner with other media creator-distributors.

To bring global health to the forefront of Americans' consciousness in November 2005, *Rx for Survival—A Global Health Challenge* forged key editorial partnerships *on air*, *online*, *in print*, and *on the go* to develop a high-impact media blitz that fired on multiple media platforms. The multi-platform project included two Brad Pitt-narrated documentary films on PBS; a global health special issue of *Time* magazine; a *Time* and Gates Foundation Global Health World Summit; a series of branded radio installments on NPR; a companion book by Penguin Press; a comprehensive Web site on PBS.org; educational materials; and a comprehensive social impact campaign.

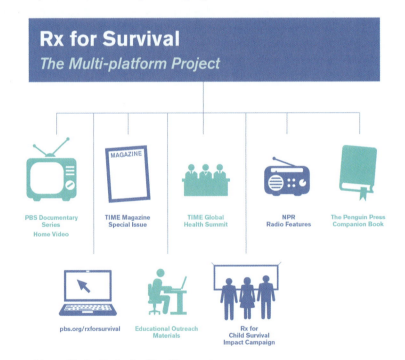

Courtesy of Azure Media; Design by Elles Gianocostas

Overview of the content and editorial partnerships for the multi-platform media project *Rx for Survival—A Global Health Challenge*.

This Bill & Melinda Gates Foundation-supported project reached as many as 66 million Americans, helping it achieve a primary goal of raising American's awareness of global health (the author was a co-lead on this project). (To learn about the project's outreach partnerships and impact results see Chapter 29, "Media-fueled Social Impact").

Not only are partnerships valuable for storytelling, content creation, production, and distribution, but they're also critical to promotion and outreach. These partners may bring marketing expertise to the project about the media platform and the target audience.

Promotional and outreach partnerships with non-media and entertainment organizations also provide credibility and spread the word. In turn, you provide these partners with a legitimate connection to a coveted media asset. This symbiotic relationship makes both partners' promotion and outreach efforts greater than the sum of their parts.

In addition to creating and promoting content, enlisting credible organizations as partners can provide a long-term community for engaged audiences of one-time media projects like TV specials that have a limited shelf-life. The last thing you want is to engage audiences and then go silent. As part of the *quid pro quo* for their content and promotion, you're delivering engaged audiences to your partner that they can sustain for their organization for the long haul.

Promotional partners are different from merchandising partners, which involve a licensing agreement between the property owner and a third party for the right to create new products using the brand or its characters, such as a *Star Wars* action figure. A promotional partner already has its own well-known brand or product, and the alliance between the media property and the promotional partner is about finding tie-ins and cross-promotional opportunities using exiting brands and infrastructure. Children's properties leverage these partnerships to the hilt. DreamWorks Animation's *Madagascar 3: Europe's Most Wanted* had restaurant, food, toy, party product, social game, and credit card tie-ins.

Whether one entity hires the services of the other; each entity handles a different platform or component, receiving separate revenue streams; or no money changes hands in a more informal "you scratch my back, and I'll scratch yours" agreement, the relationship should be a valued partnership, not a vendor relationship. A good partner fights for ideas, challenges assumptions, and inspires creative solutions. That can't happen in a subservient relationship.

In the 1950s, 1960s, and 1970s, brands and their advertising agencies had decades-long relationships, with the in-house marketing team and ad agency team stewarding the brand's external presence together, almost as equal partners. They took risks and they had mutual trust and loyalty. Now, the average length of those advertiser–agency relationships is two years, and agencies essentially act as "Yes men and women."

Partnership Criteria

Partnerships can be powerful, but you must choose partners wisely. Your partners are a direct reflection on you; partnerships must benefit both parties; and only well-forged partnerships grow and last over the long haul. In 490 BC, the Athenians entered a land and sea alliance with the Persians against the Spartans. But the treaty the Athenians signed in effect handed Athens over to Persian rule, which set in motion the attack of Marathon and centuries of war between them. The Athenians didn't truly understand what they had agreed to.

A good partner needs to be pursuing similar goals with similar audiences, but complements your strengths. Also, fewer but more fully-committed and active partners are always better than more partners with limited participation. It's not just about the logo on the letterhead, it's about what you actually achieve together.

Finding a good match is hard, whether in your personal life or professional life. The following criteria can help you identify potential project partners:

• Expertise—a substantial and demonstrated expertise in specific areas; organizations' strengths complement each other

• Credibility—in areas of expertise

• Ethics—a track-record of sterling business practices (check via WOM, Dun & Bradstreet or Charity Navigator)

• Leadership—style and goals within their industry and organization

• Partnerships—a history of successful partnerships

Now that you have a shortlist, begin conversations with key companies or organizations and go through this checklist to see whether you have a fit:

• Alignment—of both parties' brand essence, goals, objectives, and target audiences

• Vision—shared vision for future and desire to innovate

• Gives—resources and deliverables the organization will give to the effort (financial and philosophical)

• Takes—resources and deliverables the organization needs from the effort (financial and philosophical)

• Commitment—extent of organization's leadership commitment to the partnership; willingness to put resources into strategy and execution

• Promotion—willingness to co-brand and use their organization's name, leadership, and contacts publicly

- Amplification—desire to build on and learn from each other's efforts
- Timing—alignment of partnership with both entities' timeline
- Success—agreement on definition of success measurements (audience, revenue, impact, risk-taking)

Once you have the fit, you must hash out the implementation aspects of the partnership, such as:

- Roles and responsibilities—determine who will do what; identify decision-makers in each organization
- Communications—determine organizational culture and communications styles, processes, and protocols for project and crisis management

No matter how great the fit may seem, never enter a partnership without putting it in writing. Clearly spell out the financial, legal, and logistical aspects of the partnership in a contract or Letter of Agreement (LOA). Be sure to have lawyers and accountants on hand to develop or at least look over the written agreement before you execute it.

A Partnership Strategy—*Martin Scorsese Presents the Blues*

Martin Scorsese Presents the Blues vastly expanded its media, promotion, and community reach through a variety of strategic partnerships. First, the project film, television, and online project created a partnership among four film production companies to produce the seven films. They were Vulcan Productions, Road Movies, Jigsaw Productions, and Cappa Productions (currently Sikelia Productions). In addition, the project partnered with WGBH to present the films on national primetime TV on PBS and online on PBS.org, and to manage the project's overall marketing.

The project expanded to additional media platforms through editorial and content creation and distribution partnerships. For the seven-night national television broadcast and online presence, it partnered with PBS and pbs.org; for the 13-part national radio series, with Ben Manilla Productions, Experience Music Project, and Public Radio International; for the companion book, with Amistad, an imprint of HarperCollins; for the 24 music CDS, with Sony Music, Universal Music Enterprises, and HIP-O Records/Chess; for the DVDs, with Columbia/Legacy; for the travelling museum exhibit and concert, with Experience Music Project; and for the theatrical release of the concert film, *Lightning in a Bottle*, with Sony Pictures Classics.

The project expanded to the blues community through an educational and charity alliance with The Blues Foundation. And it forged an overall sponsorship and promotional partnership with Volkswagen of America. The project also had several other promotional

partnerships, including House of Blues (hosting music events and creating in-restaurant promotional items); W Hotels (serving as host hotel for the project and the site of numerous events); American Airlines (showcasing the project in flights during the month of September); Best Buy, Barnes & Noble, Tower Records, Virgin, and Borders Books (installing endcap displays in 2,000+ retail stores); and NY Saks (creating a window display and in-store reception via a co-promotion with *New York Magazine)*.

Each partner had huge responsibilities and each has it own sub-story. Two are expanded below to illustrate the potential of outreach and promotional partnerships; one with American Airlines, the other with Volkswagon. During the month of September (*The Blues'* premiere), American Airlines promoted the project through a multimedia campaign reaching 25,000 flights to 257 destinations and more than 3.5 million people. All travelers on flights of two or more hours saw a five-minute promotional video of *The Blues* on the airline's free in-flight entertainment, CBS' "Eye on the Nation." American Airlines also dedicated an in-flight music channel to *The Blues* for the month, featuring an interview with executive producer Martin Scorsese and music from the series and CDs. Scorsese appeared on the cover of the in-flight entertainment guide. *The Blues* project was also covered in a lengthy feature article in *American Way*, the airline's monthly magazine.

© Camilla Anne Jerome; Courtesy of Vulcan Productions

For the premiere month of September, American Airlines' in-flight entertainment guide featured Martin Scorsese and an entire music channel dedicated to *The Blues'* music.

Volkswagen became *The Blues'* exclusive national corporate sponsor because it complemented VW's brand essence and offered deep integration opportunities—from messaging and events to music and logo inclusion in all project materials. *The Blues* was one of the largest corporate sponsorships ever undertaken by Volkswagen, and the most fully-integrated sponsorship in public television's history. Of *The Blues'* 120 film, music, and heritage events featured in the "On the Road" grassroots tour, 50 offered VW deep brand integration opportunities for showcasing VW cars. These included concerts at the Radio City Music Hall, Sundance Film Festival, New Orleans Jazz Festival, Chicago Blues Festival, and Monterey Jazz Festival. *The Blues* sponsorship delivered almost 2 billion impressions to Volkswagen, with unprecedented exposure through the television and radio broadcast series; book; CDs and DVDs; national concert and concert film; traveling museum exhibit; educational outreach initiative; "On the Road" event tour; on-air spots; and national publicity and advertising.

Courtesy of Vulcan Productions

Volkswagen's brand integration with *The Blues* "On The Road" at key events.

In turn, the car manufacturer created and ran a national TV spot about *The Blues*, devoting 70 percent of their fall network and cable ad campaign to the project. The spot appeared on major network shows, including the season premiere of *Law & Order: SVU* and *Cold Case* and a number of cable outlets. Volkswagen also provided coverage on its radiovw.com, and incorporated *The Blues* on their VW college campus music tour across the country. Kevin Boyle, brand marketing manager of Volkswagen, said, "*The Blues* surpassed our highest expectations. The amount of exposure Volkswagen received through this sponsorship was truly phenomenal and demonstrates the kind of results companies can achieve through such fully-integrated, multi-tiered marketing opportunities with public television."

Now, imagine how difficult it was to keep all of the representatives from the various partners working on *The Blues* apprised of such a massive project. *The Blues* accomplished this by assembling all of the 30+ content-producing partners and marketers at a two-

day marketing and partner summit in New York, which included film producers from Vulcan, Jigsaw, and Cappa; PBS; WGBH; PRI; HarperCollins; Sony; and Universal. This marketing and distribution summit's goals were two-fold: to unify the team, positioning, and over-arching marketing strategies for the project. *The Blues* "Cross-platform Marketing Overview, Marketing & Branding" PowerPoint presentation at www.transmediamarketing. com is the presentation of the foundational *über* marketing plan from that summit. The second goal was to plan the timeline and details of marketing and outreach activities and encourage partners to work together on activities post-summit. After the summit, the non-producing outreach and promotional partners were folded into the process with an overall team of 60+ participants on bi-monthly and eventually, bi-weekly calls for 18 months. Volkswagen also had separate weekly or bi-weekly calls for the duration of its sponsorship.

Listening to and communicating with your partners is the single most important determinant of successful partnerships. Your project should establish work plans, timelines, meetings or calls, and written status reports to ensure everyone's on the same page. The investment is big up front and once the partnership is solidly established, the ongoing communications can be shorthanded into bullets or Excel spreadsheets. The key with partner communications is to find the balance between not being too process-oriented, yet being structured enough that partners are well-informed and invested so they can innovate.

One of the most underestimated aspects of strategic partnerships is the amount of time required to get partners up to speed and provide them with what they need to do their job. If you are in different businesses from each other, then you will both have learning curves. Each partner requires dedicated staff time. If you cannot staff up, then just establish one or two key strategic partnerships.

Also, remember that time is money. If you don't have much money, then partnerships can translate into exhibition and promotion on other platforms. But it takes many months to establish an effective partnership and usually a year to plan and execute the activities. So forge your partnerships during the early marketing planning stages of your project, not when you're in post-production. By then it will be too late to do anything except a few short-term activities.

In a world where the cost of creating, distributing, and promoting media is sometimes prohibitive, strategic partners can be critical to getting your project up and running. Having identified your influencer audiences—from distributors and funders to press and strategic partners—you can maximize their influence to advance your project. Now you are ready to speak directly to your public audiences to raise their awareness of, and engagement with, your media project.

Author's Anecdote

Forging Partnerships

In 2008 when I was helming the strategic platforms and marketing for the BBC and PBS project *Latin Music USA*, hosted by Jimmy Smits, I began planning a strategic partnership with Time Warner's *People en Español*. The seeds of the alliance were that we had fantastic video footage that could help them monetize their growing online site and they offered us additional print and online editorial and promotional platforms that reached a key target audience.

After a triumphant initial meeting with the editor-in-chief of *People en Español* and *People*'s top promotional staff, we were ready to make a deal happen. But, because of several personnel changes at Time Warner and very buttoned-up legal teams, it took nine months and 23 versions of the deal points before we had a deal. After about version eight, my intrepid lawyer suggested that we no longer "negotiate" among lawyers in legalese, but rather, I craft the deal in simpler promotional language. Once we had a fundamental understanding, he'd put it into a legal contract.

We provided *People en Español* their pick of exclusive video from our outtakes and other cleared footage for their Web site's home page for four weeks leading up to the premiere. This gave them never-seen video around which they could create content to monetize for a full month. In turn, they offered us tune-in messaging around the clips with live Web links to our site. They also created a two-page spread sponsored advertorial for the print magazine, for which we supplied materials. Because Time Warner is a conglomerate, as a bonus, their Corporate Philanthropy team hosted a *Latin Music USA* celebration event for New York influencers at the Time Warner Center, just before premiere. The event included a 30-minute preview and panel discussion moderated by Leila Cobo of *Billboard* magazine and a cocktail reception after. The event raised *Latin Music USA*'s profile and positioned Time Warner as the purveyor of a significant cultural moment among New York's top cultural and entertainment influencers.

Without my lawyer's practical suggestion to streamline negotiations, we might not have had time to execute all these elements of the partnership.

PART VI

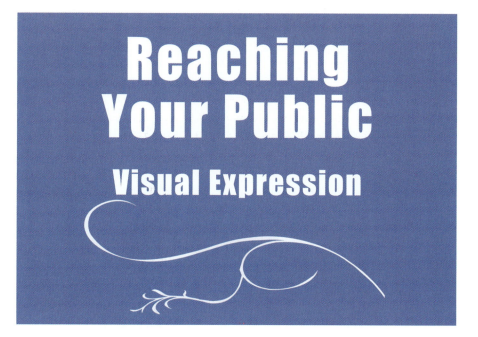

Reaching Your Public

Visual Expression

CHAPTER 20

The Art of Art

In previous sections of the book your objective was to influence the influencers, so you were activating top-down strategies. Now, your objective is to reach your public audiences directly, so you are activating bottom-up strategies. To engage public audiences with your project, you must develop audience-facing promotional vehicles. Because of humans' visually-wired brains, promotion begins with expressing your brand through strong visuals. Pictures—still or moving—are consummate storytelling devices. You can tell your story visually through your concept art, poster, one-sheet, collateral, title sequence, teaser videos, trailers, and sizzle reels.

Revisit your project's audiences, themes, brand archetype, brand positioning, messaging, logline, logo, and master creative brief. Together, these create the manifesto for your project's identity, informing mood, tonality, and feeling. You must have a strong sense of what you want to convey before you can distill it down. There are so many directions you can go, but in the end you need just one big idea or one money shot to tell your story. Good concept art is usually simple, but that doesn't mean it was easy to create. Creating good story art is its own art form.

Concept Art and Key Art

"A picture is worth a thousand words" speaks to the idea that a single image can convey a complex idea. Not only do visuals communicate concepts and emotions, but also seeing them again stimulates memory and retrieval of that complex idea.

"Creación de Adám" by Michelangelo Buonarroti (circa 1511); Licensed in the public domain via Wikimedia Commons

Michelangelo's fresco *The Creation of Adam* on the ceiling of the Sistine Chapel in Rome depicting the almost-touching hands of God and Adam is so iconic that it represents all of humanity.

Creating and capturing a desired visual style is used in many industries—from fashion and industrial design to architecture and entertainment. Film directors create lookbooks to capture the overall aesthetic of the film, which includes all the senses—visuals, action, text, wild sounds, music, dialogue, touch, taste, and smell. Every member of the production and marketing team must understand that aesthetic to ensure the film and its promotion is cohesive. In entertainment, the concept art—illustrations, photographs, and video—are paramount. They serve as the movie trailer for the written text.

Art is critical throughout development. Early on, designers create storyboards for pitches to sell high-concept or visually-driven entertainment properties to potential co-producers, financiers, and distributors. Concept art is often created during the design of the film, television show, or game to pre-visualize its look. It might begin by depicting key scenes and characters and, later on, actual locations, action, and gameplay for the final script or game design. The director or creator approves this art to guide the production team during the project's development. For film, it might illustrate key characters in an instrumental scene with a setting, background, and props, demonstrating how the shot will be framed and lit. For games, it might include 2-D and 3-D concept art; 2-D sprites or animations overlaid onto larger scenes, or 3-D computer models of characters.

Reducing all this down to a single piece of art with simple associated messages communicates your media project to public audiences. **Key Art**, a term derived from key frames in animation, describes concept art and its associated promotional pieces. It is not always derivative of the art created during the production, but is usually informed by it. Key art tells a story about the entire media property, not just about one episode or moment. Today, key art refers to the overall marketing campaign to promote the media property.

Key art has always been central to film. In the early twentieth century, Walt Disney paved the way for embedding inanimate live-action objects in film. Saul Bass, the father of modern key art, and hailed as one of the most iconic and influential graphic designers and filmmakers of the latter part of the century, took it further. He transformed the opening of films from unemotional title cards to mini-films that set up what was to come. During his 40-year career, Bass designed corporate logos—from AT&T's "bell" to United Airlines' "tulip"—but was best known for film posters and title sequences for some of Hollywood's greatest filmmakers, including Alfred Hitchcock, Otto Preminger, Billy Wilder, Stanley Kubrick, and Martin Scorsese. In recognition of his major influence on the art, branding, and promotion of film and entertainment, the *Hollywood Reporter*'s Key Art Awards now bestows an honorary Saul Bass Award.

Bass first became well-known in 1955 after creating the poster and title sequence for Preminger's *The Man with the Golden Arm,* an edgy book-to-film adaptation starring Frank Sinatra, a jazz singer battling drug addiction. Bass tackled this taboo subject by creating a semi-abstract black and white cutout of a distorted arm, which gave a nod to "shooting up." He also used off-kilter typography. The overall look signaled the transformation of the addict, but was neither literal nor sensational.

"The Man with the Golden Arm" by Saul Bass; Licensed in the public domain via Wikimedia Commons

Saul Bass' iconic art for Otto Preminger's edgy 1955 film *The Man with the Golden Arm* about drug addiction.

Concept art remains seminal to entertainment properties' identities. It's critical to videogames because it portrays the overall story universe, the key characters, and a sense of the all-important gameplay.

Posters and One-sheets

The film poster, which is synonymous with the term one-sheet, now broadly applies to all entertainment platforms. Film posters are displayed inside and outside theaters to promote movies. They're the most prized style of movie art among collectors because they're iconic and captivating, and some are of museum quality. Movie posters have become a distinct art form because they've reflected the mood of their times as much as they've reflected the film they're about.

First used in 1909 by Thomas Edison's Motion Picture Patents Company, the whole story of a film was told on a single sheet of paper. The popularity of movie posters kept apace with the popularity of films themselves.

How Bella Was Won by Edison; Licensed in the public domain under Creative Commons

Thomas Edison's Motion Picture Patents Company used one-sheets like this for *How Bella Was Won* (1911), to tell a movie's story and display in movie theaters.

Before Bass' *The Man with the Golden Gun* poster, movie posters featured illustrations of key scenes or characters from the film, often "interacting" or facing each other. Bass' art introduced graphics that made audiences think or conveyed an idea. Who can forget the ominous, massive shark lurking beneath the water's surface ready to attack an

unsuspecting swimmer from 1975's *Jaws*? Or the airplane tied in a knot with the headline, "What's slower than a speeding bullet, and able to hit tall buildings in a single bound?" from 1980's *Airplane*? Or Jodie Foster's almost colorless face, with staring brown eyes and an evil brown moth in place of her mouth from 1991's *Silence of the Lambs*?

The color palette alone can signal emotion. *Little Miss Sunshine* was all about yellow, while *Duplicity* and *Gran Torino* were black and white. Symbolic key art is now used more often in TV than film. Since the 1990s, film's signature art is mainly photos of key actors, pushing star power.

Posters also include a headline or tagline, the release date, and the director, actors, and other credits in block text. The same art that appears in movie posters usually appears in flyers, ads, billboards, Web sites, DVD/Blu-ray packaging, and other promotional materials to create the media property's key art.

Attack of the 50 Foot Woman by Reynold Brown; Licensed in the public domain via Wikimedia Commons

The iconic and collectible poster for the 1958 *Attack of the 50 Foot Woman*.

Many creatives start film, television program, or game promotion campaigns with the one-sheet because it forces clarity, distilling the message down to one big idea that will connect to your audience. To create the poster for your project you must work with designers and photographers who are steeped in your project's story, brand, and aesthetics. The poster should answer "What is this about?" and "How do I feel about it?"

To find the big idea, go to your creative brief's core communication message. You must communicate that idea in a way that speaks to your audiences, fulfilling an emotional

need. In Maslow's Hierarchy of Needs, there are primal *physiological* needs, such as food, water, sex, and sleep; *safety* needs, such as health, family, and property; *love and belonging* needs, such as friendship, family, and sexual intimacy; *self-esteem* needs, such as confidence, achievement, and respect; and *self-actualization* needs, such as morality, creativity, spontaneity, and problem-solving.

The decision to watch a program, go to the movies, or download a game is made in the subconscious when a stimulus triggers an emotional reaction. If you truly understand your target audiences, your big idea will spark a positive reaction by fulfilling a core need. This is not about logic. It's about emotion and your audience's perception that you're delivering value.

> *Always look for the single big idea. There's a comfort zone in lists. There's a comfort zone in a lot of data. But what's going to move things forward is a single big idea that captivates people. So push for that. Search for that. Force people around you to find that with you.*
>
> —Linda Button, brand personality expert, co-founder and principal, Tooth and Nail

Communicating a compelling message with one piece of art and very little text is not easy. It doesn't always happen in a eureka moment of brilliance. Usually it happens after you've done your homework on your target audience and developed your brand persona. This immerses you in the emotional connection between your property and your audience. So use the goals, themes, and conflict of your story to brainstorm around the emotional tension of your project with your core team. Think of overall poster concepts, art, and headlines, and keep going no matter what. Push out many ideas—the good, the bad, and the ugly—until the seed of a good idea emerges.

And be willing to take risks. Today, too much key art relies on the celebrity shot and doesn't ask the audience to think. *The New Yorker* showed courage in their July 8 & 15, 2013 issue featuring a silhouette of *Sesame Street*'s Bert and Ernie snuggling together on the couch watching the 12 justices of the Supreme Court on TV make their historic ruling on gay marriage. The cover engendered a firestorm of reaction, much of it negative about the implication that Bert and Ernie are gay and the irresponsibility of using children's role models to deliver a message about sexual orientation. It was a strong piece of art that told a relevant cultural story.

Because of limited available photography and art, it's difficult to create key art for historical documentaries. The 2013 PBS documentary *Rebel* demonstrates the importance of concept art and how early in the process you should be thinking about it. *Rebel—Loreta Velazquez, Secret Soldier of the American Civil War* was the brainchild of writer, director, producer María Agui Carter (Calvin Lindsay was the producer). It's the true story, shrouded in mystery and long the subject of debate, of Loreta Velazquez, a Confederate

soldier turned Union spy. A Cuban immigrant from New Orleans, Velazquez was one of an estimated 1,000 women who secretly served as soldiers 150 years ago.

Carter knew that it was a story rife with themes of gender identity, mythology, and the politics of national memory. And the true essence of the story was the duality of Velazquez' identities and the tension between her truth and her secrets. Carter wanted to communicate those complicated themes in a single piece of art. Her big idea was to photograph Velazquez' two identities—like mirror opposites—and combine them into one. Because Carter used dramatic recreation to tell her Civil War story, she had a photographer shoot the actress playing Loreta Velazquez in two different costumes, true to the archival style of Civil War-era portraiture in which subjects posed without smiling. The designer merged the photos into a composite, conveying her double identity—the "acceptable" portrait of the woman of her day and her "secret" male Civil War soldier alter ego. The stunning one-sheet used sepia tones to signal the rich historical context, and created the physical and emotional boundary between the two identities by depicting the tear of a photograph.

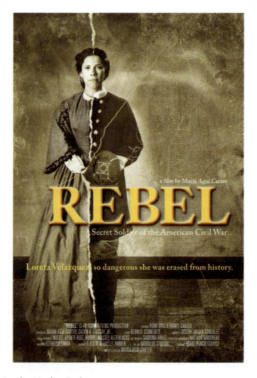

© Gerard Gaskin; Design by Hayley Parker

Rebel's poster is a composite of two studio portraits of Loreta Velazquez—as a woman on the left, and passing as Civil War Lieutenant Harry T. Buford on the right—played by actress Romi Dias.

This signature art became the film's calling card. It received 800 social media shares within a few hours of its posting on PBS' Web site. In the first month of the film's release, this image produced more than 44 million impressions. Media outlets indicated that the key art was a big draw, garnering many hits and motivating audiences to read the associated stories on their sites. Perhaps the most unexpected outcome was when Carter brought the full-length version of the poster to screenings, people took their picture next to it in the theater lobby—proof of the deep audience connection and cultural currency engendered by a fascinating film and its compelling concept art.

Key art is a valuable promotional tool for entertainment properties. The symbolic teaser poster for the second film in the *The Hunger Games* saga, *The Hunger Games: Mockingjay Part 1* was released on the film's Facebook page almost a year before the film's late 2014 premiere. It gave a nod to the original illustration art of a bird on the cover of Suzanne Collins' novel, but featured the film heroine Katniss' iconic mockingjay pin surrounded by fire, referring to her multiple nicknames. The poster generated a great deal of "earned media" for the franchise's next installment.

When *Breaking Bad*'s Season 5 (final season) poster was released with Walt (Bryan Cranston) sitting in a warehouse on a flimsy lawn chair in a bright yellow jumpsuit surrounded by money and merchandise, it created quite a stir and portended plot and mood for the entire season to come. Michael Ausiello, TV writer and founder and editor of *TV Line*, said the poster signaled Walt's "ascension to full-fledged drug kingpin." And when Warner Bros. Interactive Entertainment and TT Games released *LEGO The Hobbit* videogame's key art in February 2014 for its spring release, its art generated massive buzz.

There is usually a primary poster for media properties, but sometimes there are special versions. Advance or teaser posters create early buzz around a new project well before its release. Designed to be used in a series, these posters are more mysterious, giving people a sense of what's to come, but not revealing the plot or sometimes even the title. High-profile or big-budget films may sync the release of teaser posters and teaser trailers, first setting up the mystery, revealing a bit more with the next iteration, and providing even bigger reveals close to the project's release.

Posters are created for premiere screenings of a film at specific or limited theaters. The poster uses the same art as the main poster, but includes the marquee or premiere location. *Star Wars* premiered at only four theaters and produced only two posters for each theater, so these posters are extremely rare. Studios also issue review posters with rave press quotes and awards posters when a film has been nominated for or given a prestigious industry award. Some major film releases have more than one style of one-sheet, each with its own art to appeal to different audiences: the romantic storyline for women and the actions elements for men.

Courtesy of Vulcan Productions

Three of the five versions of *Martin Scorsese Presents the Blues*' poster: (Left) John Lee Hooker; (Center) Muddy Waters and Mick Jagger; (Right) Bessie Smith. The posters created maximum exposure at the project's 120 events and were tailored for different audiences.

Technology and special effects have entered posters. Many posters are printed on both sides for light box display or with holograms, giving them a 3-D effect or sense of movement. Some are printed with lenticular technology using 12 overlaid images that make images pop from every angle or on mylar coated with silver or gold paint in which artwork is placed over the paint with holes, allowing the metallic paint to show through.

And now motion posters—or mosters—are made with high resolution animations of original film posters. *Hard Candy* released the first moster on GeekNation.com in 2005. Mosters are less than 20 seconds, must use original poster elements, and end with the original poster art. Some include "**Easter Eggs**," which are clues or inside jokes related to the movie, making them excellent teaser vehicles. The films *Wolverine* and *The Croods* and the TV series *American Horror Story* used mosters as part of their promotional campaigns. Mosters for *Jaws*, *Star Wars: Episode IV—A New Hope*, and other films have been created after-the-fact.

Poster art is still one of the most visible aspects of film and television promotion. It's used by movie theaters, print and online media outlets, and for indexing media properties for databases and search engines.

Collateral

A media project's key art and poster spawns many other pieces such as postcards, banners, business cards, and premium items or tchotchkes—from mugs and stickers to buttons and trinkets. Together, these pieces are called collateral. Today, collateral is more digital and takes the form of online posters or postcards, banner or tower art, infographics, and graphic memes. Though printed collateral was far more important before the virtual world, it remains extremely important in live event and experiential settings. People still like to see and touch things. And all that audiences encounter in a live setting seeps into their unconscious to create an overall imprint of a brand and experience.

© Hannah Wood

Peter Espersen, head of online communities for the LEGO Group, was a speaker at TEDxTransmedia 2012 in Rome and used this toy *cum* tchotchke as his business card.

The overall look and feel of collateral pieces should remain consistent, with all expressons deriving from a few pieces of approved signature art, a color palette, and a specified typeface. Every item, from the outdoor billboard to the smallest giveaway, must reflect the property's message.

Once your designer has created your key art, (s)he should develop a visual style guide that lays out the design rules and provides examples of their use, showing how all the collateral should hang together. The style guide provides a blueprint for all designers—working across different media (print vs. on-screen) or working for your partners—to ensure all collateral looks like a single body of work.

To follow is a page from *Martin Scorsese Presents the Blues*' style guide, demonstrating how the poster, postcard, and event banner create the look for the multi-platform media

project. There's commonality among the pieces, but also room for individual expression for each piece. Because each piece serves its own purpose it must be able to emphasize certain aspects of the concept art and messaging to accomplish its singular goals.

Color postcard

4-color poster

Street pole banner

Courtesy of Vulcan Productions

A page from *Martin Scorsese Presents the Blues'* style guide demonstrating the project's design dictates through various collateral pieces.

Other in-theater collateral pieces that might accompany the film poster include standees, which are freestanding paperboard life-size images of figures from the film, additional signage, outdoor billboard advertising, and branded concession items such as cups, food containers, and toys. Similar collateral is used in point-of-purchase (POP) displays at bookstores and retail stores for books, games, music CDs, and film and television DVD/Blu-ray promotion. Many times endcap, checkout displays, in-line facing tabletop, or in-aisle corrugate stand-up displays are created for retail. In addition, standees and signage—ranging from posters to banners—are widely used in retail.

© Camilla Anne Jerome; Courtesy of Vulcan Productions

Various promotional giveaways for *The Blues* "On the Road" events, including a harmonica, promotional CD, coaster, shot glass, and event pass.

An important aspect of games, CDs, and home video is the box artwork, which requires its own special design based on the property's key message and characters and the product size and in-store placement. Not only does packaging communicate a brand, but it also signals the value of what's inside, which directly affects purchasing decisions.

Game cover art, much like a film poster, is meant to draw audiences in. Sometimes gamers find cover art misleading because it oversells the gameplay experience. Actual gameplay screen art is an integral part of games audiences' perceptions of whether they might like the game, which is why it is an essential asset for reviewers and audiences leading up to its release. Most games are packaged like home video in CD jewel or DVD keep cases. Game box art includes the game name and logo, the platform, rating, publisher and developer logos, and, sometimes, positive review quotes. Cover art is released several months before the game's release as a promotional tool.

Assassin's Creed IV Black Flag's game cover art was critical to its reception—a simple image and the name. The publisher even developed a limited edition companion art book with scenes of locations, characters, and gameplay.

There used to be a big gap between the theatrical release of a film or run of a TV series and the release of the home video, so home video art was different from the original art to make it feel fresh. Now, with short windows or simultaneous releases, the art is likely to be similar. But the classics with long shelf-lives are often repackaged.

Media and entertainment box artwork is now used digitally. So the creation of entertainment property's key art increasingly needs to acknowledge the virtual world. The experience of flipping through a digital search function scanning digital thumbnail-sized images is very different from picking up a book because of its cover and flipping through its pages.

As the dictates of the digital world inform the use of concept art, one thing won't change. Iconic, memorable, and compelling art can grab audiences. But, because of the online and mobile visual overload, concept art must evolve. To get noticed, it must connect with audiences, and register on small mobile devices. Still art must be simpler, more graphic, and rely less on text. Or it must be more interactive and bring audiences directly into the mix the way sidewalk chalk art does. When it does connect, it will be shared, commented on, and altered by audiences.

It's no surprise that this digital era has given rise to moving concept art through mosters. Even more so, video is the native medium for key art for Millennials and Gen Nexters and has taken off online and on the go in epic proportions.

Author's Anecdote

Fan "Love" for Signature Art and Brands

During a weekly idea-sharing roundtable in the 1990s for 20+ top iconic PBS brands, the senior publicist for *Mystery!* reported that our press kit, sent only to credentialed press, was being auctioned off on eBay. And the bookmarks that were part of our retail bookstore tie-ins for mystery books readers were moving like hotcakes. Like all of *Mystery!*'s press and promotional materials, these eBay items featured Edward Gorey's whimsical black and white line illustrations of Victorian and Edwardian scenes and characters as their signature art. Our press kits for sale? We were incredulous, but we knew that mystery fans are fanatical and Gorey art had its own loyal following. We contacted our lawyers to let them determine the rights implications.

But our main reaction was to laugh out loud and use this to further our understanding of fan culture, which we could mine to impassion and engage audiences in our television and media brands. To this day, Gorey's signature art is integral to *Masterpiece Mystery!* and its devotees.

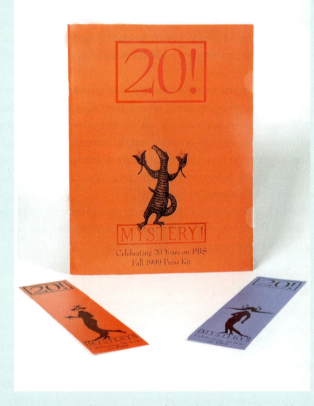

© Camilla Anne Jerome; Used by permission of the Edward Gorey Charitable Trust; Courtesy of WGBH Educational Foundation. *Masterpiece* and *Masterpiece Mystery!* are trademarks of WGBH Educational Foundation.

The *Mystery!* press kit and bookmarks that became collectible audience commodities on eBay.

The Open and Title Sequence

In an era in which audiences are ever powerful, providing content and assets that engage your public audiences is paramount. And no marketing tool is more effective than video—the first language of the twenty-first century.

Title sequences or the opens for films, television programs, videos, and games are the *entrées* to your content and the moving expression of key art using cinematic storytelling techniques. Not only do title sequences and opens set up what's to come, but the really good ones brand the property and are mini-films in and of themselves.

> *It has to set up, get you ready for what you're about to watch—mood, tone, and theme. But it also has to create a brand—that can be color, it can be typography, it can be imagery—that helps the show stand out, because there's a lot of noise and clutter out there.*
>
> —**Mark Gardner, creative director, SYPartners**

Purpose and Inspirations

Title sequences began in film as simple black and white cards, mandated by the industry guilds for more than a century. In the days before sound, they not only identified key players, but also delivered dialogue and advanced plot. As filmmaking progressed, so did title design.

The art form of modern opening title sequences or **Main Titles** that introduce the mood or theme of a film is the legacy of great designers such as Saul Bass and Pablo Ferro. They bridge two worlds, one of the audience's reality and the other the cinematic world they are about to enter. In a 1996 interview with *Film Quarterly*, Bass described the job of the title sequence as to "set mood and the primal underlying core of the film's story,

to express the story in some metaphorical way . . . a way of conditioning the audience, so that when the film actually began, viewers would already have an emotional resonance with it."

Film

In many of his film opens, Bass invented a new style of memorable kinetic typography—using animated moving text to present an idea or emotion. A title sequence that defined this new art form was the almost two-minute sequence for the 1960 Hitchcock film, *Psycho*, that Bass created for $21,000. No film opener portends the horrors of things to come more than *Psycho*'s minimalistic use of color and graphic expression.

 Psycho has two major themes: the contrast of Norman Bates' dual personality and the tension of the quest to uncover his secret. Against an all-black backdrop, Bass uses a series of simple black and grey bars to usher the white titles in and out. Controlled and sequenced, they emerge from left and right and from top and bottom on a proscribed path, never intersecting. Yet this orchestrated animation of graphic lines is set to the jagged, strings-only score by Bernard Herrmann that feels like it's about to lose control. Together, the controlled visual art and dissonant music set up the tension between restraint and break from reality. All this is punctuated by the film title being "broken" by these terrifying graphic swipes. This sequence allows the viewer to literally and figuratively read between the lines.

"Psycho title sequence" by Saul Bass; Licensed in the public domain via Wikipedia Commons

Saul Bass' chilling open for *Psycho* using controlled graphic expression and dissonant music, which helped create the modern title sequence art form.

Other title sequences that reflected their film's spirit include the slow pan over cigar box items—a pocket watch, crayons, and marbles—providing a glimpse into a sheltered child's world in the film *To Kill a Mockingbird* (1962). Or the animated antics of the Pink Panther character set to Henry Mancini's memorable score, setting the tone for the hilarious comedy *The Pink Panther* (1963).

"Films before a film" went out of vogue in the 1970s and 1980s and then had a resurgence in the 1990s when Martin Scorsese pulled Bass out of advertising to make opening titles for *Goodfellas*, *Cape Fear*, *The Age of Innocence*, and *Casino*. This spawned a new generation of title designers. The opener for the 1995 film *Seven* was almost as scary as the film itself, revealing the secretive writings and possessions of a serial killer and resolving on a black and white film title that appears to be scratched onto the lens by the manic killer himself.

The title sequence for Ben Affleck's 2012 political thriller *Argo* explained the film's complicated premise of C.I.A. agents posing as Canadian filmmakers scouting film locations during the 1979 Iranian hostage crisis as a ruse to free US diplomats from Tehran. To communicate the "film within a film" concept and deliver the historical context, it used movie storyboards to show actual historic events leading up to the film and a typeface consistent with the era.

Another trend among film title sequences is **End Titles** with elaborate epilogues, particularly common in children's films. In 2008's *Wall-E*, the end titles show humans and robots co-existing, a revitalized Earth, the history of human art, and a mini-retelling of the entire film using old-style pixelated animated characters.

The average film main title sequence today is about 90 seconds, whereas the end titles can run five minutes.

Television

From the 1950s to the 1970s, television title sequences were very popular, especially in sitcoms, which had memorable jingles that spoon-fed the pilot premise in less than a minute. Who can forget "Here's the story of a lovely lady, who was bringing up three very lovely girls, all of them with hair of gold like their mother, the youngest one in curls" and the nine faces appearing in the family grid from the *Brady Bunch*? Or the visual saga of astronaut Steve Austen going into outer space, suffering an accident, being rebuilt with bionic parts, and testing his new superhuman sight, hearing, speed, and strength for the quests to come in *The Million Dollar Man*?

But as audiences fragmented and advertising rates plummeted in the 1990s and 2000s, revenue became scarcer in network television. Network executives wanted every second of real estate to sell and forfeited the 30 to 45 seconds for title sequences in favor of more revenue. The average network open now runs five to 10 seconds. One-hour dramas have just over 40 minutes of story and half-hour comedies, about 22 minutes—the rest is mostly devoted to commercials.

Because cable TV dramas and mini-series create a film-like mood and overall experience, main titles have become increasingly important. Story-driven title sequences on cable are between 30 and 45 seconds, and are more in fashion on cable than in film. HBO, Showtime, and AMC are trying to differentiate themselves from the networks, and use creative titles effectively, especially since they don't have the same time constraints as networks. HBO's average title sequence is 90 seconds long. Many of cable's creative opens scorch over social media.

Showtime's *Weeds* opener makes a statement about the need for conformity in suburban life by using computer-generated clones conducting their routines in a planned community, accompanied by the folksong soundtrack of "Little Boxes," performed by a different artist each week. The credits for the HBO series *True Blood*, about vampires assimilating into rural Louisiana, creates a postcard flipbook of unnerving images of the deep South—from swamp homes on stilts and alligators to religious signs and unpaved roads. In the final shot, a woman is baptized in a river and emerges in a fit, setting up the fine line between deep faith and hysteria.

The Emmy award-winning opening title sequence for *Mad Men* about the high-gloss world of advertising in the 1960s and 1970s, graphically telegraphs lead character Don Draper's glamour and control on the surface, but his devolution and deception beneath. In a dream-like sequence he loses control and falls off his metaphorical high tower. The sequence's final seen-from-behind black and white silhouetted frame of the enigmatic Draper inspired the AMC series' brand-defining key art. (*Mad Men*'s title sequence and branding is covered in detail in Chapter 31, "Transmedia Marketing Case Studies").

Games

In games, title sequences are optional. As games have become more story-driven, the value of title sequences have increased because title screens, animated introductions, and attract modes tee-up the story and emotional space the gamer is about to enter. Recent game title sequence forays are matching the quality of film and TV titles. AAA game studios have created cinematic-style title sequences for games such as *Deus Ex: Human Revolution* and *The Last of Us*.

How to Open

When it comes time to create your film, television program, or video, you want to work with someone who's adept in video storytelling. Getting beyond simple cards that deliver credits for the front of the show to a mini-film that sets the tone for what's to come begins with the right talent that fully understands your media project's story. There are professional branding and title sequence companies that specialize in this work. They are expensive, but if you have a project with great promise, then it's worth every penny.

The process of creating opens starts with the script, the TV pilot, and the creator's original premise. Ideally, the people creating the open have face-time with the media project's creator, to fully understand his/her vision so they can distill it down to something simple to create a lasting and iconic open. The media project itself has an aesthetic that includes a tone, a look, and a feel. If there isn't key art for the property yet, then creating the open may do the same job as the key art—create a look and feel to develop a big idea to tell the story. You also must know whether the open is going to be 10 seconds or a minute.

Designers begin by pulling outside visual references that signal the tone and visual elements from within the show to create original sketches. Then they work with them all.

We're sort of playing at that point, trying to find something that just seems to hit. And it's not about trying to come up with a tagline. We're aiming for an image, or a mood, or a feel, or something that says to us, "This seems to sum this show up" or "This seems to be the right way to prepare an audience for experiencing it." You just don't quite know until something just feels right.

—**Mark Gardner, creative director, SYPartners**

Some opens take a graphic direction. Others, a photographic direction. Designers begin with some loose sketches of a couple of different directions and draft a paragraph for each direction explaining its vision. Then designers storyboard the sequence to show its story arc. Sometimes they will make an animatic or a motion test of one of the directions. For HBO's mini-series *The Pacific,* Imaginary Forces developed an original animatic motion test on a low resolution digital slow-mo camera shot at a high frame rate that mimicked the final product. Often times that's not the case, it changes a great deal from original idea to execution.

Music is a huge part of title sequences. Sometimes the visuals are dominant and other times the music is dominant. More often, they're equally important. They can reinforce the same message or communicate two different messages, signaling conflict or a duality. Pairing the music to the visuals is important in ensuring that the original vision is realized in an opening title sequence.

In Saul Bass' day, the title sequence and the key art were all tied together. That is less the case today, in part because of the compartmentalization of various marketing and promotional activities. Now, specialists work on the title, different people work on the PR, the Web site is created by online experts, and the marketing materials are created by a separate marketing team. Sometimes that creates a disconnect.

HBO's *Girls* is a gritty, down-to-earth, and authentic show, reflected in its PR photography, yet its posters make the characters look coiffed and glossy.

Received in author's e-mail in March 2014

An e-blast for an event with creators and cast of HBO's *Girls*, showing a glammed-up cast in its art.

The marketing materials and the open serve different purposes. The marketing materials' job is to get you to watch the film or TV show or play the game. Once you're watching the title sequence, you're already there. The title sequence's job is to set you up for what you will watch or play, so it's tied much more closely to the content of the property.

But sometimes—when all the planets align—a signature piece of art from the title sequence establishes the brand's visual identity and informs the marketing campaign, as was the case with *The Man with the Golden Arm* or *Mad Men*. In that case, the title sequence goes back to the pure roots of title sequences and key art, performing both jobs.

For *Martin Scorsese Presents the Blues*, the minute-long title sequence by Big Film Design did both jobs. It introduced the audience to the films, setting the stage for the films' exploration of how the blues evolved from parochial folk tunes to a universal language. As such, it connected seven disparate films that explored the blues through seven top directors' own perspectives and personal approaches. In addition, the open created a visual style for the project's key art and promotion.

From *The Blues'* branding and messaging in Chapter 12, "Positioning and Messaging," you'll remember that its messaging big idea was how the blues had profoundly influenced all other genres of music. That idea was expressed through the Willie Dixon quote, "the blues are the roots, everything else is the fruits." And you'll remember that the creative strategies for conveying that idea were to lead with the music, be authentic to the essence of the genre, and take the audience along on a musical journey. The project's title sequence was both the visual and aural expression of all that (see *The Blues* main title sequence in the project's style guide on the next page).

Set to Muddy Waters' deeply-expressive, quintessential blues classic, "You Can't Lose What You Ain't Never Had" from the original Chess Records album *The Real Folk Blues*, the title sequence's dominant music underscores the emotional and financial costs of human and material attachment.

Correspondingly, the title sequence has a gritty look with tinted stills and stylized historic video of the roots and myriad expressions of the blues. Instruments are peppered in between shots of people and places that are influenced by the blues' journey. The sequence uses guitar frets as a graphic motif and a color palette of soft blue and sepia brown.

Courtesy of Vulcan Productions

A screen shot from *The Blues'* main title sequence.

The Blues opening title sequence set the tone for all of the marketing materials for the project, expressly communicated in the style guide. The open informed the various print collateral executions and the promotion and advertising for the project.

Courtesy of Vulcan Productions

The Blue's style guide page outlines how the title sequence set the stage for the graphic look of the entire project.

For decades, title sequences have had a huge influence on audiences' perceptions and acceptance of a film or television program and have been recognized as an entertainment art form. The use of opens and title sequences as mini-films will ebb and flow with the dictates of audience taste and consumption and changing industry distribution. They will always signal the tone and premise of what's to follow, helping audiences bridge the chasm between their own lives and those of the characters in the universe they are about to enter.

Not only is video a segue into your film, television show, game, or Web site, but it also is one of the best promotional invitations to get audiences to come to it. Whether a six-second Vine or a sophisticated movie trailer, video is today's most engaging and sharable marketing device.

Trailers, Promos, and Sizzlers

Video is the first language of today's media makers and media marketers. Professional or homegrown, videos are created and shared as readily as taking another breath. People love telling the story of their marriage proposal or teasing a new digital app through the storytelling device of video. And others consume these videos in equal measure, fueling the creative drive.

While the moving picture has been around since the late nineteenth century, short-form video has burst on the scene because of mobile devices. You can shoot decent-looking video and easily share it from your smartphone—production equipment and distribution in a single device. Gen Xers and Gen Yers are all DIY filmmakers and film critics. And Boomers aren't far behind in embracing social video. For them it's less native and more in rebellion to the text overload wrought by workplace e-mail in the 2000s and beyond. Once humans see moving pictures, the brain is activated and takes over, absorbing the story at a primal level without conscious processing or thinking. Video is simply fun.

Trailers and Teasers

Trailers of all kinds—in film, television, games, and books—captivate today's audiences. Audiences watch more than one billion trailers a year on YouTube and consume many more on Vimeo and other video-sharing platforms. The release of film trailers is so hotly anticipated that superfans game out their timing and race to comment and share first. *Slate* even has its own trailer critic.

Trailers' popularity speaks to the dictates of current life—they satisfy audiences' yearning for story, yet in an accessible package. They're mini-movies that take audiences on an emotional journey.

People love trailers because you're distilling the best moments from a movie. Trailers and promos tell an emotional story. Posters are about the one big emotional note. Trailers and video are more of an orchestra.

—**Linda Button, brand personality expert, co-founder and principal, Tooth and Nail**

If the trailer makes an impact, it will drive audiences to the media product—increasing ticket sales, viewing, downloading, and purchasing. That's why studios, networks, and publishers enlist professional production companies or hire top-notch in-house staff to produce them. It is also a key digital asset for a publicist to leverage exclusively to top media outlets.

Film

Like everything else, trends in film trailers are cyclical, but what hasn't changed is that their primary goal is to generate big audiences for the opening weekend or the VOD launch.

Trailers began with the Golden Age of film. By WWII, the National Screen Service ruled movie marketing and created a film trailer formula. Trailers were shown after a feature film, hence the name trailers. They presented an overview of the story with few key scenes from the film, relied heavily on title cards with exaggerated messages to guide the audience's takeaway, and a voice-over to carry it all along. As the star system grew, stars became dominant in trailers and film promotion.

"Gentlemen Prefer Blonds Trailer Screenshot" by Crackkerjakk; Licensed in the public domain via Wikipedia Commons

Screenshot of trailer using hyperbolic cards to excite audiences for *Gentleman Prefer Blondes* in 1953.

By the 1960s and 1970s, the monopoly in film promotion had eroded, giving rise to new talent and more symbolic and idiosyncratic trailers. Pablo Ferro, the trailer *auteur*, created a trend-setting montage for Stanley Kubrick's 1964 *Dr. Strangelove* with fast cuts delivering a peripatetic feeling—highly labor-intensive in an era of linear film cutting. In the 1980s and 1990s, in the era of the sci-fi and action blockbusters, trailers careened back to their formulaic roots. Trailers were more about special effects and requisite explosion shots.

Trailers have returned as an art form. A trailer's job is to give the audience a sense of the story without giving it all away, yet still bring them to the film. In the *Newsweek* interview (12/20/2009), "James Cameron, Peter Jackson on Film Technology," Cameron said, "What's interesting in the marketing evolution of *Avatar* is that we put out a teaser trailer that was all about the imagery, and people were less than satisfied, because they weren't learning enough about the story. We put out a story trailer that set the stage and told you what the main character was, and all of a sudden people were wildly excited about the movie. There's the proof within the marketing evolution of a single film."

Setting up the tension in the story is paramount to a good trailer. The trailer for *Alien* (1979) is a timeless masterpiece. With no dialogue and just an eerie semi-screaming soundtrack, it begins with five white horizontal marks against a black sky in outer space that eventually reveal the graphic letters of A-L-I-E-N. The trailer shows increasingly terrifying fast-cuts foretelling the characters' plight without showing the source of their terror. The trailer resolves with the chilling tagline, "In space, no one can hear you scream."

Like the film itself, trailers focus on plot and character. Standard trailers follow the film's story—an abridged version of all three acts. Others are more theme-driven. Some use title cards to signal the film's core themes and emotional conflict. For the 2012 film *Life of Pi*, cards such as "When all you've ever known is lost" set up the film's unusual premise, and "a life of hope" signaled its uplifting nature. Different genres of films have different styles. Thrillers are fast-cutting and psychological dramas, satires, and foreign films use longer shots. Because they're released so early in the production, creators often shoot original material.

Many fans are irritated by trailers that don't leave enough to the imagination. Story purists contend that the more the trailer tells you, the worse the film is.

Trailers are distributed in various ways. For decades, trailers have been shown before the film at movie theaters to ensure audiences don't leave without watching them. Previews can last 20 minutes, and for many are integral to the live moviegoing experience. In-theater trailers used to be two and one-half minutes long, but now are two minutes or shorter.

Pairing your trailer to the right in-theater film and target audiences is important. Trailers can be directly attached to the feature, which is highly sought after for blockbuster or event films. Sometimes the trailer is the draw. The 1999 *Star Wars: Episode 1—Phantom Menace* trailer attached to *The Siege* attracted 2,000 people to an LA theater. Trailers

can be tailored to different audiences or films. For *Chicken Run*, DreamWorks created amusing and contextually-relevant *Chicken Run* parodies for both *Mission Impossible* and *Gladiator*.

Showing trailers on television dominated movie marketing by the early 1980s. As a result, tighter shots ensured their visibility on the small screen. Lengths varied from several minutes to 30 seconds; ads were sometimes tailored to the TV program in which they appeared.

Nothing has changed the tenor and the excitement over film trailers more than the Internet and social media. It has had an effect on their creative execution and created a boon to the trailer art form. Now trailers must have social currency. If a trailer gets commented on and shared widely, that's worth millions of dollars in promotion.

> *There's more pressure now for trailers to be entertaining in their own right. You're looking for that moment in the trailer or tease that pops and that people want to share and say, "Did you see that?"*
> —**Linda Button, brand personality expert, co-founder and principal, Tooth and Nail**

With no length restrictions or high costs associated with their distribution, online trailers can be any length and serve various audiences. As a result, a broad range of compelling and engaging trailers are traversing social platforms, with audiences as the natural selectors of good trailers. With the Web and social media serving as a cost-effective distribution system for trailers, independent films can reach a wide audience with almost unlimited potential for reach and frequency. Another example of how technology has become the great equalizer.

Studios and indies alike are using digital platforms to release trailers. For its spring 2012 release of *Marvel's The Avengers*, Walt Disney Company released its trailer inside the Facebook game, *Marvel: Avengers Alliance*. The *Steve Jobs* trailer was the first big trailer to be released on Instagram in 2013. Online trailers not only offer value in direct viewership, but also in the broader WOM awareness they create. Trailers' launches are integral to consumer brands' marketing and promotion campaigns. As part of its integrated tie-in with Lionsgate's 2013 *The Hunger Games: Catching Fire*, Subway offered fans the exclusive one-minute preview trailer featuring Christina Aguilera's movie soundtrack song, "We Remain" on Facebook just a few weeks before the film's opening. In 10 days it drove 30,000 "Likes" and about the same number of shares.

Teaser and theatrical trailers are included in home video and downloadable purchases of films because audiences view them as coveted bonus content.

Traditionally, theatrical film trailers were released just a few months before the film's premiere. Because of the potential of fan-based participatory culture and the huge expense to cut through the clutter to even reach audiences, video is being released earlier.

In promotional terms, time is money. If a film has a built-in fanbase you can feed trailers and teasers two years out. "Fanboys" and "fangirls" love to talk about these media properties and will become ardent ambassadors for your film. With enough carefully-orchestrated content and promotional material feeding their voracious appetites, fans can sustain and broaden public interest over a long time and help you bring it to a crescendo just before premiere.

If a project is entirely new, you can seed trailers and teasers about a year before the film's release, varying in length from two minutes for a more theatrical trailer to very short teasers. Once trailers are released, the film should have an official preview Web site with interactive elements and background on the film. The idea is to use the trailer to reward audiences with more content and deeper engagement.

The nature of the video that is released far before the film's premiere is different from what's released closer. Early video forays are **Teaser Trailers**. Teasers are about generating awareness by piquing audiences' interest and curiosity. They raise more questions about the film than they answer. They should be released in a well-conceived campaign series, incrementally revealing more information. Originally, only big blockbuster films could afford teasers, but with virtual distribution and audience amplification, they're common. Teasers fall into two camps. Those that give a glimpse of the film through montages of film footage for fan-based films and those that use no footage at all, often setting up a metamystery.

Generally, teasers are about a minute in length, although mystery-based teasers can be just seconds long. Teasers are more about establishing a mood and a tone for a film. They're rarely cut chronologically to the film and don't use much dialogue. Because teasers are made far in advance and have limited access to film footage or special effects, they must be very inventive to capture the film's essence.

The 90-second teaser for the under-wraps film *Cloverfield* first appeared before *Transformers* in 2007. It began with a yuppie going-away party when something off-screen roars into and wreaks havoc on New York City. The teaser ends on the money shot of the head of the Statue of Liberty (also in the poster) smashing to the ground. The teaser had no movie title, only J. J. Abrams' name and the release date 1.18.08. Pixar creates complete mini-film teasers as they did for *Cars* and many other films. Teasers have been central to *The Lord of the Rings*, *Star Wars*, *The Amazing Spider-Man*, and *Harry Potter* franchises because of their rabid fanbases.

Many teasers appear more than a year before the film's release date. *The Incredibles* was attached to *Finding Nemo* some 18 months before its premiere. *Despicable Me 2* teased 16 months out, attached to *The Lorax*. To leverage the two biggest moviegoing seasons of the year, summer movies are often teased during the big box office winter holiday films and *vice versa*. In 2014, the National Association of Theatre Owners restricted trailer screening to 150 days before the release of the film and display of posters to 120 days before release. This may affect the usefulness of theaters for teaser marketing strategies, giving a leg up to digital distribution.

Television

In television, trailers are also called on-air promos. They are designed to promote audience tune-in to a particular television program. Most promos include select clips of segments from an upcoming program. They include tune-in information—broadcast network, airdate, and time of broadcast. Traditionally, promos only appeared on television. Now, TV promos are viewed online and on the go.

On-air promos used to be 30 seconds, but now run 15 or 20 seconds because of the cost of commercial space. PBS and premium cable channels like HBO are the exception because they don't accept commercials. They use program breaks to run on-air promos announcing upcoming programs, often longer than commercial promos, running between a minute and 15 seconds.

Increasingly, TV promos are *clichéd* and look very similar across networks. Crime drama promos have action scenes, intense close-ups, and suspenseful endings. The big differentiator is the actors or on-air talent. Newscasts promote magnets like weather, sports, and upcoming segments during the news to keep viewers tuned in.

Increasingly, TV promos are distributed virally off air and then can be of any length. Now that entire seasons of television series are being sold or downloaded at once, seasonal television trailers look much more like movie trailers, often two minutes in length. Other promotional assets such as news announcements, key art, and interactive content on Web sites support their launches.

> We rarely put out a new announcement without some type of video content to support it. The press we break is primarily digital. Our biggest goal is to get a sneak-peak clip of a new show—a film-style trailer or a full-season super tease—out with a media alert or a press announcement. So the audience can immediately connect and you'll have their eyes on something for a minute or two instead of just scanning a headline. It's much more sharable and it can also drive them back to TLC.com for more video or to deepen that connection.
>
> —**Dustin Smith, vice president communications, TLC**

Netflix has relied on viral promos to promote *House of Cards*. The first season's movie-like trailer garnered more than 2.4 million YouTube views. The second season's two-minute trailer was released with its key art and posted more than 2 million views in the first five weeks. The OTT provider released three additional 30-second promos two days before the series "premiere" to further whet audiences' appetites. And good promos work. ABC's *Marvel Agents of S.H.I.E.L.D.*'s promos effectively drove audiences to the premiere, according to TiVo's Research and Analytics unit (TRA).

To connect promos with the second screen, many networks are creating apps for mobile devices to promote their programs and showcase their seasonal promos. CBS' 2014 Fall Preview app featured an interactive ad with *NCIS'* offbeat forensic scientist, played by actress Pauley Perrette, inside the CBS logo eye offering commentary on key series such as *2 Broke Girls* and *Person of Interest.* Each program has its own site in the app with trailers and an image-mapping memory game.

Books

Books are actively using book trailers to promote titles. Some believe using trailers for literary works cheapens the very nature of the print medium. But book trailers simply expand on the book cover, ads, and in-store displays to deliver the promotional message in a package that is relevant to today's audiences.

Distributed on television and online, book trailers are sometimes referred to as video podcasts. The higher quality trailers are called cinematic book trailers, giving a sense of the storyline and introducing its characters. They use actors to perform scenes, animation, flash video, or still photos set to music.

Because using book trailers is still new, some book trailers are stilted. But, a few have found a voice and a unique message to reach audiences. In the 2010 trailer for *Where Good Ideas Come From*, author Steven Johnson narrates a synopsis of the process and stimuli that create human innovation, accompanied by a never-ending fast-frame cartoon drawing on a whiteboard. He brings hundreds of years of creativity and invention to life in a visually-engaging and thought-provoking four-minute trailer.

Author Gary Shteyngart uses comedic short trailers that parody the act of self-promotion. In his trailer for the 2010 novel *Super Sad True Love Story* featuring various famous authors and actor James Franco, Shteyngart plays a Russian-accented alter-ego, who wrote a book and taught at Columbia University despite not being able to read. The trailer got one-quarter of a million views on Facebook.

Book trailers are used in education as well. Libraries and school media centers have programs for children to create book trailers as a tool to promote literacy.

Games

Game trailers have taken off in a big way. They are intended to provide a sense of the immersive nature of the game universe through tone, look, characters, and gameplay. There are two types of game trailers—the gameplay trailer and the story trailer. The gameplay trailer showcases gameplay elements and why the game is fun to play. A game must deliver on the gameplay experience that is "advertised." If it does and audiences like the game, then it will enjoy the loyal and fanatic promotional horsepower of the

audience. If gamers feel it's "a bait and switch," they are unhappy and equally vocal. Gameplay is so important that the gameplay video on YouTube for *Game Dev Story* (about running your own game company) shows full cycles of the game for 17 minutes and highlights for four minutes.

Story trailers focus on the experience that creators want gamers to feel—emotions and the sense of excitement or adventure. Along with communicating the narrative and story universe, story trailers also focus on gameplay. So, if you can only create one trailer, then create a hybrid. It's good to show ambiance and texture, as long as you demonstrate gameplay. As games are incorporating more story, so too are their trailers.

> *Story has absolutely become a much more important part of videogames. Now, there is the ability to create more linear cinematic moments of storytelling that really can connect with the player, as well as experiences that let the player have a great deal of agency in the kind of characters that they get involved with and the stories that they tell.*
>
> —**Susan Arendt, managing editor, GamesRadar+**

The launch game trailer for the 2006 *Gears of War* was a breakthrough for the industry. Its big idea was to set the entire one-minute trailer to Gary Jules' introspective piano rendition of "Mad World." Before that, trailers favored heavy metal tunes. With dark, moody shots of the game, the trailer created a deep emotional sense of desperation about this story world. This trailer influenced many other action game trailers to come. The trailer for 2012 *BioShock Infinite*, the second sequel to the role-playing series, took a first-person perspective of being tossed out a window and traveling through the cityscape of Columbia. As you tumbled, you encountered different aspects of the retro and futuristic story world, rich with detail and texture.

Game trailers' main point of *entrée* is online. Because audiences discover trailers in various ways, often without context, the launch trailer must embed key information, such as the game's name, when it's available, and on what platform. The average game trailer is about a minute long, but if the game has an avid following, such as *BioShock* or *Grand Theft Auto*, it can be longer because these passionate audiences are looking for a deeper experience with the content. If the trailer is a teaser, then it might be shorter.

Game trailers and video are so vital to the gaming experience, that the site GameTrailers.com is dedicated to game trailers. The site provides free access to reviews and previews, game trailers, and recorded gameplay. Users can upload videos, create blogs, and participate in forums.

Sizzle Reels

The sizzle reel was originally created for influencer audiences, to help secure production, financing, and distribution. They're the video complement to the treatment, script, pilot, or project design, showing your idea in action and providing a better sense of the look and feel of your property. But because development executives are channeling for the end audience, a sizzler also must appeal to public audiences. They're often used online and at public and industry events, acting as four-minute trailers.

There are various types of sizzle reels. Early sizzle reels may be rip-o-matics, cut from other sources. Later sizzlers use the property's footage. **Teaser Sizzlers** are one- to two-minute promos that create curiosity and interest in the project (like teaser trailers). **Standard Sizzlers** are movie-like three- to five-minute trailers that provide an overview of the story, characters, dramatic tension, and creative vision. **Presentation Tapes** run from five to 20 minutes, with overall set up and full scenes or clips. These can be created with the Standard Sizzler and a few clips attached. **Talent Sizzlers** focus on the talent or subjects, showing them in their natural environment and through interviews. All sizzlers include music and graphics. Sizzle reels need not cost tens of thousands of dollars. With lower equipment and editing costs, good reels can be made inexpensively.

Like most video expressions of your project, the sizzle reel addresses story, character, story universe, and what you want your audiences to feel—all imbued in your treatment, script, logline, brand archetype, messaging, and promotional big idea.

The semantics and intended audiences for sizzle reels, longer theatrical trailers, and all forms of video are overlapping.

For *Martin Scorsese Presents the Blues* on PBS, the network's creative team developed a stable of on-air teasers, including several short long-lead teasers (two 20-second teasers and one 15-second teaser) and one two-minute teaser with some original footage with B.B. King, Bonnie Raitt, Steven Tyler, Ruth Brown, and Bobby Rush that aired the summer before the fall premiere. The teasers' jobs were to create a sense of excitement and begin to brand the series. To promote tune-in closer to broadcast, the project made various promos to air on PBS including 60-second, 30-second, and 20-second versions of the overall series promo (series sell), plus 30-second and 20-second promos for each of the seven films (and nights). The 30-second series sell also appeared on some spot cable TV. Finally, the project's five and one-half minute "Gritty Sizzler" was used for internal team and project partner events and at about half of the project's 120 "On the Road" festivals and heritage events. Music and film fans posted that sizzler all over YouTube.

Entertainment trailers, teasers, promos, and sizzlers are beloved by audiences and are paramount to the presentation of a media property. Television networks mete them out in small doses like opiates to frenzied audiences awaiting the next season's series. Elementary school students make them with iMovie or free online software. Big consumer brands treat them like full-fledged media properties worthy of brand partnerships.

Trailers and promos have become sophisticated and precious online assets that drive interest in the media property and traffic to sites that host them. They're showcased at aggregate entertainment video content sites such as *Metacafe*, which can monetize them as valuable content. Video, in its many forms, has simply become ubiquitous in the twenty-first century.

Author's Anecdote

Producing TV News Promos

Early in my career I worked in news for the CBS affiliate in Boston. Over the course of several years I learned every aspect of news, from working the assignment desk and writing news stories to field-producing live events and producing news and feature story packages. Later, I coordinated news stories for the CBS network and conducted research for programs, including *60 Minutes*.

One of the throwaway jobs was producing the on-air promos for each newscast. But I was willing. That was where I learned how to write news copy, cut video to copy, work with an editor, and thrive under the deadline of getting something from the photographer's camera to on-air ready in an hour's time. It was perfect training for the baptism-by-fire world of TV news. The promos ran during the lead-ins to the newscast and at the end of the "A" section of the newscast to tease the "B" section, and so on. Sometimes the promos included a roundup of multiple stories; sometimes they teased one story. Making those on-air promos gave me the confidence to later produce two-minute news, political, and consumer unit packages. And it taught me about story and the close relationship between content and its promotion.

PART VII

Reaching Your Public

Advertising

The Media Plan

Advertising is the old stalwart of marketing. It's what most people think of when they hear the term "marketing" even though it is one of many promotional tactics. "Paid media" is a $200 billion yearly industry in the US and $500 billion globally. Advertising used to be based on the premise of reaching a broad audience. No other medium has more mass reach and influence than television. A 30-second spot appearing during the Super Bowl, Oscars, or Olympics reaches more people than other single media placements.

In the past few decades, technology has radically changed the nature of advertising. Audiences have fragmented across a plethora of choices on various platforms. Now, advertising is more about reaching a specific audience. While print media circulation has declined, online and mobile content and advertising have soared. Interactive and sharable creative digital executions are the new frontier.

But digital advertising revenue hasn't replaced that lost from traditional broadcast and print advertising, threatening the advertising business model. Digital advertising hasn't gained much audience acceptance, because creative executions haven't found their voice and many audiences "grew up" without online ads. So the current advertising challenge is how to capture digital audiences' attention and monetize online and on-the-go content.

Media Planning

Developing media plans is a discrete specialty of advertising. Media planning units of advertising agencies and media planning and buying companies develop media plans for placement of paid messages for advertising campaigns. The best campaigns develop

the creative message and media plan together. In today's world, the media plan—how messages are delivered to audiences—has become one of the most creative aspects of advertising.

In the traditional days of packaged-goods advertising that built the advertising industry, driven by giants like Procter & Gamble, there was a basic mass media marketing formula to ensure you reached "everyone." An advertising campaign included two TV commercials and three print ads. When there were only a few networks, media buyers would "road block," buy a 30-second spot at the same time on each network to reach the entire TV-viewing audience. With only three networks and a handful of magazines or newspapers of record, it was pretty simple to saturate most of the US.

Now, the concept of mass marketing is all but gone. To duplicate the mass marketing reach of the 1960s, you would have to buy so much time and space on so many media outlets, the costs would be prohibitive. That's why big "TV events" still have so much appeal; they're the closest things to mass marketing in today's world, with the added benefit of social saliency.

With the vast array of available media—television, radio, newspapers, magazines, Web sites, mobile devices, outdoors, wild postings, taxis—how do you decide on the "Media Mix" of where to place your paid advertising for your projects? The answer lies in knowing what media your audiences are consuming and how they're consuming it.

Illustration by Brett Ryder

You should seek a transmedia "Media Mix" in your media buy and in all of your communications.

The media planning process begins with identifying your target audiences and determining strategies to reach them. It's a mini-version of your marketing plan. The sounder the marketing plan and the thinking behind it guiding your media buyers, the more bang you'll get for every buck of your promotion. Your message will reach your audience more efficiently and directly.

Since content is so niched today, so too is most marketing and media buying. If you are trying to reach 16-year-old girls, then placing a spot during *Pretty Little Liars* along with various sponsored or shareable content on associated social media might work. If you're trying to reach the home DIY-er, then a packaged multi-platform buy with *This Old House*—TV program sponsorship, ads in the magazine, and co-branded Web content—might make sense. It's about reaching your audience in their natural habitat. Marketing isn't as much a sales job as it's providing value-added content and the promise of an engaging experience.

Define your audience. There is no such thing as a general audience anymore. It's all a collection of niches and you have to engage them, not sell to them. Every one of those niches is looking for an authentic experience.

—Ty Burr, film critic, *The Boston Globe*; author of *Gods Like Us: On Movie Stardom and Modern Fame*

Media buys occur in four key arenas: **Broadcast** (television and radio); **Print** (newspaper and magazine); **Outdoor/Out of Home** (billboards, wrapped buses, mall kiosks); and **Digital** (online, social, and mobile). Television ads can be placed on spot TV (local markets), network, or cable. Digital can be search ads (displayed on a search engine results page in response to a user's search query), display ads (text and visuals on Web sites; banner ads), mobile messages, social media platform ads, and e-mail.

Buys are always fine-tuned to the target audience. They vary demographically, such as media outlets catering to a gender (*Glamour*), age (AwesomenessTV), or geography (the national ABC TV network or certain local ABC affiliates in key markets). Buys vary psychographically by areas of interest, such as for certain sports (*Ski Magazine*) or type of media experience content (GameSpot.com). Media buyers "weight" their buy based on which audiences are the most important. That's why knowing your project's primary, secondary, and tertiary audiences is critical. You won't have the money to reach all audiences well, so you must choose. It's better to "heavy up" (put more emphasis) on one target audience and reach them well, than reach several audiences inadequately.

As the simplicity of media buying in the packaged-goods era of advertising has disappeared, there is less consensus on what makes a good media buy. Traditionalists believe in massive, broad media buys to get noticed above the cacophony of content, while pragmatists believe in thrifty, targeted niche spending.

What's a GRP?

All media buyers agree on the key dictum of media planning—obtain sufficient reach and frequency to deliver the message to enough people in your target audience through enough exposures to create impact. Media buying is born from the Hierarchy of Effects principle, like the Theory of Change applied to consumer products' branding and marketing. The audience behavior pathway is that brand *recall* and *awareness* lead to *trial*, which leads to *brand loyalty*. There's an old "Rule of Seven" in advertising: audiences must see a name, product, or brand seven times to consider using it. And to even recall it, they must see it three times. Each of these audience intersections is an **Media Impression**. Two impressions can be achieved by one person seeing the same ad twice or by two people each seeing the ad once.

The number of impressions seen over a certain period of time (recency of the impression is important) = *Frequency*. The percentage of potential consumers that see that impression = *Reach*. **Frequency × Reach = GRPs or Gross Ratings Points**. (Reach = GRPs ÷ Frequency and Frequency = GRPs ÷ Reach). This mathematical formula is born from broadcast mass advertising and is now used for all media to calculate both the size of the audience reached and the amount of exposure with your message.

So the TV spot for your game that airs four times (frequency of 4) on *Walking Dead* reaching 50 percent of your zombie-loving target audience each time it's broadcast (reach of 50 percent) has a GRP value of 200 (4 × 50% = 200). Or the billboard on a main highway about your interactive exhibit that 3 percent of your target audience drives by every day for 120 days has a GRP of 720 (3% × 2 times per day × 120 days = 720). If you add up the ratings points of each media buy, you can determine the total GRPs for that medium and entire advertising campaign. Enough GRPs leads to saturation, which is when awareness and messaging of a media project penetrate deeply.

Buyers calculate the general cost of purchasing these various media using **CPMs** or **Cost Per Thousands** of media impressions based on the viewership, listenership, readership, or visitorship of a media outlet, but a good media-buying firm can negotiate down the price of your media buys. The bigger the audience, the higher the cost to advertise on it. Other criteria also factor in. In broadcast, the longer the spot, the higher the rate. In online and print, premium locations and size of the ad matter. In print, color costs more than black and white. A full-page 4C ad in *Newsweek* or *Time* lists at $200,000. Network TV per person CPMs for 18-to-49-year-old viewers are $44; cable, about $16; and in-stream video for all demographics, $23. The broadcast/online video CPM is plummeting because of YouTube's lower costs for TV-like ads.

The most expensive ad medium is television because of its reach. Its cost is also based on perception. Reaching 18-to-49-year-olds is seen as most desirable, despite the fact that young audiences have much less disposable income than 55-year-olds. "Trending"

programs also cost more. The final 1983 episode of *M*A*S*H* set a record of $450,000 for a 30-second commercial. *Seinfeld's* farewell episode in 1998 racked up a $2 million price tag. Half-minute spots for the 2015 Super Bowl ran about $4.5 million.

A very loose rule of thumb for broadcast media buying is to secure 100 GRPs per week for four weeks, delivering a reach between 45 and 80 percent of your target. One hundred GRPs is equivalent to the number of impressions you need in order to reach everyone in your target population once. Radio buys can add "weight" to the buy through promotions such as giveaways, stunts, trivia quizzes, and contests that create additional media impressions. Outdoor buys are purchased in increments of 25, 50, 100 GRPs or "showings" per day. An outdoor buy of 100 GRPs approaches a 95 percent reach per month.

The structure of television and its breaks hasn't changed, but the length of those breaks has changed drastically. The 30-second spot reigned as the gold-standard of mass marketing for four decades. In the 1960s, a typical hour-long show, with five breaks tracking with each story act, ran 51 minutes. Today, a network primetime hour runs around 42 minutes with 18 minutes of commercials, PSAs, and promotions. Half-hour shows have three commercial breaks with 22 minutes of programming and eight minutes of "non-program material."

The 30-second TV spot is quickly being replaced by the 15-second spot, restricting storytelling opportunities. Research shows that the more commercials, the more likely viewers are to change channels. Since an hour of programming could have more than 70 different 15-second ads, audience defections could be legion.

Other forms of TV advertising are sponsorships or buyouts of an entire program. TV advertising began with this model, borrowed from radio programs such as the *Maxwell House Hour*, which morphed into TV's *The Colgate Comedy Hour* and soap operas. Today's Hallmark Hall of Fame Presentation movies target 25-to-54-year-olds and families, airing on CBS and later on the Hallmark Movie Channel. Because Hallmark owns the entire footprint for these TV events they can determine the program's interruptions, usually running cinematic, story-driven one- to four-minutes ads. This sponsorship model has come full circle, such as the "Walden Family Theater," a family-friendly TV movie night, through a partnership of Walden Media, Hallmark Channel, Walmart, and Procter & Gamble.

The old sponsorship model works for this new generation and this new paradigm. The sophisticated consumer says, "don't pitch me and don't break up my experience with the story," but if the XYZ Company is presenting this hour of programming then you have some relationship equity with the audience. They think, "You're giving me something" and perhaps on a conscious or subconscious level think, "I might be more attuned to what you're selling and what you're doing."

—Chip Flaherty, co-founder and EVP, publisher, Walden Media

Other options include banners or logo bugs as secondary events on an advertising overlay at the bottom of the screen. TV and film advertising also include product placements or brand integration in which a brand pays or barters to have its product integrated into the storyline (covered in Chapter 25, "Advertising Context").

Measuring online reach is much less precise than broadcast or print. Its key unit for measurement is the impression. Digital GRPs are the percentage of your target population you've reached. **Internet GRPs = Impressions ÷ Target Population**. If the target audience for your Webisode is women 18-to-34 years old, you determine that there are 35 million of them in the US (of 300 million total people). If you buy 26 million online impressions on sites they frequent, then you have achieved 74 Internet GRPs (26 million impressions ÷ 35 million young women × 100 = 74 GRPs).

But online impressions are deceptive. An online impression means that an ad server was called, not that the ad was seen. Current digital ads are either ignored or highly intrusive. To get audiences to notice and register their interaction with ads, marketers have developed many kinds of interruptive ads such as pop-ups and pop-unders (ads displayed over or under the initial Web browser); floating ads (overlay over the current Web content); expanding ads (rich media frames that change dimensions over time or because of audiences' mouse movement over the ad); trick banners (mimic an operating system or application message without revealing it's an ad to secure clicks); and interstitial ads (interruption ads that display before audiences can access requested content). While these techniques may get seen or secure click-throughs, many break the rules of good marketing—understanding and offering benefit to your audiences.

Also, bot traffic (hackers' programs that crawl the Web, yet count as site views) also affect calculations because they comprise more than half of online traffic.

Fishing Where the Fish Are

Advertising and media buying are about capturing and maintaining people's attention, which in today's cluttered world is a valuable commodity. When audiences are already intersecting with a media property, they're likely to continue—almost a 90 percent predictor for television according to a 2013 PricewaterhouseCoopers study on TV viewership. Brand loyalty is the Holy Grail of marketing, because unless you stop delivering on the promise or break their trust, you should be able to keep audiences. *Star Wars*, *Grand Theft Auto,* and *Harry Potter* have fiercely loyal audiences who wait outside retail stores for midnight product launches or retweet announcements within seconds of their going public. Once audiences are with you, keeping them happy is the primary product and marketing goal.

But if they don't know you, you must understand how audiences learn and are influenced about film, TV, games, and digital content to place your "paid media." For new content, the single biggest awareness-raiser and influencer is recommendations by friends or family.

The PricewaterhouseCoopers study reports almost 60 percent of TV-viewing decisions are influenced by audiences' inner circle, which is why social media has become such a powerful promotional tool. Social endorsements are the new-age versions of the rave review, and shareable videos are the new TV spots.

The next biggest source of information about entertainment content is surfing the 'net (for television, channel surfing). The biggest online influencer is positive reviews or comments by trusted sources—both professional critics and amateur bloggers and superfans. Audiences still report high awareness of media properties from TV, digital, and outdoor advertising.

Social network advertising capitalizes on the influence of family and friends' endorsements—friendertising. On Facebook, users' "Likes" and photos can appear on ads targeted to friends. On Twitter, brands can pay to have users' tweets amplified across their site. Google combines users' posts, reviews, and profile photos in ads.

Mobile media, boosted by the huge upsurge of social media on mobile devices, is the fastest growing area in all of advertising. What began in 1998 in Finland with the first downloadable content on mobile phones is now a $17 billion industry. Mobile advertising includes banner ads, coupons, Multimedia Messaging Service (MMS) ads with graphics and video messages, gamified ads, and experiential marketing tactics such as 2-D barcodes that use phones' camera features to access Web content. Mobile video views increased 300 percent in 2013 and had twice the audience interaction rate (5 percent compared to 2.4 percent) of online video. Juniper Research predicts that mobile advertising will jump to almost $40 billion by 2018.

GoogleAdSense is the gorilla of mobile ad networks, dominating the entire digital category with search, display, video, mobile, and social impressions. Twitter, Facebook, Yahoo, and AOL are all in the mobile ad game. Facebook has completely reorganized itself from a Web-based company to a mobile advertising company, with 53 percent of its income from mobile ads in 2014, double the previous year. Yahoo rolled out contextually-relevant ads for its mobile property apps, appearing in content streams that drive downloads.

With Google's pre-eminent position, digital advertising has broken into the major leagues of advertising. Now Google is one of Madison Avenue's "Big Five" suppliers of advertising along with Comcast, CBS, Walt Disney Company, and Time Warner. Combined, these five represent more than 40 percent of Madison Avenue's media-buying power.

There are infinite opportunities for online and social audiences to find the niched content that they desire in the digital universe. Online and social advertising and remarketing capitalizes on the demographic information that cookies provide about audiences' visits to sites. This is where big data meets promotion. Tracking audience interests and online behaviors enables targeting each customer with ads and messages targeted specifically for them. And it allows for cost-effective delivery of different versions of content. Digital mobility creates an entirely new model for advertising.

 For example, a digital marketing campaign allows you to send different "push" messages about your film based on the Web sites that different audiences browsed. This allows

following up with a tailored mobile alert when the film opens or when audiences are in close proximity to the theater where the film is playing. All this synergizes with "earned media" on social platforms and with media outlets. You also can target digital content by pegging messages and timing to seasons or holidays, weather, or news or cultural events.

There is no subject, project, or audience member that is too specific for the digital world. All information about you and your target audiences is deemed important. Privacy is simply a thing of the past. If the subsequent content offers true value because it meets a need, the way Amazon recommends similar book options, then audiences are more likely to overlook that it's an ad based on their personal data.

Despite the huge growth in digital advertising, don't count out traditional media advertising in your "Media Mix." Broadcast may get lift from the second screen and the multi-platform consumption and purchasing of media across television, online, and mobile. The Nielsen Co. reports that—with the same number of exposures—75 percent of consumers recalled a TV spot when viewed across multiple media platforms, but only 50 percent recalled it when it ran on TV only. Whether story or marketing, engagement is always better when cross-platform. Tumblr recently partnered with Viacom to offer multi-platform buys. The Association of National Advertisers and Nielsen predict that half of all advertising will be multi-screen campaigns by 2016.

Entertainment Media Plans

The media buy for a film is included in the **P & A** section of the budget, which stands for the **Prints**—the physical copies of the movie—and for **Advertising**—the TV, print, outdoor, and digital advertising. Marketing can be a huge aspect of the budget. *Avatar*'s production budget was estimated at $300 million and promotion budget at another $300 million. The average studio spend to market a major release is close to $40 million.

There's pressure to make back a big chunk of the production and promotion money in the domestic release's opening weekend—a holdover from the days when that determined the bulk of a film's revenue. Now, more money is made across the entire distribution chain and internationally. So a film that looks like a domestic box office flop may still be a moneymaker through VOD, home video, or foreign box office receipts.

Most movie advertising is still placed on television—network, cable, and spot TV—accounting for some 80 percent of studio marketing buys. The rest is split between newspaper, digital, radio, and outdoor. Marketers worry that fast-forwarding of commercials through DVR viewing is eroding their viability (hence, cable providers are restricting fast-forwarding on VOD). Film trailers are less likely to be fast-forwarded than other ads, so studios are aggressively signaling that they're film trailers. And for those that fast-forward, studios are inserting a static bar with key art and the URL in letterbox black bars that remain during fast-forwarding.

Hollywood is rapidly using more digital in film promotion, synergizing "paid media" (ads and promotions) with "earned" impressions (shareable trailers/teasers and online reviews).

Advertising for television is primarily on television, followed by radio, digital, print, and outdoor. Most advertising for TV shows takes place on the program's channel. The network wants to sell as much air-time as possible to maximize revenue, but holds back enough to promote its own programming. Like in film, print advertising for TV is declining, while digital is increasing. Radio is not to be discounted, especially as an online medium, where advertising has jumped more than 22 percent from 2013 to 2014. In 2012, NBC spent $10 million on a cable TV, radio, and outdoor ad campaign for *Smash,* on top of its own on-air promo campaign.

Advertising for games is mainly digital, on top game sites and YouTube channels. Occasionally, big games from AAA publishers buy TV time as they did for *Call of Duty Ghosts. Candy Crush Saga,* a WOM freemium game—free-to-download with in-game upgrades available for purchase—was one of the first games to advertise on TV.

Game marketing has taken a page from the blockbuster film industry with the massive 2013 release of *Grand Theft Auto 5*, reportedly spending $150 million on advertising. Following its success, Electronic Arts launched another huge multi-channel advertising campaign in 2014 for *Titanfall*, blending traditional and digital advertising. It was the first major new franchise game to release for Microsoft's Xbox One following a Beta launch with 2 million players.

Books have mainly advertised in print, and now digitally, based on their niche audiences. Occasionally, when a book series or author has a large, loyal following, it will advertise on television, as did James Patterson's *Cross My Heart*.

Media buying for an entertainment property is a risky proposition because big budgets can be at stake. Film studios and TV networks spend millions of dollars on advertising to promote a film, TV show, or game—from one-third of the original production costs to far exceeding the production costs. Sometimes it works out, like *The Amazing Spider-Man 2,* which spent about $42 million in marketing and garnered almost $337 million in domestic box office receipts alone. Other times, it doesn't. Since media buys are locked in beyond a certain timeframe, if a media property is a dud, the marketing expenditure feels like throwing good dollars after bad.

The media plan for the paid advertising for *Martin Scorsese Presents the Blues* for the fall of 2003 leading up to the Sunday, September 28th premiere targeted 35-to-54-year-olds. Spot television and radio was concentrated in five markets: New York, Los Angeles, Chicago, San Francisco, and Boston because of their affinity for blues music and film watching. The spot TV aired for five days leading up to premiere on cable outlets A&E, AMC, Bravo, CNN, Discovery, History, TLC, and VH-1. The radio ran for four days in those cities leading up to the premiere during drive times on oldies, smooth jazz, talk, classic rock, modern AC, adult alternative, and contemporary formats. Radio also included live street performances with local musical talent outside Virgin Megastores.

Print and online were national, including a three-page gatefold the month leading up to premiere and running through the full broadcast in *Vanity Fair*, a three-page gatefold the week before premiere in the *New Yorker*, plus three full-page four color (4C) ads the week prior to premiere in *Time* and *Newsweek*. And, for the entire premiere week, a full-page 4C ad in *The New York Times* and *The Los Angeles Times* Sunday magazines. Online advertising included rich media units with motion and sound two weeks leading up to premiere on tvguide.com, and one week prior on Billboard.com and NewYorkTimes.com. Mobile advertising included a month-long mobile buy leading up to and during the full week of broadcast on AvantGo, pushing tune-in messages to music lovers and friends of the project on their PDAs/smartphones.

	Frequency	**Reach**	**GRPs**	**Impressions**	
Spot TV	33%	2.7	90	15,736,000	*(5 markets)*
Spot Radio	44%	2.1	90	13,946,600	*(5 markets)*
National Print	22%	1.4	31	25,523,000	
Online	N/A	N/A	N/A	32,893,333	
Media Mix	**71%**	**3.0**	**211**	**88,098,933**	

This media buy didn't include the four months of on-air promotion on PBS with teases and tune-in promos heavily concentrated the month before premiere, or the bartered short on-air tags on NPR for three days leading up to premiere on *All Things Considered*, *Weekend Edition*, and *Fresh Air*. Nor did it include a co-branded Volkswagen and *The Blues* image spot that Volkswagen created and placed in 100 percent rotation as part of their regular television buy two weeks before premiere on cable TV on various outlets from SciFi and CMT to ESPN and National Geographic and on primetime network TV on programs such as NBC's *Conan*, *Law & Order SVU*, and CBS' *Cold Case* and broadcast of *A Few Good Men*.

Media buying is the discipline of understanding the media consumption habits of audiences and reaching certain audiences on preferred media. Technology can fine-tune the delivery of messages to niche audiences. But even if you can more effectively target your audiences, it won't have impact if the message doesn't fit the medium.

The context and experience of digital media must dictate the creative message. Until recently, most digital advertising took the form of display and search ads—knock-offs of print advertising. Now, video is *the* digital storytelling vehicle. But it won't reach its potential until it's made expressly for its intended medium, not just repurposed spots. The language and rhythm of online and social media are completely different from television. Stand-out advertising must celebrate its delivery medium, engage audiences with captivating and engaging content, and entreat audiences to share it.

Advertising Creative

The best advertising creative captures audiences' imaginations. It tells a story, produces emotion, and fulfills deep-seated needs. Humans love to laugh, feel smart, affirm their lives, and be part of a community. Good advertising does all that. So, despite knowing they're being sold to, audiences love great ads. A huge part of Super Bowl viewing is attributable to the promise of seeing some of the most creative or heartwarming ads of the year. The warm and fuzzies from the Budweiser Clydesdales have made beer family-friendly. The Regular Guy persona of Doritos' fan-created ads celebrates audiences' role in that shared experience, hence, the brand.

Stand-out advertising strikes big emotional cords, fulfills needs, and telegraphs value to audiences through the entire marketing gamut: Product, Price, Place, and Promotion. Accomplishing all that in an ad campaign comes from swinging for a grand slam home run, not just for a single.

I think you have to think crazy. You can't think big enough. You throw out ideas and you might say, "We can't do that, can we?" But you start there, because if you start big, you can always reel it in.

—Rose Stark, VP marketing, TLC

Advertising agencies or in-house creative divisions develop most ad campaigns. Creative teams pair graphic designers with copywriters who work together to develop a big idea.

Ads for the Ages

What's the measure of good advertising? Nineteenth-century department store pioneer John Wanamaker lamented that half of his advertising worked; he simply didn't know which half. Not anyone can create a good ad, but as demonstrated by the Super Bowl's appeal, anyone can critique an ad. Good advertising is entirely subjective, but across time, a few campaigns stand out as brilliant because of their memorability and effectiveness in selling the product.

In 1959, a little-known German carmaker was introducing a tiny, counter-culture, curved car—the Beetle—to the US, against big odds. German engineering still represented the technology behind the Axis power of World War II. Plus, American cars were long, sharply angled gas-guzzlers. The ad agency that inspired *Mad Men*, Doyle Dane Bernbach (DDB), embraced the Beetle's The Outlaw brand archetype. Their big idea came from thinking small. Their mainly print campaign featured the line, "Think Small," accompanied by the small profile of the Beetle, positioned off center and dwarfed by the page.

The additional copy felt like a personal introduction to "our little car," highlighting its personality traits, such as fuel economy. It ended with "Think it over," rather than a hard sell. Audiences looking for something different were intrigued. The campaign generated robust sales and created a brand that's still vital today. In many ways, this VW ad was the precursor to Apple's "Think Different" campaign.

"Think Small" by Magazine; Licensed under fair use via Wikipedia Commons

The 1959 "Think Small" ad for the VW Beetle by Doyle Dane Bernbach.

Others from the pantheon of great advertising campaigns include Coca-Cola, "The pause that refreshes," 1929; Marlboro, the Marlboro Man, 1955; McDonald's, "You deserve a break today," 1971; Absolut Vodka, Absolut Perfection (Bottle), 1980. These stand-out campaigns work because they bring in the audience by asking them to think just enough or by delivering unexpected twists—just like in good storytelling. Timeless ad campaigns deliver on the key maxims of strong creative. Good ads:

- Connect with the audience
- Are memorable
- Clearly provide key information
- Make the message easy to understand
- Include a call-to-action

Archetypal stories (and character personas) also apply to advertising storytelling. *Rags to Riches* is the most popular advertising plot device. Other often-told ad stories are *The Quest*, *Slaying the Beast*, and *Voyage and Return*. In healthcare, *Rebirth* ads dominate. In home improvement, *Voyage and Return* ads have the highest interaction rates. In insurance, *Tragedy* ads used to be the norm, but have been supplanted by *Slaying the Beast*. *Tragedy*, presenting startling facts or consequences, is especially effective in public service announcements (PSAs), such as the tight shot of an egg sizzling in a frying pan accompanied by "This is your brain on drugs."

Another long-standing and effective advertising technique is using celebrities to endorse products. Beginning in the 1920s, Chesterfield and Lucky Strike cigarettes used actors, comedians, and opera singers to create a whole new generation of smokers. Now, Beyoncé endorses Pepsi and LeBron James endorses Nike.

"Sex sells" is one of the oldest saws in the advertising industry, predicated on Boy Gets Girl and *vice versa*. Clairol's "Does she . . . or doesn't she?" signature 1957 campaign was about the lengths women go to look beautiful, ostensibly for men. The car industry has adorned cars with beautiful women because they make men take notice. David Beckham's almost-nude 2012 Super Bowl ad selling H & M clothes garnered almost 110,000 social media mentions within 45 minutes. Dove's groundbreaking 2004 "Real Beauty" campaign, using real women of all shapes and sizes redefined sexy.

And then there's the advertising *cliché* of puppies and babies. The mere sight of them elicits an emotional reaction, which is why animal and kid photos and videos are the most shared on social media.

For more than 60 years, Coppertone has used "Little Miss Coppertone," an energetic little girl whose fun-loving cocker spaniel grabs her skivvies to reveal her tan line. Recently, Coppertone held a nationwide audience Facebook contest to find the real little girl who best embodied the persona of the brand's beloved icon. She won a family vacation and was featured in a Coppertone print ad in 2013.

By Alexf; Licensed under Creative Commons via Wikipedia Commons

"The Coppertone Baby" on a fence in Miami, Florida.

In this same vein are animated characters and mascots, such as Kellogg's Frosted Flakes' "Tony the Tiger" and Geico insurance's gecko. Add humor to these cute creatures and you're hitting two key emotional notes. As a story plotline, *Comedy* has the highest interaction rates. Pepsi combined babies and humor in its Pepsi NEXT ad, where parents are so enthralled with the new soda as the "most unbelievable thing I've ever experienced in my whole life" that they didn't notice their diaper-clad baby playing electric guitar or breakdancing in the background. Geico's "Camel Hump Day," with an obnoxious camel crashing offices to celebrate Wednesdays, adds a third note of "sex sells" with its sexual connotations, giving it huge social salience. It's received more than 20 million YouTube views, with almost 70 percent of its 5 million shares occurring on Wednesdays.

Twenty-first-century Entertainment Creative

Since the early days of Madison Avenue, audiences have become more wary, time-crunched, and distracted, yet potentially more participatory. Today's creative messages can't tell audiences to watch a film or play a game. They must acknowledge the audience as a valued participant in, if not co-creator of, the media property and invite them to interact with it. Effective marketing feels bottom-up, not top-down. If audiences feel like they're part of the story, then they share content. That's the perfect storm of promotion—when advertising crosses the Rubicon from "paid media" to "earned media."

Even though audiences consume much of their media digitally, they still prefer looking at ads while watching TV or reading print magazines. Perhaps because those traditional media are graphically-expressive, less distracting, and their creative techniques have been perfected over many decades. Digital advertising creative that is easily digestible, cuts through the clutter, and emotionally engages audiences in shared experiences is still a work in progress.

Broadcast

The 30-second television spot has been the mainstay of mass marketing since the 1950s. It still holds a special place in people's hearts and minds. Demonstrating the storytelling links between film and TV, many film directors have tried their hand at directing TV spots, including David Fincher for Nike and Apple's iPhone; Michael Bay for Victoria's Secret; Sofia Coppola for Christian Dior; Spike Jonze for the Gap; and David Lynch for Sony Playstation 2 and Clearblue pregnancy test.

Like trailers and on-air promos, TV spots can be targeted to different audiences based on demographic and psychographic profiles. Often, ad agencies and distributors test multiple creative concepts in focus groups with different target audiences before spots are finalized.

> *Most prelaunch theatrical film testing is done by the marketing department to determine what demographic is most likely to give the film positive word-of-mouth to fill the seats with that demographic. And campaigns are heavily tested pre-release—they're testing ads, trailers, and the film to see who their target demographic is and how they react to it.*
>
> —Jonathan Wolf, executive vice president, Independent Film & Television Alliance; managing director, American Film Market

Films have used TV spots for many decades because the visual medium lends itself to trailers and spots of various lengths, ranging from five-second tags to one-minute spots. Most are 30-second or 15-second spots.

Many film spots premiere during the Super Bowl or the Oscars. *The Amazing Spider-Man 2* and *Captain America: The Winter Soldier* spots launched during the 2014 Super Bowl. Marvel employed a multi-part strategy for *The Amazing Spider-Man 2* by releasing a 40-second explosive teaser pre-Super Bowl showing Andrew Garfield's Spidey up against some of his fiercest foes, and then releasing Part 2 for amped-up superfans during the big game. Fans then got the bonus of a four-minute sizzle reel, "Enemies Unite," maintaining the mystery of the shorter teasers, but revealing more about the wisecracking superhero, Peter Parker, his mom, and the mild-mannered OsCorp employee, played by Jamie Foxx, who transforms into the villainous Electro. Other Fox TV properties such as *The Following*, *American Idol*, *Brooklyn Nine Nine*, *New Girl*, *The Strain*, *Cosmos*, and *The Simpsons* secured coveted promotion during the high-profile game.

Sometimes film characters show up within brand's TV spots. Godzilla appeared in Snickers' "You're just not you when you're hungry" campaign, with famous people showing their good sides when they're satisfied and bad sides when they're hungry, co-promoting the 2014 *Godzilla*. The lizard terrorizes cities when he's hungry and hangs out with friends and waterskis when he's eaten a Snickers.

Television has recognized the value of social currency, even in its advertising. *Gossip Girl* created TV spots for its second and third seasons using text messages "OMG" and "Seriously, WTF!" Media properties are incorporating real social media nods by friends and family in the place of expert endorsements. During the 2014 Oscar broadcast on ABC, the network launched spots for the premiere of *Resurrection,* a mid-season drama about people coming back from the dead, using public audience tweets: a signal of the pre-eminence of audiences' opinions over critics'.

© Anne Zeiser

ABC used audience tweets in its promos for *Resurrection*.

Nintendo has advertised Mario on TV since the 1980s. By immersing players directly into Mario's universe, Leo Burnett created some of the best spots of the 1990s. Decades later, Nintendo released a spot for Mario Kart 8 in 2014 on Cartoon Network.

Using a different tactic, the 2010 spot for *God of War III* spoke directly to the target audience delivering the key message: the game's so addictive your girlfriend will hate it.

Radio also has a place in entertainment advertising. In 1966, the first feature film in the *Batman* franchise used a series of 60-second and shorter radio spots featuring Batman, Robin, The Joker, and the Catwoman characters talking to audiences. In 1978, *Jaws 2* effectively used "the legend continues" radio spot with short bursts of dialogue, sound effects, and narration to fuel the fear, ending with "see it before you go back in the water." In 2007, *Cloverfield* stoked the mystery around the film, emphasizing "The mystery will be revealed" in its spots. A radio spot for the television series *Jericho*, about a post-apocalyptic world after nuclear attacks, featured a static-y broadcast of one stranded man asking, "Anyone out there?"

Print

Film and television have advertised in newspapers and magazines for decades to promote their fare using basic tune-in ads, concept ads, and proof-of-performance ads with critics' quotes. Print ads are similar to the one-sheet or the poster. They require a simple and visually-expressive concept. *E.T. The Extra-Terrestrial* used its key art, the silhouette of the boy on his bike flying across the moon, in its print ads. In 2011, Universal used the first mobile barcode in an ad for a nationally-released film, *Bridesmaids*, in publications such as *Cosmopolitan* and *In Style* to give audiences access to the trailer and other content through their mobile phones.

Social media has entered kudos ads. In early 2014, CBS Movies placed a full-page ad in the print edition of *The New York Times* for *Inside Llewyn Davis,* featuring part of a tweet by A.O. Scott, the newspaper's film critic, without his permission: "I'm gonna listen to the *Llewyn Davis* album again. Fare thee well, my honeys." This violated Twitter's policy preventing tweets from being used in advertising. Scott wasn't upset. He aptly used Twitter to register his bemusement.

a.o. scott/Twitter

The NYT's A.O. Scott reacts to his tweet used in an ad for *Inside Llewyn Davis*.

Print is effective for promoting television, often bundled with outdoor. HBO created a unique print ad in 2005 for its lavish series *Rome*, about the ancient empire. The cabler bought a double gatefold on the front and back covers (which fold out) of *Entertainment Weekly* and a two-page spread in the magazine's middle. By folding the pages in various configurations readers could mix and match key scenes from the upcoming series. This single print buy cost $700,000. HBO also used print very effectively for *The Sopranos* in their "Made in America" campaign—a *double entendre* on commerce in America and on being "made" into the Mafia. When the series migrated to A & E, the second cable channel modified the original campaign, featuring the message "A & E just got made."

In a clever print ad for PlayStation, Sony replaced the letters on the Hollywood sign with the Δ O X □ symbols used on its game controller keys, blurring the lines between reality and virtual reality. The copy read, "Live in your world, play in ours."

Digital

Almost all entertainment properties are using digital promotion. *Titanfall*'s 2014 traditional and digital advertising campaign used a *Forrest Gump*-like strategy, placing Titan in unexpected venues. Its "Old School Arcade" marketing campaign incorporated the Titan character into classic Atari games such as *Asteroids*, *Missile Command*, and *Centipede*, and in other fictional and real-world universes—via rich media, "pull down" banner ads. Advertising blanketed the Internet, in-game advertising, and Electronic Arts' YouTube channel, Xbox Live, and Facebook. "Drop the Titan" was an audience interaction and shareable element, which allowed audiences to create an animated GIF to drop a Titan on audiences' loathsome photos and watch the Titan blow them up. Traditional advertising included 60-second and 30-second spots for mainstream audiences demonstrating how a Titan shadowing a regular guy in his everyday life makes everyday life better.

Outdoor/Out of Home

Outdoor and Out of Home (OOH) are forms of experiential advertising, bringing the story universe directly to audiences in the places they frequent. Outdoor media includes billboards, street banners, signs, placards and wraps on buildings and vehicles, blimps, signs towed by airplanes, and skywriting. Other OOH marketing includes indoor billboards, signage, kiosks, and displays in airports, malls, stores, taxis, elevators, bathrooms and anywhere audiences go.

For Quentin Tarantino's 2004 *Kill Bill, Vol. 1* the New Zealand creative team created a billboard installation at a busy intersection featuring a weapon-wielding Uma Thurman and a huge splatter of blood on the building wall and the street below. DVD/Blu-ray releases for big titles may include TV spots, print advertising in retailer circulars, and point-of-purchase materials for in-store displays. Major children's film premieres often

work with third-party promotional partners such as restaurant chains and retail stores for in-store promotions and giveaways. For the 2010 launch of *How to Train Your Dragon*, DreamWorks Animation set up thousands of massive Walmart in-store Viking ship displays across the country with branded clothing, games, toys, and food.

The surprise element or delivery system can be part of the message itself. The 2007 promotion for *The Simpsons Movie* included a simple virtual tour of Springfield, video contests among towns named Springfield to determine where the film would premiere, a Homer appearance on *The Tonight Show with Jay Leno*, and a Ben & Jerry's ice cream flavor called "Duff and D'oh! Nuts." The most immersive tactic, a dozen 7-Eleven stores transformed into Kwik-E-Marts and provided *Simpsons* merchandise such as Squishees and Buzz Cola. This small-screen adaptation grossed more than $527 million worldwide.

For the Season 3 premiere of *Game of Thrones*, HBO used a single ominous image, a shadow of a dragon flying overhead, as its entire advertising creative message. It draped the image over the HBO building in New York and also bought a two-page spread in *The New York Times'* Arts section shortly after the Oscars with the dragon shadow over mock copy. HBO couldn't use the *The New York Times'* fonts for the story copy.

Left: By vera214usc/Reddit; Right: By WinterIsComing.com

Game of Thrones' coordinated outdoor and print campaign using the shadow of a dragon to tease the series' new season.

ABC's reality program, *The Fosters*, about youth in foster care, went to America's malls with its "How do you define family?" campaign highlighting the main characters of the

reality series. In this case, the medium was as important as the message, reaching people from all walks of life in various configurations of family units.

© Anne Zeiser

The Fosters promotional ads on kiosks in malls.

Guerrilla

Guerrilla marketing is an in-your-face, unconventional interactive mechanism to deliver messages to audiences. The term derives from guerrilla warfare, which uses atypical tactics to meet a goal in a competitive environment. Guerrilla marketing tactics may include wild postings, graffiti, street or performance art, sticker bombing, and flash mobs, and usually support a larger traditional marketing initiative. Guerrilla marketing is inexpensive and, if clever enough, generates "unpaid media." The *Walking Dead* zombies in Times Square on Halloween 2011 generated huge hype for AMC through social media and press coverage. Over spring break, Sony Pictures promoted 2011's *Bad Teacher* with mobile barcodes on keycards at 100 hotels from Florida to Arizona, generating massive social chatter.

For *District 9*, the 2009 film about xenophobic prejudice against non-humans, Sony used a creative outdoor media buy of posters, billboards, bus wraps, and bus benches about discrimination and segregation. The outdoor messages underscored the lowly status of non-humans and linked to a rich array of digital assets to blend the on-the-ground experience with an online experience.

For the District 9 campaign, we were creating content to drive audience awareness and engagement. When I think of the power of transmedia, I think part of the equation is to experience all of the story. Some of the story occurs in different mediums, but intention from the content creators' perspective is more important than the medium itself.

—Joseph Epstein, digital content and marketing strategist: formerly 20th Century Fox and Sony Pictures Entertainment

aharvey2k/flickr.com

The guerrilla postings for *District 9* warned audiences of the risk of mixing humans and non-humans and linked to a vast array of digital assets.

Guerrilla marketing was part of the promotion of the 2001 PBS and *NOVA* docudrama on Charles Darwin's life and his evolutionary theory, *Evolution* (the author managed the marketing and publicity campaign). The project's *on air*, *online*, and *in print* "Why?" advertising campaign posed a series of thought-provoking questions about how evolution affects audiences' daily lives. To accompany the "paid media" campaign, *Evolution* created "Why?" windshield stickers with a squished bug graphic and the question "Why should humans care about dead bugs?" with tune-in information and the Web URL, distributed on cars in five markets.

Courtesy of Vulcan Productions; Courtesy of WGBH Educational Foundation. *NOVA* is a trademark of WGBH Educational Foundation.

(Left) The "Why?" advertising campaign for *Evolution* asked questions that revealed the ubiquity of evolution in humans' daily lives; (Right) The accompanying "Why?" windshield sticker guerrilla tactic teased audiences' interest in evolution and the mini-series about it.

Sample Advertising Creative—*Martin Scorsese Presents the Blues*

An effective advertising campaign for a media property must coalesce an understanding of the media property's brand essence, its target audience, the top messages, key art, media buying, and the creative message. *Martin Scorsese Presents the Blues'* integrated ad campaign, which the author developed with PBS' Creative Services team, may bring that process to life. (The support and planning documents upon which these seven steps are based, and the final creative executions for *The Blues'* marketing campaign are at transmediamarketing.com).

The chief objective of the advertising campaign for *The Blues* was to promote tune-in with mainstream music lovers, reaching beyond blues aficionados. Research showed that mainstream music lovers didn't even know what blues music was, thinking they didn't listen to it. So the campaign's creative had to broaden the genre's and series' appeal and communicate that blues music was for everyone, without alienating blues devotees. The campaign's creative development involved a seven-step process that revisited key elements of the marketing plan.

The *first* exercise was to re-examine the project's two key target public audiences (see *The Blues* "Cross-platform Marketing Overview, Marketing & Branding" PowerPoint). The "Blues Loyalists" were defined as those with a high incidence of blues music purchasing or listening:

- 25–to-54 years old

- Caucasian

- Skews slightly female

- Instrument players

The second target was a broader music-loving audience, defined in PBS' segmentation study as "The Active Engaged Citizen." The campaign's on-air PBS promos would reach many of these within PBS' core audiences. The "paid media" campaign for *The Blues* targeted a subset of this PBS core, the 40 million adult music lovers who are part of the "The Culture Club" segment:

- 35–to-54 years old

- Active and engaged in community, civic, and cultural life

- Music and culture event seekers

- Documentary viewers

Second, the project revisited *The Blues*' Positioning Strategies and Maxims on the best techniques to engage target audiences ("Cross-platform Marketing Overview" PowerPoint).

- Broaden the target audience by conveying blues' powerful influence on music and culture
- The music's the thing—use the power of music to reach people and lead all efforts
- Be true to the essence/integrity of the music (authentic roots; fresh expression)
- Develop creative, interactive devices that unexpectedly tap into people's love of music
- Create a catalyst for people to explore their personal relationship with the music (emotional connection, journey, dialogue)

Third, the project revisited the target audience's POV about blues music that was set up in the project's creative brief (at transmediamarketing.com). This spelled out the campaign creative's primary communications challenge.

What do they think/feel now?
- What exactly am I in for with *The Blues*? Is it a documentary like the *JAZZ* show I saw? That show was pretty interesting, but I don't really want to sit down for seven nights in a row of a lecture on the history of blues music. I'm looking for something more entertaining than that; and besides, isn't the blues all about sadness and heartache and hurt? Who wants to see all that? I am a big music fan, but I'm no blues expert (in fact, I'm not even certain I know exactly what it is); so maybe this isn't really for me.

Fourth, to drive the tone and the message of the creative executions for *The Blues*, the project re-examined its The Explorer brand archetype (see Chapter 9, "Branding"): and its big communication idea from the creative brief:

The Explorer
- Learns what's valuable by discovering new things
- Challenges audiences to do new things and, in so doing, to learn about themselves

What's the key idea? (Why should the target audience tune in?)
- Blues music is the root of all music (relevance)
- *The Blues* is an authentic musical journey—a musical journey (benefit)

Fifth, based on all of this, the marketing team developed six possible creative themes for *The Blues*, each touching on various key messages points, and tested them all with focus groups of both target audiences ("Blues Loyalists" and "The Culture Club").

- Root of all American music
- Seven nights of the blues
- Cultural heritage
- Vibe . . . Are you feelin' it?
- Television event of the year
- Seven celebrated filmmakers

Both blues lovers and general music lovers sparked to these three more fully-articulated key messages:

- *Rock, rap, folk, jazz . . . The Blues is the roots of all American music* (relevance of music, importance of music)
- *Celebrate America's cultural heritage with this tribute to The Blues* (historical look at the music, chance for discovery of the music)
- *It's a non-stop musical celebration brought to your home—catch seven nights of The Blues* (offers lots of performance, up-beat, fun take on the music)

Sixth, knowing that the campaign would lead with the music and the musicians, the project tested blues or blues-inspired artists to determine audiences' reactions. The focus groups presented traditional blues artists such as B.B. King, Ray Charles, Ruth Brown, Koko Taylor, and James Brown; artists from various genres such as Bonnie Raitt, Sheryl Crowe, Norah Jones, Lucinda Williams, Bono, Bruce Springsteen, Queen Latifah, Shemekia Copeland, Lou Reed, and Natalie Cole; and artists from outside the US including Mick Jagger, Paul McCartney, and Eric Clapton. Focus group audiences knew who most of the traditional blues artists were, but were happily surprised when a musician they liked and listened to was identified as a blues artist.

Seventh, the marketing team took the focus groups' preferences and reactions to heart to ensure the advertising campaign:

- Had an upbeat tone to elicit energy and emotion
- Reflected diversity to make accessible (age, ethnicity, types of music)
- Used identifiable images and songs to create a point of *entrée* for personal journey (surprise of mainstream artists)
- Used the phrase "a musical journey" to describe the program
- Emphasized Martin Scorsese

So the campaign asked the audiences' most fundamental question: "What is the blues?" And it replied, "This is the blues . . ." pairing expected answers, such as blues icons B.B. King, with less expected answers, such as Bonnie Raitt, Mick Jagger, and other folk, rock, and country greats—demonstrating how blues is at the root of most American music forms.

Print

Without the aural benefit of the music, the project led with the key art of musicians that music lovers of all kinds—folk, rock, jazz, and county—would relate to. Audiences could see these artists' deep emotion when performing, and this would help them hear and feel the music. The print communicated that the blues included many kinds of music and gave them the promise of the personal journey

These three ads were always placed together (or used in a three-fold gateway) as a triple series in the same issue of *Time* and *Newsweek* magazine.

Courtesy of Vulcan Productions

The three-part print ad series for *The Blues* reflected various expressions of the blues.

Television

The television on-air spots opened with the strong, emotional, and musically-iconic Muddy Waters' rendition of "Manish Boy" and carried the refrain with rapper Chuck D's modern interpretation of the blues classic. The spots captured the visual stylishness of the seven films, placing the archival footage in a fresh, contemporary framework to emphasize the current "fruits of the roots." To cover 14 hours, the spots balanced historical and contemporary; traditional blues artists and unexpected artists; and performance and documentary (talking heads). The 60-second series sell spot featured performances of

B.B. King, Shemekia Copeland, and Chuck D as well as Bonnie Raitt and Steven Tyler talking on camera about what the blues meant to them. It ended with the narration, "Seven filmmakers, bring seven visions of an art that is the roots of American music. From executive producer, Martin Scorsese, comes a major television event, *The Blues*—a musical journey."

The team made 60-second, 30-second, and 20-second versions of the overall series promo (series sell), plus 30-second and 20-second promos for each of the seven films (and nights). The 30-second series sell also appeared in five media markets as part of a spot (local) television buy.

Radio

For radio, the team again led with the music, with B.B. King's classic rendition of "The Thrill is Gone," developing 60-second and 30-second spots, also airing in five media markets. The below radio script doesn't reflect the degree to which music drives the spot's feeling and tone. (The project also created scripted 10-second and 15-second on-air tags for NPR).

The Blues Radio Series Sell (60-seconds)

MUSIC: "The Thrill is Gone"

ANNC: From PBS and Martin Scorsese comes a major television event . . . *The Blues*.

The Blues are songs about feeling so bad they make you feel good.

The Blues is the root of everything from soul to rock 'n' roll.

The Blues is seven nights and seven stories about music that changed the world.

The Blues is seven films featuring performances by B.B. King, Bonnie Raitt, Ray Charles, the Rolling Stones, and many more.

PBS and Martin Scorsese Present *The Blues* Premieres Sunday, September 28th . . . only on PBS.

Digital

Because of the creative dictates of online advertising, the messages were simple, using strong images and tune-in information. Online advertising had two themes: "Roots," showcasing the various music genres, and "Legends," showcasing the artists.

Courtesy of Vulcan Productions

Online ads for *The Blues*: (Left) Billboard.com; (Right) NewYorkTimes.com.

The advertising campaign for *The Blues* took a multi-platform approach targeting music lovers *on air*, *online*, *in print*, *on the go*, and *on the ground*. Quite simply, it used the universal language of music to transport music lovers on a musical journey, exploring their personal relationship with blues music.

In the end, good advertising is hugely subjective and changes with the times. But what's constant is that to effectively advertise to your public audiences, you must use relevant media delivery vehicles and create messages that offer value and establish a relationship. To do that: Tell the truth. Keep it simple. Make it fun.

The controlled messages in your advertising never operate in isolation from a larger, less controlled environment. Today, a big part of those two-way audience conversations occur in the digital universe. Online, interactive, and socialized content promote interaction and engagement. Together, digital content and marketing are the key ingredients to make a media property go viral.

CHAPTER 25

Advertising Context

Not only is your creative content supremely important, but so too is its context through its delivery system and placement within it. You can control its placement as a media buy, native advertising, or product placement. But, sometimes your ad's context shifts and you must react when world events change its cultural suitability.

If your media property's ad doesn't make sense in the place, time, moment, and cultural context, it might be a bust. So you must be aware of your marketing campaign from a 360° perspective at all times.

Physical Context

With the vast array of platforms, context is paramount. Your ad's physical context will impact how audiences will receive your planned marketing message. To ensure your ad campaign delivers what you want it to, you must understand technology and how audiences interface with messages *on air*, *in print*, *online*, *on the go*, and *on the ground*.

> *You're delivering things in a way that you've never delivered it before or that wasn't in the traditional sense of delivering creative. So, when conceptualizing, you have to see it from both sides of the lens, not only from a creative perspective, but also from an audience consumption perspective. Does it translate the same when you're using different digital platforms and technologies? Millenials are watching everything on their computers and their iPads. They don't necessarily watch traditional television so I think the output of creative has to change in order to super-serve that audience.*
>
> —Stacy La Cotera, VP, development and global awards, PromaxBDA

Think about scale for landscape or close-up shots, detail, typeface, and font size. An ad will read differently on a 22″ monitor or in a magazine than it will on a smartphone.

Mobile content has its own dictates of intimacy and shortened timeframes for experiencing it. A trailer seen in a cinema will register differently than it will on a hand-held gaming console. Knowing that your ad will appear on a Web site is not enough. Check out that site and ensure that if the ad is viewed on a laptop or tablet with a smaller screen, it isn't cut off because the user doesn't choose to expand the window fully to see it.

Screen grab of *Huffington Post* on March 23, 2014

This online ad for *Lincoln* is cut off on both sides even with the window opened to full screen size on a 13" laptop.

If you're placing ads on subway trains, be sure someone gets on to one in each city to see where the horizontal handrails overlap the ads from a seated perspective. If the handrail covers up the killer headline, the ad won't work. Or, if part of a tree blocks a billboard from a big feeder entrance ramp, the location may not be as valuable as you thought. All of these details matter. Without accessible audience interfaces for your ads or promotional messages, you can squander energy, time, and money.

Native Ads and Brand Integration

Context is the foundation of native advertising and product placement—products appear seamlessly within the storyline or editorial of another media property. These techniques are about incorporating the promotional message into a context that audiences have already bought in to, the idea being that it eliminates the off-putting "this is an ad" aspect of audiences' reception of a message.

Native Ads are promotional messages that look like editorial or non-promotional content. Their format, tone, and look echo editorial on the site or media outlet in which they appear. Native advertising is not a new idea, but rather a new name for the well-worn *advertorial*. On print platforms, advertorials are required to self-identify as advertising or promotional content. Native ads are more vexing on digital media because their sponsored content status is not always apparent. The Federal Trade Commission is regulating the digital application of native advertising to prevent audience deception.

Native advertising is a preferred format for mobile because ads can be embedded in a Facebook newsfeed or Twitter stream, closely resembling organic content. Native is also effective online. Yahoo reports that audiences are 3.6 times more likely to do product searches and six times more likely to do related searches from native ads. Even traditional media is promoting sponsored content. *Forbes* designates its sponsored content with a question mark symbol (?), and *The New York Times* began presenting "native advertising— paid content that looks something like news" in 2014. It's often difficult to determine what's editorial and what's advertising; what's key, is transparency.

Until recently, the measurement and purchase of digital "native views" was in **Cost Per Views (CPVs)**, but is moving to **Cost Per Actions (CPAs)** models to measure native ads' catalyzation of audience actions.

In entertainment, native advertising-like techniques are widely used to provide transmedia content and rich experiences within story worlds. They're not meant to deceive; fans are complicit. Fox's *Mindy Project* characters created real-world profiles in the dating app Tinder. FX's animated *Archer* characters posted nude animated selfies on Reddit's "GoneWild," complete with bashful captions. Both were intended to immerse superfans into the universe, straddling the lines between reality and story.

Perhaps the fastest growing and most hotly-debated area of entertainment advertising is **Product Placement** or **Product Integration**—when a product or brand is embedded in an entertainment and media property's content or storyline. To handle all the matchmaking between brands and entertainment, advertising agencies now have entertainment units and talent agencies now have brand marketing units. Companies considering a product integration deal have separate divisions or hire representatives that review scripts for possible brand inclusion.

> *The philosophy is to leverage placement opportunities and generate value. The value could be in the form of free product, saving the production money on renting or buying that product. It could be in the form of a promotion in which the brand is spending their money and resources, getting behind the effort to promote the movie at the time of the release. And, last but not least, the value could be in the form of money, but money is the most elusive of the three.*
>
> —**John Polwrek, VP promotions, Eclipse**

Product placement has been in on every media platform for decades. From the 1940s through the 1960s movie stars made smoking looking cool. *Casablanca* has a classic smoking scene. To keep cigarettes on the silver screen, tobacco products secured product placements in the 1970s and 1980s. In *Superman II,* Lois Lane smoked Marlboros and Superman threw a Marlboro truck across Lexington Avenue, and Lucky Strikes were featured throughout *Beverly Hills Cop*.

A notable film example from 1983 was the storyline of Hershey's Reese's Pieces candies luring the shy alien out of hiding in *E.T. The Extra-Terrestrial*. Using candy was already in the script and Mars' M&M's passed on it. By being included in the breakthrough family film, the orange and brown candy made its mark and its sales soared. AOL was so fully embodied in the 1998 romantic comedy *You've Got Mail* that it was embedded in the title*,* referring to the signature chime for the tech company's era-defining e-mail alert. The anonymous love affair blossoms over the key characters' laptops, with the AOL chime occurring many times throughout the film.

Cars and the moving picture have had a long-standing love affair. The 1995 James Bond film, *Golden Eye*, was almost a two-hour endorsement for the new BMW Z3 before the model's release. It was the first in a three-film deal between the carmaker and the franchise. It was news in and of itself because Bond had always driven an Aston Martin. Bond's switch to BMW generated hundreds of millions of dollars of media exposure for the film and BMW. In the film, a convertible Z3 had a self-destruct feature and Stinger missiles in the headlights. The Z3 was also used in the film's marketing, escorting journalists from a dinner at the Rainbow Room to its premiere at Radio City Music Hall in New York. The film's worldwide sales were around $350 million. And BWW's Z3 launch was equally successful. The "007 model" sold out a day after it became available to order.

Every Bond film in the franchise thereafter has had major product placements with BMW, Ford, Visa, L'Oréal, Heineken, Avis, Omega SA, VAIO, and more. Films of all kinds use product placements—from *Minority Report* and Nokia and *I Robot* and Converse to *The Matrix Reloaded* and Cadillac and *Blade Runner* and Coca-Cola.

Mark Burnett shaped product placement for reality television in the 1990s with *Survivor*. To get the show up and running on CBS, Barnett had to secure sponsorship through traditional ad time and product placements to cover production costs. He landed GM, Target, Reebok, and Visa, with either a 30-second spot or a product placement. Once *Survivor* became a hit, the product placement value went up and CBS brought in $12 million in product placement fees in the program's second season. Burnett has incorporated products such as GMC, Mountain Dew, Doritos, and Sears through sponsored challenges and rewards. Other reality programs have followed suit with Travelocity and McDonald's on *The Amazing Race,* and Neil Lane Jewelers providing the engagement ring on *The Bachelor*.

Product placement is baked in to game shows and daytime talk shows—from the resort trips on *Wheel of Fortune* to the under-seat audience gifts on *Ellen*.

> *Every talk show does product placement or integration, but it's disguised as a segment. It's like payola, but it's legal. Everyone has giveaways, and of course Oprah started the whole thing with her cars, but it's all product placement. It's the best advertising that they could ever get because nobody's flipping through the commercials.*
>
> **—Glenn Meehan, supervising producer, *The Talk*; co-creator *Big World, Little People*; formerly managing editor, *Entertainment Tonight***

And product placement is widespread in scripted TV. In *Sex and the City*, the entire plot of an episode revolved around an ad campaign "Absolut Hunk" for Absolut Vodka that character Samantha Jones was managing and for which her love interest was modeling. The Times Square billboard showed him naked, except for a phallic, strategically-placed bottle. The characters created an "Absolut Hunk" drink, which became all the rage in real bars around New York. On *All My Children*, Susan Lucci's character, Erica Kane, ran a major cosmetics company whose nemesis was Revlon, which remained a storyline for many months. *The Big Bang Theory*'s Leonard is lactose intolerant so he drinks Shuhua, a Chinese lactose-free product that appears prominently on set. According to TNS Media Intelligence's 2008 report, product integration in American television is so rampant that an average hour of primetime TV contains eight minutes of in-show brand appearances and reality programming has almost 14 minutes.

Product placement or in-game advertising is common in games, especially those that create real-world universes for their characters. It began in the 1980s when Sega placed Marlboro banners in its video arcade games. Now, *Roblox*'s zombie game, *Apocalypse Rising*, features Pringles, Mountain Dew, Pepsi, Chef Boyaredee, and Coca-Cola; *Crazy Taxi* passengers may ask the driver to take them to Pizza Hut or KFC; and *Sim City* characters can work at McDonald's.

Sometimes the product simply appears briefly and sometimes it's fully integrated into the storyline. Usually, the brand is portrayed positively within the media properties. In order for product placements to work well with audiences they must feel natural and organic to the media property and the story.

> *For a content creator to secure a brand integration arrangement, you have to reverse-engineer it and look at it from the corporate POV. In essence, they treat it like a media buy and a commercial. They want to know that the project's real, so you need a production deal, a distribution deal, and a release date. They want to know that their*

product is going to be featured in a positive manner—a car crash in their car or somebody getting drunk on their alcoholic beverage doesn't deliver a positive message. And they need to know that it's a big movie or TV show that's going to get a big audience so they can calculate the return on investment. "What is the reach and frequency? How many eyeballs are going to see my product over the lifespan of this movie or show? Is the big star interacting in a way that puts us in the best possible light?" But the filmmaker and people like me have to balance this and make the placement appear like it's a natural and organic because if you make it too blatant you will get backlash from the public.

—John Polwrek, VP promotions, Eclipse

The value to the production is considerable. For the storyline, product placements impart credibility and realism. Also, through product donation, placements save money up front for the production. This may be a big nut if it's a fleet of European sports cars or supplies to rebuild a house. *Man of Steel* recouped $170 million in 2013 with more than 100 product placement deals. But the bigger long-term opportunity is the overall marketing value of the relationship, particularly if the brand promotes the media property. Sometimes sponsors will hire a "second unit" to film television spots on the set of the film during production breaks. Jeep did this in 2003 for *Tomb Raider II: The Cradle of Life*, securing the film's star Angelina Jolie to star in a TV ad—in character.

The value to the brand is also considerable. Brands become "native" to the storyline, which often creates more audience acceptance. The brand secures a halo effect from its association with a cool or audience-loved media property. And the brand gets the reach of the media property itself and its promotion and buzz. This gives the brand a peg to which it can attach its own subsequent promotion during the media property's launch, which creates a multiplier effect to the existing hype.

Recently, the context "rules" around brand portrayal of a product always being shown in a positive light have changed. In the film *Castaway*, a Federal Express executive played by Tom Hanks survived a crash landing on a deserted island and transformed himself physically and emotionally. This product integration was risky for FedEx because it connected the delivery service company to a plane crash. But FedEx saw the value of Tom Hanks and an interesting storyline and went for it. And it paid off.

Those dictates are changing on television as well. *Breaking Bad*, about the transformation of a chemistry teacher into a drug lord, had no product placements in its first few seasons. By the fourth season, producers had carefully incorporated Denny's into the storyline, with characters going to the restaurant to relax after a hit on someone. Dodge, Chrysler, and Winnebago also appeared in the series as part of the plot, but not as reveals on the

vehicles' attributes. And the videogame *Rage* showed up in the program organically. The show was a hit and the brands had no complaints about their products in this less-than-Pollyanna storyline. In fact, just the opposite.

This change in the context of product placement signals the bottom-up force of audiences at work. Instead of controlling and presenting their brand images in stilted and awkward ways, these brands let go and allowed their brands to be an organic part of a revered story world. The amount of exposure, the quality of attention every frame of the program received from ardent fans, and the coolness factor by association—all added up to a brilliant media buy. Perhaps flawed characters, rather than squeaky-clean artifices, are becoming the new role models, blurring the lines of what's "good" and what's "bad." For the next generation, authenticity must drive how brands, content, and even social causes are incorporated into scripts and how entire episodes or film concepts are crafted around them.

In fact, films inside ads instead of ads inside films are becoming the new model. They're like sponsorships, except now the brand creates, controls, and distributes the content. In 2001 and 2002, BMW created its own Web film series, *The Hire*, featuring eight 10-minute films starring Clive Owen as the "Driver." Each short was directed by a different, known filmmaker including Ang Lee, John Frankenheimer, and Guy Ritchie and had a different storyline that subtly highlighted the performance aspects of various BMW automobiles. An ARG game hid phone numbers and a Web address in the films and links on Apple, Starbucks, and BMW's Web sites, all leading to a voicemail instructing participants to meet with a contact in Las Vegas, the site of a BMW VIP party. There, a 2003 BMW Z4 was given away.

Chipotle's 2014 *Farmed and Dangerous* was an original, longer-form, four-episode, scripted brand comedy series distributed on Hulu that pitted the Industrial Food Image Bureau (I.F.I.B.) against down-home farmers trying to expose Animoil, a company whose petroleum-fed cows combusted. Using an outrageous comedy and pithy lines, Chipotle cleverly delivered its fresh food source message through humor.

Product placement is so prevalent that it's measured by In-program Performance Metrics through the Intermedia Advertising Group and recognized by advertising's prestigious Cannes Lions, with a Cyber Lions digital media award.

Cultural Context

You must understand world and cultural events to contextualize your ads and promotional materials. Pay special attention to tragedies and negative news. Since 9/11, the Boston Marathon Bombing, and various school shootings, Americans' sense of security is supremely threatened.

Even though guerrilla marketing is meant to be startling and intrusive, before embarking on a guerrilla campaign think about its context. In 2007, the animated series *Aqua Teen Hunger Force* attached several magnetic circuit boards, each with an LED cartoon figure, on metal surfaces in and around Boston. The circuit boards were mistaken for possible explosive devices. Subway stations, bridges, and a portion of a major highway were closed as police examined, removed, and destroyed the devices.

Sometimes an ad's message feels too close to home or inappropriate in the wake of sad or threatening real-world events. If so, pull the ad immediately or prepare to do some crisis management around it. After a gunman fired into the crowded audience during the Colorado screening of *The Dark Knight Rises* in 2012, Warner Bros. quickly pulled its *Gangster Squad* trailer, in which the main character fired a machine gun into a movie theater audience.

Author's Anecdote

Contextualizing World Events

I worked with the *NOVA* team for two years on the September 24, 2001 launch of *Evolution*, one of the series' biggest and more controversial mini-series. We'd conducted focus groups; brought on Jane Goodall along with other scientists, religious leaders, and educators as spokespeople; created video and print teaching tools for high school science teachers; and developed a major marketing campaign with advertising, publicity, and various events. The anti-evolutionary group, the Discovery Institute, took on the project full force, with ads, a viewer's guide, and 13 press releases excoriating the series—actually, Darwin's theory. The project was the centerpiece of PBS' fall programming.

When terrorists attacked the US on 9/11, just before *Evolution*'s premiere, everything changed. Not just for *Evolution*, but for life as we knew it. In those first 24 to 48 hours, we had to make sweeping business decisions. When the planes hit, I was an hour away from heading to the airport to go to New York to meet Jane Goodall, for appearances on *Good Morning America* and the *Today Show*. Obviously, I stayed put. After confabbing with PBS execs about whether to air the special 13 days later, we kept the original air date and added a re-broadcast in the spring, knowing that all the placed advertising and on-air promos were going to fall on deaf ears. The publicity simply ground to a halt.

Part of the major TV, print, online, and mobile ad campaign in play included this ad that I knew was wholly inappropriate in the context of world events. It was about killer infectious diseases traveling on airplanes with the headline, "Why is a safe flight still dangerous?" Luckily, we were able to pull it. And in a communications-compromised climate, we struggled to reach several thousand New York-based invitees to cancel our event at the American Museum of Natural History, scheduled for several days later. Meanwhile, there were friends and colleagues to account for and staffers who were falling apart and needing to be sent home. Jane Goodall was stuck in New York for more than a week and was touched by the humanity around her. If social media existed then, her posts would have been amazing.

On premiere night, the ratings were solid, but not close to what they would have been with the buzz that had been building. But all that was immaterial, because 9/11 was simply more important than our, or any media project.

Courtesy of Vulcan Productions; Courtesy of WGBH Educational Foundation. *NOVA* is a trademark of WGBH Educational Foundation.

This print ad for PBS' September 2001 *Evolution* docudrama was pulled right after the airplanes hit the World Trade Center on 9/11 because it was inappropriate in the context of the tragedy.

PART VIII

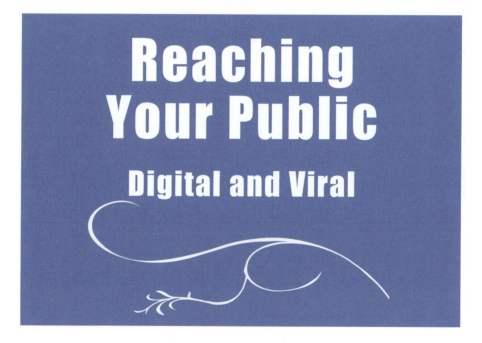

Reaching Your Public

Digital and Viral

Online and On-the-go Marketing

As the technological advances of the past two decades have turned audiences into prosumers and digital content has proliferated, pundits have decreed "content is king." The World Wide Web is the most significant advance of the last century. It has upended traditional content creation and distribution models and has become a fully-articulated content delivery system and marketing stage—with on-ramps available to almost everyone.

The Internet has advanced far beyond its roots as a Web-hosting platform or means to send an e-blast. It can support your media projects in myriad ways, allowing you to stream your film, contribute to a blog, launch a video trailer, post an infographic, share social comments, and create a community.

Mobility may be the most significant advance of this century, making the Internet accessible anywhere and providing apps, texting, photos and video-sharing that extend the frontiers of digital marketing. It has created an accessible global public square.

The intersection of traditional media and digital media in integrated campaigns is the sweet spot of today's content creation and content marketing.

Digital—one spoke in the wheel—has upped the game in all channels. One of last year's Gold winners in the Innovative Media category won for an incredible cinematic presentation at E3 for Activision's Call of Duty release. Another, same category, won for taking to the skies with a custom-wrapped blimp to promote Universal's Despicable Me 2. And teaser ads and billboards, very much prominent among the winners of the Print category last year, work in concert with their Web and mobile counterparts. The industry is always pushing the boundaries to create awareness and engagement, but what's exciting is that it does so with more traditional formats as part of broader integrated campaigns.

—Nicole Purcell, president, CLIO; oversees *The Hollywood Reporter*'s Key Art Awards

Content Creation and Curation

Content has inherent value, and in a world with so much content, so too does content curation, particularly as it serves niche audiences. The new age curators are Upworthy and "Trending" topics on Twitter, Facebook, Google+, and Tumblr. No matter its subject or genre, your project can have passionate constituencies of interest—public audiences and affinity groups—that will care about it. Affinity and niche marketing creates deep emotional engagement among audiences and inspires them to be credible third-party ambassadors and advocates for your project. Online is one of the most targeted and cost-effective ways to find and activate your authentic audiences.

As a media maker and media marketer you offer huge value to your target audiences simply through your content creation and content curation. You have a deep bench of assets. You have content, through your media project and its marketing. You have expertise and insight into the context and relevancy of your content and its associated themes. You have an array of online distribution platforms—from Web sites and social media to blogs and online video. And you have an entrenched understanding of your niche audiences, knowing who they are, where they go, and what motivates them. For a certain segment of the audience, you can be the hero.

From the beginning, approach your transmedia project and marketing from a holistic content creation perspective. Don't differentiate between story and marketing content. Step back and think of yourself as serving a passionate defined niche audience by creating and curating content. Find a narrative or a story that will enchant them. Build a brand personality, story universe, and user experience across your media platforms to fully immerse them. Cultivate a voice that enhances and reinforces your brand archetype and characters. Usher your audiences into the tent to help you find, tell, and share the story.

Deliver plot points, embellish your story world, and create audience invitations with more content—photos, video, blogs, headlines, Web sites, art, and hashtags. By doing all that you're creating your story and its marketing through a single, integrated content creation and curation impulse. And in so doing, you're fully honoring and serving your unique niche audience.

> *We live in a world where product and marketing are the same thing. I think we need more people who understand that marketing takes place at a product level, and you can use all the tools at your disposal to make your product better, whether that's data or things that you're tracking. If you have that right, then you can let your product market itself through the distributive power of digital and social media.*
>
> —**Chris Eyerman, creative director, 3AM; formerly transmedia creator for** *Prometheus, The Hunger Games, Arrested Development*

To integrate your content creation, curation, and marketing, create and distribute ongoing organic content. Think of all your content as installments in the overall experience. Keep the story moving and fresh. Add context and social relevancy. Pay attention to what resonates with audiences and create new content accordingly. Don't be self-serving. Play generously with other content makers and audiences in your space. Exchange ideas, cross-promote, and give credit to others. Create a forum for an active, ongoing community around your project. When you're lucky enough for that to happen, allow it to take on a life of its own and simply feed the beast.

If your content and its context offer value, audiences are motivated to explore further or take the next step—click, view, share, or co-create. That's why so many people vote on *American Idol*'s winner or create parody videos. With enough value-driven exchanges, audiences will choose to become part of your project's community and story as co-creators, characters, and marketers.

Audiences want to participate in both your project's story world and your production universe—from crowdfunding the shoot to talking to its characters on social media. Perhaps the most fascinating phenomenon is how audiences move seamlessly between *and* play at the intersection of these two worlds—your fictional story world and real life.

To keep audiences engaged in both worlds, provide timely content with an immediate reward and action. Also, offer long-term value by teaching or providing a service, motivating audiences to share your content as an asset. Provide insight or context for events, news stories, or trends that create collective experiences and position you as a connector or expert. Create content that builds on and shares other timely content, yet links to your project. And ensure your content catches the eye with captivating headlines, art, and video.

Many successful digital and viral entertainment marketing campaigns develop content that first, creates *mystery* around a passion topic or project; and second, rewards audiences

by making them feel special or *in the know*. The powerful tension between these emotions has an amplifying effect. It's accomplished first by providing teaser content that asks as many questions as it answers to create pent-up audience demand; and then, by releasing desired content and clues in a drip-feed to sustain the demand. This places superfans in the position of having content or information first. They share because their tribe will be interested and because they want to show they're in the know.

So, you must reverse-engineer your content. Design a carefully-orchestrated narrative around it and decide how, to whom, and when to tell your story. Seed **"Rabbit Holes"** or clues to connect audiences to a story universe or simply deliver ongoing project news. Use online content to reveal a character's POV, deliver production news, or release poster art, teaser trailers, or preview Web sites to flesh out an intriguing fictional or non-fiction narrative. This technique works well as a teaser campaign for films, TV programs, and games. Over time, the narrative takes shape on both digital and traditional media and your audience helps sustain the storyline's momentum.

Online content on different platforms can contribute to a larger offline story universe or become the story universe in its own right, as witnessed by the expansion of the Grumpy Cat meme, *I Fucking Love Science* Facebook page, *Sh*t My Dad Says* Twitter account, and Justin Bieber YouTube videos into cross-platform media brands.

Web Sites

While Web sites have been around for decades, they still serve as the workhorses of a media project's online content. They can be a key storytelling platform, a marketing platform, or both. The old saying, "all roads lead to Rome" applies to Web sites because they can be the hub for all of your digital assets, including social media, blogs, hosted video, and other Web sites. While a cool viral video may get notice, if it doesn't lead engaged audiences to something bigger then you may have squandered your moment. In the arms race of increasing digital assets, including text, video, audio, photos, and social, it's wise to anchor audiences' digital experience to one or two platforms. The secondary assets feed into landing pages of the primary assets. You can sustain a long-term relationship with your audiences on your Web site using short-term content and experiences.

An official project Web site should provide unique content that's interactive and valuable to your audiences. It should describe the media project; include the project's synopsis, bios, key art, poster, trailers, and links to partners; use graphics and video on the site or on YouTube or Vimeo; connect all the digital assets; be legible, consistent, and use meta-words throughout; invite audience interaction, such as a blog with comments, chats, or user-generated content vehicles; and include contact information.

Web sites also can be part of the story world. From the beginning, the ABC series *Lost* took the inherent mystery of the series' TV storyline and brought it online and into people's real lives during the off-season. Various Web sites featured prominently in the five-week viral campaign for the 2008 Season 4 premiere. The network created an entire backstory universe around Oceanic Airlines, whose Flight 815 lost radio contact six hours after it departed from Sydney, stranding the *Lost* characters on the deserted island. The campaign began with an airline press release reporting that it was suspending the search for the lost plane. The press release's telephone number, TV spots, and billboards for Oceanic Airlines all led to the fictional Web site, flyoceanicair.com.

The site looked like a transcontinental airline site, but the welcome video was hacked by Sam Thomas, the main character of the marketing campaign. Sam reported he wasn't giving up the plane's search because his girlfriend Sydney was a flight attendant on Flight 815. A second Web URL, find815.com, then flashed on the screen. It was also revealed during a *faux* airline TV spot and on fake billboards in each character's hometown, which were later graffiti-ed with the URL.

Courtesy of VKNRM /Flickr

Oceanic Airlines' billboard vandalized with the Web address from *Lost*'s Season 4 marketing campaign.

Find815.com had video teasers, a virtual desk (with voicemail messages and e-mails) and a *Lost* diary. It provided five weeks of clues to superfans about whether the plane had been found and why the airline was keeping mum about it. The campaign energized *Lost* devotees who created an active blog and Wiki to keep track and share it all.

Films, TV shows, or games should have a preview Web site or other digital presence as soon as launch material is available. So, when key art or trailers release, they can be posted on the project site, video-hosting sites, and review sites and should be readily shareable on social media with a single click. For major franchises or fan-based projects, the Web site should go live before or during production.

Blogs, Pods, and Vlogs

Blogs began as unheralded online text diaries and have become major sources of information and opinion. Mom bloggers serve more than 36 million women who have their own organization, BlogHer. *The Huffington Post* is the best-known international blog with columnists and guest contributors on subjects ranging from hard news to health. Perez Hilton's gossip blog about actors and musicians has made him one of the most powerful celebrity columnists. Even the White House has added a Tumblr blog to its official online presence. Every niche interest has dedicated blogs and audiences.

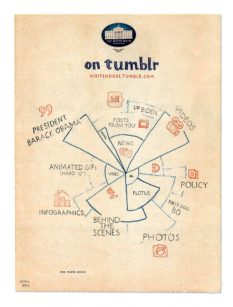

Whitehouse.gov/Tumblr; Licensed in the public domain via Wikimedia Commons

The concept design for the White House's Tumblr blog.

Blogs can enhance your project's online presence on an ongoing basis. A blog can be your project's consistent voice for telegraphing news or publishing new content, keeping your Web site fresh and giving audiences a reason to come back. Don't create a blog and then leave it dormant.

Deciding what to write and when is the art of publishing. As a content creator and content marketer, you are a publisher. You can blog to announce project news, release a new asset such as a video clip, or capitalize on a news story. The goal is to provide exclusive content that feels like a reward to audiences.

Blogs can also be a big part of your story universe. *The Daily Bugle* newspaper on Tumblr for *The Amazing Spider-Man 2* provided backstory and teaser content for the *Spider-Man* story universe in between the two acclaimed Marc Webb films. *The Daily Bugle* is a fictional New York City tabloid that has been part of the Marvel Universe since 1962 and was featured on film in 2002 in *Spider-Man*. The micro-blog online version of the publication has a masthead, a publisher—J. Jonah Jameson—a city editor, and various reporters who write stories and editorials.

> *Transmedia success is measured in the level of engagement and by the intensity of the dialog around it. With The Daily Bugle Tumblr blog, you can see that thousands of fans engage with the actual content on a daily basis, but the value is increased exponentially when some of those fans report their findings to large pop culture portals around the 'net, and articles are published about what is going on at The Daily Bugle, which in turn reach hundreds of thousands or even millions. This makes Sony very happy. For relatively low cost, they are providing entertainment to fans that is additive to their Spider-Man story world, and those excited fans are becoming apostles for the brand, broadcasting its message to millions. That's success!*
>
> **—Jeff Gomez, CEO, Starlight Runner Entertainment**

Give your blog a name that connects to your project. Check out your audiences' digital comments to be sure it's serving them. Use your authentic voice to resonate with audiences. Give away some knowledge so people feel satisfied and might share it. Keep it short (no more than 700 words). Add a great photo near the top to draw people in. Write tantalizing headlines that are short, bold, active, personal, and immediate, using numbers, lists, tips, and viral words such as "smart," "surprising," "huge," or "big." End your post with a simple call-to-action to secure an e-mail or text sign-up, or a Twitter follow. Telegraph new blog entries via social media with a direct link.

What began as text diaries later morphed into richer media, pushing the boundaries of available bandwidth. Podcasts, a term combined from iPod and broadcast, are digital content of episodic audio or video files subscribed to and downloaded through Web syndication or streamed online to a computer or mobile device. They're most closely associated with portable players. Most people think of audio podcasts as digital music or talk radio-like programs.

MTV VJ Adam Curry, known as "The Podfather," popularized audio podcasts in the mid-2000s with his weekday evening show. In 2005, the White House made RSS 2.0 feeds of President George W. Bush's weekly radio addresses available on its Web site. NPR, the biggest producer and distributor of podcasts, makes many of its popular radio programs from *Science Friday* to *Car Talk* available for download. Podcasts have gone mainstream with *Serial*, about the mysterious murder of a Baltimore teen. It has been listened to by millions and entered popular culture—from *SNL* to *The Colbert Report*.

Webcasting on the other hand is generally confined to the Internet streaming of files. When it's video they're called vlogs (video blogs), which created the phenomenon of YouTube, ranging from "Let's Play" gaming videos to curated channels. With cheap access to video shooting, editing, posting, and syndication—especially now from mobile phones— anyone can create and distribute a vlog.

Peter Jackson produces vlog diaries of the production and post-production of his films exceptionally well, including *The Lord of the Rings* and *The Hobbit*. His posts have live fan events with exclusive footage, Q & As, "how tos" on post-production scoring, and info on Air New Zealand's tie-in promotions. Almost all of his entries include new footage of him or the film. Superfans are voracious consumers of this exclusive, behind-the-scenes content about both the story world and the production world. When the first installment of the trilogy *The Hobbit: An Unexpected Journey* released, it had almost 800,000 Facebook "Likes" because of this steady stream of content connecting audiences to the film.

Vlogs can also be part of a fictional universe. Webisodes are rooted in early fictional online vlogs, such as *LonelyGirl15*. In 2006, a teenage girl named Bree trained the camera on herself and began talking on her YouTube account, *LonelyGirl15*, about normal, everyday teenage minutiae. She made reference to real-world YouTube characters and communicated with her followers on her MySpace page. But over time her vlog entries veered toward her family's mysterious cult-like religion, "The Order," and later her parents' disappearance after she refused to attend a secret ceremony required by the cult leaders. After the first season, the program was "outed" as fictional, which gained worldwide attention and angered many. At its height, *LonelyGirl15* posted five videos per week. Near the end of its two-year run in 2008, the series had more than 125,000 YouTube subscribers and more than 110 million views across multiple platforms.

By Lonelygirl15 Studios; Licensed under Creative Commons via Wikimedia Commons

The *LonelyGirl15* YouTube vlog that audiences thought was real but was fictional; Bree was played by a 19-year-old New Zealand actress.

LonelyGirl15 created a new model for transmedia storytelling and marketing in which the character breaks the fourth wall and tells the story from their POV, often joined on camera by other characters and supported by content on other media platforms. It also was the first Web series to use product integration.

Your podcast or vlog can be in your producer's voice or in a character's voice. Like blogs, it needs ongoing content. Give yours a broadcast schedule, such as daily, once per week, or once per month, and a consistent format and length. Brand it with a memorable name that connects to the project or you. Create a list of topics; the best will rise to the top. Develop catchy titles for each episode. Draft an outline or script for each, with insightful, useful, and shareable content. Be authentic and passionate, not preachy or self-serving. Seek audience feedback through comments, live chats, and polls. Connect it to and promote the podcast with your other digital assets.

Search Engine Optimization—SEO

In addition to the media assets you own and control, you want to promote your media property online. So use hyperlinks in your text to provide more information to keep audiences engaged. There are three main aspects to online promotion, Search engine optimization (SEO); getting notice of your project on other Web sites, which is a "pull" strategy; and e-mail marketing, which is a "push" strategy.

SEO is an Internet marketing strategy about increasing the visibility of your Web content on search engines' organic search function. That means increasing the chances of showing up in the top results when someone types in keywords related to your project. The higher up in the search results list, the more visitors it will receive. You can create Web sites and digital content that rises to the top of those rankings by embedding content and HTML coding with words that boost sites' or pages' relevance to keywords and by ensuring search engines index your content. Search engines' search algorithms are constantly changing, but there are some key "truths" in SEO.

SEO begins with what words and phrases are most likely to be typed into the search field on Google, Yahoo, or Bing. These are your project's **Meta-words**, **Keywords**, and **Tags**. Some are obvious: your project's title, tagline, genre, platform, type within a platform, subtitle, themes, top characters, cast members, artists, and partners. Images can be searched, so your art and photography should also be labeled with those words.

Use these meta-words on your Web site in text and in headers' meta tags. Most content management systems have meta tag settings that allow the loading of your meta-words. Be sure to use your keywords within the blog and the blog tags, press materials, social media, and any content that will go digital. The more you use these keywords, the more likely your online content will rise to the top when people search them.

Also, your Web design should be dictated by SEO. Don't use splash pages (the page that appears before the home page as a brief intro to your site). Web crawlers will index your splash page and not other pages, sending traffic only to your splash page.

A landing page (lander) or lead capture page is a Web page that appears after clicking on an SEO search result, ad, or other content with a link. Promoting inbound links to those pages is also part of SEO, achieved by online and mobile marketing to pay off on calls-to-action that motivate the click. By tracking the click-through rates or conversion to the desired action from the landing page, marketers determine the effectiveness of a tactic.

Increasing your overall footprint on the Internet, especially in places your audiences frequent, is another key tactic of online marketing. Securing a big "hit" on a top online Web site can be as valuable as coverage on a traditional media outlet. To secure coverage on others' Web sites, you should approach their publishers the same way you would traditional journalists through your media relations efforts (see Chapter 14, "Media Relations").

Also guest-blog and comment on other entities' Web sites or blogs. You should be active on online forums and social media sites around your project's genre or subject. Don't shamelessly plug your project, but rather offer insight and refer audiences to other valued content on the subject, not just yours.

E-mail is a "push" promotion Internet technique. Alerts can be informational, such as a newsletter, or promotional, such as a teaser clip, ad, or contest. They should use graphics and video. SMS marketing, or texting, is the mobile version. Like Twitter, texting has

limited characters so you must write parsimoniously and shorten URLs. Both techniques must allow for opting in, have a call-to-action, and link to the project's digital assets. Through its 120 "On the Road" events and preview Web site, *Martin Scorsese Presents the Blues* gathered thousands of e-mails. The project sent 12 issues of its newsletter with production notes, artist news, film previews, and events schedules to fans and the membership lists of its many partners—always linking to the project's Web site.

Online Visuals and Video

With so much content overload and distraction from second screens eroding audiences' attention spans, it's increasingly difficult to get noticed. In the digital universe, graphics and video are excellent storytellers, amplified by their hyper-socialization. Strong key art and photos convey a project's story and mood.

> *People check their Facebook through mobile about 45 percent of the time. That speaks to the nature by which we're engaging them with. So lo-fi pieces like photos, memes, and graphics all perform very well, sometimes even better than video. Short bursts and shorter clips.*
>
> **—Joseph Epstein, digital content and marketing strategist; formerly 20th Century Fox and Sony Pictures Entertainment**

That's why Instagram, Flickr, Pinterest, Tumblr GIFs and micro-video sites such as Vine, Instagram Video, MixBit, Twitvid, and Cinemagram are growing so quickly. These attention-getting digestible bites of visual content can be stand-alones or lead audiences to deeper content.

Video is the fastest growing commodity in the online space. Online viewing of film and video has changed video's context, but the overall appeal is the same. YouTube and Vimeo have revolutionized the Internet because they allow for uploading and streaming of video, inexpensively adding video content to your digital universe. Your project's video may be long-format full-length films or six-second micro-videos. You can use your video streaming sites as a repository of your video assets or as a curated channel to which audiences subscribe.

Digital marketing is the *de facto* definition of twenty-first-century marketing. Every campaign includes some online or mobile marketing, social media, or interactive media. As more media content is consumed on mobile devices, digital media is gaining more social saliency. The amount of traction media content gets in the social arena is often the key determinant of content and marketing campaigns' success.

Author's Anecdote

The Dawn of Digital Content Marketing

The first major digital campaign I developed was for *NOVA*'s *Evolution,* a docudrama on Darwin's life and scientific theory, premiering on PBS in 2001 before social media. This blast from the past reveals technology's inherent ability to engage audiences and is a reminder of how quickly tech companies can become irrelevant. *Evolution*'s digital marketing complemented an array of traditional marketing tactics of TV, print, and radio advertising; publicity; guerrilla marketing; and special events leading up to the premiere. The campaign had two goals: to drive audiences to the Web site and to the national broadcast.

The interactive team embedded the Web site with meta-tags for SEO (Google, Yahoo, AltaVista, Excite, and Goto) and produced and streamed program and behind-the-scenes videos on the site. We sent text, graphic, and video e-mail blasts with share-with-a-friend prompts and digital postcards to our partners' affinity groups to drive click-throughs. We designed enriched editorial content and banner ads on the AOL Network, Yahoo, TVguide.com, and People.com; created an AOL "Evolution" keyword and features; and hosted live chats with program talent on AOL and Yahoo— all linking to the project site. And we used AvantGo to "push" ongoing Web and TV updates to people's Palm Pilots or PDAs. While only a few million PDAs were in use, our mobile conversion rate "pulling" people to the *Evolution* Web site was triple the average online click-through rate.

Launching at the dawn of our digital awakening, this effort would have been more easily achieved today through social media. Still, the foundation of this marketing experiment—directly engaging audiences with both digital content and marketing—is still relevant today. Some 15 years later, the *Evolution* project Web site still enjoys Google's #1 ranking for the keyword "evolution."

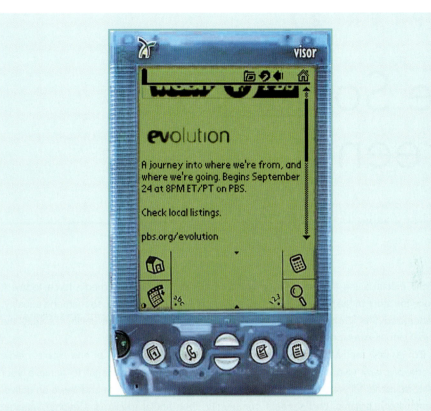

Courtesy of Vulcan Productions; Courtesy of WGBH Educational Foundation. *NOVA* is a trademark of WGBH Educational Foundation.

An early 2001 digital AvantGo mobile "push" message designed to "pull" audiences to *Evolution*'s Web site and broadcast.

The Social Screen

Social media is the fastest growing and perhaps most influential media force today. It broke the story of the Navy SEAL's raid on Osama bin Laden, advanced marriage equality, reenergized *Star Trek*-er George Takei's career, and launched the selfie. It's truly the global virtual water cooler.

But no new media channel is an end unto itself; it's a means to an end. Social media is one of many valuable tools in the content and marketing arsenal to achieve your strategic plan's fully-articulated goals. If your goal is to connect with and serve an active, participatory, organic, and sentient community, then social media is a mighty valuable tool.

Second screens and Facebook, Twitter, and YouTube have already made film, television, games, and digital media into rich two-way experiences with heightened fan participation— from *Pretty Little Liars* to *Minecraft*. Social media has provided the conduit for audiences to directly enter conversations, which can be amplified by project news, stars' chats, story world assets, exclusive content, contests, and games.

The socialization of cinema, television, computer, mobile, and console screens is positively impacting audience awareness of and engagement with entertainment properties.

We live in a social world, so when I think about audience engagement I'm no longer bringing people to the mountain, I'm bringing the mountain to the people. With content, I'm not building a giant presence or giant piece of real estate, I'm chopping up what's going to be engaging. And I'm driving engagement on a daily basis on the platforms that we as a consumer base are on, and are obsessively checking on an hour-by-hour basis. And that's Twitter, Facebook, Instagram, Tumblr, and YouTube. So I'm looking to fight for my audience everyday.

—Joseph Epstein, digital content and marketing strategist; formerly 20th Century Fox and Sony Pictures Entertainment

Social Storytellers and Ambassadors

Social media rarely operates in a vacuum. It's the connective tissue to other elements in your transmedia project or content marketing—both traditional and digital media. It markets the story and *is* the story. The social universe is about self-expression: audiences sharing what they deem to be interesting, important, or funny; telegraphing who they are and what they believe in; and recommending products or supporting causes. This is personalized social storytelling. If your social audiences become co-protagonists, connecting their personal stories to your project's narrative, then you've got a social hit.

Social storytelling operates under the aegis of basic social mores. There's an evolutionary advantage to humans being social animals. The lessons of shared stories teach us how to survive, and social graces bind us to our kin and our neighbors to ensure that survival. So good social media invites audiences to join a community, collaborate with the creator, and share ideas about content. If the invitation begins with your social assets, then you're the host of the party. Like any great social event, the real measure of whether you've been a great host is whether everyone's having fun without you (when you're in the kitchen). That's how it should be on your social media platforms. Your content may start it, but the conversation takes on a life of its own.

There are many kinds of stories you can tell on social media. The one-offs—single videos, images, selfies, or comments—that resonate the best on social platforms are the weird, funny, gross, or heartwarming . . . or those with celebrities, babies, and puppies. Not every single piece of content is expected to take off on its own, but it can have value. If you do something deeper—make your social media assets part of a larger story universe or content experience—then your audiences will keep coming back. With enough built-up audience engagement or anticipation, the right content—launched at the right time—just might heat up on social media.

So look again at your media project as a brand and your marketing plan as a storytelling device. See how social media fits in with or carries the weight of a specific message or function.

With social media you can look at it from two types of practices. There's the strong marketing approach, which is creating content and creating promotion, and then there's an editorially-driven type of communications. With online and mobile, communications are easier to push out to a broader audience.
—Rachel McCallister, chair, MPRM

Social can be the voice of a fictional character, the forum for audience contribution to the plot, the big reveal of the project's poster, or the launching pad for project news. Using all of your project's assets, you can create a global, real-time conversation among your project's follower base of passionates, influencers, evangelists, and co-content creators. These ambassadors can help you explore, embellish, and spread your story.

You already have the seeds of ambassadorship of your project within your own tribes. Even if it begins with only 50 fans, treat them like gold. Reward them with almost every interaction—from sneak peaks of new content to acknowledgements on your media project. Then, reward them further by listening to them and responding on your subsequent posts.

Trending and Viral

Shared content through social media is an inexpensive distribution mechanism to widely spread content for your media project. It's also an endorsement of it. In a world where friends and family's approval means as much as critics', audiences are likely to check out the content that others in their tribe deem share-worthy.

According to Nielsen's 2013 American Moviegoing report, approximately 81 percent of moviegoers said they used Facebook to decide on a movie, while 34 percent used Twitter, 21 percent used Pinterest, 20 percent Google+, and 18 percent Instagram. Viacom's 2013 Social Media Survey reports that the top ways audiences discover TV shows are watching promos, word-of-mouth, and social media.

All this social media usage adds up to certain social stories rising to the top. Share-worthy social content is aggregated and curated by "Trending" or "hot" topics on Facebook, Twitter, and Google+. Upworthy is dedicated to "Trending" topics. In the spring of 2014, Twitter's top stories were #Scandal and #Crimea. This minute-by-minute global focus group of what's important or interesting will help you react in real time to shape your posts, videos, ads, and other digital content to resonate with audiences. You can "newsjack" "Trending" topics if there's a natural link with your project. Be sure to use that topic's

most popular "Trending" hashtag to reach the greatest number of people, along with your own hashtag. Or, peg your social presence to news stories, anniversaries, seasons, or events. Those short bursts can reinforce or boost your project's *über*-narrative.

Many entities pre-plan their social media strategy around live events like Arby's did at the 2014 Grammys, jokingly asking Pharrell Williams for their hat back (his signature hat looks like the Arby's logo). At the 2014 Oscars, Ellen DeGeneres' super selfie with many stars got 3 million retweets—engineered by sponsor, Samsung.

With so much social happening on second screens and on the go, sharing is easier than ever. Many Facebook users are "mobile only" and one-quarter of 18-to-44-year-olds keep their smartphones next to them all the time. Sharing is a split-second decision that takes just a few moments to execute. The main goal for your social media content is shareability. Is there a secret sauce to making a media or entertainment property's content go viral? No, but two genres of storytelling are social media-friendly: *Mystery* and *Comedy.*

Creating intrigue and mystery around a passion topic or project helps it spread. Before social media, there were viral story mythologies around media projects that propelled real audiences into fictional story worlds. Early in the twentieth century, the *War of the Worlds* and, later, *The Blair Witch Project* embodied that concept. Both made audiences believe that the fictional documentary-style radio broadcast and film marketing materials were factual accounts.

Imagine how those mysteries would have played out on social media. They'd spread instantly, but would have been exposed as hoaxes just as quickly. Today, if content is tantalizing enough, audiences are willing to suspend their disbelief and voluntarily enter the fictional universe. They become complicit and active participants in the narrative.

Comedy is so central to the sensibility of social media that the Shorty Awards have a category just for it. Go to any of your social platforms' newsfeeds and more than half of the content you find is someone's idea of funny.

Paramount Picture's campaign for *Anchorman 2: The Legend Continues* used comedy to push the boundaries between reality and fantasy. They made the 1970s throwback news anchor, Ron Burgundy, ubiquitous: in Buick ads extolling the virtues of glove compartments; on *Conan* remarking how babies have gotten uglier; on a huge billboard near Penn Station with a 3-D moustache; and as a live anchor on a newscast in South Dakota. Each sighting delighted social audiences, keeping them speculating about where he'd show up next. Burgundy also posted about real-world events, like the UK royal baby. Paramount created shareable Burgundy-inspired games and original videos tagged with Burgundy's tagline, #StayClassy. Because of Will Ferrell's genius at making the character hilarious in any context, Ron Burgundy went viral.

So, to boost your content's shareability: create mystery with open-ended questions; provide audiences exclusive or info-rich content; and, make the experience fun or funny.

Tips to make your social media posts shareable and go viral include:

- Be provocative and have a POV
- Be timely and relevant
- Pique audiences' curiosity
- Create an emotion or reaction
- Riff on others' ideas more than your own; give others credit
- Make posts easy to understand quickly
- Offer a reward
- Provide a call-to-action
- Be visual; use graphics and video
- Make all content shareable with one click
- Link to your other digital assets
- Provide superfans or influencers exclusive content
- Think SEO; embed meta-words
- Write catchy headlines
- Choose a hashtag that fits the subject and your audiences

Hashtags are critical to digital and social success. They're mini-headlines, taglines, tags, or meta-words preceded by a # that help curate content on social media, pulling it into a separate content stream so audiences can follow posts on that topic. Create a short hashtag for your project and use it consistently. It can be your project's name, description, a key theme, or a catchy phrase. Hashtags are recognized by search engines, so should be incorporated into your SEO strategy.

Word choice *does* matter. A headline, photo, or link that offers a surprise or twist captures audiences' attention. In 2014, Groupon created a President's Day $10 off coupon honoring president Alexander Hamilton (who never was a US president). Groupon purposely created this erroneous promotion and social media went wild with the mistake. The rest is history, or in this case, revisionist history.

Socializing Real Worlds

Media and entertainment properties socialize a project's real-world universe by leveraging the property's artists, fans' social chatter, promotional assets, and production news.

Social loves celebrities. Back in the day, celebrities' value was measured by a Q Score —how likable and influential they were with audiences. Now, a celebrity's social following

is a determinant of their value. Many believe that Universal cast Rihanna in *Battleship* because of her 26 million Twitter followers or Ashton Kutcher replaced Charlie Sheen on *Two and a Half Men* because of his 6.7 million Twitter followers.

Celebrities can be instrumental in advancing a project's story and promotion. As a result, conducting social media for a project is built in to celebrities' contracts, like press interviews and promotional appearances. Publicists and social media specialists manage celebrities' social media profiles.

RADiUS-TWC, the boutique label of The Weinstein Company, which tailors films' distribution and marketing to ensure they find their natural audiences, has successfully used a social celebrity strategy. In 2012, RADiUS leveraged the social media presence of the cast of the Sundance sensation *Bachelorette* to promote the film's pre-theatrical VOD release. A romp about three best friends whose night of prenuptial debauchery threatens to ruin their closest friend's wedding, *Bachelorette* starred a slate of fresh, young talent including Kirsten Dunst, Isla Fisher, Lizzy Caplan, Rebel Wilson, James Marsden, and Adam Scott.

> *Bachelorette's young, hip cast lent itself perfectly to our social media efforts leading up to the film's pre-theatrical VOD release. The actors' posts connected directly with audiences, generating even more fan and celebrity tweets about the film. The social media buzz aligned with the heightened awareness from the actors' 25 high-profile television bookings and fashion spreads to create huge word-of-mouth for the film.*
>
> —Liza Burnett Fefferman, executive vice president, publicity, RADiUS-TWC

Retweeted by Bachelorette

Kirsten Dunst
@kirstendunst · 10 Aug 2012
I'm going to have a red carpet in my mom's living room for the VOD premiere of #Bachelorette
↩ Reply ⇄ Retweet ★

@kirstendunst/Twitter

Celebrities such as Kirsten Dunst tweeted about *Bachelorette*, giving it huge social lift among its target audiences.

Joining the chorus of actors' and audience devotees' posts were celebrities, including Jimmy Fallon, Emma Roberts, and Paris Hilton; media outlets, including *Variety*, *Details*, and *Elle*; and VOD platforms, including iTunes Movies and DIRECTV—amplifying the film's social footprint. *Bachelorette*'s pre-theatrical VOD release became the first to reach #1 on iTunes' Top Movies Chart, the only multi-platform release to reach #4 among top Cable VOD performers, and subsequently generated more than $10 million in revenue, outpacing most VOD releases.

Contestants or hosts of reality television shows—from to *American Idol* to *Survivor*—are viewed by audiences as celebrities and also energize social audiences. TLC's reality series *Here Comes Honey Boo Boo* was created on the strength of the audience's social reaction to the unconventional child beauty contestant Alana when she appeared briefly on a different program. (*Here Comes Honey Boo Boo* is a case study in Chapter 31, "Transmedia Marketing Case Studies").

Bravo has capitalized on the social currency of its reality program casts, such as the *Real Housewives* franchise and *Top Chef*, by using programming chief Andy Cohen to host *Watch What Happens: Live* featuring reality stars and audience questions from social media. This engages audiences in a cycle of TV programming, social media reaction, and TV programming about the social chatter. This symbiosis of digital and broadcast platforms is about listening to audiences and giving them what they want.

> *In non-scripted television, we ask our audience to connect with these "characters"—these real people—and engage with them and welcome them into their homes. To make that personal connection, you have to go where that audience is, where they're communicating, and how they're connecting, and that's obviously through social media. It's the modern water cooler, or town hall.*
>
> **—Dustin Smith, VP Communications, TLC**

TLC socialized its TV fare using this technique for its 2013 mid-season opener for *Long Island Medium*. The live "Tweet to Win" Twitter event featured a viewing party with Theresa Caputo with dozens of real-time on-air fans and a contest for viewers to win coveted readings with Theresa. The event dominated social conversation, earning the top ranking among non-sports programming. The #LongIslandMedium hashtag was used more than 880,000 times—"Trending" on Twitter in the US along with eight other terms and hashtags. The show's daytime walk-up marathon also generated more than 1 million tweets. Among 25-to-54-year-old women on cable, the mid-season premiere's episode won the top Nielsen ranking in its timeslot and second for primetime. TLC reprised the social event for its Season 5 premiere in 2014.

© TLC/George Lange

Long Island Medium Tweet to Win key art.

Breaking Bad became a social media sensation in its final season, because AMC invited audiences into its production universe to say farewell to the series. Early in its five-season run, the series engaged a small but loyal following. But what was unusual was how many new fans *Breaking Bad* created in its final season.

Scheduling, social media, and VOD contributed to its standing as the third most watched series finale in cable history behind HBO's *The Sopranos* and *Sex and The City*. AMC stretched out the final sixteen episodes into two eight-episode runs. By splitting up the season, AMC created an environment that was ripe for audience speculation on social platforms. And because of the series' availability on Netflix, Apple's iTunes, and DVD, the social conversation propelled newcomers to binge-watch to catch up on the show's storyline and join the experience in real time at the end. Viewership doubled between the first and second half of the final season.

AMC's final season strategy was to join the network, program creators, stars, and fans to celebrate the series' end in a series of socially-binding experiences. They included a "goodbye" image for audiences' profile pictures that riffed on *Breaking Bad*'s periodic table-inspired key art; open-ended questions about the series' ending; and an appeal for farewell messages using #GoodbyeBreakingBad. Cast and audiences alike tweeted. Aaron Paul, who played Jesse Pinkman, live-tweeted throughout AMC's super-marathon of all *Breaking Bad*'s episodes leading up to the series' finale.

AMC created various online assets, including a farewell video. Leading up to the final episode, fans could enter to win or purchase tickets to a finale screening party. During the final episode, fans furiously tweeted and posted on Facebook. The East and West Coast airings of the finale garnered 1.24 million tweets, with 22,000 tweets-per-minute at its peak. On Facebook, 3 million people generated more than 5.5 million interactions. The social conversation reached such a frenzy that AMC hosted a post-finale one-hour talk show about the scripted series, *Talking Bad,* filmed live at the finale party with series creator Vince Gilligan, several cast members, and Jimmy Kimmel, answering fan questions from Facebook. It drew a record 4.4 million viewers.

In its last season, *Breaking Bad*'s Facebook page had 6 million "Likes" and 23 million *Breaking Bad*-related interactions from 11 million users. The series' finale attracted 10.3 million viewers—up 300 percent from the previous year's finale. The social media engagement for *Breaking Bad* demonstrated social media's value in driving viewing and creating loyal audiences. The entire *Breaking Bad* socialized experience in its final season was about creating a satisfying closure to the acclaimed series.

"Fanboys" and "fangirls" of beloved properties and story worlds are so interested in the minutiae of a project that product news or promotional assets offer viral opportunities. Two days before the box art reveal for *Halo 4*, Xbox used it as a shareable social opportunity to keep fans feeling like insiders. They sliced the box art up into 32 pieces and seeded each piece across 32 popular social fan communities, challenging fans to cooperate and solve the puzzle together. Within a half-hour, the puzzle was solved; within an hour, *Halo 4*'s box art and the social puzzle was the top story on *Kotaku* and was then picked up by numerous game, entertainment, and news sites. The social media conversation tracking registered a 92 percent positive sentiment.

Socializing Fictional Worlds

Like their real-world celebrity counterparts, entertainment property's characters and story worlds offer huge opportunities for socialization, especially among comic book-inspired properties, big franchise films, and AAA game sequels.

For centuries, fictional characters have dominated children's storytelling. Young children do not distinguish between the real world and characters' story worlds, accounting for characters populating kids' entertainment and products. No surprise, these characters have migrated to social media. M&M's mascots, Mickey Mouse, Pokémon, Mario, and Clark Kent have huge social followings. Today, adults accept blurred lines between fiction and reality to enter narrative experiences and engage with characters on social media—from *Batman's* The Joker to *House of Cards'* Frank Underwood.

The release of *Marvel Super Heroes* characters on social media was the basis of Warner Bros. Games' *LEGO Marvel Super Heroes* videogame launch in early 2013, allowing

audiences to relate individually to the characters they loved and be immersed in a thriving community of fandom for all things Marvel and LEGO. The campaign used real-time social media listening tools to introduce the game's characters, support key announcements and the retail release, and engage fans. The team used social sites as portals to insert the characters into broader, real-time pop culture happenings. They created humorous photos with different *Marvel Super Heroes* characters commenting on different cultural conversations. There were postings for Thanksgiving, "Pass the Shawarma, Please" and the opening weekend of the *The Hunger Games*, "Shot arrows before it was cool."

By connecting the *Marvel Super Heroes* characters to pop culture, the *LEGO Marvel Super Heroes* Facebook page received 163 million impressions with 10.8 million Facebook users and 500,000 fans. Superfans loved it: "@_jesus_chris__Lego Marvel just made a *Pulp Fiction* reference. That's the single greatest thing ever. Thank you."

Fans of the award-winning UK to US phenomenon *Downton Abbey*—about the Crawley family and their servants living on Lord Robert Grantham's Downton Abbey estate—have set up *faux* Twitter accounts. Even Isis—Lord Grantham's cream-colored labrador retriever who appears in the series' opening title sequence from behind, waddling along with her beloved master—has her own fans. Her Facebook *Masterpiece* photo post received more than 7,000 "Likes" and she has her own fan-created Twitter account, DowntonLabby.

The author wished DowntonLabby a Happy Easter on Twitter in honor of Isis' iconic rear-view persona in the series' opening.

Today, film studios are creating immersive social media experiences with fictional universes. To launch the first *The Hunger Games* film in 2011 based on the moderately popular novels, Lionsgate harnessed the interests and values of its young target audiences to power a non-linear year-long social and digital media narrative experience.

The core narrative took place in the dystopic nation, Panem, formerly North America. Its wealthy and tyrannical Capitol required each of its 12 poor outlying districts to send one teenage boy and girl to compete against each other in The Hunger Games, a televised yearly battle to the death for the amusement of the Capitol's decadent citizens. Ignition's challenge was that *The Hunger Games* was a story about kids killing kids.

> *The strategic rationale for The Hunger Games was that we never showed the games, we never showed the violence that took place in two-thirds of the film. The campaign was everything before that and was deliberately designed to be a drip-feed of content so you could unravel things you hadn't seen about the world. And then your ticket to The Hunger Games was going and seeing all of the other stuff play out in the theater.*
>
> —**Chris Eyerman, creative director, 3AM; formerly transmedia creator for** *Prometheus, The Hunger Games, Arrested Development*

They brought the story's universe to life, juxtaposing a world of inequality and oppression in the 12 districts with a world of decadence and cruelty in the Capitol. The campaign allowed audiences to experience the Panem universe first-hand through its rules and constraints, creating mystery for new audiences and activating book fans with a new experience.

It began with a motion poster of a golden mockingjay pin on fire and a teaser trailer with a Twitter hashtag leading to "The Capitol—The Official Government of Panem" site, thecapitol.pn. There audiences could become citizens, receive job assignments, get ID cards, and learn about the bifurcated world. The Games were referenced in profiles of district victors and in mandates for all citizens "to watch the televised Games." A nearby ticket link led to Fandango, the real-world movie ticket site.

Each Panem district had its own Facebook page and Twitter recruiters encouraged audiences to join districts and run for mayor, rewarding them with Capitol clothing, exclusive communications, and recognition on social platforms. Alliances and battles played out on social media, mirroring the dynamic in the film's universe.

The campaign also provided sneak peaks of the decadence of Capitol citizens through fashion publication *Capitol Couture* (capitolcouture.pn/) on Tumblr. Capitol TV on YouTube allowed fans to experience Panem's state-run Capitol TV service. A new poster in 100 pieces was distributed across 100 Web sites. Finally, an HTML Capitol Tour experience allowed citizens to see new locations.

The campaign's Twitter account linked all the digital elements that together revealed that the Capitol was a twisted world of terror and decadence. Audiences never knew the film plot or The Hunger Games rules, but knew there was much more, propelling them to watch the *The Hunger Games* film.

The Hunger Games campaign issued more than 1 million ID cards, increased the Facebook fanbase by 3,000 percent, and generated 22 million video views. The film's $45 million mysterious and immersive marketing initiative, including traditional media, helped the film gross $673 million worldwide and boost the number of copies of the book in print from 9.6 million to 36.5 million.

On television, HBO blended the real world and the fictional universe of *Game of Thrones* for their social story to promote the Season 4 premiere. The previous season's final *Game of Thrones* episode, "Red Wedding," killing off some of the show's most beloved characters in a bloodbath, was HBO's most social show in its history. The campaign, created by 360i, capitalized on the vehement conversation about the most despised character on all of social media, King Joffrey Baratheon, and sustained it off-season. It mixed the emotion of hate for the young king with the socially-viral technique of *Comedy*.

HBO launched an irreverent social media roast of the program's reviled ruler on Twitter, Instagram, Vine, and Facebook using the hashtag #RoastJoffrey. Superfans, citizens such as Arya Stark and Hodor, stars such as Maisie Williams and Kristian Nairn, and even real-world brands spewed their venom. The *Game of Thrones* Twitter account hosted the roast, the hashtag tagged the roast content, and the Web site, RoastJoffrey.com curated the content. The campaign garnered more than 40,000 tweets, including @Charmin's, "There are some people so crappy even we won't go near them. #RoastJoffrey #tweetfrom-thethrone." Rival network @NBCHannibal chimed in, "#RoastJoffrey? Sounds delicious." The social currency of the campaign demonstrated the degree to which audiences and other brands would cross that reality-fiction line.

With diminishing attention spans, audiences may be more likely to participate in shorter experiences such as *Game of Thrones*' roast than in multi-month campaigns such as *The Hunger Games*. Hybrid campaigns may emerge, with multiple stand-alone engagements that together add up to something bigger.

Social media and transmedia are perfect bedfellows, allowing organic communications with audiences about real-world and fictional media universes. Social media creates interest in new properties among potential fans in various niches and amplifies existing fandom for film franchises, ongoing TV series, and game sequels.

What rises to have social currency is like the process of natural selection. In evolutionary theory, the changing environment renders some variations in traits more advantageous; in the current media landscape, the changing appetites and tastes of audiences render some new ideas or innovations more engaging. So media makers and marketers should keep mutating, that is, creating new content to see what catches on.

Transmedia has always been a process of exploration, and it still is. X Media Lab has an expression, "Climb one mountain, climb another." For me, that's absolutely what this is. It's about constantly being in the space and seeing what's bubbling up and responding. It will continue to change because that's how the world works now.

—Ingrid Kopp, director of digital initiatives, Tribeca Film Institute

Author's Anecdote

Creating a Meme for *Transmedia Marketing*

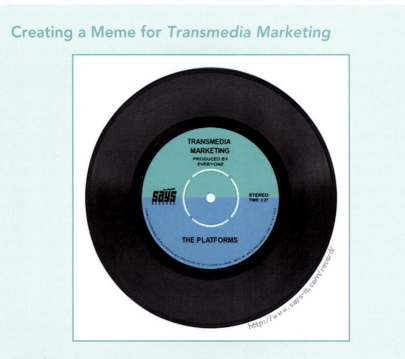

Created on www.says-it.com

A meme for *Transmedia Marketing: From Film and TV to Games and Digital Media*.

Interactive Content and Marketing

In 2004, Burger King quietly seeded subservientchicken.com (conceived by Crispin Porter + Bogusky) among select audiences. On the site, a man in a chicken costume performed more than 300 commands that audiences typed into a field—from blow your nose to dance the Riverdance—using pre-recorded footage that mimicked an interactive Webcam. The chicken metaphorically acted out the tagline for Burger King's new Tender Crisp sandwich, "Get chicken just the way you like it."

When told to perform sex acts, take off his mask, or do anything the Subservient Chicken considered offensive, he shook a scolding chicken finger into the camera. When told to eat food from rival McDonald's, he placed his finger down his throat. The Subservient Chicken delighted audiences with the humorous site going viral, receiving more than 1 billion hits. Visitors spent an astounding average of six minutes playing on the feature.

Fast forward to iPhone's voice-activated assistant, Siri, that truly interacts with audiences by searching the Web, dialing phone numbers, and drafting e-mails, making *2001: A Space Odyssey*'s Hal and *Prometheus*' David 8 feel eerily real.

Interactivity acknowledges the value of audience participation in communications. Social media ratchets up audiences' interactivity with content. Viral ARGs, interactive storytelling, and game-like features can create even more highly-participatory audience experiences.

Internal vs. External Motivations

Audience engagement and interaction derives from two motivations—*internal* and *external*. Internal is the intrinsic value and satisfaction of participating because of a deep emotional connection to the media property. External is the transactional value of receiving a concrete reward for doing something, but thereafter audiences may walk away.

> *The real power comes when you tap into intrinsic motivation—that is, when people are doing things because they care about the goals or outcomes they are working to achieve, because the causes they are working to support are meaningful to them. Fan activism works much more in this way: it works by helping people to understand these issues in new ways which may deepen their personal motivation because it draws meaningful connections between these causes and things people already care about in their everyday lives.*
>
> —Henry Jenkins, provost professor of communications, journalism, and cinematic arts, USC

Audiences who watch PBS' *Frontline* or *Antiques Roadshow* year-round and are members of their local PBS stations are internally motivated. Audiences who watch a single PBS pledge program, *Doo Wop 50* and buy the DVD, but don't watch other programming, are externally motivated. They've both engaged with PBS and shelled out money, but for different reasons and with different levels of engagement. Both audience interactions offer value, but internally-vested audiences are much harder to earn and are more loyal in the long run.

Alternate Reality Games

Nothing demonstrates the level of audience investment in a property more than Alternate Reality Games (ARGs), which connect fictionalized worlds and audiences' real worlds.

> *The ARG component of transmedia is like a rock concert. It requires a lot of people all at one time to give up their normal lives and get involved in this thing right now because it's happening right now. And that's a very high bar to ask for an audience to do.*
>
> —Jordan Weisman, transmedia pioneer, founder of 42 Entertainment and other innovative entertainment companies

The tangible rewards of ARGs—new content, name listed on a leader board, or tickets to a premiere—seem miniscule compared to the commitment required. But for superfans, the emotional reward of participating and achieving is spectacular. ARGs demonstrate deep, internal audience motivation around gameplay or cooperative quests.

The genre-defining entertainment ARG, Microsoft's "The Beast" for Steven Spielberg's 2001 futuristic film, *A.I. Artificial Intelligence*, harnessed collective audience intelligence to uncover a mystery set in a future universe (profiled in Chapter 31, "Transmedia Marketing Case Studies"). Another ARG developed by 42 Entertainment (the creators of "The Beast") was "Why So Serious?" for Warner Bros.' *The Dark Knight*. It also joined participants in a common goal. The 2007 film's tagline, "Why So Serious?" gave a nod to the film's protagonist, The Joker, who had not appeared in a *Batman* film for almost 20 years. "Why So Serious?" connected the fiendish character to audiences' real worlds, engaging fans with Web sites and real-world sites that fleshed out the fictional Gotham City universe. Appropriately, it launched on April Fool's Day—14 months before the film's release.

The Joker's Web site, WhySoSerious.com, had a "to do" list for audiences that grew as the film's release approached. Superfans who completed these tasks were rewarded with communications from The Joker, leading them through elaborate scavenger hunts with teaser videos, Web sites, real-world bakeries, and bowling alleys. These steps further rewarded die-hard fans with working mobile phones that eventually sent them texts about hidden online games and clues. This multi-month campaign culminated in free tickets to pre-release screenings of the film. The "Why So Serious?' campaign engaged more than 10 million unique players in 75 countries in a highly-interactive game experience with the ultimate reward of direct interaction with The Joker.

Other films such as *Cloverfield* and *Prometheus* have effectively used highly-immersive and participatory elements or ARGs to engage audiences in film releases. (See the bonus *Prometheus* case study on transmediamarketing.com).

Dexter's two-month long "Infinity Killer" ARG in 2010 kept audiences rapt in the *Dexter* story world (Dexter Morgan is a serial killer who is a forensic expert working for Miami PD) leading up to the series' next television season. Showtime kicked off the ARG at Comic Con, sending audiences to scvngr, a location-based mobile game tracking murder victims, which was simply the "rabbit hole" for the larger ARG. They could join forces with the Serial Huntress, a former FBI agent with her own Web site and YouTube updates. Audiences could crowdsolve the elusive Infinity Killer's crimes by investigating crime-scene clues from his series of grisly and creative murders. And they could enter the serial killer's creepy world through riddles, therapy sessions, and trophies from his kills.

Through Twitter, Facebook, and online clues, hidden geographic coordinates to real-world locations, location-based check-ins, and phone numbers, players were led to the ARG's finale, a live-streamed face-off between the Serial Huntress and the Infinity Killer. In one more surprise twist, they had to decide which of the two characters die. *Dexter*'s season premiere a few days later enjoyed its highest ratings to date.

Game studios also create ARGs to heighten anticipation around new game launches. In 2004, Microsoft commissioned 42 Entertainment to launch *Halo 2*. Its "ilovebees" campaign began with jars of honey sent to select ARG devotees and a subliminal message in a *Halo 2* trailer—both leading audiences to the ilovebees.com Web site. But something was amiss with the bee lovers' Web site. It had been hacked by a mysterious life-form that had invaded Earth, the Covenant.

The ARG created a "hive" of participants to solve puzzles, such as identifying GPS coordinates and time codes that led to real-world locations with ringing payphones and commands to record audio. A series of solved puzzles unlocked audio log updates on the site that, pieced together into a six-hour broadcast, revealed that this intelligence had been stranded on Earth and was trying to put itself back together. Through unexpected techniques and a breakthrough storyline, the ARG connected audiences with the *Halo 2* universe. The "ilovebees" experience captured the attention of 3 million players, created major buzz, and drove sales of *Halo 2* to $125 million on the first day of its release.

Many other games have employed ARGs for their releases, including *Gun*'s "Last Call Poker," *Call of Duty: Black Ops*' "GKNova6," and *Portal 2*.

Interactive Storytelling

Interactive storytelling internally motivates audiences to connect to entertainment brands, both through demanding ARGs and shorter online narratives. In interactive storytelling, through interaction with content and platforms, audiences influence the storyline by guiding the protagonist's actions or acting as the overall director of the experience.

> *Transmedia and interactive storytelling explore the relationship between technology and story. There's been a real shift in rethinking what a film is. It doesn't necessarily need to be a film or video. When you think about the Web and social media as the project itself, not just as a way to support a linear film, then storytelling kind of pops.*
> —**Ingrid Kopp, director of digital initiatives, Tribeca Film Institute**

For AMC, Playmatics created several stand-alone online and mobile interactive graphic novel games that allowed audiences to become key characters in hit dramas, *Breaking Bad* and *The Walking Dead,* exploring their story worlds and determining the narratives' outcomes.

AMC wanted to create an interactive narrative brand extension of the Breaking Bad series to reach new audiences and provide narrative content. Our intent as game designers was to build an interactive story that was part of the Breaking Bad universe and leveraged the power of the brand to create an engaging experience.

—**Nick Fortugno, chief creative officer, Playmatics**

In *Breaking Bad: The Interrogation,* players could become DEA Agent Hank Schrader and interrogate a suspect who witnessed a suspicious fire in the basement of a church. As Hank, players grilled the only witness, weasly Hadley Berkitz, who volunteered at the church and did the bookkeeping to uncover a sinister secret. Players were presented with sets of dialogue options (in comic book style) to choose from that were hard-hitting or oblique. The goal was to get the suspect to give up evidence (following a dialogue tree) to uncover more information without the suspect lawyering up, which ended the game.

Courtesy AMC Network Entertainment LLC

AMC's *Breaking Bad* interactive narrative brand extensions. (Top) *Breaking Bad: The Interrogation*; (Bottom) *Breaking Bad: The Cost of Doing Business.*

The Walking Dead: Dead Reckoning was a browser-based online and mobile game that combined classic point-and-click adventures with motion comics, borrowed from the TV show and Robert Kirkman's original comic series. The game allowed players to be Shane Walsh as the zombie outbreak happens, requiring them to make key decisions to survive and protect others from the zombies.

Interactive storytelling can also move audiences across storytelling platforms—from film, TV, and online to game, book, and the real world. For the animated reality program *Total Drama Island,* Cartoon Network created an interactive online game version of the on-air challenges, *Total Drama Island: Totally Interactive.* Audiences could create avatars to compete in each episode's challenges. The network found audiences were playing the interactive game while watching the episode.

Audiences' digital interaction can write the TV script for reality television. In the fall of 2011, *Top Chef* used foodie audiences' intense connection with the award-winning Bravo reality program's contestants and outcomes to create an interactive digital series, *Last Chance Kitchen*. The online and mobile series combined on-air and digital assets to transform the linear cooking contest program into a two-way transmedia conversation in which fans interacted directly with the contestants and judges. *Last Chance Kitchen* allowed the eliminated chefs to cook against each other for judge Tom Colicchio to earn a chance to return to the television series finale (unbeknownst to the chefs still competing on the TV series).

Last Chance Kitchen was available online and on mobile platforms, Bravo's Now app, VOD, and EST. More than 50 percent of *Top Chef's* on-air audience participated in *Last Chance Kitchen.* Bravo also integrated the experience with its other social engagement efforts—awarding points for online activity. The *Top Chef* episode revealing Beverly's return to the on-air series because she won *Last Chance Kitchen*, garnered some of the top ratings in the Austin, Texas season.

The following year, Bravo gave audiences a direct say in granting that "last chance" through its online "Save a Chef" competition. The chef with the most audience votes won a slot on *Last Chance Kitchen.* That heightened role for audiences created a continuous multi-platform loop for audience engagement, which has further propelled the successful *Top Chef* franchise.

Books also employ interactive cross-platform elements. Scholastic's *The 39 Clues* is a series of 10 children's adventure novels written by various authors that chronicle the lives of a boy and girl who are on a quest to find 39 clues that reveal their family's secret power. Each book has hidden clues that send them to collectible cards and interactive online games at the *39 Clues* Web site. The first book series débuted at #1 on the *New York Times* bestseller list and the highly-popular book collection has created tie-in merchandise—cards; a board game; an iPhone app, *Madrigal Maze*; and a Steven Spielberg film. *CSI* creator Anthony Zuiker's adult horror novels, the *Level 26* series, have code words that lead fans to Level26.com's interactive cyberbridges with video clips that bring scenes to life or reveal backstory. Together, the clips create a longer film.

Gamification

Gamification, the use of game mechanics—competition, achievement, status, self-expression, altruism, and closure—is being used widely in marketing and social entrepreneurship. Gamification appeals to audiences' core drivers and desires to motivate them to solve problems or complete challenges. It incentivizes behavior or participation on Web sites or apps with mini-games or check-ins, by providing audiences with giveaways, points, leaderboard status, or downloadable content. It also may connect to media promotions with trivia contests, stunts, or interactive events, which offer prizes.

Audience interactions with gamified content are usually motivated by external factors related to the reward. There is an explicit *quid pro quo* in gamification. Perhaps the property receives media impressions in exchange for a chance at a trip. There's usually a cost-benefit analysis in audiences' minds as to whether to participate. The call-to-action (the "ask") has to be extremely easy or fun in order for audiences to participate.

> *The base level of gamification is to provide a compulsion to make you feel good about doing something by giving you a point or an achievement and making you smile. But that's not as powerful a motivator as actually providing a completely different context for what you're doing than whatever it was that you were doing already.*

> —**Andrea Phillips, transmedia creator**

These transactional activities usually operate over the short-term and require the promise of immediate gratification. But they can be valuable in raising awareness of a property and lead to other interactions that may create deeper audience engagement.

Consumer brands, entertainment properties, and causes gamify content. American Express' Rewards program, Jackson-Kendall's wine connoisseurship app, the profile completeness progress bar on LinkedIn, the documentary *Half the Sky*'s Facebook game, McDonald's and Hasbro's *Monopoly* sweepstakes, state lotteries, and flash mobs all use gamification concepts.

For the launch of *Despicable Me 2*, the Branding Farm helped Universal use the irreverent Minions in a multi-channel, cross-device digital game that engaged audiences in both the fictional Minion and real-world NBCUniversal universes. *Missing Minions* began with a special video invitation from Steve Carell urging audiences to play. The premise: the Minions were missing and one Minion would be released every day at noon on one of NBCUniversal's 27 Web sites, from June 10 to June 30 leading up to the film's premiere. At the MissingMinions.com site, a calendar showed the shadow of the Minion that would appear each day and provided a clue about the NBCUniversal online property where they were last seen. Audiences could scour the site to find the mischievous creatures and "bring them back home" with a simple click and they would appear on the calendar.

The first Minion appeared in a photo bomb in a *Real Housewives of New Jersey* Facebook cover photo. Minions popped up for three weeks on Web sites and social posts in unexpected and comical ways, from the golf course on an NBC Sports photo to *Daily Candy*. Each "rescue" equaled an entry for a trip to the Universal Resort in Orlando. Fans were randomly rewarded with Fandango tickets. The campaign was supported by on-air promos on NBC Universal's channels and extensive social media chatter. On its opening weekend, *Despicable Me 2* raked in $142 million at the box office, one of Universal Pictures most profitable films. And millions of fans sampled NBC Universal's 27 online sites.

CW's *Gossip Girl*, the television program based on the popular teen book series, has demonstrated the power of simple rewards to incentivize audiences. In 2009, before Twitter, the AMP Agency seeded a promotion on *Gossip Girl*'s Twitter profile to launch an online series, *The Private*, and promote a fan Web site. It encouraged users to retweet a special message in order to win an 8GB iPod touch. The message was "Gossip Girl loves #privatetheseries. Watch it on Teen.com/Private http://bit.ly/iyUn3 retweet for your chance to win an iPod touch!" The campaign's goal was to secure spots on Twitter's "Trending Topics." This easy Twitter contest launched #PrivateTheSeries to the top "Trending Topic," *Gossip Girl* to number four, and *Teen* to number five within 15 minutes. It sent more than 14,000 new unique visitors to the Teen.com/Private page and boosted *Gossip Girl's* Twitter followers by 10,000 in one day.

The USA Network, the top basic cable network, gamifies engagement to create "digital loyalty" and promote its series line-up from week to week. The network rewards audiences for watching videos, playing games, and creating and sharing content on social platforms with points that they can redeem for tangible and virtual rewards. For *Psych*, the network created a *Club Psych* online game. It appealed to audiences by "Calling all Psych-os" to join the club and earn points. Online, audiences created profiles, checked weekly challenges, watched videos, and played mini-games; and on social media, checked out leader boards, friended other club members, and spread the word about *Club Psych*—to rack up points. USA Network saw a 130 percent jump in page views and a 40 percent increase in return visits with the *Club Psych* game.

Mobile apps are excellent gamification devices. *USA Today* incorporated the mobile trivia game *Trailerpop* into its movie trivia game and engagement iPad app. In the spirit of "Listen and Win" radio promotions, it allowed audiences to play a movie trailer while posing trivia questions. Gameplay was incentivized with sweepstakes, such as winning free movie tickets. These contest ads with studio and branded partners have delivered up to a 16 percent click-through rate.

Nickelodeon Digital created the free *Nick* app, a one-stop shopping TV network that allowed kids to watch and play Nick through interactive content that supported the full Nickelodeon on-air line-up and that wasn't seen on television. With new content daily,

audiences could explore more than 1,000 pieces of Nickelodeon-themed content, including short-form videos of original skits, sketches and comedic bits, behind-the-scenes clips and photos from Nick stars and animated characters, full episodes, polls, and games.

The Cartoon Network's free *Cartoon Anything* mobile app featured original 15-second video content, games, trivia, and polls, delivering a blend of lean-back and interactive elements. Audiences could swipe through selections and "Like" content, providing feedback that CN could monitor to assess the popularity of new ideas.

Entertainment check-in apps such as Viggle, Shazam, IntoNow, Zeebox, IMDb, Movies by Flixster, gamerDNA, Raptr, and Goodreads use game mechanics concepts such as badging and rewards with brand partners. Many of these apps use gamification to incentivize audiences' social engagement with entertainment properties. They allow users to "check-in" with entertainment properties by "Liking" them or chatting them up with their friends, and they broadcast their "check-ins" on other social platforms. Audiences receive incentives such as points, virtual stickers, discounts, and recommendations on other entertainment. AMC created a "*Mad Men* Trivia Challenge" on the former tvtag based on the era in which the popular series was set and on the show itself. The reward, 40 percent off the *Mad Men* Blu-ray or DVD. Similarly, Disney used stickers as incentives around the promotion of the film *Tron.*

The game industry continues to perfect audience interactions with game mechanics. Xbox Live, the online multi-player gaming service, found ways to use gamification concepts to further enhance its interface. Microsoft added achievement points and visible leaderboards to the service to encourage players to earn Gamerscores by completing specific tasks or actions. *Halo 2* was the first game for Windows to feature achievement points. This incentive has encouraged players to interact with game titles they otherwise might not have played to increase their bragging rights. Other game brands and platforms have followed suit, highlighting points, leaderboards, and gamer profiles.

Books too have energized fans with game theory. *Harry Potter*'s Pottermore.com, a joint venture of J.K. Rowling and Sony, offers an immersive experience around the *Harry Potter* books with interactive features and games such as the House Cup event or challenges to earn a Rematch Badge. The site also provides new information from Rowling's extensive collection of notes.

Interactive and online content, amplified by social media, have the ability to transform audiences' relationships with brands from short-term transactional experiences to long-term brand-building experiences. When the communication is truly two-way, the audience can interrupt and steer the conversation. If you have invited audiences to engage with your film, TV program, game, or digital media property, then you should listen to what they have to say.

What makes a successful brand, ad campaign, or title sequence hasn't changed fundamentally. But how it gets expressed certainly has. It's now basically leaving the traditional linear broadcast medium and becoming something interactive. There's a physicality to experiential design that you have to acknowledge when you're creating—a one-to-one conversation. You're giving up a certain amount of control in the digital interactive space.

—Mark Gardner, creative director, SYPartners

But that doesn't mean you must relinquish all control. You can plan many aspects of your project's public image, story, and message through traditional marketing by communicating your brand archetype, targeting key media, choosing your events, and creating advertising and trailers. Then you can invite audiences in to participate with and shape your image, story, and message further through digital marketing by developing online, social, and interactive content and experiences.

When traditional and digital marketing techniques are combined and activated across multiple media platforms, they provide a perfect storm of top-down and bottom-up content creation and marketing that ring true to and satisfy your audiences. That's your overall goal with transmedia marketing.

PART IX

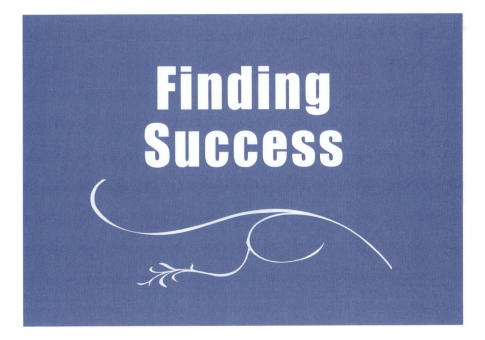

Finding
Success

Media-fueled Social Impact

Now that you've learned the tools of the trade for engaging audiences around your film, TV program, game, or digital property, you're ready to bring your project to the end zone. But before attending to the business and practical aspects of your project, step back and think about your responsibility to society.

Can your project or your work do more than entertain audiences, such as raise awareness of a critical issue or catalyze social change? Do you feel a deep sense of moral responsibility around social issues? These are assessments only you can make, but you will make a more informed decision if you understand what a media-fueled social impact campaign is.

Transmedia is both emotionally and socially transformative. It offers opportunities to combine the techniques of good *storytelling*, the proven methods of *content creation* and *content marketing,* and the principles of sound *social impact campaign* design into a holistic, ongoing media-anchored campaign for an issue or cause.

A Greater Purpose

Promoting social good is a big part of what it means to be human. Humans are driven by both altruistic and selfish impulses. Altruism is imbued in the spiritual, political, cultural, and biological aspects of daily life. We take care of our own not only because it's the right thing to do, but also because we might need others to do the same for us some day.

The more people are personally connected to need, the more likely they are to feel the pull to help. Hurricane Katrina in Louisiana, attracted more US goods, money, volunteerism, and media attention for the victims than most natural disasters occurring outside of the US. Cancer programs are more likely to secure support from people whose circle of family and friends have been touched by cancer.

The Dedication of Institutions

Promoting social good is so central to modern human existence that it is institutionalized. Government entities, non-governmental organizations (NGOs), and corporations are all engaged in social efforts.

Government is a major purveyor of social well-being through programs and expenditures for health, welfare, and education. US spending in this arena is one of the lowest, 26th among 29 developed nations, and the US has the third highest poverty rate. Still, the US Department of Health and Human Services (HHS) oversees a budget of more than a trillion dollars for 11 government agencies including the FDA, CDC, NIH, ACF, and CMS. In addition, there are agencies dedicated to education, science, the environment, the arts, and the humanities.

Non-governmental organizations also promote social good, embracing charitable, service, participatory, and empowerment orientations. Usually charities and foundations are not-for-profit entities that are granted a 501(c)(3) tax exemption status from the IRS based on their charitable, religious, educational, literary, scientific, or other social purposes. Charitable NGOs administer money and services directly to recipients, receiving funding from individuals, foundations, corporations, and government. Foundations fund or support charitable organizations' efforts, providing $42 billion in grants yearly to social and educational causes.

Giving back is a big part of corporate America's heritage—from Ford and Carnegie to Gates and Skoll. US corporations spend $2 billion yearly in **Cause Marketing**—when a for-profit company or brand raises awareness, money, or consumer support around a social issue—and another $14 billion in **Philanthropy**—giving money directly to a cause. Many companies espouse a *double bottom line* philosophy—the pursuit of the twin objectives of making money and promoting social good through a company's day-to-day business—from Toyota's ecofriendly Prius product to Panera Bread's retail and community initiatives. Pioneers Ben & Jerry's and Starbucks integrate **Corporate Social Responsibility** programs (CSR) into their DNA with self-regulatory practices around free trade, environmental footprint, sustainability, and ethics.

You can partner with these committed institutions and organizations that are working from the top down on improving the health and welfare of others.

The Passion and Will of Audiences

But for any issue or cause to get political, financial, and philosophical support, it needs traction with public audiences. Like content creation and engagement, social change also happens from the bottom up. Niche audiences are always passionate audiences, whether about science fiction or ADHD.

Participatory fan culture is a key ingredient of inspiring audiences to social action. Some 88 percent of Americans give to social causes, with individuals being more generous

than foundations, corporations, or government entities. Two-thirds of audiences worldwide are socially-conscious, preferring to buy products and services from companies that have programs to give back. Socially-conscious audiences also care about resolving the world's woes directly through policy change, cultural movements, and volunteerism. In 2011, 64.3 million adults volunteered 15.2 billion hours of service, worth an estimated value of $296.2 billion.

When human passion fuels social causes, the outcome is extraordinary. In 1986, to raise awareness of the hungry and homeless, more than 7 million people across 16 states each donated $10 and joined hands to make a Human Chain for Charity. Add social media, and the impact is exponential. In 2012, Susan B. Koman pulled funding to Planned Parenthood, ostensibly due to conservative political pressure around birth control. Because the story torched social platforms, within 72 hours of the announcement, Planned Parenthood raised five times the money lost from Susan B. Koman and the engineer of the policy change was ousted.

For a cause to take off, it must reach beyond niches and inspire broader audiences. Someone or something needs to provide that reach and tell audiences the story.

The Power of Media

Nothing raises awareness or creates deeper understanding of an issue or a cause than storytelling through media. Archimedes said, "Give me a place to stand, and I will move the world." Media can be that place to stand. It can have a higher purpose. Since the first cave drawing or moving frame, media has had the power to influence and transform society. Media has affected Americans' perception of truth and justice—from biting episodes of *All in the Family* in the 1970s to the "live" Gulf War in the 1990s. Across a half a century, media has continued to be a relevant social influencer around the environment

In 1962, Rachel Carson's *Silent Spring*, first published as a *New Yorker* serial and later as a book, caused a public uproar, calling for a ban on longer-lasting pesticides such as DDT. The spunky conservationist's treatise raised consciousness and dialogue around environmentalism and sparked action—environmental legislation and, eventually, the creation of the EPA. Edward R. Murrow's 1960 Thanksgiving Day broadcast of the documentary, *Harvest of Shame,* exposing the underbelly of the American Dream through the plight of migrant workers, gave rise to national and state reforms to provide healthcare and educational facilities for farm workers and their families.

In 2006, Participant Media's *An Inconvenient Truth* created a tipping point in Americans' social awakening around climate change. The film had several major things going for it. It was preceded by a decade-long heated public debate about Kyoto and the climate effects of burning fossil fuels, and it had Al Gore as its messenger. *An Inconvenient Truth* was the perfect storm of content and context, creating a critical advancement in environmental understanding. But media hasn't always been harnessed to promote social

good. Hitler commissioned Leni Riefenstahl's *Triumph of the Will* as a propaganda film for the Third Reich. For better or worse, media provides a powerful platform to inform, influence, and motivate.

Like corporations' double bottom lines, your media project can have also have multiple goals—to entertain *and* transform the world.

> *The movies we make all touch on contemporary social issues with the goal of helping inspire people to become active in making positive change. But people go to the theater to be entertained by emotional stories, not be taught lessons. Our movies have to compete as entertainment just like any others. If there is medicine there, the key is to hide it in the popcorn.*
>
> —Jonathan King, executive vice president, narrative film, Participant Media

When times were simpler and the media landscape was uncluttered, the mere distribution of media projects with a mission message was enough to effect positive change. But in this multi-plexed cultural landscape, the TV broadcast, film premiere, or book launch is rarely enough. To catalyze social change through your media project, you must also develop a strategically-designed, measurable social change campaign around it and fire it up on multiple media platforms.

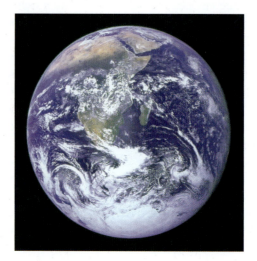

"The Earth Seen from Apollo 17" by NASA/Apollo 17 crew, Harrison Schmitt or Ron Evans; Licensed in the public domain via Wikimedia Commons

"The Blue Marble" photo of the Earth taken from the Apollo 17 mission signifies our profound responsibility to the environment and mankind.

Transmedia Social Impact Campaigns

No doubt, audiences of entertainment and media properties are hugely passionate. Fans saved *Star Trek: The Original Series* from NBC's cancellation after two seasons in 1968, inspiring Paramount Studios' first *Star Trek* movie. A fan-organized Facebook online petition and e-mail campaign kept *Friday Night Lights* on NBC for five more seasons.

The key to transmedia social impact campaigns is to harness the power of media narratives to activate audiences' passion to act for the benefit of social and civic good. The power of media in this equation lies in its ability to raise awareness, deepen understanding, and stimulate participatory culture.

> *Transmedia has the opportunity of creating awareness horizontally, reaching several audiences at once and engaging them in proactive activities to make change . . . Through its narrative, it is possible to inspire change makers and trigger proactivity.*
>
> —**Nicoletta Iacobacci, curator, TEDxTransmedia**

Media-fueled social impact campaigns are especially powerful for younger audiences who feel disconnected from government, corporate, and religious institutions and are more likely to view media properties as their chief "institutional" influencers, appropriating popular culture narratives and characters as their social and moral beacons.

The *Harry Potter* Alliance is a coalition of *Harry Potter*, *Dr. Who*, *Star Trek*, *Firefly*, and *Glee* fans that uses story and fandom to inspire social change. Even though it was not sanctioned by the film, the Alliance "newsjacked" the hype around *The Hunger Games* to sponsor "Hunger Is Not a Game" to raise money for Oxfam. Without the motivation of the myths and narratives of the *Harry Potter*, *The Hunger Games*, and other fictional universes, these audiences might not have become real-world social activists.

The Theory of Change

How do social impact campaigns create awareness, affect attitudes, and inspire audiences to rally around an issue? Through social change movements based on the principles of the Theory of Change. Used widely in economics, sociology, and psychology, the Theory of Change outlines the process of change as chronological, causal linkages in an initiative— the outcomes pathway—that leads to long-term goals. Because change is a process, not an event, sequential triggers and motivations influence individuals' perceptions and behavior around an idea, cause, or even media project. Change can take many forms, including individual attitudinal or behavioral change, social or cultural transformation, and institutional and policy change.

Whether individual or collective, the process of change is the same. There are several models of behavior change, but a widely-tested and applied model is the Transtheoretical Model (TTM), which presumes that at any given time, a person is in one of five stages of change: *pre-contemplation*, *contemplation*, *preparation*, *action*, and *maintenance*. Individuals move from one stage to the next, with each stage preparing them for the next stage. Hurrying or skipping stages is likely to result in complete disengagement.

Suppose your personal goal is to improve your health through a better lifestyle. A startling doctor's visit might move you quickly from *contemplation* into *preparation*— putting a plan in place. A good plan has specific objectives: "I'll bicycle 30 minutes a day" is better than "I'll exercise more." It should limit the number of objectives to avoid diffusing your finite attention span and willpower. So set one objective around each key area: exercise, nutrition, and sleep. Plans also set up practical devices to help you overcome barriers. If you're prone to snacking while watching TV, then have water or a healthy snack nearby. Now you're ready to *act*—walk daily, eat carefully, go to bed early—which requires a great deal of motivation. But action gets easier the more you receive the rewards of having more energy, clothes fitting better, feeling refreshed, and getting compliments—helping you reach your specific objectives and *maintain* desired behaviors.

These principles can also be used in transmedia-anchored initiatives to catalyze measurable social change. Azure Media (the author's company) has applied the Theory of Change to the design of social impact transmedia projects that inspire audiences to participate in action-oriented social solutions. This approach harnesses the power of transmedia platforms and storytelling, strategic partnerships, and affinity groups to activate human will, creating social change from the top down (among influencer audiences) and the bottom up (among public audiences).

This Awareness-to-Action Ripples model of media-fueled change demonstrates how audience participation in a movement creates a "Ripple Effect," where small motivations and acts can contribute to big change. The transmedia narrative triggers outwardly-expanding ripples representing stages of change—from awareness to action—each with a deeper level of audience engagement around the media project and its associated issue. Ongoing, strategically-designed content propels audiences outward to the next ripple, further broadening the campaign's impact.

The process begins with audiences' exposure to a captivating transmedia narrative around the social issue. This sets in motion the ripple effect of the engagement process, raising audiences' *awareness* and amplifying their *understanding* of that issue. Similar to saturation in advertising, frequent and ongoing interactions with these narrative messages affect audiences' attitudes, predispositions, belief systems, and behaviors, priming them for deeper participation.

Awareness-to-Action Ripples™

Courtesy of Azure Media; Design by Elles Gianocostas

The Awareness-to-Action Ripples is Azure Media's media-fueled impact model of the Theory of Change.

When the narrative is combined with cross-platform content that motivates participation, audiences move into deeper *engagement* and, ultimately, *action* around the project and its cause. Audiences engage by having a two-way conversation around your content. And once emotionally engaged, audiences act because of compelling, research-tested messages encouraging them to participate in simple, concrete, and proven **Calls-to-Action**. They include sharing content on social media, signing an online petition, donating money, contacting an elected official, attending an event, volunteering time, or spearheading a local effort. The transmedia project activates a sense of agency—that audiences can and should act—and the social impact campaign points them toward beneficial actions.

Once audiences directly engage with the project, they receive emotional and tangible rewards through more content, which inspires them to further engage in deeper actions. The project offers various calls-to-action on a sliding scale of engagement—ranging from simply clicking on a link to hosting a fundraising event. Therefore, there's a place for everyone in the transmedia impact campaign no matter his or her level of engagement or willingness to act. All of these actions feed into a few carefully-crafted, measurable objectives.

Moving public and influencer audiences outward through these consecutive ripple stages catalyzes action that can seed authentic, measurable, and sustainable behavioral, social, and policy change.

Translating Action Into Impact

Creating measurable change and impact is the ultimate goal. While activism is great, it doesn't necessarily translate into social change. Collectively these actions must create a critical mass of support or pressure that delivers desired outcomes and impact. So the key to social impact campaign design is to establish measurable objectives that deliver social outcomes, which over the long haul, deliver true impact. These results are much more than your tactics, activities, or outputs. To understand the difference, look at them through the lens of a hypothetical transmedia project about outbreaks of vaccine-preventable diseases in the US.

Outputs are usually *simple, short-term activities*, such as materials disseminated or Web page views, which can be expressed by metric <u>results</u>. In part, they're controlled by your *internal* efforts and are quantifiable aspects of your project's accountability. An Output for your vaccines project might be "*An outreach partnership with the American Academy of Pediatrics disseminated 500,000 materials in 10,000 pediatrician's offices in five key outbreak states.*"

Outcomes are about *complex, long-term results* of your efforts that deliver <u>value</u> to the overall goals or audiences of the project. They're affected by *external* forces and require planning to ensure they're measurable. An Outcome of your project might be "*A 2 percent increase in measles vaccinations in those five outbreak states.*"

Impacts are even *more complex, long-term effects* that are about creating meaningful <u>change</u>. An Impact of your project might be "*A 6 percent decrease in the incidence of measles in those states.*"

To create real positive impact, the energy of those passionate audiences must be channeled into strategically-designed campaigns with proven calls-to-action leading to measurable outcomes and impacts. So your impact plan must be reverse-engineered. The calls-to-action must funnel awareness and support into fulcrums, which when they reach a tipping point—enough money raised or enough pressure on critical influencers—create desired outcomes and impacts. The tenets of behavioral change impel audiences to act, but sound strategy ensures those actions add up to true social impact or change.

You possess key skills for developing measurable social impact campaigns through your knowledge of content creation and marketing that engages audiences around your project. Now, you're also engaging audiences around a social issue or cause. So, direct your marketing plan's goals, objectives, strategies, messaging, partnerships, public engagement, tactics, and calls-to-action toward the social issue, as well as your project.

Most successful campaigns have some key elements in common:

- Passionate spokespeople
- Audience ambassadors
- Awareness-raising activities

- Organized calls-to-action efforts or fundraising
- Iconic symbols for the cause
- Ongoing marketing
- A commitment to stay in the field for the long haul

Transmedia social impact campaign design follows the marketing plan outline, but should also include:

- Advisory Board—bring on experts on the issue to ensure that your approach, content, messages, objectives, and calls-to-action are appropriate. The board lends credibility to the project and helps attract the right partners and funders. Board members can also serve as spokespeople for the project.
- Spokespeople—enlist high-profile, genuine, and passionate ambassadors who will push the project and cause with their fans, press, and others in their sphere of influence. They can be policy makers, experts, celebrities, or other influencers who join the project's existing stable of spokespeople of producers, non-fiction subjects, and cast and crew.
- Calls-to-action—develop concrete "to dos" for your influencer and public audiences that are clear, proven, and doable. If your project evokes an emotional response with your audiences—outrage, moral responsibility, and hope—then your calls-to-action can activate a sense of agency—a feeling of power over those emotions by acting. You must make a compelling case to motivate audiences to act and then reward them. These actions or outputs should add up to measurable outcomes that create real social impact.
- Evaluation—ensure that the goals and objectives of your social impact campaign connect to outcomes and impacts and are measurable. Bring social science or community outreach evaluators on during the planning to determine what will be evaluated, set quantifiable goals, and develop a process for mid-stream and final evaluation of the project. This is usually required by and accountable to funders.

These key elements, along with all of the other elements of your marketing plan, can help you frame a media-fueled social impact campaign that creates change and lasting impact.

Social Message Placement

Another form of transmedia activism is the social impact version of product placement—message placement—inserting social issues into existing entertainment properties. Norman Lear tackled bold subjects such as abortion, rape, racism, and anti-war activism in *All in the Family*. *Cagney and Lacey* took on apartheid, and countless made-for-TV movies and theatrical films have covered socially-relevant subjects. The Kaiser Family Foundation, the "Hollywood, Health and Society" program of the Norman Lear Center at USC's Annenberg School for Communication and Journalism, and the National Academy of Sciences' "Science and Entertainment Exchange" proactively insert storylines on health and science into entertainment.

Social message placement is valuable for the first two stages of the Awareness-to-Action Ripples—creating awareness and understanding. When combined with other transmedia experiences designed to engage audiences, it can move audiences to engagement and action.

Lights, Camera, Social Action

There are many inspirational examples of media contributing to social action. In particular, non-fiction projects with social, civic, and cultural missions lend themselves to social change initiatives. Documentary films—on television or in the movie theater—have a legacy of exposing social issues and injustices from humanitarian issues to the environment. PBS has a long-stranding tradition of presenting critically-acclaimed ongoing documentary strands including *Frontline*, *NOVA*, *American Experience*, *POV,* and *Independent Lens*, as well as many documentary specials. HBO has a vibrant documentary unit airing many groundbreaking specials, as do Discovery, Sundance TV, Science, Military, History, CNN, and Smithsonian channels.

Participant Media develops both compelling and entertaining films—from *The Help* to *Charlie Wilson's War*—that create awareness of the social issues that shape people's lives. Some projects are more mission-driven, such as the documentary film *A Place at the Table*, about food insecurity, and the narrative feature film *Contagion*, about our preparedness in the face of a deadly virus outbreak. In addition to theatrical distribution, these and other films are broadcast on Pivot, Participant's cable TV channel for socially-conscious Millennials. TakePart.com, the production company's online social impact arm, supports Participant's mission-driven films with campaigns that inspire audiences to get involved in solutions around their films.

Every once in a while a film alone can change the world. Robert Kenner and Participant Media's Oscar-nominated and Emmy award-winning documentary, *Food, Inc*. was a startling *exposé* on the USDA and FDA-regulated US industrial food production system that churns out unhealthy food, often in unsafe conditions.

Variety said *Food, Inc*. "does for the supermarket what *Jaws* did for the beach."

I set out to make a film about how our food is produced, but quickly realized it was nearly impossible to gain access onto industrial farms and into large food corporations. The food producers were just not interested in letting us see how our food is made. So the film became more a look behind the curtain to see the truth about our nation's food supply: how it is controlled by a handful of corporations that often put profit ahead of consumer health, the livelihood of the American farmer, and the safety of workers and our own environment.

—**Robert Kenner, filmmaker,** *Food, Inc., Two Days in October,*
Merchants of Doubt

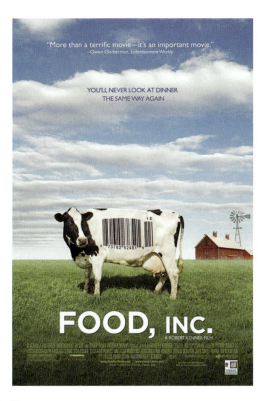

Courtesy of Magnolia Pictures

The official film poster for *Food, Inc.*, which revealed hidden truths of the food production business.

Just viewing the film may have changed audiences' attitudes and behaviors. To find out, Participant engaged the Norman Lear Center at USC to develop a proprietary survey instrument, polling more than 20,000 people. It compared film viewers and non-viewers who were virtually identical in 17 key traits, including their degree of interest in sustainable agriculture and their past efforts to improve food safety. The study found that those who saw *Food, Inc.* had significantly changed their eating and food shopping habits after seeing the film. Film viewers were more likely to:

- Encourage their friends, family, and colleagues to learn more about food safety
- Shop at their local farmers market
- Eat healthy food
- Consistently buy organic or sustainable food

TakePart also supported *Food, Inc.* with an awareness campaign about the rise in unhealthy, cheap processed food and the lack of access to healthy foods—contributing to the childhood obesity epidemic. Two years later, the film and social awareness campaign inspired an additional social media and video campaign, FixFood, dedicated to changing the food system—from its antibiotic use to genetic modification of foods. *Food, Inc.* has become a cultural icon for food quality and food sourcing.

Another project, *Girl Rising*, was dedicated to educating girls to alleviate extreme poverty in the developing world. *Girl Rising* began with the seeds of a social movement and followed later with a documentary film. Started in 2009 with a Facebook page, the Documentary Group and Vulcan Productions founded 10x10—an organization dedicated to providing proper schooling for girls and young women worldwide. Later, Intel Corporation joined the project. Five years later, *Girl Rising* had become one of the top-grossing documentaries of all time and one of the most powerful social media success stories of its era.

> *We had three key goals: to change minds by raising worldwide public awareness about the importance of educating girls; to change lives by increasing resources directed towards girl-focused programs globally; and to change policy through partnerships with policy leaders to influence governments and global institutions to advocate for laws that support girls' education.*
>
> —Bonnie Benjamin-Phariss, formerly director of documentary production, Vulcan Productions; supervising producer, *Girl Rising*

To change minds, the project first raised awareness and understanding through the film, *Girl Rising*, a story about nine extraordinary girls and their struggles to attain quality education, written by nine celebrated writers, and narrated by nine renowned actresses. Using Gathr, a theatrical on demand platform, *Girl Rising* gave its fans the power to crowdsource theater screenings, choosing a local venue, date, and time to screen the film in their areas and invite whomever they liked. Once they'd secured a minimum number of reservations, the screening became a reality. The film had almost 6,000 theatrical screenings, a worldwide television broadcast on CNN Films, and 778 campus screenings. The project received more than 4.8 billion "earned media" impressions, 777,000 social media followers, 988,000 YouTube views, and 1,500,000 Web hits.

To change lives, the project encouraged bottom-up audience engagement and action in solutions. *Girl Rising* partnered with various NGOs, including CARE, GirlUp, Because I Am a Girl, Partners in Health, A New Day Cambodia, and World Vision. Through a digital framework created by CafeGive that integrated the Web site, an online donation platform, social media, and mobile content, the project catalyzed grassroots action among a worldwide community. These digital assets showcased the film, welcomed new *Girl Rising* supporters, energized the growing community, and hosted a fundraising campaign for girls' education projects. The fully-mobile Web site, girlrising.com told girls' and journalists' stories from around the world, brought the partners together in one place, linked to programs educating girls, and offered seamless, action-oriented solutions. Social media and text-driven communications connected the various digital assets.

Girl Rising inspired more than $1.3 million in donations, provided bilingual education to more than 11,000 children, supported reading and writing in 2,500+ classrooms, provided 23 World Vision scholarships, donated 200+ bikes in Cambodia, Costa Rica and Sudan, built schools in Afghanistan and Cambodia, donated computers, and provided shelter, supplies, nutrition and schooling for orphaned girls. NGO partners reported increased engagement of existing donors and increased organizational visibility through press coverage as a result of their partnership.

To change policy, the project encouraged top-down audience engagement and action in solutions. The project hosted more than 147 policy-oriented screenings at multi-lateral institutions, governmental organizations, NGOs, policy schools, and policy-oriented organizations. Gordon Brown, UN special envoy for global education, authored four *Huffington Post* articles citing *Girl Rising*; Queen Rania of Jordan secured a high-level UN panel's support toward earmarking girls' education at the top of the next-generation Millennium Development Goals for 2015; and the First Lady of Uganda established a steering committee on girls' education after an Intel-hosted screening.

Serious games (also called transformative games) are often about key social or environmental issues. Games for Change (also known as G4C) is a movement and community of practice dedicated to using digital games for social change. Games for

Change is also a non-profit organization that hosts the Games for Change Festival, during the Tribeca Film Festival.

> *Documentaries are much more ahead of the curve in using games or seeing their project as part of a transmedia package. Because in addition to being an entertainment form, a lot of the purpose of the message is to forward a message or a cause. There's a journalistic, or activist, or educational interest so foundations that sponsor documentaries and the filmmakers themselves are interested in the documentary space in making sure that outreach and impact happen. You want to make sure that people are continuing that process of learning and engaging. Games are seen as a way to tell more of the story, provide access to people who might not watch the documentary, give people a different lens on how they receive the content, and point them toward action.*
>
> **—Nick Fortugno, chief creative officer, Playmatics**

Digital agency, Mother partnered with Zynga to create *Repair the Rockaways* to help the hardest hit from Hurricane Sandy. In the *Farmville*-like Web simulation game, audiences bought bricks to build houses, which were used to buy supplies, materials, and labor to rebuild the destroyed homes in Rockaway, NY. Other noteworthy games for change: *iCivics* taught civics and inspired students to be active participants in US democracy; *PeaceMaker* challenged players to succeed as a leader where others had failed; *Darfur Is Dying* uncovered the reality of genocide in Darfur and embedded activism opportunities; *Re-Mission 2* taught young cancer patients about the disease; *Virtual Iraq* helped treat veterans with PTSD; and *Foldit* allowed audiences to participate in a puzzle game about protein-folding that contributed to AIDS research.

The transmedia impact project *Half the Sky* developed a game as part of its cross-platform mix to highlight the oppression of women worldwide and offer empowering solutions for them to realize their legal, economic, and cultural power. Through a partnership with Games for Change and Zynga, the project created the *Half the Sky* Facebook game, which transformed players' in-game actions into real-world solutions. Available in English, French, Hindi, and Swahili, the role-playing game took the POV of Radhika, an impoverished mother in India, as she navigated difficult choices, such as getting medicine for her sick child. Players had to decide how Radhika should respond to different situations. She traveled to Kenya, Vietnam, Afghanistan, and the US on various missions, including obtaining books for her community, collecting mangoes to sell at market, and starting small businesses. At different junctures, players could make corresponding real-world donations to non-profit organizations, including the Fistula Foundation, GEMS, Heifer International, Room to Read, and World Vision, and learn about the work of the ONE Campaign and the

UN Foundation. The *Half the Sky* Game attracted more than 1.25 million registered players, who contributed more than $470,000 in direct and sponsored donations.

Alternate Reality Games (ARGs) can activate passionate audiences for social good. ITVS' *Independent Lens* and CPB worked with Ken Ecklund to develop *A World without Oil*. This real-world game involved a set of gaming parameters delivered over 30 days by the puppetmasters, including game doyenne Jane McGonigal, via blogs, videos, and other digital assets. The ARG asked players to work in collaboration with each other and live their real lives based on a world without oil and document the experiment. As a result of playing the game—not using cars, changing their purchasing habits, and finding new ways to power their lives—audiences changed their relationships with travel, energy, food, and each other. In just a month's time, the ARG collected the wisdom of 60,000 players from around the world and received more than 1,500 submissions of life-altering effects of this imagined universe.

Social media also educates and creates social impact. When NASA sent the Curiosity rover to Mars they created a first-person Twitter account @MarsCuriosity to share the robot's story and the mission's science, including its journey to Mars; interactions with students, journalists, and science lovers; testing stages; and exploration of the red planet. NASA enlisted *Star Trek* actors to describe the Mars landing on videos and partnered with Disney's *Wall-E* for students to name NASA's next Mars Rover. A mix of transmedia storytelling and engagement programs contributed to the massive buzz around the landing, which helped Curiosity attract more than 1.2 million followers on Twitter and inspired a new generation of the science-curious.

@MarsCuriosity/Twitter

The Twitter page from NASA's Curiosity Rover that engaged the science-curious.

Even toys can create social impact. GoldieBlox was created by Debbie Sterling, who was one of 181 women to graduate in engineering from her Stanford class of 1,000. GoldieBlox's main character, Goldie, is a female engineer, intended to reach young girls when they're still scientists at heart. The GoldieBlox toy kit comes with figurines, a construction kit, a book and app story of *GoldieBlox and the Spinning Machine*, and step-by-step instructions for building a spinning device. Goldie encourages girls to see her as a role model and use STEM skills to solve problems. GoldieBlox's video received more than 8 million YouTube views, and the toy won a Super Bowl ad from Intuit QuickBooks. GoldieBlox grew from a Kickstarter prototype to a stand-out toy that secured $1 million dollars in pre-sales and sold out during its first Christmas.

Designing social impact campaigns for media projects is a specific area of expertise that's in demand because many media funders require outreach, engagement, and impact campaigns for films and media projects that truly move target audiences. BRITDOC has worked tirelessly to recognize the role of the **Impact Producer,** even creating master classes around it. Impact producers work with media projects from their development through to post-project impact measurement.

To authentically engage audiences with your media-anchored social impact project you should tell your story across multiple platforms; develop your impact campaign early, when you're crafting the story; frame the issue's problems and solutions to create audience agency; forge strategic partnerships with media, NGOs, government, and corporate entities; launch digital, community, and institutional outreach and change campaigns; develop clear calls-to-action that feed into desired measurable outcomes; and create or mine active communities of affinity groups and stakeholders.

You can inspire audiences—from soccer moms and faith-based communities to political leaders and educators—to take positive action that leads to measurable outcomes that just might change the world. Transmedia campaigns to catalyze that fuel positive social impact are not for the faint-of-heart, but they are some of the most rewarding work you can ever do as a media maker or media marketer.

You've learned how to harness the power of media and human will to engage your audiences in your project's social impact initiative. Now you must measure the various aspects of your initiative. This will allow you to make mid-course corrections and learn more about audiences for the development of future projects.

Author's Anecdote

A Transmedia Social Impact Campaign for Global Health

In the mid-2000s, I designed the transmedia social impact campaign *Rx for Survival—A Global Health Challenge*, co-produced by PBS' *NOVA* Science Unit and Vulcan Productions and co-sponsored by the Bill & Melinda Gates Foundation. This media-fueled social impact initiative addressed some of the world's most critical and under-acknowledged health threats, and inspired my founding Azure Media, which develops media-fueled transmedia social impact projects.

The project had a multi-platform editorial presence—*on air*, *online, in print*, and *on the go*—on PBS, pbs.org, NPR, *Time* magazine, and Penguin Press. The transmedia project powered a social impact campaign that catalyzed public audiences from the bottom up and influencer audiences from the top down.

In partnership with CARE, Save the Children, UNICEF, Global Health Council, Girl Scouts, Rotary, American Academy of Pediatrics, and others, the impact campaign, *Rx for Child Survival*, inspired newly-aware public audiences—*in communities*, *schools*, and *churches*—to raise awareness, speak out, volunteer time, and donate money for child survival, a subset of global health. These calls-to-action helped provide five critical interventions, which, if administered to the world's most vulnerable children before the age of five, would dramatically increase their chances of survival.

The impact campaign also educated and motivated influencers—*in newsrooms*, *in Congress*, and *in classrooms*—to dedicate more resources to global health through their spheres of influence. This included increasing media coverage of global health, expanding support for global health aid, and providing previously non-existent global health curricula.

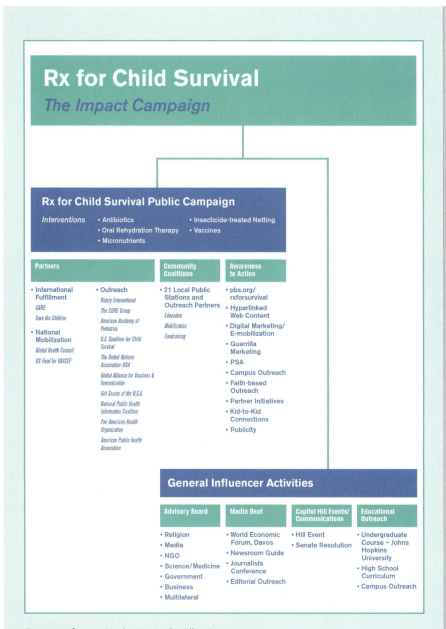

Courtesy of Azure Media; Design by Elles Gianocostas

The public and influencer elements of the social impact campaign for *Rx for Survival—A Global Health Challenge*.

Rx for Survival catalyzed millions of audience actions, or outputs, around global health. They included: 300 community events, 40 college campus initiatives, and 112 religious groups' "Month of Prayer for Child Survival"; UNICEF's project inclusion on 6 million "Trick-or-Treat" boxes; the American Academy of Pediatrics' distribution of project posters to 45,000 pediatricians' offices; and a Girl Scout troop creating an *Rx for Survival* participation patch. The project measured how these actions translated to outcomes and impacts. Some connected to benchmark research on audience attitudes and predisposition to get involved in global health (2,000 adults nationwide in January 2004; follow-up research of 1,200 adults in November 2005). These outcomes contributed to significant social, institutional, and policy changes that created lasting impact for global health.

Awareness to Understanding

- As many as 66 million Americans intersected with some aspect of the *Rx for Survival* transmedia project
- The project generated a billion media impressions (one-half billion publicity and online impressions each) on an under-reported topic
- The target audience's understanding of and level of commitment to "helping developing countries improve the health of their people as a top priority for US international aid" increased by 14.3 percent

Engagement to Action

- Americans' (not just target audiences') "personal commitment to becoming personally active on global health" increased by 37 percent
- Fulfillment partners' US donations increased by an average of 128.5 percent, providing increased services and saving untold millions of lives (Save the Children and CARE 2005 Annual Reports)
- US print media coverage of global health increased 30 percent from the year before launch (including a *Time* magazine cover for Bill and Melinda Gates and Bono as "2005 Persons of the Year")
- Middle and high school lesson plans and undergraduate courses entered classrooms, inspiring a new generation of global health leaders
- Three years post-launch, the US tripled AIDS, malaria, and TB funding
- 2008 marked the first year there were fewer than 10 million child deaths worldwide (UNICEF)
- Other initiatives—from USAID to the One Campaign—continue to support global health and child survival's five critical health interventions

Measuring Outcomes

You're ready to execute your marketing plan, but first you must revisit your goals and objectives to ensure they're measurable and connect to your desired outcomes and impacts.

Why evaluate your project? As the CEO or CMO of your media project, you're accountable to your content co-creators and co-marketers, stakeholders, and audiences. Evaluation provides evidence-based judgments about the value of strategies or tactics, allowing for mid-process changes and project takeaways that will improve outcomes of future projects.

Measurement of outcomes is an opportunity to track your resonance with your audience, communicate your collective impact back to them, and further drive audience engagement and other impacts, such as revenue or social change. As a media maker and media marketer, don't look at measurement as a sword of Damocles hanging over your head, but rather as a valuable, ongoing learning circle.

Goals Meet Impacts

As you finalize your marketing and audience engagement plan, consider some guiding principles of evaluation and measurement. Evaluation:

- Starts at the beginning of your project
- Measures your goals and objectives
- Continues throughout your project's lifetime
- Is adaptable to changes in the project
- Reflects your project team, stakeholders, and audiences

As you look again at your measurable objectives, you might need to add more up-front research to your evaluation plan to better understand different audiences' attitudes (see Chapter 6, "Research to Win"). This can help you identify your primary or secondary audiences. Perhaps you want to pilot content approaches or marketing forays to see what works. This can help you finalize the story or frame the message. If you can afford this up-front **Formative Evaluation**, you're protecting the larger sums of money you'll spend across the project's execution.

No matter what, you must conduct **Summative Evaluation**—the assessment of results at the end of you project. To do this, you must ensure your measurable goals or objectives tie-in with your outcomes and impacts. Again, outcomes are the short-term and mid-term changes that occur as a direct result of your audiences interacting with your project. Impacts are broader or long-term changes that occur among your audiences or within key communities as a result of your project's outcomes. An outcome might be "*The film secured $16 million in box office receipts on its opening weekend.*" An impact might be "*The distributor widened the distribution of the film based on strong box office receipts.*"

Project success can be evaluated through the compilation of specific data, such as Nielsens or social media reach. If your project is complex, you may need an evaluation firm to oversee the collection and analysis of all of the data. Ensure that all your experts on each media platform, marketing discipline, and area of social impact contribute to setting your project's goals and objectives and success measures. Also include key stakeholders' perspectives, such as partners and funders. And build the evaluation plan into the overall budget.

By Lite; Licensed under Creative Commons via Wikimedia Commons

The old carpenter's adage, "measure twice, cut once" applies to media projects.

Metrics That Matter

Quantitative data—anything that you can count numerically including "how many" or "to what extent"—is the first place to start measuring the reach or effectiveness of your media project's "owned," "earned," and "paid" content. One of the most common goals of a media project is to secure high levels of awareness, reach, engagement, and participation among primary audiences.

Some common quantitative measures in this arena are:

- Revenue
 - Box office receipts
 - Home video sales
 - Game sales (or in-game purchases)
 - Book sales
 - CD sales
 - Content provider subscriptions (e.g. online, cable, satellite, OTT services)

- Reach and impressions
 - Media impressions
 - Nielsen ratings
 - Web visitors, page views, time spent viewing
 - Advertising GRPs
 - Ad equivalencies

- Engagement and action
 - Social media and online "Likes," followers, shares, and comments
 - Subscriptions (newsletters, RSS feeds)
 - Conversions (content downloads)
 - User-generated content (content uploads)
 - Calls-to-action completed
 - Petitions signed
 - Money donated
 - Hours volunteered
 - Event attendees
 - Behavior changes (lifestyle or purchasing habits)

- Awareness, attitudes, and actions
 - Awareness and recall
 - Attitude
 - Predisposition to act

Revenue

Revenue is one of the simplest and most concrete outputs for media projects. In film, the primary metric for awareness, reach, engagement, and action is box office receipts. Film cuts to the chase. Did the movie make money, and how much? The distributor's split takes half or more of the receipts with the rest going to the theater chains. That revenue, minus the cost to make and market the film, determines its profitability. A profitable film is *the* outcome for studios, producers, and distributors. That's why it's called show *business*.

The opening domestic weekend is an early barometer of how well a film will do over the course of its run, so massive resources are dedicated toward it. Big opening weekends often give a film a longer theatrical run. But films' successes vary by geography and cultural context. Some films bomb in the US, but perform extremely well internationally, making huge profits. Numerous Web sites monitor film box office receipts, including Box Office Mojo, BoxOffice, and ShowBIZ Data.

And, in a "TV Everywhere" world, home video and VOD sales affect film and television profitability as much as revenue from theatrical or TV premiere distribution windows. Shifting distribution models have made predicting revenue almost impossible.

> *It's extremely confusing for anyone involved in the profitability factor. You can't run numbers. You just don't know where the money is coming from. It isn't really migrating—from theatrical to home entertainment or from DVD to digital download—it's literally changing.*
>
> **—Mark Urman, theatrical film distributor and marketer, president, Paladin**

In television, as ratings rise, so do ad rates and sales. A TV show's success can drive a distributor's success. *The Sopranos* boosted the HBO channel's subscriptions. *Mad Men* and *The Walking Dead* breathed new life into AMC. *Arrested Development, House of Cards*, and *Orange Is the New Black* branded Netflix as an original content creator.

Like film, theater is more often measured in box office receipts. Game sales are now predominantly charted based on revenue. Books are reported based on copies sold or in circulation, via leader boards of bestsellers, and by revenue. Music is charted by digital downloads, albums sold, and revenue.

Reach and Impressions

Counting the **Reach**—the number of people who could access a message, and **Media Impressions**—the number of interactions with a message, are common measures of a project. Impressions apply to most platforms—broadcast, print, and digital—and to "owned," "paid," and "earned" media. There are various ways to determine impressions.

If your transmedia project has an owned content *broadcast* element, then Nielsen Media Research will measure it, estimating how many people watched or listened. These ratings determine advertising rates. Rating services gather this data via telephone surveys, viewer/listener diaries, and electronic meters connected to TV sets and people meters connected to people. Nielsen develops small, random samples based on age, gender, ethnicity, education, geography, income, and family status that are extrapolated to reflect the local or national audience viewing or listening habits. Advertisers are most interested in the 18-to-49-year-old age bracket.

TV and radio measures both households (HHs) and individuals viewing or listening. **Ratings** are reported by the percentage of *total HHs with a TV or radio* that are watching or listening. Most US HHs have TVs and radios, so this is close to the percentage of total US households—about 115.6 million. **Share** is the percentage of households that *have the TV or radio on* during the time of that program. **Households Using Television (HUTS)**, are all *households using television* at a particular time. So **Share x HUT = Rating**. Suppose a town has 1,000 people and 50 of them are watching television and all 50 are watching *Resurrection*. For that town, the program has a 5 rating and 100 share—designated as 5/100.

Ratings are also reported by people, by **PERS 2+**, the estimate of the number of people two years old and older in the US—about 294,000,000 people. The total 18-to-49-year-old demographic is about 131,000,000 people, less than half of the total population. The **Cumulative Audience (Cume)** is the number of *unique people tuned in to a program at a given time*, usually expressed as the estimated viewers/listeners in any given quarter-hour. Nielsen not only looks at all these numbers for live-viewing of the broadcast, but also for DVD and VOD viewing three **(C3)** and seven **(C7)** days after broadcast.

"Owned" or "earned" *digital media* is also tracked by impressions. Begin by analyzing the amount and nature of your project's Web traffic and its sources—search, direct, social, and referral. You can understand which of your Web content your audiences prefer. The following data is often collected when monitoring online traffic:

- Number of visitors
- Average number of page views per visitor
- Average visit duration
- Average page duration
- Conversions (downloads, RSS feed sign ups)

- Participation in interactive features
- Number/nature of comments
- Most requested pages
- Referrers (source of links sending traffic to site)

Nielsen has tracked Internet content since the mid-1990s. As a result of the huge explosion and dominance of online content, there are now thousands of online monitoring service firms, including Google Analytics, Site Meter, StatCounter, GoStats, and AWStats.

> *Measurement is a difficult question that everyone's trying to ask in digital. Across our campaigns we look at three things: Awareness, such as mentions and impressions; Quality, which is sentiment, both positive and negative; and Engagement, which is number of social actions.*
>
> **—Chris Eyerman, creative director, 3AM; formerly transmedia creator for *Prometheus, The Hunger Games, Arrested Development***

Social media tracking monitors engagement for both "owned media" (your Facebook page or blog) and "earned media" (others' participation with your project on Facebook, Twitter, etc.). Generally, social measurement tracks blogs, micro blogs, wikis, news sites, social media networking sites, video/photo sharing sites, forums, and message boards. It measures fans and "Likes" on Facebook; followers on Twitter; shares; references on Digg, StumbleUpon, and Delicious; and overall social and online blog comments.

Social activity can be converted to advertising equivalencies, or the cost of acquiring those impressions through paid advertising. Ellen DeGeneres' 2014 Academy Awards selfie had an "earned" value of more than $800 million. There are many social media monitoring and analytics services, including Sysomos, Radian6, Lithium, Collective Intellect, SDL SM2, and Sprout Social.

Nielsen monitors the socialization of TV with the Twitter TV Ratings service, tracking the overall audience for each show, based on the total tweets, the number of unique account tweets, and how often those tweets are seen.

> *A program could be huge on social, which means that people are watching, right? You would think. And then the numbers come in and they're not equal. So sometimes the show is hugely social and it doesn't show up in the Nielsens, and then sometimes a show blows the numbers out of the water and then it's not really talked about on social. At the end of the day, we have to answer to the Nielsen gods. That's our bread and butter. That's where we get our revenue.*
>
> **—Rose Stark, VP marketing, TLC**

Another form of "earned media" is *publicity*, also measured by impressions. So, the audience of a television program, the circulation of a newspaper, or the number of views on a Web site can be added up to estimate the number of impressions delivered by a publicity campaign and can be converted to ad equivalencies. Publicity is tracked through search engines, Internet discussions, and clipping services such as BurrellesLuce, Vocus, NewsReal, WebClipping, and CyberAlert.

Advertising, or "paid media," is measured by **Gross Ratings Points (GRPs)** across all media. Remember from the media plan that GRPs are the frequency, which is the number of impressions seen over a certain period of time, multiplied by the reach, which is the percentage of the total population. Frequency x Reach = GRP. The more GRPs a project gets, the more it saturates audiences' mindshare. The imprinting or branding of the media project creates more impressions and legitimizes it, leading to trial (engagement and action) and loyalty (superfandom).

GRPs can be calculated for broadcast, print, and digital campaigns. Recently, Nielsen introduced Online Campaign Ratings, which measures online ads' audiences with TV-comparable metrics of reach, frequency, and GRPs, and demographics, allowing for direct comparisons of broadcast and online content. Advertising is costed out through **Cost Per Thousands (CPMs)**. Digital's equivalent is **Cost Per Views (CPVs)** or the more action-oriented **Cost Per Clicks (CPCs)**. Mobile programs are based on CPCs.

When your media-buying firm plans and places your ads across broadcast, print, digital, and outdoor, they provide you with the calculations of reach, frequency, and GRPs of your media plan and cost metrics of CPMs or CPCs. If you're doing online advertising on your own, you can use CPCs to buy ads near search engine results for a particular search query through Google's AdWords, Millennial Media, Yahoo, and Microsoft. You can measure product placements with in-program performance metrics provided by companies such as the InterMedia Advertising group.

Engagement and Action

Measuring engagement and action is subjective, in part because definitions vary between organizations and projects. For some, clicking on a link is an action, while for others it is only a preliminary engagement towards a bigger action, such as a purchase. But in media measurement, everyone agrees that engagement and action are more valuable than simple awareness impressions. That's because engagement and action deliver a greater **Return on Investment (ROI)**, which is a monetary or quantifiable assessment of its value. **Return on Engagement (ROE)** gauges how captivating and engaging your content is to your audiences. As a result, newer cost metrics of **Cost Per Engagement (CPE)** and **Cost Per Action (CPA)** measure how interaction with content catalyzes audience actions. This is prevalent in native advertising.

One evaluation model that measures actions and outcomes is **SCORE**:

- **S**ubscriptions to project-supported assets (newsletters)
- **C**onversion actions (downloads)
- **O**utcomes presentations (longitudinal case studies or real-world audience reported outcomes)
- **R**esponse (use of social features, e.g. shares with friends)
- **E**ducation and measurable shifts in understanding

The measurement of media-fueled social impact projects discovers the relationship between audiences' consumption of media content and their action around the associated issue or cause. It quantifies outputs such as media impressions, social shares, petitions signed, advocacy events created, influencers contacted, dollars donated, and hours volunteered. It also tracks how the Theory of Change propels audiences from awareness and understanding to engagement and action—seeding individual, social, and institutional change and creating long-term impacts.

Social impact campaigns usually combine quantitative and qualitative evaluations to measure audience changes in:

- Knowledge—increased awareness and understanding of an issue
- Skills—ability to identify and address social issues and act on their behalf
- Attitudes—alignment of sense of responsibility and belief systems
- Intention to act—increased predisposition to act or reach social goals
- Behavior change—acting on behalf of the social issue

Determining real impact requires long-term evaluation of educational, health, environmental, humanitarian, and welfare improvements. Many social scientists are developing measures such as **Cost Per Outcome (CPO)** and **Social Return on Investment (SROI)**.

Awareness, Attitudes, and Actions

If you want to understand your audiences' perceptions around a project or issue, you might want to commission a quantitative survey to measure their awareness of, attitudes toward, or predisposition to act around it. Researchers recruit a sample profile of respondents and then apply inferential statistics to generalize those findings to a wider population. Each person surveyed or every percentage point is a proxy for a larger number of people. This research is expensive and must be managed by professionals to ensure it's designed using best practices of social science research. Often, the quantitative study is preceded by qualitative research, such as focus groups, to ensure the questions on the survey instrument are the right ones to ask.

Waiting for Superman, about the US educational system, conducted a six-month study on the film's effect on people's awareness, belief systems, and public discourse. It analyzed press coverage, social media analytics, focus groups, an online survey, online "Trending" reports, and in-depth interviews with education industry leaders. The evaluation found that 80 percent of audiences who saw *Waiting for Superman* remembered key facts from the film's discussion of public and charter schools, and 66 percent indicated that the film made them want to learn more about education policy. The evaluation found that the film's use of gambling metaphors in the context of education entered the national consciousness through repeated use in mainstream media.

If studios or networks want to know what audiences thought of a film, television program, trailer, or advertising they can also dial-test it. Viewers register positive or negative sentiment about elements of the video in real time, showing how scenes register with audiences.

Another method of gathering respondent feedback is asking audiences to complete questionnaires, a common method for events. But with self-reporting, the response rate is lower and the bias rate may be higher (only those who were very happy or very unhappy respond). Always consider this effect when looking at comments on blogs or social media. They're generally skewed by more extreme sentiments.

Anecdotes That Amplify

Qualitative feedback answers the "why" more than the "how many." Qualitative methods are often open-ended, such as quotes, ideas, analogies, feelings, opinions, reasons, belief systems, and other subjective information. It's much harder to put this feedback into boxes, but it can speak to the profound influence of your media project. Some key qualitative mechanisms for securing feedback include:

- Open-ended questions on surveys
- Focus group discussions
- Personal interviews
- Observation of behaviors
- Online comment boards, diaries, and visitor books

The open-ended question on a survey questionnaire allows respondents to discuss their opinions and feelings about media content or an issue. More labor-intensive and expensive methods include one-to-one interviews or focus groups, allowing for in-depth and exploratory studies. These are helpful in shaping and later evaluating the success of the project. It's important to capture both quantitative measures and anecdotal comments about audience perceptions from polls or focus groups.

Current measures of publicity not only quantify impressions, but also evaluate how it positively affects the social discourse or influences outcomes. The measurement of pick-up of key project messages, audience sentiment, and cultural influence is invaluable to understanding the value of "earned media." This includes press or online bloggers' reviews, influencer feedback, and audience comments. Others are e-mails, social media comments, online forums, chats, comment boards, comments at live events, and telephone voicemails.

Social media evaluation not only quantifies its reach and awareness, but also tracks its **Social Sentiment**—whether references are positive or negative. Because endorsements from friends and family matter so much, social media can have a huge influence. Monitoring social conversations allows a project to respond in real time and informs the creation of new content. In addition, parodies, mashups, memes, and popular culture allusions can serve as proof of cultural currency.

Document all qualitative and anecdotal feedback carefully to ensure you have the exact quote, person quoting it, date, and context of the feedback (newspaper review, event comment, or e-mail). Alone, these anecdotes seem small. But when combined in your project results report with quantified measures of outcomes and impacts achieved, they can give life and authenticity to the achievement of your goals and objectives.

An Evaluation—*Martin Scorsese Presents the Blues*

For *Martin Scorsese Presents the Blues,* the project set forth key goals and quantifiable objectives (see *The Blues*' combined marketing plan and results in the "Cross-platform Media Project and Case Study" at www.transmediamarketing.com). Key quantifiable goals and results were:

- **Awareness**—the project garnered 1.7 billion positive media impressions via publicity, online marketing, events, on-air promos, and advertising—*more than tripling the goal* (not including VW's marketing efforts)

- **Participation**—the project's cross-platform content delivered *The Blues* to up to 60+ million people—*almost doubling the goal* (not including international audiences)

- **Boosted Genre**—*Billboard* reported a 40 percent overall sales increase of blues titles the week after broadcast and up to 500 percent increase in blues sales at key retailers in the three weeks after the broadcast premiere

The project also had some subjective goals, such as receiving critical acclaim, spawning authentic dialogue, and creating lasting cultural impact. The number of positive reviews and awards mattered, but qualitative quotes captured the essence of the **Critical Acclaim**:

> "At a time when many documentaries embalm their subjects, this series brings the blues screaming to life."
> —*Newsweek*, 9/29/03
>
> "*The Blues* marketing campaign was brilliant and well-organized. This was a challenge because the blues are not mainstream by any stretch, but the project's team came up with a plan that more than met that trial."
> —Judges for *PR Week* Awards (*The Blues* won "Arts & Entertainment Media Campaign of the Year")

There were various measures of the project's **Authentic Dialogue** and **Lasting Cultural Impact**, such as the hundreds of feature stories on the blues; increased listenership of blues music; participation in 120+ events that reached more than 2 million people; online chats including 12.5 million users; and the standing-room-only influencer event at Kennedy Center. Anecdotal comments communicated the project's influence on key audiences and society in a unique way:

> "Public TV rocks . . . *The Blues* could be the best 14 hours you'll ever spend."
> —Cornell University *Daily Sun*, 10/02/03
>
> "Popular interest in roots music [has] grown in recent years, especially after the PBS series produced by Martin Scorsese, *The Blues*."
> —*The New York Times*, 3/21/04

By all accounts, *Martin Scorsese Presents the Blues'* transmedia marketing project was a big success. The project reached millions of people, sold music and home video product, generated huge buzz, dominated PBS' media coverage around broadcast, and received critical acclaim from influencers and grassroots audiences alike. Even the marketing campaign received notice in trade publications from *Variety* to *Crain's*, and won many awards.

The key to *The Blues*' success was that the campaign marketed blues music as much as it did the project, giving lift to a neglected genre. *The Blues* resonated with audiences because the campaign made emotional connections. It linked music lovers with big name music artists; film aficionados with top movie directors; the past with the present; and blues music with all music. It did so by integrating multi-platform content marketing and traditional, top-down media marketing with bottom-up audience engagement by employing best practices in partnerships, media relations, film and music events, advertising, digital marketing, experiential and guerrilla, and promotions.

Each project must be planned and evaluated based on what's intuitive for that project. The development of marketing and engagement plans and the reporting of their results are never cookie-cutter. They all have measurable goals or objectives that must be tracked and measured during the project's execution, tweaked mid-stream, and reported when the project is completed. While the definition of success is often subjective, today it is almost always about both metrics and cultural currency.

> *The calculus involved in defining a "hit" on TV is blurring like everything else in this multi-platform universe ... In the current culture when our viewing is so fragmented and time-shifted, a "hit" would seem to describe any show that manages to break out of the clutter whether in terms of size of audience or in terms of the buzz it creates in the media and/or online in streaming and On Demand platforms. It's encouraging that many networks, including network and cable, are letting many of their more challenging and intriguing series percolate into hits or even long-running critical cause célèbres instead of quashing them instantly when they don't deliver big numbers.*
>
> —**Matt Roush, senior TV critic, *TV Guide* magazine**

Bringing your project to a close and evaluating what worked and what didn't is both fruitful and satisfying. If offers you a chance to reflect on choices and outcomes along the way. It turns the creation and execution of your project into a narrative, documented in your final report. That report follows the same structure as your marketing plan, but adds a results section based on your measurable goals and objectives. Not only is this a narrative you must tell to the stakeholders of your current project, but it is also a key story in your career, shaping who you are, and guiding and helping you sell future projects.

Transmedia Marketing Case Studies

Now that you have acquired the building blocks of knowledge on how to develop a marketing plan for your transmedia project, it's valuable to apply that cumulative insight in a different way—through appreciation and inspiration. It's fun and informative to step back from your own project and survey other media and transmedia projects. Examining other projects' odysseys while they've navigated various opportunities and challenges can motivate you as you set forth on your own project.

Martin Scorsese Presents the Blues has served as an overall teaching case study throughout this book, providing you with the structure and elements of a sound marketing, outreach, and engagement plan. It has taught you how to frame and support that plan with use of secondary and primary research, identification of key audiences, determination of brand essence, and setting of measurable goals and objectives for evaluation. This multi-platform project has also provided insight and detail on executing that plan—from announcing the project to the press, industry, and audiences to developing a promotion campaign to reach audiences through ads, trailers, online content, and events. (*The Blues* audience and brand analysis, "Cross-platform Marketing Overview" PPT, and its combined marketing plan and final report, "Cross-platform Media Project Case Study," are available and enhanced with more content and marketing elements at www.transmedia marketing.com).

This book has also highlighted many other projects on various media platforms throughout, as examples of specific points.

This chapter brings it all a step further, outlining four more exceptional case studies, each telling a different story and showcasing a different content creation or marketing approach: the captivation of cooperative tribal audiences in both fictional and real worlds through Steven Spielberg's film *A.I. Artificial Intelligence*'s alternate reality game; the branding stand-out of TV drama, *Mad Men,* inspired by the mini-story in its title sequence; the modern digital Jane Austen adaptation, *Lizzie Bennet Diaries*' holistic narrative, told on multiple digital platforms; and the fully-socialized and interactive audience experience of reality program, *Here Comes Honey Boo Boo*.

These entertainment and media project case studies share common characteristics that make them winners. They:

- Engage the audience directly and emotionally with the story, characters, or universe
- Create unique content on multiple media platforms to advance the story and market the project
- Integrate the story and marketing elements into a holistic audience experience

Oleksiy Mark/Shutterstock.com

Close-up examinations of other projects can inform and inspire you as you develop your transmedia project.

A.I. Artificial Intelligence's "The Beast"— Participatory Tribal Audiences

When Jordan Weisman, the creative director for Microsoft Entertainment, described his transmedia game idea to Steven Spielberg for his upcoming film *A.I. Artificial Intelligence*, Spielberg may not have understood the meaning of transmedia, but he fundamentally understood the value of the kind of audience experience Weisman envisioned. Spielberg saw it as the sequel to his film about artificial intelligence and human longings. Not only did this groundbreaking distributive narrative experience, dubbed an Alternate Reality Game (ARG), advance its own story within the futuristic *A.I.* universe, but it also created exposure and audience appetite for the film. "The Beast" was a seminal experiment in Weisman's dogged pursuit of the entertainment triangle of story, socialization, and game-playing that spawned a new media genre and a new way of interacting with audiences. Ultimately, *A.I.*'s "The Beast" is an anthropological case study on audience. It's about understanding audiences' motivations to act, examining the cause and effect of their interactions with various content, and creating a collective consciousness among them.

"The Beast" began at the 2000 CES trade show. Spielberg had taken over the *Pinocchio*-inspired film from the recently deceased Stanley Kubrick. Spielberg and his Amblin Entertainment producing partner, Kathleen Kennedy, pitched the under-wraps film to Microsoft's home division for game licensing, including the upcoming Xbox. While the meeting went very well, Microsoft's conundrum was that *A.I.* was a personal story about an artificial intelligence boy with real feelings, desperate for a mother's love. That storyline would have limited appeal to the core gamer audience. But eventually the two parties struck a deal for Microsoft to make six games based on the movie.

With a script, storyboards, and some models at that stage, *A.I.* was already set against a dynamic story world with melted polar icecaps, humans living in the interior of continents, and realistic robots serving them. And because it was a film about artificial intelligence, it presented key themes that could be mined.

> *The core theme of the movie was the definition of humanity. We define humanity conveniently for our own needs as different cultures do at different times, thus allowing us to enslave people forever, or kill people, or whatever we need to do. You can define them as not human and then you're OK. That fight for recognition as humans often has a lot of drama and explosions associated with it, which would work better for the 18-to-35 male gamer audience. So I said, "We need to tell the story of how the world got to the point it's at and where it's going to from there." In other words, place the movie in the context of the larger universe.*
>
> **—Jordan Weisman, transmedia pioneer, founder of 42 Entertainment and other innovative entertainment companies; creator of *A.I.*'s "The Beast"**

Through a mutual acquaintance, Weisman enlisted Sean Stewart, a sci-fi novelist, and together they started writing an elaborate future history for Spielberg's *A.I.* universe—from the current day up to the planet's ice-ball future. They created additional characters and populated the story world. Spielberg loved the non-linear process because it was so different from film storytelling. With the in-depth story world mapped out, game and experience designer Elan Lee planned how to communicate the background of the story and engage the audience.

Weisman's big idea was a massively multi-player storytelling experience that was an extension of the role-playing dynamic—worldwide audiences collaboratively finding and telling a story from atomic story pieces. In this distributive narrative, the team would write the story—a Web-based murder mystery involving humans, robots, and a variety of other A.I. forms. They would place story assets or evidence across the physical and digital world for audience members to find, allowing them to collaborate online in the mystery-solving game and storytelling experience. Originally, the experience was designed to run for six months—three months before the launch of the movie and three months until the release of the games.

When Weisman pitched it to the head of Microsoft's home division he got a big "No." In fact, the idea was dubbed "anti-marketing" because so much of the content was hidden, requiring audiences to discover it. So Microsoft didn't fund it. When he pitched it to Spielberg and Kennedy, they liked it, but wanted to know if it was funded. Weisman told them that Microsoft would pay half if Warner Bros. paid for the first half. And so they did.

So on a big gamble, and in just two months, the small seven-person core team created an astounding 666 story assets, which inspired the game's name, "The Beast." They assumed they'd produce 80 percent of the content up front and 20 percent in reaction to the audience. Ranging from Web sites and billboards to TV spots and e-mails, the content was designed to engage and challenge a collective hive-mind.

And they created all this content under a veil of secrecy to enable audiences curious about this Kubrick-*cum*-Spielberg film to unravel the story in bits, become willingly and deeply immersed in the fictional universe, and culminate the experience by attending the film. Shockingly, the team also kept their higher-up bosses at Microsoft in the dark about going ahead with the non-approved hive-mind game idea.

Courtesy of Jordan Weisman

A sampling of the many Web sites created for the massively multi-player storytelling experience of *A.I. Artificial Intelligence*'s "The Beast."

Based on Spielberg and Kennedy's directive, Brad Ball, the VP of marketing at Warner Bros., which distributed the film domestically, submitted all the film's marketing materials—TV ads, print ads, and posters—to "The Beast" team so they could surreptitiously place clues in those materials; no questions asked.

"The Beast" team identified the film's March Coming Attraction poster for movie theaters as the perfect launch vehicle because it was Warner Bros.' first marketing piece for the June 2001 film. By placing two key clues or "rabbit holes" in it, 99 percent of the audience would never notice, but 1 percent would—the community of film fans who study one-sheets.

The first "rabbit hole" was the film credit, "Sentient Machine Therapist" for "Jeanine Salla," placed in the poster's film credit block. They painstakingly chose a name that when entered into a search engine would only deliver intended results: Jeanine Salla's personal Web site and her employer's site, Bangalore World University.

The second, more subtle "rabbit hole" was embedded in the film poster's launch date, "Summer 2001," whose 10 characters could communicate a phone number. They embedded a specific number of tick marks in the typeface of each character, which yielded a phone number. When called, its cryptic voice message eventually sent audiences to an e-mail stating, "Jeanine is the key" and "You've seen her name before."

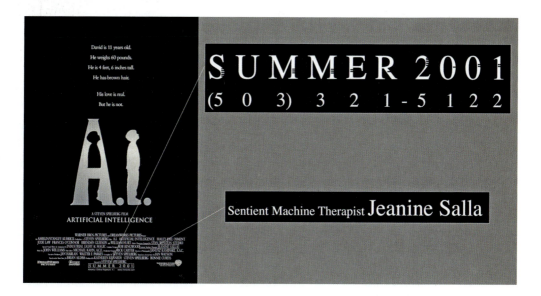

Courtesy of Jordan Weisman; Licensed by Warner Bros. Entertainment Inc. All Rights Reserved.

The two "rabbit holes" placed in the *A.I.* poster: the telephone number coded in hash marks on "Summer 2001" and the Sentient Machine Therapist film credit for Jeanine Salla in the credit block.

At this point, the creators held their breaths. In a chat room in the *Ain't It Cool News* movie media site, someone asked what a sentient machine therapist was. Just minutes later, someone mentioned finding the university site in India and the game was off and running. These clues led to a labyrinth of Web sites, phone numbers, games, puzzles, *Alice in Wonderland* allusions, and live telephone conversations with in-game characters. They all revealed backstory and more clues to the mystery of the murder of Evan Chan, Jeanine Salla's friend and a researcher in "thermal imaging and analysis in both salt and fresh water." Evan had been killed on his boat, *Cloudmaker* on March 8,

2142 under highly-suspicious circumstances—some 50 years after the film's timeframe—in a world in which global warming had flooded coastlines and robots were protesting slave labor.

Right away, the team learned that audiences would engage with the experience, but what the team thought they would take weeks to uncover, they devoured in a matter of days.

We discovered two things in those first couple of weeks. First, that my assumption and prediction that the hive-mind could do anything, was right. Second, that I was off by an order of magnitude about how fast they could do everything. What I failed to take into account is that not only do they have every knowledge base and skill base under the planet, but they also have infinite time, infinite resources, and infinite presence—they're everywhere simultaneously.

—Jordan Weisman, transmedia pioneer, founder of 42 Entertainment and other innovative entertainment companies; creator of *A.I.*'s "The Beast"

Instead of having produced 80 percent of the content up front, it turned out they had only produced 10 percent beforehand and still had the remaining 90 percent to produce. So "The Beast" had to move fast to create enough content and story chapters to keep the hive buzzing for the three months until the film opened. Working around the clock, and supported by outsourced help that was also in the dark about the ARG, the team struggled to stay ahead of the curve of the audience's tribal will and appetite. They created thousands of assets, some 35 Web sites and a plethora of videos, puzzles, TV spots, print ads, billboards, photos, e-mail messages, phone calls, faxes, and in-person events.

In early April, the film trailer released, echoing the "rabbit holes" in the one-sheet and broadening the reach of the ARG. At the same time, a few tech and entertainment sites received packages from Anna Ghaepetto, with a double-sided *A.I.* poster. The circles and squares around letters on the backside of the poster spelled out "Evan Chan was murdered" and "Jeanine is the key."

Audiences coalesced online and a Web-based audience group, the Cloudmakers, popped up on Yahoo to share information and theories about the latest bits of information in the complex game. Some 7,000 people registered as Cloudmakers members, with a small group among them providing the bulk of activity. Dubbed Puppetmasters by the players, the creators of "The Beast" tried to slow down the audience by making the clues harder. But the players were willing to go through huge hurdles as long as they were emotionally- or logically-connected to the story and the setting.

I was at work one day and a friend of mine pasted a link to this Web site for the Anti-robot Militia. And it was a hate group against robots, and it was super weird. We weren't quite sure what to make of it. There were a couple of other Web sites that were linked from it, so we visited those and we found the constellation of existing Web sites at the time. And my friend found the Yahoo group Cloud-makers and the chat room to go along with it. And then it started updating. This was a living thing, not a static thing that someone put out there. And it was such an amazing experience that I had to be involved in it.

—**Andrea Phillips, transmedia creator; moderator, "The Beast" Cloudmakers; producer, *Perplex City***

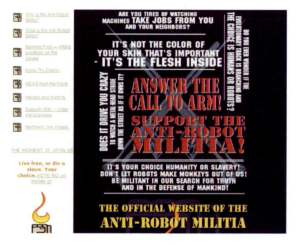

Courtesy of Jordan Weisman

A human call-to-action against artificial intelligent beings (A.I.s) at the Anti-robot Militia Web site.

The level of organization within this organic organization and among the players was astounding. In one instance, the Puppetmasters made the audience jump through many hoops to find their way to a Web site, which was totally white except for two eyes—a key image from the trailer. Underneath each eye was a place to enter text. Players figured out that if they entered a character's name on the left eye and paired it with a certain emotional state on the right eye they would get a video, audio, text, or a photograph related to that character and emotional state. They also worked out that each person could only enter text combinations once a day because of a cookie placed in their

browser. To overcome the creators' strategy to slow them down as individuals, the audience worked as a tribe. The Cloudmakers sent out a message to the millions of players worldwide to stop entering combinations. They assigned one group to research emotional states, another to find unique combinations of characters and emotional states. The players emptied out the entire database of assets in a single day.

Courtesy of Jordan Weisman

The site with the character-emotion puzzle that players of "The Beast" cooperated on to uncover more clues to the ARG murder mystery.

The transmedia ARG also had two layers of mystery. Who killed Evan Chan? Plus, the meta mystery, who had created this amazing collective game experience? Players dug up the Web sites' registrations, all in the names of famous puppeteers. Together those Web addresses on a US map revealed more info. But then players found a few abandoned Web sites that weren't used in the ARG, registered to a Microsoft employee. They staked out his house for three days. To avoid any public acknowledgement of their role, the Puppetmasters made that employee stay home until the players gave up the hunt. At another time, someone went on a chat pretending to be an ARG creator, saying that the players were supposed to be playing as individuals, not working cooperatively. The creators sat back and watched the other players debunk the phony Puppetmaster.

The audience's participation and reaction not only set the pace, but it also shaped the narrative. A minor character, the Red King, was an A.I. who fed on nightmares. The more nightmares he consumed, the more powerful he became. Players loved him and started

posting their nightmares online. In response, the team increased the Red King's presence and kept him throughout the rest of the story. Thereafter, the Red King spoke exclusively in lines taken from the players' nightmares—the ultimate reward of acknowledgement in a community experience.

> *They took all of these bad dreams and spun them into a really creepy piece of flash animation. And they actually mentioned the Cloudmakers as a group in a couple of places. That was a revelation for us. They knew about us. They saw us watching them. That was a really validating moment to feel like someone saw you caring about them. And they cared that you cared.*
>
> —Andrea Phillips, transmedia creator; moderator, "The Beast" Cloudmakers; producer, *Perplex City*

"The Beast" blended online and offline experiences like nothing had before. At an MIT artificial intelligence conference, the Puppetmasters had one speaker leave a Jeanine Salla business card on the podium. One side was in English and the other in a dialect spoken in a small town in Bangalore. Two hours after the conference concluded, the card's image was up on the Internet. Six hours later, a player in India had translated the card, sharing the new clues with all players.

Meanwhile, the traditional promotion campaign for the film—trailers, newspaper ads, and publicity—was running in parallel with the game. No one connected the two, although Kennedy and Spielberg delivered "The Beast" lines in some of their publicity interviews.

The worldwide publicity for "The Beast" was massive, some say bigger than the film's, further fueling curiosity over who had created it. Just a few weeks before *A.I. Artificial Intelligence*'s release, *The New York Times* discovered that Microsoft had created the game. The Puppetmasters tried to stay behind the curtain, deciding not to do any interviews until the film opened. The head of Microsoft's home division brought the "outed" story into Weisman, reminding him that they weren't going to do this campaign. Weisman claimed he'd thought he'd said, "Let Warner Bros. start paying for it and I'll pay my half afterwards." Microsoft's Xbox helmer chuckled and said, "Yeah. That must be what I said." Immensely good-spirited about the disregard for his decision, he kept the project's funding going.

As the film's premiere approached, the Puppetmasters placed a set of bread crumbs that led players to theaters around the world that were running secret previews of *A.I. Artificial Intelligence*, rewarding these superfans with an exclusive glimpse. When the players eventually saw the film, the cooperative narrative gave them a deeper and richer experience, which they dissected and shared. But because the film's US box office receipts didn't warrant the release of the traditional videogames that Microsoft had in development, the Puppetmasters had to find a way to wind down "The Beast." In keeping with its core

humanity theme, they allowed players to vote on whether to grant A.I.s equal status as humans. This storyline engendered a thoughtful and emotional discussion between the players and A.I. characters campaigning for equal status. The project ended with the players' vote, which, not by a landslide, granted A.I.s full recognition as humans. For the experience's coda, the Puppetmasters created two versions of a live-action video based on the two possible outcomes of the vote.

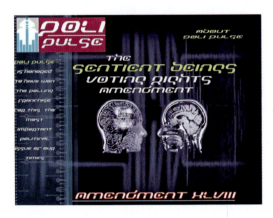

Courtesy of Jordan Weisman

The voting rights amendment that brought the campaign to an end and underscored its humanity theme.

The *A.I. Artificial Intelligence* film cost $100 million to produce and was a worldwide box office success, earning about $235 million. "The Beast" cost just shy of $2.5 million to produce, but created many millions of dollars in "earned media" exposures. The campaign generated more than 300 million mainstream-press media impressions in outlets such as *Time*, *USA Today*, and CNN, and many more on online outlets such as *Wired* and Slashdot. *New York Times* magazine deemed it the "best idea," and *Entertainment Weekly*, the "best Web site." Trailers and other assets were highlighted on TV and the Web, considered a big event in pre-YouTube days. The experience engaged more than 2 million players, some highly active and others watching the mystery unfold while superfans solved it.

When it was over, players and creators of "The Beast" were exhausted and exhilarated. And they were forever changed. The players created lasting relationships, several resulting in marriages. The experience inspired a new model of entertainment, ARGs. Many of the Cloudmakers went on to form ARGN, the genre's primary news source, and Unfiction, a community hub. Others worked together to design other ARG experiences, such as Mind Candy's *Perplex City*. Weisman later founded several top innovative entertainment companies, including 42 Entertainment, where he created other leading ARG experiences, such as *Halo 2*'s "ilovebees" and *The Dark Knight's* "Why So Serious?"

A massive experiment in cooperative storytelling, "The Beast" unleashed something audiences had never experienced before and would never quite experience again.

> *That consensus and the evolution of the story was an ongoing, living, breathing thing. When they reconstructed the story, it wasn't exactly the same as the story we wrote because it had gone through the filter of their millions of minds. And if you'd played it again with a new audience, they would have come up with a slightly different version of the story.*
>
> —Jordan Weisman, transmedia pioneer, founder of 42 Entertainment and other innovative entertainment companies; creator of *A.I.*'s "The Beast"

"The Beast" exercised many new muscles for creators and audiences alike. It expressed and fed a holistic, transmedia content creation and content consumption impulse; it blended the story world's fictional and the players' non-fiction universes; it integrated online and offline experiences; it assumed and welcomed audiences' intelligence and creative talent; and it banked on their cooperative, tribal behavior.

In the end, "The Beast" was a gamble and a meta commentary on the altruism of humanity.

Inspired by interviews with Jordan Weisman, transmedia pioneer, founder of 42 Entertainment and other innovative entertainment companies, and creator of *A.I. Artificial Intelligence*'s "The Beast"; and Andrea Phillips, transmedia creator, moderator of "The Beast" Cloudmakers, and producer of *Perplex City*.

Mad Men—Branding the American Dream

The branding for the Emmy award-winning *Mad Men*, some of the most distinctive and stylized creative work in television, was not an accident—not if Matthew Weiner had anything to do with it. And Weiner's artistic vision and attention to detail had a lot to do with it. Weiner had been incubating the series about the halcyon years of the post-WWII advertising industry for a very long time. In fact, it was Weiner's 1999 *Mad Men* script that compelled David Chase to bring him on as a *Sopranos* writer. After the *Sopranos* ended in 2007, Weiner tenaciously pursued a network for the drama he believed in. To Weiner, the period in US history from the late 1950s through the early 1970s spoke volumes about past, present, and future life in the US. HBO and Showtime passed on it, but eventually he sold 13 episodes of *Mad Men* to AMC, a network with no successful original programming to date.

So in 2007, the untested period drama with unknown actors needed a brand and a look. *Mad Men*'s creator Weiner had a clear vision, not only for what the series was about, but also how to communicate it. The series' key theme was encapsulated into the credo of Don Draper, the series' primary ad man, "Advertising is based on one thing: Happiness." *Mad Men* was a reflection of an era that sold the American Dream, but Draper, as a stand-in for many other Americans, was confused by what that truly meant and how to genuinely find himself within that dream.

It was the irony of this man's success at hawking happiness, while struggling to find a modicum of his own that Weiner wanted to communicate. That and the inner conflict of this Madison Avenue boys' club, who were doting suburban family men on weekends, and hard-drinking, chain-smoking, and philandering rakes during the week.

Imaginary Forces' creative directors Mark Gardner and Steve Fuller were tasked with creating an open that matched the series' complexity and emotion and communicated its core themes. They had two amazing assets to work with: the series' pilot and direct access to Weiner. Weiner wanted the title sequence to communicate two stories: the one that you see, and the real story that you only see in glimpses. And he didn't want it to have a 1960s *pastiche* look, but rather to be placed firmly in the era. Gardner and Fuller sought a visual style representing the 1960s that was also contemporary. And they wanted to convey the dual life of a man who was both cool and sophisticated, but also out of control.

> *He essentially didn't even know who he was and he was a conflicted character. We wanted to show everybody that on the surface he's very in control, a very confident person, but is living a lie. And that's something that's obviously come out far more over the seasons, but was there even just in the pilot. And so we wanted to have something that got to that.*

> **—Mark Gardner, creative director, SYPartners**

Weiner presented the concept of a man walking into an office building, entering his office, placing down his suitcase, and jumping out the window. But of course, the title sequence story needed to be much more than that. The creative directors explored the loss of control that falling represents by gathering their favorite falling scenes from films. Saul Bass' final title sequence for the film *Casino* and many Hitchcock films, including *North by Northwest,* inspired the creators.

> *We were trying to get at the heart of what the show was about in falling. It just seemed like this is something everyone recognizes. Everyone dreams about it. It's a very powerful metaphor.*
>
> **—Mark Gardner, creative director, SYPartners**

And with the benefit of CGI (computer-generated imagery) they created a more modern, stylized look. They had the man fall into a chasm of false and conflicting advertising promises—from pantyhose and alcohol to wedding rings and families—abstractly and monochromatically depicted on the sides of skyscrapers. Rather than present the fall in a continuous CGI camera move, it looked like a real film shoot, as if there were cameras on the surrounding buildings creating a variety of shots—wide shots, medium shots, and telephoto lens shots.

Stills taken from *Mad Men*; Provided through the courtesy of Lionsgate

The multiple "camera" POVs of the falling man created in CGI.

In early creative rounds, the sequence was one continuous fall. But Weiner wanted something to set up the fall. So the creators created an abstract office world that shattered and led to his fall.

The clincher was how the man was depicted. The creative directors chose the power and mystery of a black and white silhouetted man, ostensibly Don Draper, shown first from behind as he entered an office, echoed in tight silhouetted shots of his foot and briefcase. The motif of the backside of inscrutable figures has penetrated culture—from the brooding photo of JFK during the Cuban Missile Crisis to the *Following* fan movie clip montage of people shot from behind on YouTube.

Stills taken from *Mad Men*; Provided through the courtesy of Lionsgate

Mad Men's Don Draper is a mysterious and conflicted silhouetted man.

And the title sequence resolved on a signature, seated silhouette of an enigmatic Draper, in control, holding a burning cigarette. The silhouette shot sealed the deal for Weiner when Imaginary Forces pitched their initial work to him, and it ended up carrying the series' marketing materials.

> *It was that image of him from behind, sort of unknowable, but full of confidence and mystique that was the thing. He said, "That's my show. You summed it up in one frame."*
>
> —Mark Gardner, creative director, SYPartners

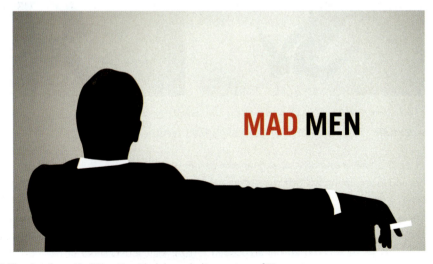

Stills taken from *Mad Men*; Provided through the courtesy of Lionsgate

The signature final silhouetted shot of *Mad Men*'s title sequence, which drove the series' branding and marketing materials.

The team developed three or four ideas, but it was clear to Weiner that the approach in the final title sequence was the best. But this sequence concept was chock full of problems for AMC and Lionsgate. First, they had concerns about associations of the falling man with photos of 9/11 victims jumping from the Twin Towers. And then there was the overt depiction of an indulgent, if not decadent, lifestyle.

> *I was witness to some of those conversations such as, "We can't have someone falling out of a building. We can't show someone with a cigarette in their hand. We can't have references to alcohol," which all are there in the title sequence. And Weiner said, "No, we need all of those in." It's quite inspiring to hear someone defend their project. You see how these things can get ruined by people insisting on compromising. And he just didn't.*
>
> **—Mark Gardner, creative director, SYPartners**

In the end, the network and studio took a chance on Weiner's singular vision and Gardner and Fuller's unique expression of it. Silhouette Man's reappearance, back in control, in the final frame, sold them on Falling Man. To bring the title sequence fully to life, Weiner chose "A Beautiful Mine," a moody and evocative jazz arrangement by RJD2 as the open's theme music. The song has a Hitchcockian quality, akin to Bernard Herrmann's music. Its foreboding is realized with a major break in tone and tempo when the man's world falls apart and he tumbles downward.

Mad Men's title sequence is a 36-second cryptic, dream sequence of a silhouetted man lost and trapped in the American dream that he peddles.

> *A number of people that I've spoken to ask, "What does it mean?" I think it was great to be able to get something that wasn't hitting people over the head with what it was supposed to be. It was sort of deliberately ambiguous, which I'm a big believer in.*
>
> **—Mark Gardner, creative director, SYPartners**

The title sequence débuted with the show on July 19, 2007 and it set the tone for what was ahead that night and for the next six seasons thereafter. Knowing how difficult the series was to market, especially in words or taglines, AMC's marketing team wisely seized the visual assets and ran with them. The sequence's clean and bold final shot became the foundation for the *Mad Men* brand and key art. AMC Marketing's campaign for the Season 1 launch featured a silhouetted Don Draper, nursing a whisky and cigarette on the poster, print and outdoor ads, and on-air promos. The campaign teased an intriguing, sexy, and provocative world and a cypher of a man. The cigarette was a bone of contention and was absent on iTunes during the first season, but later reappeared.

Stills taken from *Mad Men*; Provided through the courtesy of Lionsgate

Mad Men's **key art and marketing materials from its Season 1 premiere through to its final Season 7 were inspired by the series' signature title sequence image.**

Because of its iconic quality and ability to translate to so many applications, the silhouette man—both sitting and falling—was used in marketing materials throughout the life of the series. The falling man appeared against a white background with no other text except the premiere date in the Season 5 poster. And the iconic seated Don Draper silhouette carried through to the final season's poster, catapulting viewers into the 1970s. Created by renowned artist Milton Glaser, who developed the "I Love New York" logo, *Bob Dylan's Greatest Hits* album poster, and the DC Comics logo, it juxtaposed what Glaser recognized as the slick "figure that has become symbolic of the program" with the psychedelic art of the era. His poster was another graphic representation of Draper's conflicting parallel worlds.

Year after year, AMC created outstanding marketing campaigns that maintained a tension between mystery and the big reveal, always reflecting the core themes of the series and the era. Because of its knack for teasing the season's storylines, the series' key art became a story unto itself. Traditional media outlets and fans on social media alike speculated on what each new season's key art meant—propelled by the enigmatic tone of the title sequence.

I think that the way Mad Men drips out limited information is pretty masterful. I think it's brilliant how they use this idea of secrecy, and no spoilers, and we're just going to give you this cryptic trailer from the next episode, and here's the poster of Don Draper from the new season, and what does it mean? It has a tremendous effect of creating a desire and sense of excitement about it. I think it's one of the greatest TV shows of its time and its greatness comes from things that are almost entirely not about plot.

—James Poniewozik, senior writer, television critic, *Time* magazine

Mad Men's open, which has remained relevant for the entire series' run, won the 2008 Primetime Emmy Award for Outstanding Main Title Design. The series has racked up major accolades including multiple Golden Globes, Primetime Emmys for Outstanding Drama Series and Outstanding Writing for a Drama Series, Writers Guild Awards, and a Peabody Award. *Mad Men* has also deeply penetrated popular culture. Its cast donned the cover of *Newsweek* for a 2012 double retrospective issue of 1965 life; Banana Republic created an enormously popular *Mad Men*-themed clothing line; the Mets designated a *Mad Men* seating section at one of their games; and, the series got its own category on *Jeopardy*. *Mad Men* put AMC on the map as a premium original programming destination, along with two other dramatic stand-outs, *Breaking Bad* and *The Walking Dead*.

The silhouette and falling man opener for *Mad Men* found the answer to the untested series' biggest communications problem: how to market a period show about marketing. Instead, it marketed a show about the universal and current themes of conflict and human frailties. It told a mini-story that set up the larger story and themes; it established a visual style that communicated an earlier era, but still felt modern; it distilled complex stories and meaning down to a distinctive, bold graphic imagery that supported an entire brand; and it sustained multi-year marketing campaigns with the iconic power of its visual language.

Inspired by interviews with Mark Gardner, creative director, SYPartners (former creative director, Imaginary Forces); and James Poniewozik, senior writer, television critic, *Time* magazine.

Lizzie Bennet Diaries—Perspective Storytelling

When Bernie Su, a screenwriter with a knack for writing short-format online creative narrative, met entrepreneur and vlogger Hank Green at an event in March of 2011, he was about to redefine transmedia storytelling. Green asked Su whether it was possible to adapt a book into a vlog or a YouTube series. Green wanted to create a modern, interactive version of Jane Austen's classic novel *Pride and Prejudice*, about Elizabeth Bennet and her three unmarried and fortuneless sisters in nineteenth-century England, who encounter wealthy bachelors Charles Bingley and his awkward friend, William Darcy. Through a complicated maze of social misunderstandings, secrets, and protection of sisters' honor, Elizabeth and Darcy's love is thwarted, but, in the end, found.

Su clarified that Green didn't mean simply chopping a film into 50 pieces, but rather breaking the fourth wall and allowing audiences to participate. And because Green meant just that, the pair spent three hours theorizing about how it could be done, what the limitations might be, and how those limitations could enhance the storytelling.

> *The key thing that Hank wanted was for it to be interactive, which I agreed with. With a large canvas like YouTube you can do a lot of things, but that doesn't mean you should do them all. We needed it to be producible.*
>
> **—Bernie Su, storyteller and head writer, *Lizzie Bennet Diaries***

So the co-creators, along with Pemberley Digital transmedia producer Jay Bushman and editor Alexandra Edwards, spent the next nine months developing *Lizzie Bennet Diaries*, a contemporary digital adaptation of the novel told on YouTube vlog episodes and across other media platforms including Twitter, Tumblr, and Facebook. The primary media platform was the personal YouTube channel of 24-year-old grad student Lizzie Bennet. There, the eponymous character chronicled the travails of school pressures, a mountain of debt, living at home, and a paltry love life in the first person, while her best friend Charlotte Lu ran camera. And she regularly revealed her passive-aggressive feelings for her love interest, William Darcy. Beginning in April of 2012 and over the course of a year, the *Lizzie Bennet Diaries* team posted about two, two- to eight-minute episodes per week, allowing the complex love story to unfold in real time. Like a rolling TV show production, the team was writing, shooting, editing, and releasing simultaneously—shooting about a month in advance and writing about two months out.

Lizzie Bennet Diaries/YouTube

The primary transmedia platform, Lizzie Bennet's personal YouTube account.

When *Lizzie Bennet Diaries* débuted, only four characters appeared on screen: three Bennet sisters Lizzie, Jane, and Lydia, and Lizzie's best friend, Charlotte. For varying periods of time, other characters remained off screen, including Ricky Collins, Caroline Lee, Bing Lee, Mary Bennet, George Wickham, Maria Lu, Fitz Williams, and Gigi Darcy. Perhaps the most significant was Lizzie's love interest, William Darcy, who was kept off screen to build anticipation and whose eventual on-screen arrival was heralded with the hashtag #DarcyDay. But even while off screen, many characters were active on social media or started their own YouTube channels. These characters' "real-world" footprints vastly expanded the *Lizzie Bennet Diaries*' universe if audiences wanted to explore further.

© Pemberley Digital

The first four cast members; (Left to Right) Julia Cho as Charlotte Lu, Ashley Clements as Lizzie Bennet, Mary Kate Wiles as Lydia Bennet, and Laura Spencer as Jane Bennet.

And explore they did. Because Lizzie Bennet and others were active on other digital channels, audiences found new characters, dialogue, and interactions that drove critical plot points.

In transmedia multi-platform storytelling you create a great story world and surround the simple narrative with other great content. So, it's out there if you want to consume it as a user. You can go on Lizzie Bennet's personal YouTube channel and click "play." And, if you want to dive deeper, you click around. You click on Lizzie's Twitter and see who she's talking to. You click on Lydia's YouTube channel and see what she's doing when Lydia and Lizzie are sharing the same room together. You can even see what Gigi's doing ten months before she actually appears on screen.

—**Bernie Su, storyteller and head writer,** *Lizzie Bennet Diaries*

From the beginning, the creators provided audiences with immersive ways to engage with the story on social media. In a seminal early moment in the story, they opened up the project's first "rabbit hole." In April, Lizzie and her sister Lydia chatted on Twitter about an upcoming wedding. During the wedding, unseen characters Caroline and Darcy tweeted about how bored they were and noted how Bing was dancing with one girl all night. The next day, Bing and Jane followed each other on Twitter. Lizzie posted the screen grab of the characters' interaction on her Tumblr. The Twitter and Tumblr platforms revealed the storyline that eligible bachelor Bing and Lizzie's sister Jane had the "hots" for each other. In the next post-wedding YouTube installment (Episode 5), sisters Lizzie and Jane talked about what happened at the wedding. Audiences that hadn't caught the Twitter exchange could still follow the story.

@LooksByJane/Twitter and @bingliest/Twitter

Lizzie Bennet Diaries' first "rabbit hole," when friend Bing and sister Jane follow each other on Twitter, joining together Darcy's and Lizzie's worlds.

As the story progressed, it mirrored the storylines from the book, with some modern-day adjustments. The creators knew that Jane leaves for London, so in *Lizzie Bennet Diaries,* she went to Los Angeles. As more audiences followed the story on the various digital platforms, they interacted with the characters and reacted to the plot and the minutest of story elements. Because of the unique online video rolling production model, Su and the team could react to the audience.

In fact, the audience determined the heightened role of characters Gigi and Fitz. Gigi, Darcy's sister, had already been established and her character demonstrated that Darcy had compassion. Later in the production Fitz Williams was introduced briefly as a minor character simply to show that Darcy had a friend and to share key information with Lizzie. But the fans went crazy for Fitz on Twitter and Tumblr, asking him to come back, so Su quickly created a Twitter account for Fitz. Su also noticed on Tumblr that the audience was imagining that Gigi and Fitz were BFFs.

> *I played it out in my head, "Does this affect anything? Does this change any of the core narrative if we turn these two into a dynamic duo that provides the color commentary of this whole next arc?" And it didn't. So I said, "Let's just have them go crazy." So, they became what the fans dubbed Team Figi—F-I-G-I for "Fitz and Gigi"—it became a thing. They started a bromance (even though Gigi's a girl), where they would snark at each other on Twitter every week or so.*
>
> —**Bernie Su, storyteller and head writer,** *Lizzie Bennet Diaries*

This "best buds" relationship of Team Figi became a vehicle for deeper perspective storytelling, allowing the audience to experience layers of narrative from different POVs. In the book *Pride and Prejudice*, the perspective is Elizabeth Bennet's. In *Lizzie Bennet Diaries'* Lizzie Bennet YouTube channel, it's Lizzie Bennet's. With other transmedia elements, it could also be other characters' perspectives. So the creators used this character dyad to showcase the story's central theme and advance a key storyline—the revelation of many misunderstandings that had kept Lizzie and Darcy apart. After Gigi learns of Lizzie's vlog, she watched and "Liked" the first YouTube episode, which created an automatic tweet saying she'd "Liked" the video. The fans went nuts, realizing that Gigi was on track to learn about the many misunderstandings between the would-be lovers. This began Gigi's seven-hour, real-time binge-watching of the diaries, with her reactions playing out in dialogue with Fitz on Twitter. Audiences were captivated while she progressed through the episodes, creating a unique alchemy between the characters and the audience.

Near the end of the transmedia experience, after Lizzie and Darcy's series of frustrating missed connections, Lizzie and Gigi, Darcy's sister, went to lunch (their lunch photo posted on Twitter) and decided to go to San Francisco the following weekend.

By then Gigi had more than 20,000 followers on Twitter. In the next vlog episode, Gigi mentions that her brother Darcy will be in San Francisco, placing the two star-crossed lovers together.

To pay off on this big storyline, the cast and crew went to San Francisco and documented the weekend trip digitally. They commented on key moments and posted a series of photos on yfrog of the three characters sightseeing. Audiences were so excited to finally see Lizzie and Darcy having fun together that one tweet that linked to the photos garnered more than 1,800 favorites.

@ggdarcy/Twitter

Audiences marked their excitement at finally seeing photographs of Lizzie and Darcy together by retweeting and favoriting this tweet.

In my opinion, this was the greatest thing in transmedia that we did. If you go to those posts you can see the engagement, and it's crazy. They were captivated. And then the Monday video is of Darcy and Lizzie post-tour where they're much closer and have fallen in love. It was great.

—Bernie Su, storyteller and head writer, *Lizzie Bennet Diaries*

The early marketing for *Lizzie Bennet Diaries* was purposefully minimal. The team didn't want a lot of attention for a story that had little content available at the beginning and would unfold slowly over time. They wanted word-of-mouth and press to translate into binge-watching of the videos and the creation of an engaged fanbase. Their targets: young digital audiences and Austenites, Jane Austen devotees.

Hank Green tweeted, tumbled, and created a few videos promoting the show on his YouTube TV show, *VlogBrothers.* The team also used Facebook as a promotional vehicle. A few months after the series started, with just four characters having appeared on screen to date, *Lizzie Bennet Diaries* held an event at VidCon 2012. Expecting an intimate event, it was a standing-room-only affair. They also held an event at LeakyCon, a Harry Potter convention, and some cast and crew attended Comic Con. The team conducted one key interview with online video outlet, *Tubefilter*, which led to coverage in *Mashable, Time,*

USA Today, *EW*, and CNN. The press got out ahead of them, sometimes getting the creators' vision wrong because the project hadn't drafted a press release.

Lizzie Bennet Diaries engaged big audiences and created loyal superfans. On the primary YouTube account alone, the series received more than 46 million views (Episode 1 had 1.7 million views) and 240,000+ subscribers. The project advanced the story and interacted with audiences on many other live, interactive digital channels, including four auxiliary YouTube channels, four Web sites, 21 Twitter accounts, six Tumblr accounts, and Pinterest, LinkedIn, and Lookbook accounts. Fans created legions of their own Lizzie-inspired fan fiction. At the end of the series, the creators' modest $60,000 Kickstarter campaign to create DVDs raised almost a half million dollars and secured a partnership with DECA, a cross-platform media company targeting women, which jump-started Pemberley Digital's subsequent Austen adaptations, *Welcome to Sanditon* and *Emma Approved*.

The industry also recognized *Lizzie Bennet Diaries*' interactive innovation, winning the 2013 Primetime Emmy Award for Outstanding Creative Achievement in Interactive Media—Original Interactive Program. It also won the Streamy and IAWTV Awards for Best Interactive Series and the 2012 TV.com award for Best Web Series.

© Pemberley Digital

Cast of the *Lizzie Bennet Diaries*, 2013 Primetime Emmy Award Winner for Outstanding Creative Achievement in Interactive Media.

Lizzie Bennet Diaries invited all audiences into the tent, whether they sought a linear or a fully-immersive experience. The transmedia project explored the boundaries of perspective storytelling using multiple platforms to present different characters' POVs; it authentically told the story in real time with real-world platforms; it engaged and interacted directly with its audience ambassadors; and it responded to their reactions, allowing them to shape storylines and character development.

Lizzie Bennet Diaries' 100 episodes—six and one-half hours—and other transmedia content are still available at Lizziebennet.com. They are a testament to Jane Austen's legacy and proof of the timeless appeal of a good story, engagingly told, that reflects our current times.

Inspired by an interview with Bernie Su, co-founder, executive producer, showrunner, and head writer, *Lizzie Bennet Diaries*, Pemberley Digital.

Here Comes Honey Boo Boo "Watch 'n' Sniff" Premiere Event—Socialized Talent and Content

If you've seen Alana "Honey Boo Boo" Thompson, even for a brief moment, then you've witnessed the *tour de force* personality of a child who at the age of six launched a hit reality television show, became a popular culture phenomenon, and established a successful business franchise. The TLC reality TV program *Here Comes Honey Boo Boo* emerged out of Alana and her family's 2012 season-opener appearance on *Toddlers and Tiaras*, a reality show that follows the child beauty pageant circuit. As the pint-sized, outspoken, and untraditional beauty contestant unapologetically doled out her down-home-Georgia, tell-it-like-it-is axioms such as "a dollar makes me holler" and gulped her "Go-Go Juice" recipe of Mountain Dew and Red Bull, it was obvious that Alana was a stand-out. The media and audiences alike took notice of Honey Boo Boo and her family. She took the media by storm, including appearances on *Doctor Drew*, *Good Morning America*, and *Anderson Cooper*. Social memes and conversations about Honey Boo Boo exploded, with two of her clips garnering a combined 2.4 million YouTube views.

Because of Alana's breakout as a pop culture sensation in early 2012, TLC created the stand-alone series *Here Comes Honey Boo Boo* following the outrageous and spontaneous family of Alana "Honey Boo Boo," her stay-at-home mom June "Mama," chalkmining dad Mike "Sugar Bear," sisters Lauryn "Pumpkin," Jessica "Chubbs," Anna "Chickadee," and baby niece, Kaitlyn.

TLC fully embraced Alana's family's unique Southern redneck vernacular and way of life by featuring a big fart in *Here Comes Honey Boo Boo*'s theme song. A few show detractors saw the show's immersive reveal on Alana's rural Georgia life as offensive or exploitive. But not so with most audiences. What may have begun as voyeurism of a junk-food-hoarding, gas-passing, and don't-give-a-damn circus act, soon became a love affair with a genuinely caring family that was refreshing and fun to watch.

While Honey Boo Boo was the infectious and unfiltered point of *entrée* to the unique family, its heart and soul was the sometimes crude, extreme couponer "Mama" who adored her family. Her ironic wit and shocking self-awareness were expressed through a mantra of "You like us or you don't like us. We just don't care." This allowed audiences to laugh with, not at the family, thereby eliminating any sense of exploitation. After a few episodes, the farts and redneck comments fell away, leaving a loving family navigating modern life, trying not to lose sight of what's important.

At TLC there's a lot of heart in our programming. We often talk about being at the intersection of remarkable and relatable. And I think remarkable in the instance of Here Comes Honey Boo Boo is just how over-the-top and larger-than-life they are. But also there's a ton of relatability in how they live their lives and in them as a family unit.

—**Dustin Smith, VP communications, TLC**

© TLC/George Lange

The Shannon and Thompson family.

The short first season of *Here Comes Honey Boo Boo* was shot in the summer while the kids were out of school to capture the program's sweet spot of family interactions. It launched later in the summer and continued through the fall. The publicity team at TLC promoted the new season with media interviews with Alana and other family members, with coverage appearing in CNN, *Salon*, *Time*, *USA Today*, Gawker, *Washington Post*, and *The Los Angeles Times*.

The media relations strategy started with a TV critic campaign, and we sought very select, high-return media interviews. But the bread and butter of the show was the pop culture . . . the passion. So we went heavy on clips to showcase their love and humor.

—Dustin Smith, VP communications, TLC

Those video clips were show lifts of a minute or two in length that showcased a balance of both outrageous and tender family moments that TLC's publicity team placed with various digital outlets and broadcast press. The social media team embedded hashtags of the family's catch phrases such as "beautimous," "redneckognized," and "smexy" into the programming to fuel the social media meme craze. Celebrities from Johnny Depp to Tina Fey broadcast their affection for or fascination with *Honey Boo Boo*—both the child and the reality show. The fall season's programs averaged 2.3 million viewers.

Because of the success of the first season, the network shot four seasonal specials, again when the family was together during holiday breaks, airing in late 2012 and early 2013. *Honey Boo Boo* became the face of TLC with the network's "Happy Boo Year" promotion leading into New Year's Day. Alana and the family were also featured on Anderson Cooper's CNN New Year's Eve show with a live remote from Georgia with the family. The show and its cast had enormous social currency because of Alana's *Little Miss Sunshine* quality, the hilarity of the characters, and the universal appeal of the program's family themes.

When the second season débuted in July of 2013, TLC had listened carefully to its audiences and was at the ready with targeted content and assets to keep audiences engaged. Their goal was to signal to their target audience of women 18-to-49 that the new season was more outrageous than ever and bring them into the family's crazy lifestyle.

The unique sights, sounds, and smells of Alana and her family became the perfect wink-wink nod-nod audience experience to kick off the Season 2's double-stacked premiere. The *Here Comes Honey Boo Boo* World Premiere Watch 'n' Sniff Event integrated on-air and off-air content and capitalized on the program's quirky and social factor. The big idea was to bring the 360° experience of the family's story universe directly to audiences. To do that, TLC's marketing team created an interactive promotion that would allow viewers to get a whiff of what was happening on the air through scratch cards that released scents correlating to specific scenes in the premiere.

If there ever was a show that we wanted to put a smell into, it would be Here Comes Honey Boo Boo. So production came to us and asked, "What if we develop this scratch 'n' sniff episode? What could you guys do with it in marketing?" And I said, "We could create a scratch 'n' sniff ad of course." We had to go through the show bit by bit and identify moments that we could put a smell to. For instance, the train going by could smell like diesel. The barbecued ribs were awful smoky. Was there a fart smell? What about pleasant smells like Baby Kaitlyn who smelled like baby powder, and a vanilla cupcake?

—**Rose Stark, VP marketing, TLC**

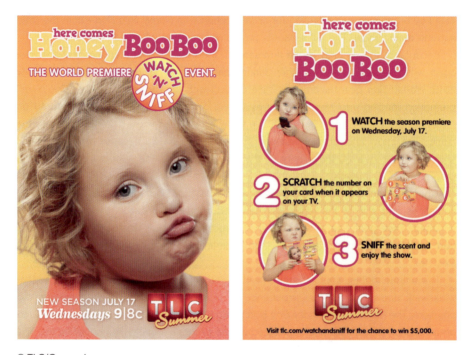

© TLC/George Lange

Here Comes Honey Boo Boo Watch 'n' Sniff insert cover and instructions.

The team created 9 million 5 × 7 Watch 'n' Sniff cards with six signature smells from the premiere episode. They were: Baby Kaitlyn; Train; Pork and Beans; Butter; Go Karts; and Cupcake. To deliver this immersive viewing experience to audiences, TLC placed the cards in a closed insert in *People* and *US Weekly* along with a full-page ad with the promotion's signature art—a cheery, summery headshot of Alana pursing her lips. The tear-off card provided specific instructions on how to watch, scratch, and sniff.

While audiences watched, indicators appeared on the screen, such as a flashing number one to signal the first smell. Alana would then appear in a bubble smelling and reacting to the smell, prompting audiences, "Smell number one." (In the end, the fart smell fell by the wayside because of the media publications' policies on bodily functions.)

Fans could also enjoy a virtual Watch 'n' Sniff experience at TLC.com/HoneyBooBoo, where they could mix and match the smells featured in the show and enter to win $5,000. The Watch 'n' Sniff premiere event was heavily cross-promoted on air through the Discovery cable family including TLC, Discovery Channel, Animal Planet, OWN, and more. The marketing team also placed spots on other national cable channels, such as HGTV, A & E, E!, WE, TBS, and Nick@Nite. And, they promoted it through a local cable and radio buy in key markets supported by street teams distributing the Watch 'n' Sniff cards. Cards were also available at select Time Warner Cable retail stores across the country.

To build buzz prior to the event, the social media and publicity teams sent influencers the Watch 'n' Sniff card along with a package of *Here Comes Honey Boo Boo*-inspired items, such as cheese balls and a whoopee cushion. Celebrities, press, and hard-core fans were encouraged to snap a picture of it and post it on their Instagram, Twitter, or Facebook. And celebrities from Kathy Griffin to Perez Hilton were game.

Perez Hilton/Instagram

Perez Hilton socializes the *Here Comes Honey Boo Boo* Watch 'n' Sniff promotion.

The team also supported the premiere and the entire season with creative digital engagement tools, for example, downloadable ringtones featuring popular phrases such as "You better redneckognize" that echoed the customized hashtags for each episode. Other digital offerings included an application to *Honey Boo Boo*-ize photos on Facebook and share with friends, quizzes about Alana and the program, exclusive family photos, and an online nickname generator to give audiences their own redneck names.

The Watch 'n' Sniff promotion blew up on the social networks before the premiere, with fans speculating about the possible aromas, especially whether there was a fart smell among them. The social buzz continued during and after the premiere with a steady stream of accessible and digestible content, such as hashtags, soundbites, animated GIFs, screenshots, and video clips that inspired tweets, comments, shares, and views.

More than 2.9 million viewers tuned in to *Here Comes Honey Boo Boo*'s Season 2 premiere, with it taking the top spot for the night among women 18-to-49 and outpacing the first season's premiere. The off-air efforts reached 40 million women aged 18-to-49, accounting for some 62 percent of the target audience. *People* magazine mused, "Anybody smell a hit?" The premiere launched a stand-out second season that culminated in even higher viewership for the finale, featuring the commitment ceremony of "Mama" and "Sugar Bear."

All of TLC's promotional activities acknowledged *Here Comes Honey Boo Boo*'s brand archetype, The Regular Guy. The Watch 'n' Sniff event listened carefully to the target audience and mined the "hot" topics; paid off on the brand archetype by using humor; invited audiences directly into the *Honey Boo Boo* universe; and created interactive and socialized content that integrated on-air and off-air experiences. And in a time-shifting world, the promotion made *Here Comes Honey Boo Boo*'s premiere must see and must smell live TV.

> *We are always trying to figure out ways to get viewers to watch the night of, hoping they're not considering it a DVR-able show. That means the pressure is on to be creative in marketing that pushes them to think, "Oh, my gosh, I have to watch it when it's on because I have to be part of that conversation while it's happening on social media or the next day with my friends."*
>
> —**Rose Stark, VP marketing, TLC**

After several seasons, *Here Comes Honey Boo Boo* became a reality television program poised to explore the older kids' coming-of-age stories and had burgeoned into a franchise with home video, T-shirts, calendars, and other merchandise. In a world where comedy rules, the parodies and satires of the *Here Comes Honey Boo Boo* way of life, in fact, were celebrations of it. As such, the brand, the show, and the child became a cultural meme offering a humorous, but heartfelt lens into American family life.

And so, when "Mama's" association with an alleged sex offender jeopardized the show's accessible The Regular Guy persona—an essentially wholesome, relatable, everyday family—TLC had no choice but to cancel the socially "hot" reality series in 2014.

Inspired by interviews with Dustin Smith, VP communications, TLC; and Rose Stark, VP marketing, TLC

Author's Anecdote

Remembering That Success Comes From Risk-taking

At the winter Television Association Press Tour in 1998, my eagle-eyed *Masterpiece* senior publicist pointed out Sarah Jessica Parker having lunch with a top critic at the outdoor café overlooking the majestic swimming pool and gardens at the Ritz Huntington in Pasadena (now the Langham Huntington Hotel). I asked her why Parker was at Press Tour, and she said that she was starring in a new comedy on HBO, launching in June. Based on my preconceived notions of Parker's work and HBO's non-existent track-record in comedy, I casually remarked that I didn't think the show would go beyond one season. I couldn't have been more wrong. Sarah Jessica Parker was at the TCA Press Tour to promote *Sex and the City*, what became HBO's six-year smash comedy hit.

Market It!

You're in the home stretch, steeped in insight about content creation and content marketing. You've been inspired by some amazing transmedia projects. Your treatment or script is in good shape. And your content, marketing, and engagement plan is written, refined, and approved by all your stakeholders. You're *almost* ready to execute.

But to execute it, you must sell it. Orson Welles, a great storyteller, magician (literally), and huckster once said that the film business is "about 2% moviemaking and 98% hustling." Hustle is what you must do to bring your transmedia project to the end zone.

The Business of Show Business

Making the right business decisions is critical to protecting your ideas and realizing your project. That's as important as your project's creative concept and marketing. So put on your CEO hat again and channel the business, legal, and sales aspects of your multi-tentacled job description. Begin by researching the business and legal implications of developing your transmedia project. Go online, buy books, talk to other content creators, and consult with experts.

Professional Counsel

Hollywood's reputation is deserved, so you should arm yourself with the best counsel and negotiators on your behalf. While it may be expensive up front, it's worth every penny in the long run. To find the best fit, do your own sleuthing. Ask your contacts and colleagues whom they trust, and look for experts who understand your type of project.

If your project is successful, then co-production, financing, and distribution contracts will be a big part of its future. Any time you sign a contract, whether it's for an option on an intellectual property or a distribution deal, you will need an experienced **Entertainment Attorney** (not a general practice business attorney) to look over the contract and perhaps

negotiate a better deal. You might be able to get to the point of a deal without an attorney, but you should never sign anything without one. Your attorney's fees will be hefty, in the several hundreds of dollars per hour. So be sure to find one who's a good fit. Every time you engage with them, you will be charged. The first conversation, about representing you, should be free, but clarify that up front.

Depending on what you do, you may also want an **Agent**. Agents represent actors, directors, writers, composers, musicians, athletes, and companies' brands. There are five big agencies in Hollywood (CAA, ICM, UTA, WME, and Paradigm) plus many other smaller boutique agencies. Agents shop your creative work or talent around. Because the agent receives a percentage, usually 10 percent, they have an incentive to get you the best deal possible. A good agent hustles hard on your behalf and has excellent contacts with producers and studios. Getting an agent can be very difficult. If you have no track-record, then agents rarely want to take a chance on you. Once you have a deal in the works, it's much easier. Then you can apply his or her expertise to negotiating the deal and have someone representing you moving forward.

Some people also have **Managers**, who steer the overall trajectory of your career. Managers generally charge 15 percent and are able to receive producing credits on project. As a result, many agents are becoming managers.

At the distribution phase you'll bump into other players. If you have sold the rights to your project to a studio or an equity investor, they may have control over whom to license it to for distribution. If you're an independent, you may still retain the rights and determine licensing for domestic and foreign distribution. Sometimes distributors engage in pre-sales agreements to obtain the property at a lower price than they would at a later stage. They can be more involved in its development and pre-sell it into foreign territories to raise money for production. These deals are usually reserved for creators with proven track-records.

If you're an independent filmmaker seeking *domestic* distribution, you might be contacted by a **Producer's Representative** looking for you to license the rights to the film for a fee or provide them with a percentage of the domestic deal. Some producer's reps troll the Internet or the festival circuit looking for projects. Research what they've gotten distributed and ask for references. There are also self-distribution models in which companies distribute and market films for a fee, but the creator retains ownership of their rights. If you have a great project, and excellent contacts, you might be able to land a domestic deal with smaller theatrical distributors on your own.

If you're looking for *foreign* distribution or sales in additional media formats, you should hire a **Sales Agent** because these areas are specialized. In film, a sales agent licenses your movie to another company from a foreign territory, which will handle distribution and marketing for that territory. **Aggregators**, not unlike sales agents, work in different *media platforms*. Digital aggregators acquire digital rights for online and mobile and cable

aggregators acquire rights for cable VOD, pay cable, and basic cable. Most specialize in just one area or platform.

You can negotiate film and television *home video* on your own. Simply pick up the phone and call them directly. But first have someone who knows home video look at your materials—cover art and press kit—to ensure you're putting your best foot forward. Then just send out a few at a time. Don't shotgun them. If you get a few "Nos," find out what's wrong. If you get feedback, tweak your presentation and send it out to a few more.

Start and end by remembering this one key mantra with sales agents, producer's representatives, and aggregators: never sign away the worldwide rights to a single entity, unless it's to a major studio.

Intellectual Property

Intellectual Property (IP) rights are exclusive rights to creations of the mind, which is what your transmedia project is. Intangible IP assets include literary, musical, and artistic works; words, symbols, phrases, and designs; and discoveries and inventions. Some typical IP rights are copyright, trademarks, patents, and industrial design rights.

Before you have a full treatment or script, you can **Register** your idea with the Writers Guild of America (WGA). The WGA allows writers to register ideas during development because notes, outlines, and general ideas are vulnerable to theft. So file early with the WGA (www.wga.org). The fees are minimal, less than $25. Filing does not establish statutory ownership, but it does provide a dated record of the writer's claim to authorship and possession of the material being registered. This is important because many legal disputes are based on who first possessed the idea. If necessary, WGA registration serves to provide evidence at trial. Be sure to create a paper trail when pitching your idea to anyone.

A **Copyright** grants the creator of a work exclusive rights to the use and distribution of a work, usually for a limited time in a specific territory. Copyright covers literary; musical, including any accompanying words; dramatic, including accompanying music; motion pictures and other audiovisual works; pictorial, graphic, and sculptural works; sound recordings; pantomimes and choreographic work; and architectural works. Copyright's intent is to give creators control of and profit from new works. Copyright doesn't cover the idea, but rather the manner in which it's expressed. If you register your specific idea in a complete treatment or script with your characters and plot, then you own the rights to that substantive and discrete execution of that idea. The title or tagline of your project cannot be copyrighted.

The copyright duration is the life of the creator plus 50 to 100 years from the creator's death. Copyrights are also territorial, registered within a country, although most nations recognize a standardized international copyright agreement. In a highly-global media landscape, making sure you're covered globally is important.

Once your idea is complete you should register it with the US Copyright Office to protect yourself (www.copyright.gov). The filing fee is less than $50. By filing a copyright registration form with the US Copyright Office you are fixing it in a tangible medium, meaning you own the copyright of your work at that moment you write it down or record it.

David Wees/flickr

Register your fully-articulated creative idea with the US Copyright Office to protect it.

Be sure to mark your work clearly with your copyright. According to the US Copyright Office, the notice for visually perceptible copies should contain *all* of these three elements:

1) The symbol © (the letter C in a circle), or the word "Copyright," or the abbreviation "Copr.";

2) The year of first publication of the work. In the case of compilations or derivative works incorporating previously published material, the year date of first publication of the compilation or derivative work is sufficient. The year date may be omitted where a pictorial, graphic, or sculptural work, with accompanying textual matter, if any, is reproduced in or on greeting cards, postcards, stationery, jewelry, dolls, toys, or any useful article;

3) The name of the owner of copyright in the work, or an abbreviation by which the name can be recognized, or a generally known alternative designation of the owner.

 Example: © 2015 Anne Zeiser

 Example: Unpublished Work © 2015 Anne Zeiser

If you feel that someone has stolen your work, you can file a copyright infringement case in civil court to prevent the infringer from using it and perhaps secure monetary damages. There are some copyright limitations to the creator's exclusivity of copyright, allowing "fair use" of certain works, giving users certain rights. Digital media has become

one of the thorniest areas of copyright law, giving rise to differing interpretations of these exceptions and presenting additional challenges to copyright law's philosophical foundation. If your work is digital and copyright infringement issues arise, be sure your attorney is an expert in digital copyright law.

You may option your IP to another party. An option is a contract between the owner of the IP and a producer or production company to hold the work for a specific period of time to develop the project. The timeframe is usually 12 or 18 months and the cost varies greatly. Be sure that any transfer of copyright is recorded with the US Copyright Office.

In sharing or licensing copyright ownership, you may be sharing a percentage of the proceeds from the property with other rightsholders. When you cut those deals, be attentive to issues of copying, credit, adaptation, performance of the work, and financial benefit.

> *Proper and timely registration with the U.S. Copyright Office of a work at the time of its creation is obviously a critical first step for parties looking to protect their intellectual property. Thereafter, it's primarily about the deal terms for the exploitation of that work, i.e., has the scope of rights that the creator intends to grant been properly defined (i.e., what rights in what media are being granted versus being reserved to the creator, and what holdbacks or other encumbrances might apply to the rights being reserved); the applicable term of the rights being granted; what consultation and/or approval rights will the creator have, if any; what "first opportunity" rights to create any derivative works (assuming derivative production rights are being granted in the first place) and/or passive entitlements with respect to the production and exploitation of such derivative works does the creator have; and what "profit" participation in the proceeds of the exploitation of the works and any ancillary rights therein does the creator have, etc.*
>
> —Stephen Saltzman, partner, Loeb & Loeb, LLP

You can **Trademark** your IP if it's a word or graphical sign, shape or color, or sound. Trademarks must be distinctive, identifying and distinguishing the goods or services they protect as originating from a particular organization. This is to ensure that potential buyers are not tricked into buying a product of one company while believing it is a product of another company. You can register for a trademark at the US Patent and Trademark Office (USPTO) (www.uspto.gov). The cost is less than $300.

A common registration is a trademark (for a product) or service mark (for the source of the service), which can be a word, phrase, symbol, or design, or a combination of

them. A logo or a phrase, such as a tagline, can be trademarked. Words are easier to trademark if they are part of a graphic expression, making them more distinctive. Trademark your logo and/or tagline once the graphic treatment is final.

You can use a ™ symbol on any mark that you wish to designate as a trademark. No registration is required, and in most states this provides some "common law" trademark rights. You may only use the ® symbol, which means your trademark is "registered," once you obtain a federal trademark registration from the US Patent and Trademark Office. The process of applying for a federal trademark takes about a year. During the application process, you must continue to use ™ until the federal registration is issued.

Pitch Perfect

You're ready to pitch your project to potential producers, funders, or distributors. To initially sell partners on the project, you need communications tools that are accessible and engaging. The best sales tool of all is *you*. Ideally, you present your project to decision-makers in a face-to-face meeting. Be sure you have a strong script or treatment, a sound marketing plan, compelling materials, and excellent artwork and visuals. And adopt a positive attitude about your project's value.

> *I try to create a sense of inevitability and certainty when taking material out in the marketplace. So the question to financiers and distributors is not "Will you help us make this film?" but rather "We're making this film, would you like to be part of it?" In order to create that sense of the inevitable, the script is as close to perfect as possible, there is meaningful talent attached, and the producer/ filmmaker team is aligned in expectation of budget and aesthetic and unified as to the ideal of what the film will be. I always like to have a sense of the budget, some comp films as examples for scale and tone, and an easy way to describe the film that is digestible and repeatable to/by others—in case I meet with someone who has to talk to their partners about it.*
>
> —Anne Carey, film producer, *The American*, *The Savages*, *Adventureland*

To secure that pitch, develop a one- or two-page project overview. Write it in user-friendly and compelling language. Start with an overview of the project (your Executive Summary) and logline, a brief synopsis of the plot and characters, and a few bullets of the target audiences and key marketing strategies. Include visuals, credits, and contacts.

To get your foot in the door with the right people, mine all of the contacts you and your partners have. Even the most successful writers, producers, directors, and marketers stump for their projects every day to get them up and running. Hopefully, you've been networking for a long time. It's a critical ingredient to success.

> *The most important thing is to make connections. You need to put yourself out there and you need to start meeting people and putting people in your back pocket so that you've created your own base, structure, and foundation of people that you can rely on to help you with your career as you're strategizing and moving forward.*
>
> **—Nancy Robison, director of education programs, Television Academy Foundation**

Once you've secured the introduction, send your project overview with a short (three-paragraph) e-mail. Make the case for why this project is a good fit with their organization. Be clear what you're looking for (development, production, financial investment, distribution) and ask for an opportunity to pitch in person. If they're interested, they might ask for more written materials, the sizzle reel, business and marketing plans, or a meeting. Ideally, send treatments, scripts, sizzle reels, and plans after the meeting so you can alter them based on what you learned from the meeting.

If a reputable prospective partner asks you to sign a NDA (non-disclosure agreement) before the meeting to protect confidential and proprietary information, it's OK, but have your attorney look at it first. You can try to alter theirs so that it's mutual and protects both parties. Most entertainment organizations transcribe or take detailed notes in pitch meetings to protect themselves from claims of stealing ideas. If your idea is copyrighted and registered with the WGA, and you've kept a meticulous paper trail, it's much less likely to happen.

Now you have the pitch meeting. Careers and projects are made and lost on pitch meetings. Be sure you know how long the meeting will be and what you're expected to do. If they expect a full presentation, that's an entirely different meeting than a casual conversation.

Start by *knowing your audience*. Make sure you have the name, title, and internal responsibilities of everyone who's attending the meeting. Determine who the decision-maker(s) are. Google each person and learn everything you can about them. See what they've been working on. Also, know the organization. Their previous projects and budgets are a good barometer of the projects they'll do in the future. If they're in television, know their per episode budget criteria. Stash all that information in the back of your brain.

Now it's time to *plan* your pitch meeting. Make the pitch one-quarter of the total meeting, and the Q & A, at least one-half. Create a meeting agenda, which for a 60-minute meeting

would be: The first 10 minutes everyone gets settled and the meeting is tee-ed-up. You present for 15 minutes. Then there are 30 minutes of Q & A and discussion, and a five-minute wrap-up.

As you plan your pitch, don't assume it's a 15-minute oral presentation of your treatment or marketing plan. Even though you have to convey much of the same information, you must present it very differently in person. In the pitch, you must be *relevant*, *personal,* and generate an *emotional* reaction from your audience—while delivering key information. You want plenty of enthusiasm and passion, tempered by business practicality. The most important thing when communicating with any audience is to be authentic to you and your project.

As a storyteller, the faster you connect your audiences emotionally to your project, the better. So, find an opening that grabs your audiences' attention immediately, such as a big idea, an analogy, a personal anecdote, or a first-person character recount. Or, if you have a fantastic short (30-second to one-minute) clip or sizzler, you can open with this. Your short opening reels in your audiences to connect with a general idea, feeling, mystery, or key character's big challenge.

Then segue to your creative vision for the project. This one-minute overview (the elevator pitch) enables audiences to fully grasp what the project is. You can embellish your story's logline with the themes, conflict, mood, and genre, and add highlights of the SWOT Analysis, audience appeal, and *über*-goal. Mention major partners here to lend credibility to the project. Now audiences want to hear more.

The next section, at about five minutes, should answer the "what, who, when, why, and where?" of the project: its plot, characters, style, media platforms, and executional specifics. Next, bring it all home by demonstrating how the project will be commercially viable through its marketing, outreach, and engagement possibilities. Give an overview of the audiences, goals/objectives, strategies, and tactics. Demonstrate how a few of these techniques will work. This three- to five-minute segment is where they sense that this project just might be a hit or fill a niche for the organization.

Finally, focus on the budget. Cover the overall cost to accomplish all that you've described, what's been raised so far, and your plans to raise the rest. Close by reminding your audience of the fit between your project and their organization and end with an ask, "That's why we'd love Company X to join us as our (partner, distributor, funder, co-producer)." The conclusion should be about a minute. Sometimes a clip is a good way to conclude if it ends with a big emotional point.

Even if you don't have tape, use visuals somewhere. If your three-minute sizzle reel is a stunner, then show it at the meeting. But know that its production values, pacing, writing, editing, and tone will be evaluated as a barometer of the quality of project you will deliver. If your sizzler doesn't pass this litmus test, then it's better to show a short video lift, still photos, illustrations, storyboards, director's lookbook, or a short GIF animation to bring your concept to life.

Two presenters is the maximum for short presentations. Practice your presentation with friends, family, and colleagues. Solicit feedback and take their suggestions to heart. If your practice audiences don't get it, neither will the people in the pitch meeting. And practice for time. The presentation should be generally committed to memory, but delivered in a natural, conversational tone.

Also, prepare for the Q & A. This is where deals go south. The presentation was great, but the strategic thinking and business acumen don't back it up. Refer to your written project Q & A and add all the questions you can think of. Some questions will offer an opportunity to provide details not covered in the formal part of the presentation. Other questions may crop up in areas you wanted to avoid. Be prepared to differentiate your project from other competitive projects. If your expertise is weak in an area required by the project, then mention the experts you are bringing on board in that area.

Be prepared for lots of questions about the budget. Know the topline numbers such as production, animation, or marketing and provide a general timeline from greenlight to launch. Have the complete plan, budget, and timeline with you at the meeting for specific questions. Deliver solid answers to all questions—easy, tough, and detailed.

Now that you've planned your presentation, be flexible if it plays out differently. Set a good tone by showing up early. When people enter the room, introduce yourself to each person. That gives you a leg up on who's attending and makes an instant connection. Make sure you and your team are introduced before you start, and watch the clock.

Remember, the goal of the meeting is to present an overview, your vision, and some details to get to a vibrant Q & A. In reality, meetings vary a lot. Some organizations expect you to present with no interruptions. Usually it's more fluid and there are questions along the way. Pay close attention to the questions and who asks them. Adjust your presentation on the fly to overcome any concerns and beef up their areas of interest.

The Q & A is where deals get closed in people's minds so you want to look confident and steady. You'll get questions you didn't think of or that you don't like. Be honest, look your audiences in the eye, and acknowledge a failure, disappointment, or area of weakness. Then counter with a positive or a mitigating factor. If you get a question to which you don't know the answer, say "I'm not sure about that, but I will get back to you."

Before the meeting ends, determine the next steps. Then you'll understand their process, clarify decision-makers, and determine timing to guide your follow-up. If you can, thank each person individually for the opportunity. If not, thank the larger group and thank the host or your contact personally.

Your first follow-up e-mail should be prompt (within 24 hours) and should be addressed or cc'd to everyone who attended, unless you're instructed differently. Thank them for the opportunity; provide requested information and additive content; and express interest in their feedback. If you have a special champion inside the organization, send them an additional private e-mail and ask if there's anything else they need. Show that you're a

responsible, trustworthy, and courteous prospective business associate. Then, follow up thereafter in the timeframe that they provided at the end of the meeting.

Remember, the opportunity to pitch your project can arise anywhere—from the boardroom to the dog park. Always have the elevator version of your pitch at the ready.

Your Transmedia Future

Transmedia is here to stay. Humans are impelled to tell stories—over the campfire or through the cloud. Media is the first language of the youngest generations. They're curating their own YouTube channels, participating in ARGs to solve fictional universe mysteries, and becoming citizen scientists to help cure major diseases. Their ease in moving across platforms and willingness to participate directly with different kinds of narratives, speaks to the bright future of transmedia.

Audiences' appetite for media has accelerated with each new storytelling platform and content experience. And entrepreneurs' capitalization of the media business has fed that demand with a dizzying array of technologies and products. The mass circulation newspaper press barons of the nineteenth century gave way to the film studio, broadcast network, and publishing house media moguls of the twentieth century. The new media behemoths of the twenty-first century boast transmedia portfolios including film, broadcast, print, online, streaming, games, social media, and mobile media. Whatever the century, there have been business forces with dominant ownership, control, and influence over mass media enterprises—operating from the *top down*.

Today's new media barons are Apple, Comcast, Amazon, Google, and Facebook, operating over entire ecosystems and controlling and selling content, distribution systems, and devices. Apple, Comcast, and Amazon dominate distribution—how you access the Web through tablets and other screened devices. Google and Facebook dominate audience data and psychographic profiles—who you are and what you do.

> *I think the most interesting thing to watch will be the way in which the Internet invades television. And I think that that will be much more consequential than what's already happened. I don't think we know what that's going to look like yet. There's not just a corporate fight to be had, the most interesting fight to follow is the fight between Google vs. Apple on the digital front or either of those players versus Comcast on the kind of traditional versus new insurgent front.*
>
> —**Andrew Golis, general manager, The Wire,** *The Atlantic*

But what's different in the twenty-first century is that the massive media enterprises are joined by a new crop of media moguls, people like *you* who create and consume

content alike—operating from the *bottom up*. As a collective, audiences are the most powerful new force in media and entertainment. With increased access to videocameras, editing software, broadband, and wireless connectivity, audiences are media makers, media distributors, media marketers, and media consumers. And they're operating side-by-side and in league with big media. Technology has truly become the great equalizer.

The tectonic shifts in content creation, distribution, and consumption have ushered in a new Platinum Age of media and entertainment. Media and entertainment growth and innovation are exploding, with media stocks out-performing the overall market. Some key drivers already in play are:

- Globalization of entertainment, with China and India emerging as powerful forces
- Accessibility of cross-platform media production, attracting new and diverse creative talent
- Time-shifting and mobile media consumption revolutionizing distribution models
- Entertainment proactively linking with technology, witnessed by the surge in Silicon Beach startups
- Socialization of media—making audiences co-producers and co-marketers
- Big data providing targeted, actionable insight
- Brands becoming content, rather than interrupting it
- Comedy serving as the context for almost everything

As transmedia progresses, it won't look like you or your neighbor. It will look like a mosaic of everyone.

> *The most powerful element at the moment is the globalization (or at least the transnationalization) of transmedia. Transmedia assumes different shapes depending on the cultural contexts in which it operates. We can point to the differences people have identified between the West Coast "Mothership" model and the East Coast ARG model within American media, we could think about the Japanese Media Mix model, the more public service-oriented models in Canada or the EU, and a more multi-cultural model in Brazil and other parts of Latin America. But wait until Bollywood or Nollywood get ahold of transmedia and reshape it to their local particulars. What will transmedia look like in China, Russia, or the Islamic world?*
>
> **—Henry Jenkins, provost professor of communications, journalism and cinematic Arts; USC**

Transmedia not only affects how people are entertained, but also influences culture. There are several technologies on the forefront of shaping culture:

- The cloud—allowing audiences to store, share, and collaborate virtually
- The Internet of Things—connecting people, data, processes, and things (offices, homes, cars, media devices, people, and animals)
- Wearable personalized media systems (headsets, clothing, and devices embedded in human bodies)—integrating technology and humanity
- 3-D printing—creating customized objects for construction, vehicles, medicine, and art

The most exciting or far-reaching advancements are limited only by our imaginations.

iStock.com/scanrail

The cloud and the Internet of Things will connect everything in the near future.

Transmedia will be on the leading edge of all of those possibilities because transmedia is a pioneer, an experiment, a journey, and an evolution. Its players will come from many other walks of life—musicians, artists, comedians, scientists, doctors, philosophers, politicians, technologists, entrepreneurs, architects, and students. Along with entertainment and media makers and marketers, they will innovate across integrated media platforms to entertain, educate, inspire, and motivate.

> *I believe that media will cross more and more with science and serve different functions besides entertainment and advocacy. Media as emotional and behavioral tools could become a healing vector, while Augmented Reality (with Google Glass) and Virtual Reality (with Oculus) could earn a strong place in education. In all of this, transmedia is and will be the glue, the fil rouge that could make this evolution happen.*
>
> **—Nicoletta Iacobacci, curator, TEDxTransmedia**

In the future, transmedia simply will be part of everything we do. It will push the boundaries of storytelling, communicating, and innovating. Transmedia might be called something else, because describing our relationship with media may be more about the audience *experience* than about the media *platforms* that deliver it. No matter what, transmedia 2.0 will be about discovery, goals, challenges, feedback, socialization, impact, and fun.

You're already part of that transmedia future. You've got a great concept or are on a team working on a terrific project. You've written your transmedia content and marketing plan with an eye toward engaging your audiences. You've prepared for your project's financing and distribution. As the CEO, CCO, and CMO of your media project, you have communicated your vision, demonstrated your mettle by taking the helm, and shown wisdom by surrounding yourself with smart and talented people. *You're ready*.

You're ready to explore these new frontiers of transmedia. You're ready to launch your project into the marketplace of ideas. You're ready to understand how your transmedia marketing approach can create emotionally- and socially-transformative experiences.

Your call-to-action is to go forth and create and market your transmedia project. Like Nike says in its tagline, "Just Do It!" In so doing, you will enjoy at least two kinds of success—the inherent fulfillment of creating content and the contentment of believing in yourself.

Be dogged.
Take risks.
Stay flexible.
Have fun.
Swing for the fences.
Be transmedia.

"Blue Check" by Gregory Maxwell; Licensed in the public domain via Wikimedia Commons

You're transmedia ready.

Author's Anecdote

Bringing This Media Project to the End Zone

Transmedia Marketing: From Film and TV to Games and Digital Media was my first book. It added a new media platform to my original creation portfolio. The only way I could bring it to the end zone—get it written to my satisfaction and delivered to my publisher—was to think about or work on this book almost every minute of every day for a year. It wasn't always fun, but it was always gratifying. Now my publisher and I must market it! If you're reading this right now, our marketing efforts must have worked, in some part.

My hope is for this book is to help media makers and media marketers learn their craft or do their jobs better. Whether you're a seasoned entertainment professional, a media newbie, or a university professor, I'd love to have your feedback. Contact me at www.transmediamarketing.com

Index